Antiquity in Gotham

Antiquity in Gotham

The Ancient Architecture of New York City

Elizabeth Macaulay-Lewis

ESE

Empire State Editions

AN IMPRINT OF FORDHAM UNIVERSITY PRESS

NEW YORK 2021

Fordham University Press has no responsibility for the persistence or accuracy of URLs for external or third-party Internet websites referred to in this publication and does not guarantee that any content on such websites is, or will remain, accurate or appropriate.

Fordham University Press also publishes its books in a variety of electronic formats. Some content that appears in print may not be available in electronic books.

Visit us online at www.fordhampress.com/empire-state-editions.

Library of Congress Control Number: 2020925117

Printed in the United States of America

23 22 21 5 4 3 2 1

First edition

CONTENTS

FIGURES

Antiquity in Gotham

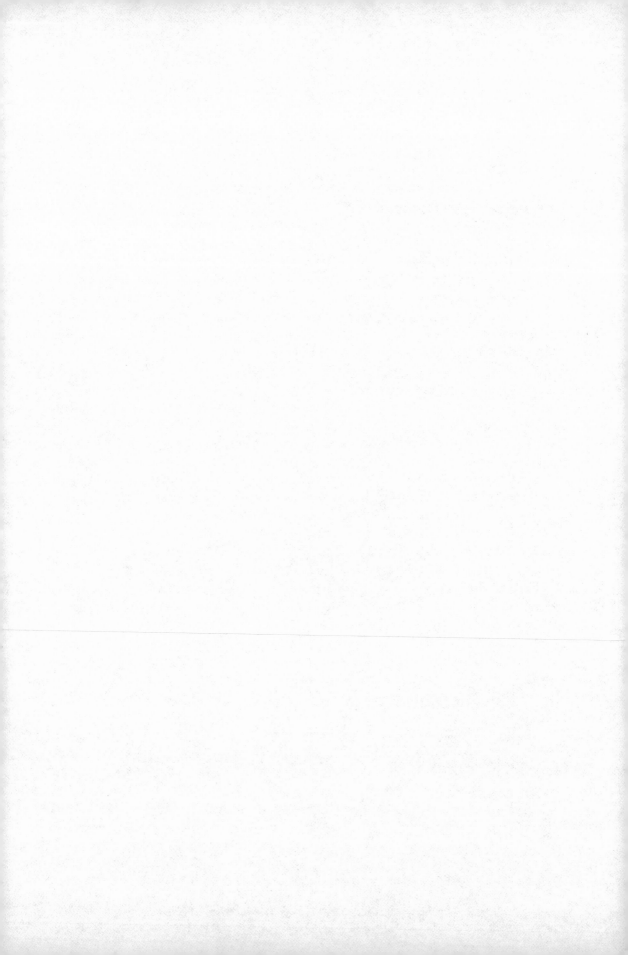

Introduction: From the Appian Way to Broadway

This study, *Antiquity in Gotham: The Ancient Architecture of New York City*, stems from a chance encounter. As the child of an ornithologist, I spent many hours in the storerooms of the American Museum of Natural History, drawing or reading, while my mother photographed and documented bird skins. Since we lived in Connecticut, we would drive into New York City and enter the museum via Columbus Avenue. My childhood memories of the museum are filled with brightly colored, exotic birds, dioramas of cougars about to pounce, skeletons of dinosaurs, and the wondrous universe as experienced at the Hayden Planetarium.

I was therefore struck dumb when I returned to New York City in 2011 after almost a decade abroad: I walked through Central Park toward Manhattan's West Side to find the Arch of Constantine attached to the façade of the American Museum of Natural History (see Figures 21 and 50). At this moment, as an utterly confused classical archaeologist, I wondered aloud, "Who stuck the Arch of Constantine to the American Museum of Natural History?" Far more sensible New Yorkers walked past, ignoring me as if I were a tourist.

Upon closer inspection, it was evident that a modified version of the Arch of Constantine had actually been affixed to the museum's west façade. This elaborate arch and its accompanying plaza served as the main entrance to the museum and as the New York State Memorial to Theodore Roosevelt. The now controversial equestrian statue of Roosevelt, accompanied by two highly problematic and racist figures of a Native American and an "African,"[1] stood in front of the arch rather than atop it, as such a statue group would have done in ancient Rome. The explorers and naturalists—Lewis, Clark, Audubon, and Boone—took the place of the bound Dacian captives who stood on top of the Corinthian

columns on Constantine's arch. The seals of New York State and New York City replaced the Hadrianic *tondi* of sacrifices and hunt scenes.

Why on earth did an early fourth-century CE Roman arch, which celebrated Constantine's victory in a civil war, serve as a model for a commemorative memorial to a beloved American president and famed son of New York? Why did the New York legislature and Henry Fairfield Osborn, the president of the museum, select the arch? Did they know that it was a triumphal arch? Did it matter that it celebrated a victory in a civil war? These questions stayed with me. Soon I started seeing columns, temples, obelisks, and personifications of Victory throughout New York City's five boroughs. I became more and more puzzled: If the skyscraper was the quintessential New York building, then why was the architecture of imperial Rome, fifth-century BCE Athens, the Hellenistic world, ancient Egypt, and the ancient Near East present on practically every other street corner? Why had ancient architecture been of sustained interest and use to New York's architects, artists, officials, patrons, and elites throughout the city's history? Such quandaries led to this project, which investigates why the architecture of classical antiquity, ancient Egypt, and the ancient Near East has been repurposed in the architecture of New York City since the late eighteenth century.

Why Antiquity?

Since the United States' inception, classical antiquity and, to a lesser extent, ancient Egypt and the ancient Near East have been powerful models for American art and architecture because of the flexibility, diversity, and potency of meaning that these forms carried. As the scholars Shane Butler and Brooke Holmes note, classical antiquity is not monolithic[2] but fluid, flexible, endlessly mutable,[3] and untimely.[4] Classical antiquity changes with place and time, and thus the legacy of antiquity is complex and rich. The classical world held a special place for the United States. Not only were Greece and Rome seen as the originators of "Western Civilization," but the political, philosophical, and intellectual traditions of the classical world, specifically the concepts of tyranny and good governance, were core to the Founding Fathers' arguments supporting the Revolutionary War, while the ideas of republicanism and democracy informed the development of the government of the newly formed United States.[5] The architecture of ancient Athens and Republican Rome could symbolize the ideals of democracy; unsurprisingly, classical forms were used for some of the earliest public buildings in Washington, DC, including the original Capitol building and Palladian-style White House, both of which burned down in 1814. Thomas Jefferson's home Monticello, his Rotunda at the University of Virginia, and his designs for the Virginia State Capitol emulated Roman models, specifically the Pantheon and the Maison Carrée. The Roman Empire, once avoided as a model because of its decline and fall, was embraced as the United States was politically and economically on the rise in the late nineteenth century. With its imperial power and majesty, Rome became a model for emulation—with certain American caveats. The exceptional American empire, built on trade and merit and composed of citizens (not subjects),[6] would prevail, unlike the Roman and European empires, where a king

or emperor reigned. However, the imperial overtones of Rome would not resonate easily with American democracy in the early twentieth century, so the relationship between ancient Roman forms and American architecture would once again be renegotiated.

Likewise, the Latin language was seen to have a degree of permanence and universality that later civilizations and languages lack, allowing it to transcend religious, ethnic, and social differences.[7] The monumental pyramids, obelisks, and sphinxes of Egypt were also considered by later architects and artists to reflect technological achievements and to have an enduring timelessness.[8] The architecture of ancient Egypt's thousands of years of history undoubtedly brought a sense of permanence to a nation that was less than a century old. Likewise, the ancient Near East also offered highly original and exotic—although not often replicated—forms. The events of the Bible also played out across Egypt and the ancient Near East, forging another tie.

Ancient architecture could offer a new nation suitable political references, bring gravitas to newly founded cultural institutions and universities, dignity to a civic edifice, or a touch of luxury to a restaurant. Immigrants, veterans, and others who did not belong to the city's elite also used ancient forms to create architecture that could convey their aspirations and identity. In New York City, different places and points in antiquity and its rich architectural history provide useful, diverse models to architects, patrons, tastemakers, and politicians to express their status (or their company's strength), document key moments of New York City's history and the city's goals, as well as to create much-needed infrastructure. Together Greece, Rome, Egypt, and the ancient Near East provided the new nation and city with a series of useable pasts ripe for repeated reinvention.

Methodologies, Evidence, and Themes: Archaeology, Reception Studies, and the Neo-Antique

Drawing upon the new theoretical framework of the "Neo-Antique," which I developed with Katharine von Stackelberg,[9] this book presents an original analysis of the reception of ancient architecture in New York City from the mid–eighteenth century through the early twenty-first century. Since the 1970s, reception studies has emerged as a major subfield of classical studies that critically examines the appropriation and reinterpretation—what scholars call the reception—of ancient literature, drama, art, and architecture in postantique periods.[10] This study marks the first comprehensive study of the reception of ancient architecture in New York City.[11]

Breaking with the convention of classifying neoclassical (and Greek Revival), Egyptianizing, and Near Eastern–inspired architecture as distinct categories, the Neo-Antique framework brings together these diverse sources of inspiration into focus in a single continuum. As different as these ancient models are, the choice to draw upon one or more of them participates in a common set of impulses and strategies. When we look at the repurposing of antiquity as a single broader phenomenon, we can understand the strategy more clearly and better define the intellectual, conceptual, and chronological divergences that mark the reception of different ancient architectural traditions.

The Neo-Antique also functions as a framework like the "Medieval Revival,"[12] an umbrella term that describes the diverse engagements with medieval art and architecture that started in the mid–eighteenth century. While the Gothic and Romanesque revivals are undoubtedly different, they are clearly connected. The same is true of the reinterpretation of Greek, Egyptian, Roman, and ancient Near Eastern architectural forms in New York City—they are distinct but also intrinsically linked.

Furthermore, by thinking of the Neo-Antique almost as an ancient revival style of its own, we can discuss, analyze, compare, and contrast the use of Egyptianizing or Neo-Egyptian architecture[13] to those reinterpretations of Greco-Roman architecture and to that of the ancient Near East in New York City, rather than seeing them as separate phenomena.[14] Using the more flexible and inclusive framework of the Neo-Antique, I explore why models from different ancient civilizations were used for certain types of buildings in New York City. Although there is a tendency in the existing scholarship to emphasize the use of classical forms for civic and banking architecture, ancient architectural forms can be found in everything from restaurants to reservoirs. For example, both classical and Egyptian architectural forms were used for grand mausolea in Green-Wood and Woodlawn cemeteries. Roman, Egyptian, and "Babylonian" motifs were pressed into service in garish new restaurants in the first decade of the twentieth century. The appropriation of architecture from the ancient Near East in New York City's buildings was relatively rare, and with too few examples for a book-length study, scholars often ignored them.[15] Their inclusion in this project brings them the scholarly attention they deserve and allows us to explore why these forms were not as popular as borrowings from the classical world and ancient Egypt.

Architects and patrons were often making specific, informed choices about the ancient forms they repurposed. Many of these individuals combined different ancient styles together in new and original ways, especially after 1870.[16] Therefore, calling some of these buildings (or interiors) Neo-Antique means that these different elements (whether Greek, Roman, or Egyptian) can all be given their due rather than subsumed in the generic "neo-classical," where anything not Greek or Roman is typically subservient to the classical. Likewise, the inclusion of nonancient elements deployed in conjunction with ancient forms can also be included in the discussion. Where two styles are used together in the same building or site, often creating a visual, cultural, and intellectual stacking of forms and eras, the frame of the Neo-Antique allows us to explore why these forms were combined.

Ancient art, especially sculpture and painting, and ancient mythology are also part of these dialogues. Personifications—human figures who symbolized an idea, ideal, or value—are a hallmark of classical art. Personifications, like Victory, are highly recognizable, infinitely mutable, and immediately convey authority. They routinely appeared on many of these Neo-Antique buildings, and American sculptors created new personifications for their structures. Likewise, classical gods, especially Mercury, the god of travel and commerce, made regular appearances on these monuments. Thus, sculpture and decoration are an important part of the Neo-Antique conversation.

Furthermore, because many contemporary sources are silent regarding the choice of Greek temple architecture for a bank or custom house, I bring my training as a classical archaeologist to bear in order to assess how well the creators of these buildings (as well as those who engaged with them on a daily basis) understood the ancient motifs, models, and

histories they mined and how these reinterpreted forms acquired quite different connotations in the course of their appropriation. Using firsthand observations and formal analysis, I can identify ancient architectural forms accurately and decipher how modern interpretations of such architecture either replicate or diverge from ancient examples. These observations are then considered in their historical and social context—to understand "the why" behind such forms. Likewise, in many cases, the sculpture of these buildings and monuments are considered in order to understand how American sculptors also looked to antiquity for inspiration.

Connected to this, a knowledge of ancient buildings and what was actually known about them at various points in the eighteenth, nineteenth, and twentieth centuries is critical. For example, Knossos, a site that has captured the imagination of scholars and the public, was not excavated until the end of the nineteenth century; Howard Carter would not discover Tutankhamun's tomb until 1922. Thus, the history of archaeological excavations allows us to understand which models were available and why certain well-documented and reproduced buildings, like the still-standing Choragic Monument of Lysicrates, were so often referenced by American architects. This culture of architectural quotation also meant that savvy, cultured viewers could go on a Grand Tour without having to leave New York. The architecture of other monuments, for example the Mausoleum of Halicarnassus, the Tower of Babel, and the Hanging Gardens of Babylon, do not really survive at all, giving New York's architects and patrons a blank sheet for creative and useful reinterpretations of antiquity for their own purposes.

Recent scholarship, especially highly technical UV studies, has also demonstrated that ancient architecture and sculpture existed in Technicolor; it was a world of polychromy.[17] Indeed, for much of classical architectural sculpture to be legible from the ground, it would have needed to have been painted. However, the engagement with this fact, which was known but often challenged or ignored by leading scholars, architects, and sculptors before the late twentieth century, means that understanding the reception and use of the polychromy of ancient architecture in New York City is complex. While many Beaux-Arts buildings were constructed using white or gray-white marbles, seeking to go back to the supposed "purity" of classical, especially Greek, architecture and sculpture, Roman architecture used brick and colored marble, and the surviving remains from Pompeii demonstrate that color was a major part of the vocabulary of Roman architecture and interiors. While the façade of the Metropolitan Museum of Art eschewed color, Edward Robinson, its director, embraced color for his Pompeian court, where classical art was to be shown in a realistic setting to convey how ancient art was actually displayed; the design was, in Robinson's words, intended "to illustrate the important part that color played in classical architecture."[18] In other Neo-Antique buildings' exteriors and interiors in New York, color would play a surprisingly important part. The exteriors and interiors of the Gould Memorial Library and the Madison Square Presbyterian Church used color, as did the interiors of Grand Central Terminal and Columbia's Low Library. While it was not necessarily standard, it was not uncommon. Painters such as Lawrence Alma-Tadema, Frederic Leighton, and others embraced and integrated color into their paintings of ancient subjects, as well as in their interiors. The reception of both ancient Egyptian and Near Eastern art and architecture embraced polychromy, as is clear at the Pythian Temple,

the Fred French Building, and, to a lesser extent, 130 West Thirtieth Street.[19] Color was one way for buildings to stand out in the competitive real estate market of New York.

Key movements in American architectural history are also integrated into this analysis. The political ideas behind the Greek Revival are vital to understanding the widespread adaption of classical architecture in the early nineteenth century. Likewise, the influence of the Beaux-Arts tradition—which emphasized Roman and Renaissance architecture and design principles—and the City Beautiful movement of the late nineteenth and early twentieth centuries are inextricably entangled in the history of New York City's architecture and in the appropriation of ancient, especially Roman imperial, architectural forms. These architectural movements were distinct, and the architects who worked in these styles were clearly appropriating antiquity in different and informed ways to suit their ends. However, the strategy that they used—purposefully evoking and interpreting a specific moment in antiquity, be that the world of ancient Persia, democratic Athens, Ptolemaic Egypt, or imperial Rome—was the same, though deployed differently to convey the appropriate meaning of gravitas, culture, luxury, security, or whatever might be appropriate in that context. While some architects and patrons were very thoughtful in their selection of a Roman arch or Greek column, others missed these important differences. By using a Neo-Antique framework, we can bring these various movements and styles together—rather than seeing them as unconnected—to understand the evolution in the appropriation of ancient forms and the various attitudes that architects, patrons, and critics held toward such forms to gain new insights into New York's architectural history.

New York did not exist in a vacuum. Throughout this book, New York's Neo-Antique architecture is contextualized within larger American architectural trends. The well-known columnar architecture and domes of Philadelphia and Washington immediately come to mind,[20] but Chicago, San Francisco, St. Louis, Cleveland, and countless other American cities had individual buildings or groups of buildings—civic centers, museums, and libraries—that were classical in concept and design.[21] State capitol buildings from Indiana to Minnesota featured white columns and towering domes, while the Roman temple façade became the defining architectural idiom for America's court architecture.[22]

European architecture, especially Britain's great houses (and their Pompeian interiors), temple-like banks, and exchanges, were important influences on American architects. Classical architecture was not only considered the source of European architecture, but neoclassicism was a major force in the creation of European art and architecture from the Renaissance onward. For Americans, Europe provided cultural and artistic inspiration, and European interpretations of ancient forms were important—and sometimes as important—as the ancient models themselves. Therefore, New York's architecture is compared to its European precursors and contemporaries; Neo-Antique buildings were an important part of New York's process of becoming a world-class, cosmopolitan metropolis.

This fundamentally interdisciplinary project draws upon all available evidence and archival materials—such as the letters and memos of architects and their patrons and commentary in contemporary newspapers and magazines—to provide a lively, multidimensional analysis that examines not only the city's ancient buildings and rooms but also how New Yorkers envisaged them, lived in them, talked about them, and reacted to them.

One key type of evidence is the books on antiquities that were first published in the mid–eighteenth century in Europe. Before the mid–nineteenth century, very few Americans traveled abroad. If they did travel, it was typically to Western Europe, particularly to Britain and France. However, books, such as *Recueil d'antiquités*, by the Comte de Caylus (1753–1767); Julien-David Le Roy's *Les ruines des plus beaux monuments de la Grèce* (1758); James Stuart and Nicholas Revett's four-volume *The Antiquities of Athens* (1762–1816); Johann Winckelmann's *Geschichte der Kunst des Alterthums* (1764); Dominique-Vivant Denon's *Voyage dans le Basse et Haute Égypte* (1802); the twenty-two-volume *Description of Egypt* (1809–1822); and others brought ancient architecture to a much wider cross-section of the population. These books were expensive; for example, the first volume of *The Antiquities of Athens* was being sold by Thomas Arrowsmith in London around 1800 for seven pounds and three shillings,[23] or a cost over 590 British pounds in 2019. In 1854, a complete set was selling for 24 pounds,[24] which is equivalent to over 3,070 pounds in 2019.[25] That said, by the 1810s, public and private libraries would make these books accessible to a wider audience. The architectural books in Thomas Jefferson's library are probably the most important early collection of their kind in the United States.[26] As early as 1760–1762, he bought at least one or possibly two copies of James Leoni's *The Architecture of A. Palladio* (1715–1720 or the 1742 edition); he also purchased James Gibbs's *Rules for Drawing the Several Parts of Architecture* (1732) and other practical guides to building.[27] His library also included works by the Italian architect Vincenzo Scamozzi, who worked with Palladio, and Vitruvius's *De architectura*, as well as editions of Robert Woods's 1757 *Ruins of Balbac* [*sic*], Le Roy's 1759 *Ruins of Athens* (the English translation of his 1758 work), Castell's 1728 *Villas of the Ancients*, the first volume of *The Antiquities of Athens*, and works by Giovanni Battista Piranesi. In 1815, he sold his library of 6,000 books, including these works, to the Library of Congress,[28] making them accessible to future generations of architects, designers, and patrons.

Ithiel Town, the important early American architect and engineer, had over 11,000 volumes in his library, which he opened to other architects.[29] These expensive works were also digested by successful British architects who had emigrated, like John Haviland, the architect of the Tombs, who owned a copy of the *Description of Egypt*, and American architects, like Minard Lafever, who wrote guides for builders, such as the widely used *The Modern Builder's Guide* (1833), where classical architecture was central, thus spreading the classical idiom further afield. Classical and Near Eastern art was also experienced through an important intermediary: casts. These replicas were held in many American museum collections and were considered to be the most accurate way to understand ancient art until the emergence of photography.[30]

The first wave of professional interior designers, like the Herter Brothers, had a central role in popularizing ancient interiors in the late nineteenth century. Coming from Europe, they brought their knowledge of the designs of the old and ancient world, which could confer a cosmopolitan sophistication on their patrons. Likewise, the interiors of the rich and famous also started to appear in the popular press, as we will see in Chapter 5, bringing Pompeian and other ancient-inspired interiors to a wider audience, which then emulated their richer peers.

By the mid–nineteenth century and especially after the Civil War, American architects, such as Charles McKim and Stanford White, and artists started to train in Europe and gain firsthand exposure to the art and architecture of antiquity, which they readily incorporated into the American tradition. Paralleling these developments, Americans started to travel abroad. Not only could the wealthy spend the winter season in Paris, but increasingly the upper ranks of the newly enriched middle class could afford to travel to Europe; there were now tourists in the modern sense. One need only think of Edith Wharton, who spent much of her childhood in Europe, or of the affluent friends of the March sisters, including their beloved neighbor Laurie, in *Little Women* (1868), who spent time in France and Italy. Mark Twain's humorous *Innocents Abroad* (1869) chronicled his travels with a group of Americans to France, Rome, Odessa, and, of course, the Holy Land. The culmination of Twain's trip to the Holy Land also signaled the wider horizons of American travelers, who also started to venture to Egypt, especially in the late nineteenth century. Americans now had firsthand access to many of the ruins that previous generations had only seen on the printed page. Patrons who saw interesting architecture on their travels could purchase postcards, stereographs, and photographs, which became popular in the 1860s,[31] to document their trips or the trips they aspired to take one day, thereby replacing the drawings in expensive archaeological publications with affordable likenesses. By the 1880s commercial photography was a major business, and publications such as *National Geographic*, founded in 1811, would become increasingly photograph dependent, thereby bringing archaeological sites to a wider audience. Likewise, design magazines popularized ancient designs as well as the interiors of the well-to-do, as *Architectural Digest* does today.

Organization of the Chapters

One cannot possibly chart every use of a Corinthian column, winged Victory, or temple-like bank in New York. Many ancient artistic and decorative motifs became so internalized in the vocabulary of American architecture that they ceased to reference antiquity and simply became American. This study is neither a site gazette nor a guidebook, although there is scope for a future project like that.[32] Rather, the nine chapters take the reader on a tour of curated architectural examples of a specific building type or types that engage with and appropriate ancient architecture and examine the reasons behind this reception through time and space. These buildings serve as metonymic examples for the architecture inspired by antiquity. Each chapter is designed to stand alone, so that a reader can read them individually; as such, some repetition of key ideas and themes is necessary.

Chapter 1 examines the city's innards and edges to explore how ancient architecture was appropriated in the infrastructure of New York City from c. 1800 into the early twenty-first century. The city's defining grid pattern, the first major urban improvement in New York City, has its origins in the city planning of classical antiquity. New York's Croton Aqueduct, the city's next major infrastructure project, was clearly understood through the lens of its Roman predecessors, and the Murray Hill distributing reservoir was built between 1836 and 1842 using Egyptian-style architecture, in a proud nod to a

civilization that was considered an exemplar of technological innovation. Moving downtown to the Manhattan Bridge, I argue that the arch and colonnade served the dual purpose of beautifying the Manhattan approach to the bridge and facilitating the flow of traffic. The chapter then examines the old Pennsylvania Station and Grand Central Terminal, perhaps New York's most famous examples of the reinterpretation of ancient architecture, fashioning great twentieth-century transportation hubs on the model of Roman imperial baths. A bath house and a train station might seem a surprising pairing, but both need to circulate large numbers of people efficiently and to immediately communicate the power and prestige of their builders (a city or an emperor). Furthermore, as I and others have noted, the adaption of Roman bath architecture for train stations was in fact an apt and successful design solution that fulfilled functional, aesthetic, and symbolic needs.

Chapter 2 considers how Greek Revival architecture, drawing specifically on classical temples, was widely adapted for the civic, judiciary, and administrative—what might be termed public—architecture of early nineteenth-century Manhattan and Brooklyn to erect buildings meant to embody the political values of the new United States. The US Custom House, one of New York's earliest and most important civic buildings, was modeled on the Parthenon. Its Grecian architecture embodied the ideals of the Greek Revival style and demonstrated that many of the United States' first professional architects were learned men who used new archaeological publications to design their buildings. An exceptional example of civic architecture—New York's first court-and-jail complex, nicknamed the Tombs—was built in an Egyptian style, again based on archaeological knowledge, providing a telling exception that illuminates the larger trends. At the end of the nineteenth century and into the early twentieth century, Roman architecture supplanted Greek and Egyptian temples as the favored model for public buildings. This is evident at the various court buildings at Foley Square; the new courthouse in Richmond, on Staten Island; and the colossal vaults and arched façade of the Manhattan Municipal Building—a development that, I argue, reflected the rise of imperial Rome in place of the Greek *polis* as the primary ancient political model for the United States, which now had an empire and global ambitions.

Trade, banking, and financial services have been emblematic of New York and its economy since the city's founding, and in building impressive edifices for the city's banks, stock exchanges, warehouses, and skyscrapers, New Yorkers have continually engaged with ancient architecture. Chapter 3 examines how the Greek temple served as the key reference for many financial buildings, as it did for civic architecture, in the early nineteenth century. In the late nineteenth century, these Greek models gave way to a preference for Roman forms that were used in an eclectic way with little regard for specific ancient models, as evidenced in such new creations as McKim, Mead & White's Bowery Bank. In the twentieth century, ancient architectural elements could be found on skyscrapers—both at street level and on the lofty topmost stories. Turning to the Bankers Trust Building at 14 Wall Street and the Fred French Building on Fifth Avenue in Midtown, this chapter concludes by demonstrating how skyscrapers appropriated ancient architectural forms for the familiar reasons of their aesthetics and their lasting cultural appeal as symbols of strength and endurance—but did so in surprisingly divergent and original ways. As the appeal of the symbolic nature of ancient architecture waned in the early twentieth century,

the principles of classical architecture continued to play an important and perhaps unexpected role in the design of some of New York City's most important modernist, mid-twentieth-century buildings, including the Seagram Building.

Chapter 4 examines the museums, zoos, universities, and libraries that sprang up in New York as a signature element of the city's surging cultural life in the nineteenth century, especially between 1865 and 1930. The Metropolitan Museum of Art, the American Museum of Natural History, and the New York Zoological Society (better known as the Bronx Zoo) were all established at this time. The trustees and directors of these new institutions, as well as of the Brooklyn Institute of Arts and Sciences (later rechristened the Brooklyn Museum), chose classical architecture for their buildings because it was felt to embody, in a readily recognized visual language, the scientific and educational ideals of these new institutions as well as the idea of an established intellectual tradition. By reinterpreting ancient forms for their new campuses, with Pantheon-inspired libraries at their cores, New York University and Columbia University asserted their status as elite universities. Likewise, Lewisohn Stadium, an amphitheater-inspired stadium, articulated City College's academic ambitions. The chapter concludes with a brief discussion of the architecture and aims of public libraries in New York City.

Chapter 5 steps inside mansions and rowhouses to look at the many colorful and eclectic ways that domestic architecture in nineteenth-century New York took inspiration from ancient architecture and interiors. In the first half of the nineteenth century, the use of the Greek Revival style in private homes allowed homeowners to express the patriotic ideals of the young nation. During the Gilded Age in New York City, opulent Pompeian rooms became popular in the palatial residences of America's newly minted millionaires, allowing the robber barons of the era an opportunity to display their wealth and status. The Greco-Pompeian music room of Henry G. Marquand is a case in point to understand how these fanciful, ornate rooms were created—and, moreover, how they tacitly navigated new cultural tensions. In the late nineteenth century America's middle class embraced art and furniture inspired by antiquity, in mass-produced forms and quantities, to display their social aspirations and their desire to emulate the very wealthy. The chapter ends with a look upward again, to the tops of apartment buildings, where the use of classical decorative elements in the twentieth century was the latest reinterpretation of ancient forms in domestic architecture.

Chapter 6 examines the "lobster palaces," restaurants that flourished in the roaring years between 1890 and 1920 as favorite spots for New York's fast set to socialize and indulge in the conspicuous consumption of food, women, and wine. Murray's Roman Gardens and the Café de l'Opéra stood out for their ebullient appropriation of ancient art and architecture in their décor, creating over-the-top dining experiences for the wealthy. The opulence and luxury of imperial Rome, Ptolemaic Egypt, and the ancient Near East, I argue, offered highly original—and culturally valid—models for the pleasure pavilions of the unabashedly wealthy. It is no accident that aspects of antiquity such as luxury, exuberant hedonism, and the attractions of empire, which had been seen as problematic at the start of the nineteenth century, were now embraced. Vast fortunes had been created in the wake of industrialization, and the United States now had an empire, which its optimistic new patricians believed would be exempt from decline.

Green-Wood (1838) and Woodlawn (1864) cemeteries are two of the most influential—and loveliest—rural cemeteries in the United States. Neo-Antique tombs were very popular with the established elite and the nouveau riche that dominated the upper spheres of the United States' economic, cultural, and social worlds, and in Chapter 7 I explore the web of reasons behind the fashions that followed New Yorkers to their graves. An ancient temple in a bucolic setting appealed to an aesthetic sensibility informed by decades of Romanticism, but formal reasons are not to be overlooked: Mausolea often copied classical or Egyptian temples, which were exceptionally well suited to a tomb, as a temple's cella was easily translated into a space for burials. Furthermore, in a country whose churches, courthouses, and banks had been dignified with columns and pediments for almost all of its young history, interment in such a tomb signaled that one belonged to the social elite. For specific examples, this chapter peers into the tombs of John Anderson, Jay Gould, Henry Bergh, Jules S. Bache, and others.

From the late nineteenth century onward, columns and Roman-style arches were erected to commemorate veterans, prominent Americans, and historical figures. Chapter 8 argues that the arches and columns that became popular monuments at important physical intersections in late nineteenth-century New York allowed New Yorkers to celebrate not just specific personages or events but also, more broadly, the history and grandeur of their city. The Washington Square Arch and the Soldiers' and Sailors' Memorial Arch in Brooklyn are examined as case studies. For the elites that ran the city, monuments, along with their inscriptions and artistic programs, provided highly visible public sites to promote approved ideologies and to "educate" the city's new immigrants about important moments in and versions of American history. At the same time, the potency of grand classical forms was recognized by nonelite immigrant populations, as demonstrated in this chapter's analysis of how different populations in New York City participated in the four-hundredth anniversary of Columbus's "discovery" of the Americas in 1892, with a specific focus on the column erected by Italian Americans to celebrate the explorer.

While there were clear patterns in New Yorkers' appropriation of ancient architecture, there were also buildings that engaged with ancient architecture in unique ways. Chapter 9 shows how the fluidity and diversity of ancient architectural forms—their abundance and adaptability—allowed for their use in a broad scope of buildings ranging from churches, like St. Peter's Roman Catholic church on Barclay Street in Manhattan, to Sailors' Snug Harbor, a retirement community on Staten Island, both of which used Greek architecture. Private clubs and lodges, like the Pythian Temple, where ancient architecture was reinterpreted, are also considered, as are public baths. Together these examples demonstrate the almost limitless and lasting appeal of ancient architectural forms and their ripeness for reinterpretation.

The conclusion reviews the themes of the book, examines the declining popularity of ancient architecture and decorative motifs in New York in the 1920s, and summarizes the book's key arguments. Additional vistas open up as other avenues for further inquiry are considered. And now, please come join me on this journey as we venture from the tomb-lined, leafy Appian Way, one of ancient Rome's main thoroughfares, to Broadway, New York's Great White Way.

ONE

Herculean Efforts: New York City's Infrastructure

After nearly a century of planning and many delays in construction, the Second Avenue Subway opened on January 1, 2017, with much fanfare and Governor Andrew M. Cuomo riding in attendance.[1] Well-lit stations with colorful mosaics of New Yorkers greet commuters at East Seventy-Second, Eighty-Sixth, and Ninety-Sixth Streets. The Second Avenue Subway has been transformative for residents of Yorkville, giving them a swift transit alternative to the routinely delayed 6 train, where a commuter too often feels like a tightly packed sardine. Unfortunately, most New Yorkers' experience of riding the subway, before COVID-19, is typical of the 6 train. In January 2018, just 58.1 percent of all trains ran on time, a new low.[2] While the subway lament is a refrain so common that it belongs to a Broadway chorus, it is a reminder of how fundamental infrastructure is to the running of any metropolis.

Since its founding, New York City's politicians, bureaucrats, and businessmen have known that a well-functioning infrastructure—the basic physical and organizational structures that any city needs to operate—is vital to their city's success. This chapter examines how ancient architecture, art, and ideas informed the conceptualization and creation of New York City's street grid, water supply, bridges, and train stations. Before 1850, the city undertook two major infrastructure projects, both of which drew on ancient ideas and designs: the creation of Manhattan's grid and the erection of the Croton Aqueduct and reservoir system, which included the monumental Egyptian-style Murray Hill distributing reservoir (1836–1842). The next great expansion of New York City's

infrastructure started at the end of the nineteenth century as the city became the mega-
lopolis of Greater New York in 1898. Of these projects, three directly appropriated the
architectural and artistic language of antiquity in their design, conception, and execu-
tion: the Manhattan Bridge (1909), the old Pennsylvania Station (1910), and Grand Cen-
tral Terminal (1913). In the early twenty-first century, architects and planners have
begun to revisit antiquity as modifications and improvements are made to Penn Station,
demonstrating that the shape-shifting nature of antiquity makes it an enduring, multi-
faceted architectural source upon which New Yorkers could and still do draw for their
functional and symbolic needs.

The Grid

Navigating many cities requires local knowledge or Google Maps; however, finding
one's way around large parts of Manhattan is relatively straightforward. Intersections
between cross streets and avenues are the easiest way to direct someone in New York
City, as Manhattan is predominantly gridded north of Houston Street.[3] The decision to
grid Manhattan was a direct response to New York City's exponential growth in the late
eighteenth century. In the 1790 census, the city's population was 32,328. By 1810, the
population had tripled to 96,373.[4] To stay competitive, New York City needed to maxi-
mize its economic potential and harness its population growth. In 1807, the state legis-
lature appointed three commissioners, Simeon De Witt, Gouverneur Morris, and John
Rutherfurd, to improve, lay out, and design the streets of Manhattan. They hired John
Randel Jr. to survey the island. The result was the Commissioners' Plan of 1811. Most of
Manhattan is laid out following Randel's grid, although there have been significant
modifications, such as Central Park and upper Manhattan, whose topography defies the
rigidity of an orthogonal grid.[5] The early grid facilitated trade, prevented traffic jams,
monetized the property market, and helped the city manage its ever-increasing popula-
tion, which had reached 515,000 by 1850.[6]

The "Remarks of the Commissioners" in the Plan of 1811 makes no explicit reference
to the planning traditions of the classical world. Rather, the city planning conventions
of antiquity seem to have been implicit in New York's grid. The origin of the rectilinear
street grid is traditionally ascribed to Hippodamos, who laid out Piraeus, the new port
of Athens, immediately after the end of the Persian wars (480/479 BCE) and possibly his
hometown of Miletus (in c. 479 BCE), according to an orthogonal grid.[7] The "Hippoda-
mian plan" was widely adopted in the Greek world and then in Roman cites and colo-
nies, especially those built for veterans.[8] While the grid fell out of use in the fortified
cities of medieval Europe, Europe's colonization of the New World renewed the grid's
popularity in city planning. The Law of the Indies, which was widely applied in Spanish
colonial cities, was predicated on a grid.[9] Buenos Aires, Santa Fe, Albuquerque, Savan-
nah, Philadelphia, and Albany were all gridded early in their history. Thus New York
City's adoption of the grid seems connected to larger trends in the urbanism of the New
World.

Rivaling Rome and the Sphinx:
The Croton Aqueduct and Murray Hill Distributing Reservoir

Like the grid, clean water was crucial to New York City's economic development. When New York was settled, the murky Collect Pond in lower Manhattan was the city's primary source of water. As early as 1774, the need for an improved supply of water and a better water system was acknowledged. The search for a permanent source of potable water for New York City would be an on-again, off-again pursuit until 1832, when yet another outbreak of cholera finally convinced the Common Council that the situation had to be rectified.[10] Five water commissioners were appointed to report on possible water sources by January 1834, and the engineers Canvas White and D. B. Douglass of the US Corps of Engineers were to assess the technical requirements and engineering challenges of bringing water to New York City. A resolution to create the aqueduct was then approved by the electors of the city and county of New York. Douglass served as the chief engineer until October 1836, when John B. Jervis replaced him. Construction started in May 1837 and was completed on June 22, 1842.

The dammed reservoir at Croton-on-Hudson fed the aqueduct, which crossed the East River at the High Bridge into upper Manhattan. The water then flowed to a receiving reservoir between Seventy-Ninth and Eighty-Sixth Streets between Sixth and Seventh Avenues. From here, the water traveled to the colossal Murray Hill distributing reservoir, which had a capacity of 20 million imperial gallons.[11] The reservoir stretched from Fortieth to Forty-Second Street at Fifth Avenue, occupying half of a crosstown block. As the highest point in the middle of Manhattan, Murray Hill was an ideal place for the reservoir because gravity helped distribute the water to the low-lying, densely populated tip of lower Manhattan.

On June 27, 1842, the water began its forty-odd-mile-long journey from Croton to New York City, arriving at the distributing reservoir for the Fourth of July celebrations. American flags flew from the reservoir's corners, and thousands of New Yorkers trooped uptown to marvel at what was sure to be the first of their city's many engineering and architectural achievements. Rather than enjoying a celebratory glass of cider, early Americans' favorite drink, more than twenty thousand New Yorkers received a glass of fresh, pure water.[12] Like the Erie Canal, the aqueduct and its reservoirs were representative of what the new American nation could accomplish.[13]

In their accounts of the aqueduct's construction, Jervis and his contemporaries do not cite ancient Roman aqueducts as a technical model.[14] However, the scope, scale, and achievement of the Croton Aqueduct were framed through the lens of ancient Rome and Europe. Writing in 1843, Fayette Tower, one of the aqueduct's engineers, justified its whopping $12 million cost,[15] arguing that "the vast expense incurred in the construction of Aqueducts by the Ancient Romans, as well in Italy as in other countries of Europe, proves the value that was attached by that people to a plentiful supply of pure water."[16]

A July 9, 1842, article in *New World* announced: "This great work surpasses in magnificence and magnitude the famous aqueducts of ancient Rome; and we earnestly hope it may prove as durable as those stupendous structures. As a work of art and enterprise it

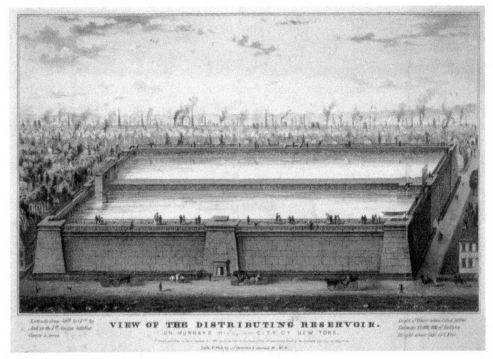

FIGURE 1. Murray Hill distributing reservoir, Manhattan, 1842.
Source: The Library of Congress.

may be considered a monument of the age in which it was created."[17] The reservoir system was a technical and artistic achievement that heralded New York's arrival not merely as a city but as a metropolis. The observation that the Croton Aqueduct had eclipsed Rome's aqueducts reflects the idea that Americans could create versions of ancient and European architecture superior to the original. Likewise, the author's comment that infrastructure should have an artistic quality demonstrated that aesthetics and utility could work harmoniously to produce something exceptional.

Working under Jervis, James Renwick Jr., later the architect of Grace Church in New York City and the Smithsonian, designed the distributing reservoir and supervised its construction.[18] The distributing reservoir was built of massive gray stone blocks in the style of an Egyptian temple (Figure 1). Furthermore, it had an Egyptian cornice, which was noted as an extra expense in the construction bill,[19] suggesting a deliberate choice. The corners of the reservoir were decorated with forty-foot Egyptian "pilasters,"[20] which are more accurately identified as pylons. The "pilaster" over the Fifth Avenue entrance rose up seven feet above the main wall, while the others only rose up four feet. The walls also sloped inward, another feature typical of Egyptian architecture, and this slope also helped counter the pressure and weight of the water.

According to Jervis, the Egyptian cornice "accord[ed] with the general style of the work."[21] His approval implies that the employment of Egyptianizing architecture for a distributing reservoir was a suitable choice. At this time, travel to Egypt was not possible

for most. However, starting in the mid–eighteenth century, publications of Egyptian antiquities started to popularize Egypt's art and architecture and sparked a wave of Egyptomania—a desire for all things Egyptian.[22] The detailed illustrations and analysis of Egyptian art in the Comte de Caylus's *Recueil d'antiquités égyptiennes, étrusques, grecques, romaines et gauloises* (1752–1767) and Piranesi's *Diverse maniere d'adornare i cammini ed ogni altra parte degli edifizi desunte dell' architettura Egizia, Etrusca, e Greca con un ragionamento apologetico in difesa dell' architettura Egizia e Toscana* (1769) made Egyptian art more accessible. When he invaded Egypt in 1798, Napoleon, like Alexander the Great, brought scientists and scholars to document the campaign. Published over a period of two decades and in twenty-two volumes, the *Description of Egypt* (1809–1822) was revolutionary;[23] it was a major scientific publication that contained extensive descriptions and plates of Egypt's archaeological sites, people, flora, and fauna. The *Description* brought Egyptian antiquities to a much broader audience in Europe and the United States. Patrons, architects, and engineers soon started to perceive Egyptian architecture as having the qualities of strength, permanence, technical superiority, and monumentality.[24]

Contemporary responses to the building underscored the fitting nature of the Egyptian architecture. On June 22, 1842, the *New-York Daily Tribune* observed that "the style of the architecture is Egyptian—well fitted by its heavy and imposing character for a work of such magnitude."[25] Other newspapers and magazines reprinted this article in part or full, indicating the widely held sentiment that Egyptian architecture was suitable for such a structure.

The Board of Aldermen's reports and contemporary accounts do not identify a specific model for the distributing reservoir. Albany's modest reservoir (1811) was constructed in an Egyptian style and had a "Moorish"-style pump house.[26] Although Jervis likely knew this reservoir, as he hailed from upstate New York, it was probably the general idea of Egyptian architecture and what it represented—monumentality, strength, technological progress, and indestructibility—that made this style attractive for the distributing reservoir.

Clean water was transformative for New York City; it curtailed disease and furthered the city's rapid expansion. Like the fountains that were often located at the end of or along Rome's aqueducts, the Murray Hill distributing reservoir was not only a symbol of progress but also an amenity. From the Fifth Avenue entrance, one could climb a staircase and promenade along the top to enjoy views of New Jersey and Brooklyn (see Figure 1). The reservoir also monumentalized this section of Fifth Avenue, and parades would process next to the reservoir, especially in the second half of the nineteenth century. The Egyptian-style reservoir was a fitting terminus for a truly impressive piece of infrastructure, which physically embodied what New York and the United States were capable of. By the 1890s, however, the monumentality of imperial Rome had supplanted Egypt's technological superiority, and the reservoir was now considered an unhealthy eyesore.[27] The reservoir was torn down and replaced with the main branch of the New York Public Library, another Neo-Antique building (discussed in Chapter 4), which used Roman and Renaissance architecture to great effect.

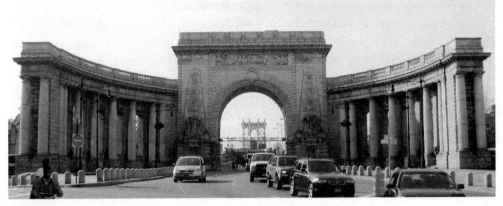

FIGURE 2. Arch and colonnade, Manhattan Bridge, Manhattan, 2011.
Source: Beyond My Ken (CC BY-SA 4.0).

Bridging the East River in Style: The Manhattan Bridge

Since New York City's inception, the Hudson and East Rivers have been both a blessing and a curse to the city's development. New York Bay is a large natural harbor; ships could dock and offload goods efficiently, facilitating trade. While Manhattan became the epicenter of late nineteenth-century New York, it was still an island. For most of New York's early history, ferries were the only way to travel to Manhattan. As Brooklyn and Manhattan expanded, their economies grew more intertwined, and the need for bridges to move people and goods between the two efficiently became unavoidable. The Brooklyn Bridge (1883) was the first to link the two sides of the East River, but the increasing numbers of daily commuters meant that soon one bridge was not enough. Because it was farther north, the Williamsburg Bridge (1903) did not do much to alleviate the traffic on the Brooklyn Bridge. Therefore, another bridge, to be called the Manhattan Bridge, was planned for just north of the Brooklyn Bridge. By 1903, the architect Henry Hornbostel had made preliminary drawings for the bridge. After a reshuffling of bridge commissioners and architects, Carrère and Hastings, the architects of the New York Public Library's main branch, were appointed as the bridge's architects, and it was completed in 1909.

An arch, colonnade, and plaza serve as a monumental and functional entrance and exit for the bridge's Manhattan approach (Figure 2). The single-bay arch (36×40 feet) was constructed of rusticated Hallowell granite from Maine.[28] The arch reinterprets the form and decoration of the Porte Saint-Denis (1672) in Paris (Figure 3),[29] which in turn is modeled on the Arch of Titus (81–82 CE) (see Figure 94).[30] European architecture was often a lens through which Americans interpreted ancient architecture.[31]

The arch's sculptural program also utilized the forms of antiquity. A highly decorated band of classical ships (with *rostra*, the metal beaks of Roman ships), oak leaves, dramatic classical-style masks and shields with various classical motifs, including the fasces (a bundle of wooden rods, the symbol of political power in ancient Rome), frames the arch's single bay. A wizened American bison watches over the traffic from the keystone. Above the

FIGURE 3. Porte Saint-Denis, Paris, 2010.
Source: Coyau / Wikimedia Commons (CC BY-SA 3.0).

bay, the frieze displays an unexpected scene of Native Americans riding galloping horses, hunting bison and animals of the Great Plains, a popular theme in early-twentieth-century American art.[32] Charles Cary Rumsey, a celebrated sculptor of American animals,[33] created this relief. The dynamic composition and the depiction of the horses owe a clear debt to the muscular horses in the reliefs of the Panathenaic Procession on the Parthenon (Figure 4) and to the Porte Saint-Denis, where Louis XIV appears in battle on horseback (Figure 3). Above the relief is a series of dentils and egg-and-dart motifs, surmounted by a cornice. The arch's simple attic is decorated with six lion heads and *strigil* decorations, a motif found commonly on Roman sarcophagi.

The arch's two monumental piers are decorated with obelisks and two sculptural groups, both by Carl A. Herber. The *Spirit of Industry* stands proudly on the north pillar; on the

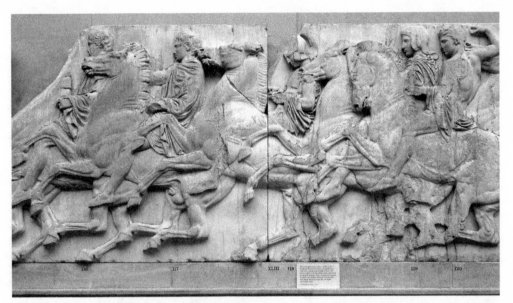

FIGURE 4. Section of the North Frieze XLIII, the Parthenon, British Museum, 2010.
Source: S. Zucker (CC BY-NC-SA 2.0).

south pillar is the *Spirit of Commerce*. After the Civil War, nude or classically attired per-
sonifications increasingly became a part of the United States' sculptural landscape.[34] They
were the perfect tool for an artist who needed a symbolic and malleable language to ex-
press the ideals or achievements of the United States and, in this case, New York City.

The winged *Spirit of Industry*, wearing a flowing *peplos*-like garment and a wreath,
proudly strides forward, arm raised (Figure 5). On the right, a nude woman stares up at
her, awestruck. On the left she is flanked by a nude male holding a lever and wheel, em-
bodying the factories and machinery of industry driving New York's economy.[35] Workers
would have traversed this bridge to labor in Manhattan's factories; the goods they manu-
factured also crossed the bridge. Behind the sculptures, a three-tiered trophy is carved in
shallow relief into the obelisk and is decorated with an eclectic mix of classical symbols
and maritime motifs, which symbolize commerce and trade.

On the south pier stands the *Spirit of Commerce*, who with his wings and caduceus (a
staff with two intertwining snakes) closely resembles Mercury, the god of commerce and
travelers (Figure 6). His leg rests against a globe, which shows North and South America,
alluding to the United States' power in the Western Hemisphere. On the left, a partially
nude woman holds a basket overflowing with produce, while on the right a man holds a
package. The globe, agricultural bounty, and package embody the trade and commerce
that drove New York's economy. As on the north pier, the trophy above *Commerce*'s head
is a mélange of a ship's prow and an eagle (a symbol of the United States) along with other
maritime and classical motifs. The sculptural groups communicate a compelling message
about the strength and power of New York's economy and two of its leading sectors—
industry and commerce. While the subject of the bison hunt is jarring next to these clas-
sical personifications, at the time critics did not even remark on this combination. This

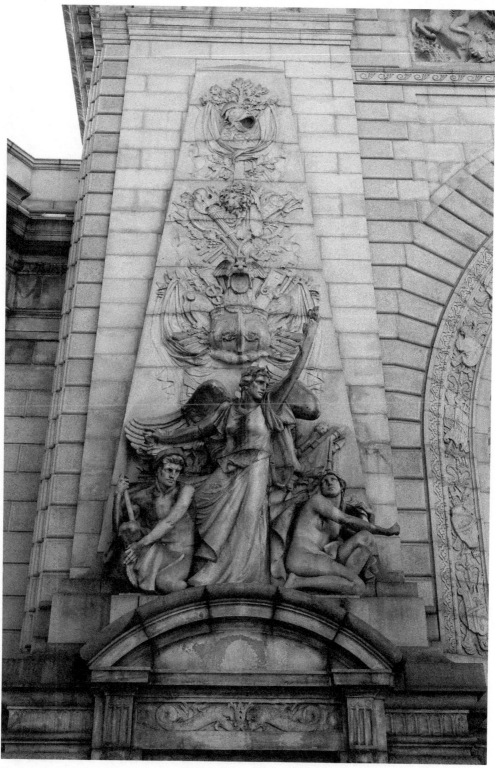

FIGURE 5. *Spirit of Industry*, north pier, Manhattan Bridge, Manhattan, 2018.
Source: Author.

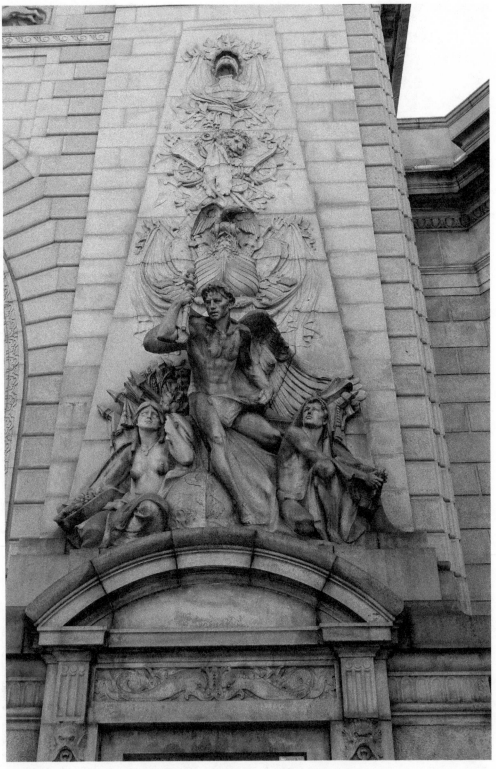

FIGURE 6. *Spirit of Commerce*, south pier, Manhattan Bridge, Manhattan, 2018.
Source: Author.

eclecticism, a defining element of the Neo-Antique, is exemplified here: Different ideas and forms—here, Greek, Egyptian, and Roman, as mediated through a seventeenth-century French interpretation—could be combined to convey aspects of American history and mythology, such as the unconquered West and the progress of American industry and commerce.

A Doric colonnade, modeled on that of St. Peter's Basilica in Rome, flanks the arch;[36] it is likely a celebration of Bernini's Renaissance genius rather than of Catholicism. Another precursor for this arch may be the late eighteenth-century Brandenburg Gate (itself modeled after the Propylaea of the Athenian Acropolis) in Berlin. The intercolumniations of colonnades are infilled with impassable balustrades. Set above each balustrade is a carved stone decorated with classical motifs, including a cuirass (Roman chest armor) and boats decorated with ancient motifs, rosettes, and dentils. The entablature is decorated with roundels with a simple floral pattern. In front of the arch and colonnade was a landscaped park, which, according to one contemporary account, was designed in "harmony with the central feature."[37] Only two carved lions adorn the base of each pillar of the arch's Brooklyn façade.

Since the erection of the bridge, the arch, colonnade, and plaza have helped direct vehicular and train traffic.[38] The arch and colonnade also aggrandize the bridge, creating an attractive terminus to the bridge's Manhattan approach. The tension between utility and aesthetics in New York City's major infrastructure projects remained a topic of constant debate. *Scientific American* criticized the unadulterated steel and the austere appearance of the Williamsburg Bridge as too functional.[39] By contrast, the beauty and practicality of the arch and colonnade was immediately recognized as an example of good design and cosmopolitan taste. According to the *New York Times*, Bridge Commissioner Arthur J. O'Keeffe opined that bridges "should be ornaments to the city, that their approaches should be as beautiful as possible. . . . In Europe this sort of bridge [the Manhattan Bridge] approach has received a great deal of attention, but up to the present time, with but few exceptions, has been neglected in this country."[40] The *Brooklyn Eagle* agreed: "Heretofore our bridges have been just bridges and nothing more. . . . The Manhattan Bridge will be not only something to get across the East River upon, but the sight of it will be a joy even to those who have no occasion to cross it."[41] The approach to the Manhattan Bridge from Brooklyn was composed of a series of grand choreographed spaces, starting with a large, open plaza with balustrades and terraced parks.[42]

The arch, colonnade, and grand plaza reflected the principles of the City Beautiful movement. This movement, one of the most important urban planning movements in the United States,[43] had its roots in the improvement societies founded in New England in the 1850s to make the cities of the United States the artistic and cultural peers of European cities through improved urban design, architecture, and planning. The proponents of the City Beautiful movement received a major boost by the 1893 Columbian Exposition, also known as the Chicago's World Fair, and actively sought to better urban living and the character of city dwellers and the urban poor through good urban design and beautiful architecture. The journalist and author Charles Mulford Robinson was a leading advocate of the City Beautiful movement, and his 1903 work *Modern Civic Art; or, The City*

Made Beautiful is the movement's bible. Architects, planners, and designers tried to implement many of the movement's ideals through the creation of city centers; New York's Foley Square, discussed in the next chapter, is one such example.

Train Stations: Appropriating the Colonnades and Baths of Imperial Rome

While the Williamsburg, Brooklyn, and Manhattan bridges connected Manhattan to Brooklyn, Manhattan still needed to be linked to the rest of the country. The late nineteenth century was the golden age of rail travel, and a train station was the gem in any railroad's—and city's—crown. In a span of less than fifteen years, New York City saw the erection of two major train stations, Pennsylvania Station and Grand Central Terminal, built by rival firms, which connected New York to New Jersey and beyond.[44] They symbolized New York City's arrival as a world-class metropolis. These train stations were also vital parts of the city's infrastructure. Both Pennsylvania Station and Grand Central Terminal, arguably the best known and well-studied examples of the appropriation of ancient architecture in New York City, artfully incorporated the aesthetic language and design principles of the Roman imperial *thermae*, or baths, in their design.[45]

PENNSYLVANIA STATION

To continue at the forefront of the US economy, if not the global economy, New York City needed better connections to the railroad network that stretched across America. Travel time by train had improved dramatically; by 1902, the journey between Philadelphia and Jersey City only took seventy-nine minutes, down from four and a half hours in 1839.[46] Yet travelers still had to disembark and transfer to a ferry to cross the Hudson, which took about twenty minutes in good weather, an abysmally slow crossing by contrast.[47]

In 1896, 94 million New York–bound passengers disembarked from trains in Jersey City.[48] Ferries were not a viable, long-term solution. Nor was the costly construction of a bridge, which might interfere with boat traffic. In June 1899, Alexander Cassatt, the newly elected president of the Pennsylvania Railroad, conceived of constructing a monumental station in New York that would be connected to New Jersey and Long Island via tunnels. Having observed electric-powered trains at the Gare d'Orsay in Paris, he realized that electrified trains could run through the tunnels.

Central to the success of the project would be hiring an architect with the vision to create a station that would match the technical achievements of the tunnels. On April 24, 1902, Cassatt asked Charles McKim of the legendary firm McKim, Mead & White to design the station. The importance of McKim, Mead & White—and its two leading architects Stanford White and McKim—to the development of architecture in New York City can scarcely be overstated. They designed some of the most important buildings ever erected in New York, and they saw classical, especially Roman, architecture as a treasure trove for some of their most brilliant buildings.[49] Construction started in 1903; McKim

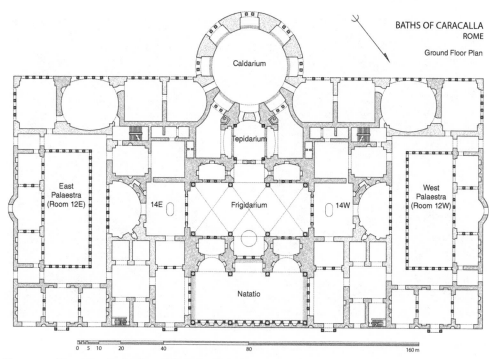

FIGURE 7. Plan of main bathing block, Baths of Caracalla, Rome.
Source: J. Burden and J. Montgomery, Building History Project.

stepped back in 1906 due to poor health, and William Symmes Richardson, a partner at the firm, took over. The station occupied eight acres and was located between Thirty-First and Thirty-Third Streets and between Seventh and Eighth Avenues, and the railroad yard extended to Tenth Avenue, occupying twenty-eight acres. While being privately funded to the tune of $113 million, Pennsylvania Station was effectively a public ceremonial gateway to New York, reflecting the ambitions of both the city and the railroad.

For his design, McKim drew technical and artistic inspiration from the Baths of Caracalla (inaugurated in 216 CE), perhaps the grandest and most extraordinary of all of the imperial baths ever erected. Bathing was a central Roman cultural institution.[50] Everyone from the emperor to a lowly freedman visited the public baths on a daily basis. Beginning with the Baths of Agrippa, Roman emperors and their associates had created ever-larger and more impressive complexes to accommodate the large number of daily bathers in Rome and other Roman cities.

The main bath block (702 × 361 feet) of the Baths of Caracalla was set within a complex of gardens, porticos, and other rooms that stood on a massive terrace (Figure 7). The bath block was designed symmetrically around a central axis of rooms, composed of the *natatio* (swimming pool), *frigidarium* (room with cold bathing pools), *tepidarium* (room with tepid bathing pools), and *caldarium* (room with warm bathing pools).[51] The triple-bayed, cross-vaulted *frigidarium* (183 × 79 feet), which served as the model for the waiting room of Penn Station, was remarkable in its own right. Its coffered ceilings would have stood 125 feet tall, and natural light would have filtered through the large lunette clerestory windows.

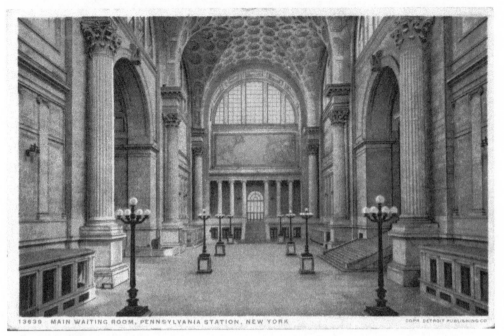

FIGURE 8. Waiting room, Pennsylvania Station, Manhattan, historic postcard, 1911.
Source: Author's collection.

Polychrome marbles from across the empire decorated the wall and floors, and columns of Egyptian gray granite and red porphyry stood tall. Colossal sculptures, including the *Farnese Hercules*, were displayed in the wall niches and upon bases on the floor, contributing to an overall atmosphere of luxury and grandeur. Because the vaults of the *frigidarium* had collapsed centuries before, McKim also must have drawn upon the well-known nineteenth-century reconstructions created by members of the École des Beaux-Arts in Paris, where he had studied.[52] The Beaux-Arts–trained architects closely studied ancient architecture, especially that of Rome, and Renaissance forms, and as a result, ancient forms pervaded much of the Beaux-Arts architecture of the United States. The *natatio* of the baths also served as the model for the station's concourse.[53] In the Baths of Caracalla's scale, technological sophistication, and luxurious materials, McKim found a prototype for the vast waiting room of Penn Station both in terms of architectural grandeur and functionality.

The vast waiting room (300 × 100 feet) occupied two city blocks (Figure 8).[54] The coffered ceiling stood 150 feet tall. At the north and south walls, two colonnades of six Ionic columns framed a staircase. Jules Guerin's painted topographical maps of the Pennsylvania Railroad network and other parts of the globe decorated the register above these columns. Just as the materials and sculptures in the Baths of Caracalla testified to the vast scope of the Roman Empire, the maps encompassed the reach of the Pennsylvania Railroad system, conveying the importance of the railroad. Natural light poured in from the eight lunette clerestory windows. These large, semicircular bath windows, often called

thermal windows, were known from the Baths of Diocletian (dedicated in 306 CE), the best-preserved Roman baths. They were widely replicated in Palladio's work (and then in eighteenth-century Britain), ensuring their transmission to later architects. Any human would feel dwarfed by the pristine travertine and clean lines of the space. Aesthetically, it was a grand entrance to New York City. While the sixty-foot-tall Corinthian columns appeared to support the ceiling, it was an illusion. Just as colored marble, stone, and stucco had adorned the brick-faced concrete core and vaults of the Baths of Caracalla, Pennsylvania Station was constructed of steel with a travertine veneer. The station, like the Baths of Caracalla, used the most advanced building technology of its day.

The design of the baths informed McKim's approach to the waiting room. On a June day in 1901, Charles McKim visited the Baths of Caracalla with the architect Daniel Burnham; Charles Moore, the urban planner behind the McMillan Plan for Washington, DC; and the landscape architect Frederick Law Olmsted Jr. The baths, although in a ruinous state, made a lasting impression upon McKim. Having the foresight to know that the baths would one day prove useful for his designs, McKim sketched workmen he had hired to walk and pose within the ruins so he could get sense of scale and movement.[55] The baths clearly also inspired Burnham, whose Union Station in Washington, DC, evokes the Baths of Caracalla, and Philadelphia's Thirtieth Street Station also uses Roman architecture.[56] These American stations also had British precursors, including the Doric Propylaea (1835–1839) of London's Euston Station, Monkwearmouth (1848), and Newcastle's more austere Central Station (1846–1855).[57]

McKim must have understood that Roman baths faced the same problems that train stations did: How does one organize large numbers of people to move through space in an orderly way? Scholars have estimated that six to eight thousand bathers used the Baths of Caracalla each day;[58] the smooth circulation of people was therefore crucial to the building's success. For McKim, the Baths of Caracalla were not merely an aesthetic model; they also provided a model for establishing an efficient flow of people that could be replicated.[59] Like the *frigidarium* in the Baths of Caracalla, the waiting room would be the heart of the station, pumping about half a million passengers in and out on a daily basis.[60]

Pennsylvania Station had street frontages of granite Doric colonnades on all sides (Figure 9). The clocks located in the central pediments on each side were flanked by eagles and personifications of *Day* and *Night* by the sculptor Adolph Weinman. Clocks were essential, functional elements of train stations, reminding passengers to keep a spring in their step to catch their train. *Day* glanced down upon the traveler, holding a garland of sunflowers, while *Night* gazed down seriously, draping a cloak over her head.

But within a mere half-century, Pennsylvania Station would be no more, a casualty to technological progress. Although rail travel had been a major innovation of the nineteenth century, the twentieth century was the age of the car and plane. As these modes of travel became ever more affordable and widespread, the railroads declined. The Pennsylvania Railroad was soon in a precarious financial state, and demolishing the station in 1963 to make way for the new Madison Square Garden sports complex was the best financial outcome for the railroad company. The legendary architectural critic Ada Louise Huxtable decried its destruction: "Penn Station is a tragic example. Nothing short of legal protection

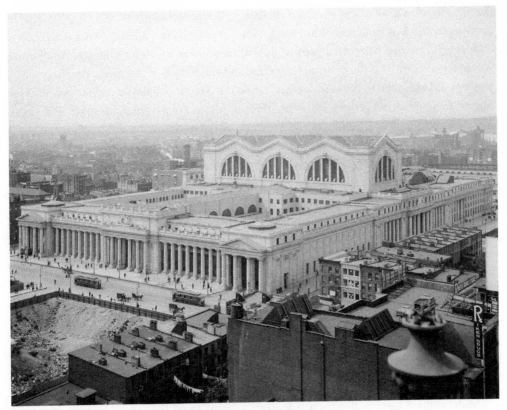

FIGURE 9. Pennsylvania Station, Manhattan, between 1910 and 1920.
Source: The Library of Congress.

could have stopped its destruction, in spite of the fact that every qualified critic confirms its architectural merit and the beauty and even the solidity of its materials."[61] The demolition of Pennsylvania Station did spur the creation of New York's Landmarks Preservation Commission.

Today, the rabbit's warren of subterranean tunnels that has replaced the elegant waiting room condemns commuters to regret almost any time spent in Penn Station. This unpleasant experience of leaving or arriving in New York City, however, might soon be altered—for the better. Across Eighth Avenue between Thirty-First and Thirty-Third Streets is the old James A. Farley Post Office (1910). Also a McKim, Mead & White building, its elegant Corinthian colonnade on its Eighth Avenue façade embodies the tradition of classically inspired civic buildings to be discussed in the next chapter. A quotation from Herodotus's histories (8.98.1) on the façade, "Neither snow nor rain nor heat nor gloom of night stays these couriers from the swift completion of their appointed rounds," about the couriers of the Persian Empire, celebrates and emphasizes the importance of the Post Office's role (Figure 10). When first erected next to Penn Station, the Farley Post Office created an elegant hub of Neo-Antique architecture embodying the values of the City Beautiful movement. Yet like the railroads, the post office experienced a steep decline during the twentieth century, and soon the Farley Post Office was yet another rundown public building.

FIGURE 10. Eighth Avenue façade, Farley Post Office, Manhattan, 2019.
Source: Author.

In 2017, after a quarter-century of discussion, construction commenced to transform part of the Farley Post Office into an extension of Pennsylvania Station. The project, which is estimated to cost $1.6 billion, is part of Governor Cuomo's push to upgrade New York's aging infrastructure. The plan for the train station, to be named for the late Senator Daniel Patrick Moynihan, who first proposed this idea in the early 1990s, is on its fifth iteration. While the plan will not solve critical issues facing the railroads, such as aging tracks and the need to increase train capacity, it would, as the *New York Times* notes, "provide many passengers with a more pleasant place to wait to board trains."[62] Penn Station might no longer be the most reviled train station along the Eastern Seaboard. Governor Cuomo boldly proclaimed, "This will be an entrance befitting New York."[63] The classical forms and design that had transformed New York into a leading metropolis at the start of the twentieth century have remerged in the twenty-first century to provide New York with a grand gateway.

GRAND CENTRAL TERMINAL

Grand Central Terminal,[64] the terminus of the New York Central and Hudson Railroad, was constructed between 1903 and 1913. It too used the language of classical architecture to design a truly awesome terminal. New York Central Railroad, the Pennsylvania

Railroad's great rival, was the creation of "Commodore" Cornelius Vanderbilt, who got his start operating ferries to and from Manhattan. In the 1860s he consolidated his holdings in railroads, first buying the New York and Harlem Railroad and then the Hudson Line, as well as acquiring stock in the New York Central Railroad (which ran from Albany to Buffalo), in an attempt to extend his railroad empire westward across the United States. While expanding his network of railroads, the commodore recognized the need for a terminal to consolidate his passenger operations and selected the Harlem Railroad's property at Forty-Second Street, near the city's northern most edge.

The terminal was intended to convey and symbolize Vanderbilt's successes in the railroads.[65] Completed in 1871, the Grand Central Depot was the largest rail complex in the world, even surpassing London's St. Pancras. Built in the French Second Empire style, its façade looked a great deal like the Louvre[66] and hid a monumental train shed. The terminal was an immediate success, with more than 4 million passengers passing through its doors during the first year of operation.[67] As train travel increased, a three-story addition to the terminal was erected, and the waiting rooms were reconfigured. While these modifications facilitated the flow of passengers in the station, it did not solve the fundamental problem of too few platforms to serve the ever-increasing number of passengers.

An 1899 *New York Times* editorial complained that Grand Central was "one of the most inconvenient and unpleasant railroad stations in the whole country."[68] These criticisms prompted discussion about the creation of a new terminal, but only a tragedy made the new terminal a reality. At this time, steam-powered trains accessed Grand Central Terminal via tunnels. Smoke and steam filled these tunnels, creating conditions with limited or no visibility, thereby setting the stage for disaster. On the morning of January 8, 1902, a train from White Plains ignored stop signals and warning lights and crashed into the 8:17 commuter train from Danbury, Connecticut, which waited in the Park Avenue tunnel at Fifty-Eighth Street, killing fifteen and injuring others. As a result, New York City and the State of New York outlawed the use of all steam engines south of the Harlem River, that is, on all of Manhattan, effective on July 1, 1908.

The New York Central Railroad now needed an innovative solution for what seemed an intractable problem.[69] William J. Wilgus, the self-trained chief engineer of New York Central, developed a series of practical design solutions that enabled Grand Central Terminal to remain in its desirable location at Forty-Second Street, to build a new terminal, and to solve the problem caused by the ban on steam engines in Manhattan. First, Wilgus expanded the terminal vertically, stacking the two terminals one atop the other, thereby increasing capacity without expanding the terminal's horizontal footprint. Second, he realized that New York Central's trains needed to be electrified. His ingenious solution to pay for these innovations was to sell the air rights above the new underground terminal, making Wilgus among the first to sell air rights. He proposed erecting a fifteen-story office building on the site of the old terminal building and train shed, which would produce $1.35 million in annual rental income, covering much of the cost of burying the tracks, improving the train yard, and electrifying the trains.[70] New York Central's board of directors unanimously approved his plan, and the terminal was constructed with almost all of the elements Wilgus had enumerated.[71]

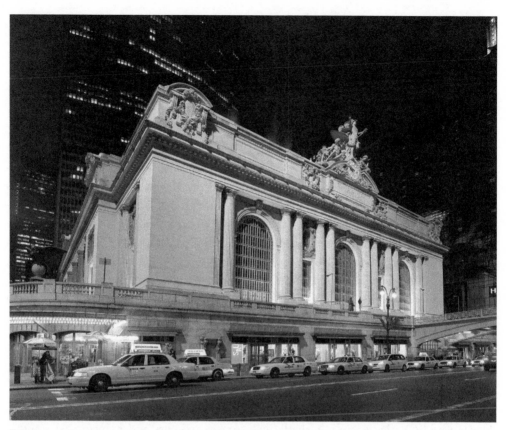

FIGURE 11. Forty-Second Street façade, Grand Central Terminal, Manhattan, 2008.
Source: Eric Baetscher (CC BY-SA 3.0).

D. H. Burnham and Company; McKim, Mead & White; Samuel Huckel; and Reed and Stem were invited to submit designs for the new terminal. Reed and Stem had the inside track, as Wilgus was married to Charles Reed's sister. Impressed with Reed and Stem's work on local stations for New York Central, Wilgus advocated on their behalf,[72] and unsurprisingly, Reed and Stem's design was selected. Whitney Warren, an École des Beaux-Arts–trained architect and designer of the New York Yacht Club, also wanted this commission. He moved in New York's most elevated social circles and lobbied his cousin, William K. Vanderbilt, to have his firm, Warren and Wetmore, appointed as the architects of the new terminal. Despite winning the competition, Reed and Stem were ordered to work with Warren and Wetmore, and the Associated Architects of Grand Central was formed. Although Whitney Warren remains most closely associated with the design of Grand Central Terminal, the final design was the result of the two firms' unhappy union.[73]

The architecture of imperial Rome, with its vast interiors and monumental scale, brought a grandeur to Grand Central Terminal that no other architectural style could offer, and nowhere is this clearer than in the Forty-Second Street façade (Figure 11). Whitney Warren drew an analogy between his grand terminal and the triumphal arches of old, declaring:

In ancient times, the entrance to the city was through an opening in the walls or fortifica-
tions. This portal was usually decorated and elaborated into an Arch of Triumph. . . . The
city of to-day has no wall surrounding that may serve, by elaboration, as a pretext to such
glorification, but none the less the gateway must exist and in the case of New York City
and other cities it is through a tunnel which discharges the human flow into the very
centre of the town. . . . Such is the Grand Central Terminal, and the motive of its façade
is an attempt to offer a tribute to the glory of commerce as exemplified by that
institution.[74]

A massive sculptural group stood atop the terminal's south façade, as if surmounting a tri-
umphal arch. Created by Jules Alexis Coutan, *Progress, Mental and Physical Force* weighs
1,500 tons and stands fifty feet tall.[75] At the center of the group is the world's largest Tif-
fany clock. Appropriately perched on the clock is Mercury. Embodying the spirit of the
place and the New York Central Railroad, he watches over the travelers and merchants
passing through the terminal. Accompanying him are Hercules, who embodies physical
force, and Minerva, who embodies mental force—both requirements for a successful rail-
road and a successful city. A monumental eagle, the symbol of ancient Rome and the United
States, spreads his wings behind Mercury.

The main concourse (275 × 120 feet) was just as impressive as the south façade (Fig-
ure 12). It is a soaring architectural symphony of warm golden hues and cerulean blue.
It has ninety-foot-tall double windows with functional walkways between them. On the
cavernous ceiling (125 feet tall) is displayed a seemingly infinite mural of the constella-
tions.[76] Warren and Paul Helleu devised the mural, which was executed by J. Monroe
Hewlett and Charles Basing, with the help of astronomers and painting assistants.[77]
Two thousand five hundred stars were painted into the sky, and sixty of these stars were
painted in varying shades of gold to create a twinkling effect, which was further en-
hanced by the five clerestory windows on each side of the concourse, effectively bring-
ing the heavens into the building.[78] New York City received its second grand entrance
when the terminal opened to celebrations and fanfare on Sunday, February 2, 1913, at
12:01 AM.

The creation of such a terminal and concourse reflects the artistic, architectural,
and cultural values of the United States at this moment in time. It was the peak of the
influence of the Beaux-Arts, which used classical forms extensively in art and architec-
ture, and of the City Beautiful movement, whose proponents advocated that good ar-
chitecture and design could improve the lives of and uplift urban dwellers.[79] By
facilitating a better commuting experience, the design of Grand Central Terminal also
fulfilled the practical considerations of a terminal that needed to circulate large num-
bers of people. Like the Roman baths, there are multiple entrances in and out of the
terminal. Not only could one walk through the main concourse, but a series of ramps
allow one to avoid the main concourse if entering from Forty-Second Street. This prac-
tical design facilitated the easy movement of passengers through the station. Twenty-
three million people passed through Grand Central Terminal in 1913, and by 1926, this
number had doubled to 43 million.[80] In 2018, over 750,000 people passed through
Grand Central each day.[81]

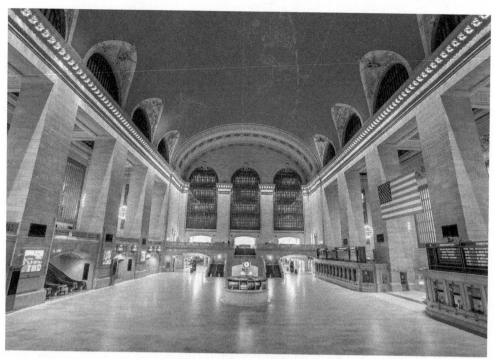

FIGURE 12. Concourse, Grand Central Terminal, Manhattan, 2015.
Source: MTA (CC BY 2.0).

Grand Central Terminal was landmarked on August 2, 1967, by the newly established
Landmarks Preservation Commission. However, only a year later, when Penn Central, the
amalgamated company formed of the New York Central and Pennsylvania Railroads, leased
Grand Central Terminal to UGP Properties, Inc., the developer proposed erecting a fifty-
five-story tower, designed by Marcel Breuer, directly on top of Grand Central Terminal.
While the Forty-Second Street façade would have been preserved, the main waiting room
and most of the concourse would have been destroyed. After a decade of legal wrangling,
the US Supreme Court upheld Grand Central Terminal's landmark status in 1978, thereby
saving the building.

Grand Central Terminal's survival, partially ensured through Pennsylvania Station's
tragic demise, was also due to the very public interest taken in the building's survival by
Jacqueline Kennedy Onassis and Ed Koch, later the mayor of New York. Mrs. Onassis
acknowledged the value of Grand Central Terminal, writing, "Is it not cruel to let our
city die by degrees, stripped of all her proud monuments, until there will be nothing left
of all her history and beauty to inspire our children? If they are not inspired by the past
of our city, where will they find the strength to fight for her future?"[82] The former first
lady was right; buildings like Grand Central are a testament of great civilizations and their
great cities. Between 1988 and 1998, Metro-North started on a major restoration of Grand
Central Terminal. Today, the terminal is a destination in its own right, where one can
dine or shop for gourmet food, clothes, or an array of electronic gadgets.

Conclusions

Without good infrastructure, a city can still function, but it cannot achieve its full potential. A grid, a safe and consistent supply of clean water, bridges, and train stations are vital parts of New York's infrastructure. To construct these necessities, New York City's architects, patrons, and engineers looked to the forms, designs, and ideas of the art and architecture of ancient Egypt and classical antiquity, especially that of imperial Rome, for suitable technical and architectural models. The grid of classical antiquity provided an orderly plan for New York City's growth up the island of Manhattan. Egyptian architecture, with its overtones of solidity, strength, and technological advancement, offered the appropriate resonance and forms for the distributing reservoir in the 1830s. The demise of the once much-fêted Egyptian reservoir underscores how engagements with antiquity and its architecture were both specific and changeable. New Yorkers looked to the different architectures of the ancient Mediterranean world at various times: Egypt's connotations of technological innovation, tapped in the 1840s to convey New York's arrival as a modern metropolis, were replaced by the imperial majesty of Rome a mere sixty years later.

Ancient architecture provided attractive aesthetic and artistic models as well as design and structural models. McKim's examination of the design of the Baths of Caracalla helped him determine how to move commuters effectively through Pennsylvania Station, while the sloping walls of the Murray Hill reservoir worked to counterbalance the force of the water. The large thermal windows of Grand Central and Penn Station allowed in light, and, in the case of Grand Central, these windows opened to allow breezes for ventilation and cooling. The arch and colonnade of the Manhattan Bridge had both a functional and aesthetic purpose. It facilitated the movement of people and vehicular traffic on and off the island of Manhattan while also creating an attractive approach to the bridge. Utility and beauty were not at odds in the design of ancient architecture or in New York's architecture; instead, they worked in concert. The repurposing of the Farley Post Office as the new Amtrak and Long Island Railroad station at Pennsylvania Station speaks to the powerful afterlife of ancient architecture. The timeless and flexible nature of these forms also meant that ancient architecture had a great appeal to New Yorkers when they constructed the civic institutions that were essential: custom houses, courts, and municipal buildings, the topic of the next chapter.

The Genius of Architecture: Ancient Muses and Modern Forms

> There is no walk of the elegant arts in which our defects in science and taste are
> more palpable than in that of architecture. . . . The Genius of architecture seems
> to have shed her maledictions over this land.
>
> —GULIAN VERPLANCK

Gulian Verplanck's 1824 address[1] to the American Academy of Fine Arts in New York must
have hit a nerve. The United States and arguably its most prominent city, New York, was
a wasteland, with "short-lived" architecture that would "scarcely outlast their founders."[2]
A cultured European who had come to experience the American democratic experiment
firsthand would view "the general taste and character of public edifices . . . with disappoint-
ment."[3] The genius—an ancient personification or spirit—of architecture had not graced
New Yorkers with its inspiration.

From the "ignorant present," New York would need to develop its own architecture.[4]
Verplanck, an attorney, politician, and writer, argued that the most effective way of ele-
vating the United States' reputation abroad was through "the grandeur or beauty of [its]
public structures."[5] Given its capacity as the United States' primary entrepôt, New York
needed outstanding public—that is, civic, judiciary, and administrative—architecture.

Verplanck was explicit about the United States' current architectural failings, but he
also offered a solution: "We have borrowed most of it from France and England, and by
no means from the best models which these countries afford; it is only within a very few
years that we have begun to think for ourselves, or draw directly from the purer fountains
of antiquity."[6] American architects needed to reject European models, including Palladian
architecture, which he detested, declaring it "that corruption of the Roman . . . which de-
lights in great profusion of unmeaning ornament."[7] Rather, American architects should
go directly to the ancient source, which offered the best models for the new nation's ar-
chitectural requirements. He mused:

The ancient legislators understood the force of such principles well. In the mind of an Ancient Greek, the history of his country, her solemn festivals, her national rites, her legislation, her justice, were indissolubly combined with the images of everything that was beautiful or sublime in art. Every scholar knows, too, how much the remembrance of the *Capitolii Arx alta*, the lofty majesty of the capitol, entered into every sentiment of love and veneration, which the Roman citizen, when Rome was free, entertained for his native city.[8]

Good public architecture did not merely reflect the ideals of the new nation or impress European visitors; it also forged social cohesion. Architecture, Verplanck opined, allowed the poor man "to forget the comparative hardships of his lot, and to feel a more real and palpable community of interest with his wealthy neighbour."[9] This idea foreshadows the ideals of the City Beautiful movement, discussed below in the context of Foley Square,[10] and the use of architecture and monuments by patrician New Yorkers to educate and assimilate new immigrants in the late nineteenth and early twentieth centuries (discussed in Chapter 8).

Verplanck's prescient speech demonstrates that public architecture expresses and embodies a city and nation's ideas and values. Good architecture also makes a city livable; it can inspire people and improve one's quality of life. Verplanck's address is one of the few texts to discuss the ideas surrounding the architectural choices of the 1820s—so one could think of it as a prototheory of American architecture. Practical manuals for building, like the architect Minard Lafever's extremely popular *The Modern Builder's Guide* (1833), abounded;[11] however, they offer no explanation for the inclusion of ancient orders and motifs or ground themselves in a theory of architecture.

Civic buildings that served the public and were related to the administration of a city are a logical starting place because they were constructed to serve key civic needs and embody the ideals of the new nation. They set the tone for much of New York's architecture. This chapter first examines two of New York's earliest civic buildings: the US Custom House (1833–1842) and the Halls of Justice and Detention, better known to history by the ominous sobriquet, the Tombs (1835–1838). The Custom House, at the time, was arguably the most important building outside of Washington, DC,[12] and the imposing Halls of Justice and Detention (henceforth referred to as the Tombs) was one of the finest examples of Egyptian-style architecture ever built in the United States.

Here, the idea of the Neo-Antique is particularly useful: Two civic buildings key to the orderly running and administration of New York City were purposefully built in two different ancient architectural styles. The frame of the Neo-Antique allows us to compare these two buildings—one Greek and one Egyptian—to determine why the Athenian Parthenon embodied civic and democratic ideals and why Egyptian architecture conveyed technical advances and the seriousness of the newly formed American legal system. Furthermore, it allows us to examine the next shift in New Yorkers' engagements with ancient architecture. While Greek forms were initially used at Borough Hall in Brooklyn, the deployment of Roman forms emerged as the preferred choice for the ensembles of buildings at Foley Square in Manhattan and the adjacent Manhattan Municipal Building

in the early twentieth century, underscoring the shift from Greek to Roman architecture as the United States became an imperial power. Egypt and its cultural resonances would also be left behind.

The Parthenon on Wall Street: The US Custom House

If one walked east from Trinity Church in 1915, crossed Broadway, and arrived at the intersection of Wall and Broad Streets, one could be excused for believing that one had accidentally stumbled into an ancient Roman city. On the right is a Corinthian temple–like building that houses the New York Stock Exchange, across from which is an austere, squat building decorated with a few classical details, once the headquarters of J. P. Morgan. On the left, one would pass the Bankers Trust Building at 14 Wall Street, which had an Ionic colonnade at street level and a step pyramid for a roof (discussed in the next chapter), and arrive at 26 Wall Street, where stood a Parthenon-like, octastyle Doric temple that one would expect to find atop the Athenian Acropolis. Rather than serving as a temple to Athena, the building is the US Custom House, also known as Federal Hall.

The site is rich with history. In 1704, a new Georgian-style city hall had been built here, replacing the old Dutch Stadt Huys on Pearl Street. In 1788, Pierre L'Enfant, who planned the grid of Washington, DC, remodeled the building, converting it into the nation's first capitol building. Rechristened Federal Hall, George Washington was inaugurated there as the first president of the United States on April 30, 1789. The much-celebrated building met the same fate that so many of New York's historical buildings have; New Yorkers demolished it in 1812 and erected rowhouses in its place.[13] While New York was busy replacing historical structures with functional, mundane architecture, other cities, such as Philadelphia, embraced Grecian architecture, which embodied the young nation's democratic principles, for their civic and bank buildings. Benjamin Latrobe's Ionic-style Bank of Pennsylvania was constructed between 1798 and 1801. William Strickland, Latrobe's pupil, erected the Second Bank of the United States (1819–1824), which was the first Parthenonesque public building in the nation and still stands today in Philadelphia. These buildings established the classical temple as a model for civic and banking buildings, and this trend would reverberate across the United States. The Virginia State Capitol (1785–1788), designed by Jefferson, is modeled on the Maison Carrée (Nîmes, France), the world's best-preserved Roman temple (see Figure 30).[14] The original United States Capitol that burned down in 1814 was classical as well.[15]

The Parthenon, arguably the most famous temple from the Greek world, was a suitable model (Figure 13). Located atop the Acropolis, it was dedicated to Athena Parthenos, the patron goddess of Athens. In the fifth century BCE, Athens became the first democratic state in the world, giving male citizens the right to vote, serve on juries, and administer the city's government. Furthermore, in a series of remarkable battles at Marathon, Salamis, and Plataea between 490 and 479 BCE, Athens and its allies achieved the unthinkable: They defeated the Persian Achaemenid Empire, the superpower of the ancient world, and

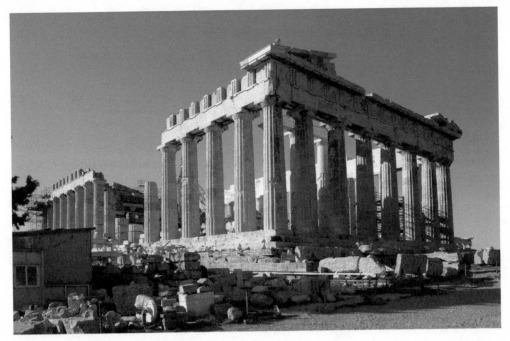

FIGURE 13. Parthenon, Athens, 2012.
Source: S. Zucker (CC BY-NC-SA 2.0).

ensured their freedom and the continuation of their radical democratic experiment. Athens was thus an ideal political model for the new United States, which had recently thrown off the tyranny of the British Empire.

Knowledge of monuments such as the Parthenon reached Americans through archaeological publications.[16] Of these publications, none was more important than *The Antiquities of Athens* (1762–1816) by James Stuart and Nicholas Revett. This richly illustrated, four-volume publication brought the Parthenon and the Erechtheion (also on the Athenian Acropolis), as well as other artistic and architectural achievements of Athens and the classical Greek world, to Americans for the first time, providing architectural and artistic models for the democratic ideals, philosophies, and history that informed the founding of the new nation. While these books were expensive, copies were circulating in the United States; Jefferson's books on architecture had been in the Library of Congress since 1815.[17] The library of Ithiel Town, the architect whose work is discussed below, had an estimated 11,000 volumes and 20,000 engravings, to which architects, artists, and his friends had access.[18]

The Founding Fathers were classically educated.[19] Classical culture pervaded the intellectual and civic life of the early republic, as a classical education was considered essential in creating informed citizens who could govern justly.[20] Not only did the classics pervade the intellectual life and curriculum of colleges, but, as Caroline Winterer has argued, "classicism was an important part of . . . 'civic culture.'"[21] For example, Washington showed his troops the 1712 play *Cato*, by Joseph Addison, when stationed at Valley Forge. This play

dramatized Cato the Younger's principled opposition to Julius Caesar before his death, a suitable topic for the Revolutionary War era.[22] Unsurprisingly, the architectural ideals of the new nation primarily took a classical—and predominately Greek—form.

In his 1842 address to the Royal Academy, C. R. Cockerell termed this architecture style, with its embrace of classical, predominately Greek architectural forms, the Greek Revival.[23] The scholar Steven Dyson has challenged the definition of the revival as a properly "Greek," arguing that the use of domes and the Corinthian order were more Roman than Greek.[24] While Dyson is not incorrect—many of these forms were Roman—his interpretation overlooks several key points about the Greek Revival and its name. First, many of the architectural elements and motifs are Greek or first originated in Greece; they can be thought of as Grecian, that is, in a Greek style. Second, architects and critics of the time identified these forms as Greek. William Ross, an English architect who later worked as a draftsman on the Custom House, wrote in late 1835 that "the Greek mania here is at its height, as you infer from the fact that everything is a Greek temple from the privies in the back court, through the various grades of prison, theatre, church, custom-house, and state-house."[25] Third, the architects of the time were interested in creating archaeologically informed buildings, not accurate copies.[26] The thoughtful modifications of ancient building types or the combination of Greek and Roman forms made the buildings original, American creations and led to the development of the Greek Revival style as the first truly national style of building.[27]

Then as now, New York City *was* the epicenter of the US economy. Between 1817 and 1825, the Erie Canal was constructed by the sheer will of New York's governor, DeWitt Clinton. This watercourse connected New York's bustling harbor to the Great Lakes and America's newly settled agricultural interior, facilitating the flow of goods, services, and people. The canal made New York the largest, busiest port in the United States and spurred on the city's growth. At the start of the Civil War, New York handled more than 60 percent of the nation's exports.[28] This was not only a financial boon to New York City but also to the US federal government. By 1852, 95 percent of the federal government's revenue came from customs duties, the tariffs on imported goods, and New York City accounted for an astonishing 80 percent of this revenue.[29]

Between 1799 and 1815, the New York Custom House occupied Government House at Bowling Green. After 1815, the Customs Service was located in one of the rowhouses on the site of the old Federal Hall. In 1833, it was agreed that the US Customs Service needed a proper building, and Town & Davis was hired to design the new Custom House, reflecting the importance of such tariffs to the United States.

A talented engineer who had invented and patented the Town lattice truss for bridges (which made him a small fortune), Ithiel Town was one of the United States' most important early professional architects. In 1827, he opened an office in New York City. In 1829, Town entered into a fruitful seven-year partnership with Alexander Jackson Davis. Davis was an exceptional artistic polymath—a draftsman, an architectural renderer, an engraver, and one of America's earliest lithographers.[30] In the early 1820s, around the time when Gulian Verplanck made his address, Davis studied at the American Academy of the Fine Arts and at the National Academy of Design, which counted Ithiel Town among its founders,[31] and

FIGURE 14. Original design, US Custom House, Manhattan, 1834.
Source: Courtesy of the Metropolitan Museum of Art.

one wonders if Davis might have even heard Verplanck's address. Clearly, ideas about Greek architecture were circulating in the creative milieu of New York City.

The firm of Town & Davis was the McKim, Mead & White of its day, winning prestigious public commissions left, right, and center, including the Connecticut State Capitol (1828–1831, demolished 1889), the North Carolina State Capitol (1833–1840), and the Indiana State Capitol (1831–1835). They also had a hand in the erection of the Ohio State Capitol (1838–1857, with Henry Walters).[32] These buildings embraced Grecian colonnades and Roman domes, affirming the popularity of such forms for America's public architecture.

Town & Davis was responsible for the bulk of the design of the Custom House, which the secretary of the Treasury approved in 1833. In clear homage to the Parthenon, the original Town & Davis design included a double row of Doric columns on the building's front and rear porches, triglyphs and undecorated metopes, and plain triangular pediments (Figure 14). Acroteria were intended to surmount the apex and corners of the triangular pediments on the front and the rear. The original plan was organized around a Greek cross with a high central dome and lantern that would be clearly visible on the exterior, which also evoked Rome's Pantheon, with its blank pediment and vertical stacking of a triangular pediment and dome.[33] The use of the Greek-cross plan also secularized a design historically associated with the Catholic and Greek Orthodox faiths. While the dome could be seen as a deviation from pure Greek forms, Town & Davis can be understood to be

heeding Verplanck's call to interpret ancient forms, here the Parthenon and, to a lesser extent, the Pantheon directly.

Construction began in January 1834, and Samuel Thomson, who worked on Snug Harbor, another set of resplendent Greek Revival buildings on Staten Island,[34] was hired as the builder. Almost immediately, the US Customs Service instructed him to modify the building, ostensibly to rein in the skyrocketing costs. The central rotunda was deemed to be too large and the dome too structurally complicated.[35] Consequently, the rotunda was scaled back and moved toward the front of the building (on Wall Street), and the reduced dome was no longer visible on the exterior. Each portico received a single colonnade rather than a double.

From the start, Thomson's tenure was filled with tension. So when his responsibilities (and pay) were abruptly reduced by the US Customs Service, he quit in April 1835 and made off with the plans. In July 1835, the stonemason-turned-architect John Frazee was hired as Thomson's replacement. Frazee had to draft his own plans to follow the already-laid foundations and cut stone. His influence on the design is most evident in the interior, the detailing, and his transformation of the third floor from a storage attic to a full office floor. Imported thick French glass, which resembled marble, was fixed in the metopes of the entablature, providing light to the third-floor offices.[36] The building was composed of matt white marble, which was shipped from nearby Eastchester.

In 1842, the Custom House (192 × 90 feet) finally opened (Figure 15). Nassau Street slopes down sharply between Pine and Wall Streets, giving the Custom House an imposing air. Its portico is reached by a steep set of stairs; one can imagine a merchant, arriving for the first time in New York, climbing the staircase to pay his customs duty in surprised awe at the classical temple that greeted him. The pediment had no sculpture. Although some contemporary buildings had simple carved pediments,[37] the lack of sculptural decoration may have been an aesthetic choice, which Francis Morrone has argued might have reflected a "romantic cult of ruins."[38] Given the economic realities and lack of qualified sculptors, such a decision was an easy choice.

Behind Doric porticos, one would expect a rectangular space, like the cella of a classical temple. Instead, a visitor was greeted by an airy rotunda, evocative of the Pantheon, with a diameter of sixty feet, supported by sixteen Corinthian columns and eight pilasters, each twenty-five feet high (Figure 16).[39] The fifty-four-foot dome with a skylight provided good natural light. This was the heart of the action: the collector's room, which was filled with desks where tariffs could be levied, enriching the coffers of the United States. The second-story balcony's iron balustrade was decorated with mermaids, a likely allusion to the trade that drove New York's success.[40]

The US Customs Service outgrew its home at 26 Wall Street within a mere twenty years, moving to the former Merchants' Exchange (1836–1842) at 55 Wall Street (discussed in the next chapter). 26 Wall Street then served as a federal subtreasury building until 1920. Despite its demotion in 1862, the building has remained an important historical site to this very day. In 1883, John Quincy Adams Ward's outstanding bronze statue of George Washington was erected on a high granite plinth at the bottom of the steps on Wall Street to commemorate the centennial of the Revolutionary War's end.[41] In 1955, the building

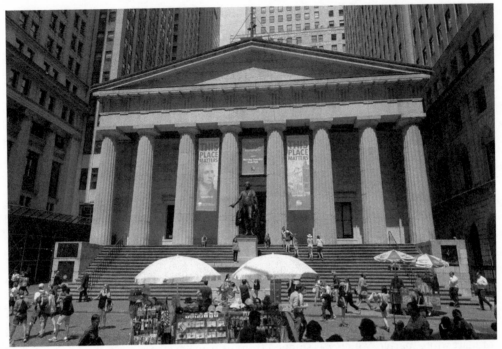

FIGURE 15. Wall Street façade, US Custom House, Manhattan, 2017.
Source: Author.

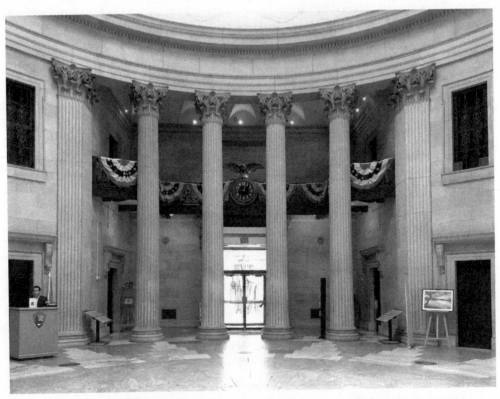

FIGURE 16. Rotunda, US Custom House, Manhattan, 2017.
Source: Author.

was renamed Federal Hall, and in 1965, it was landmarked. As a symbol of the early United States, Federal Hall has become a historic anchor in an ever-changing city. Since 1800, Congress has only convened outside of Washington twice. It met in 1987 in Philadelphia to commemorate the bicentennial of the ratification of Constitution, and on September 11, 2002, Congress met in Federal Hall to commemorate the one-year anniversary of the 9/11 terrorist attacks. Thus, ancient architectural forms still resonate as symbols of the nation's pride, resilience, collective loss, and democratic values.

Brooklyn Borough Hall, the Manhattan Municipal Building, and Foley Square

The US Custom House established classical forms as a leading style for civic buildings such as city halls, municipal buildings, and courts in New York City. Clearly, the classicism of the building lent authority to public buildings. While Manhattan's City Hall looked to French architecture for its inspiration, Brooklyn appropriated classical forms for its city, then later borough, hall (Figure 17).

In 1835, a year after Brooklyn became a city, plans were underway to erect a city hall.[42] Located on a triangular plot edged by Fulton, Joralemon, and Court Streets, the building would symbolize Brooklyn's status as a thriving city and provide much-needed space for conducting civic business. Calvin Pollard won the design competition, and the cornerstone

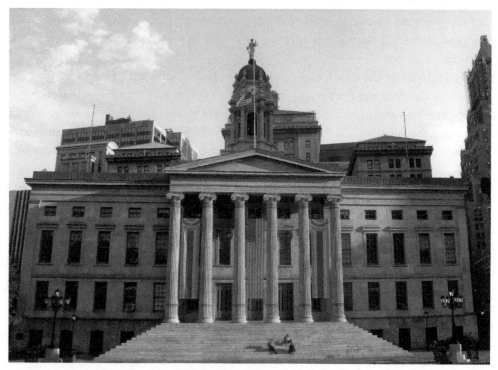

FIGURE 17. Brooklyn Borough Hall, Brooklyn, 2009.
Source: Jim Henderson (CC0).

was laid in 1836. However, like the US Custom House, the construction of Borough Hall progressed in fits and starts. Together, these two buildings followed a process that most New Yorkers would still recognize today: one dominated by inconvenience, cost overruns, inevitable delays, and, of course, a lawsuit. Almost immediately, the panic of 1837 and Brooklyn's near bankruptcy halted the project. Construction resumed in the early 1840s, but only a bond issue of $50,000 in 1845 put the construction back on track. Gamaliel King, who was runner-up to Pollard in the design competition,[43] was then hired to complete the building. Like Frazee, King faced the same challenge of designing a building whose foundation had already been laid. Modifying Pollard's design, he used the already-cut light gray Tuckahoe marble (for which the contractor had been suing for payment for years)[44] to create a fine, if not austere, Greek Revival structure, which was completed in 1851.

The rectangular, four-story building with its tall pilasters is an archaeologically informed building adapted to the needs of a thriving mid-nineteenth-century city. The focal point of the building is an elevated hexastyle portico supported by Ionic columns, each three stories tall, reached by a grand staircase. The undecorated pediment is akin to those of the US Custom House. Perched above the pediment was a wooden cupola topped by a statue of Justice. The cupola served as a fire lookout and bell tower until 1893. Ironically, in 1895, a devastating fire caused the collapse of the cupola; the bell and the figure of Justice unceremoniously crashed through the roof. A cast-iron cupola was erected in 1898. The new cupola with its undulating curves framed by columns seems to be modeled on the Temple of Venus at Baalbek, Lebanon (Figure 18), which was well known thanks to its inclusion in Louis Cassas's *Voyage pittoresque de la Syrie, de la Phoenicie, de la Palestine et de la Basse Aegypte* (1800) and from mid-nineteenth-century photographs by Francis Bedford and others.[45] The new cupola reflects the shift in preference from Greek forms to Roman.

The inclusion of the cupola also testifies to the lasting influence of Georgian forms on American architecture; European architecture was often an intermediary lens through which American architects accessed ancient art and architecture.[46] The imposing portico dominates the building, and for those at street level it demands attention. To achieve the same effect vertically, the spire was necessary. In this building, we can literally see an effective stacking of styles as the cupola reaches far into the air.

As in Brooklyn, City Hall (completed in 1812) in lower Manhattan became a magnet for public architecture at the start of the twentieth century, as the newly incorporated city of Greater New York needed more civic buildings to accommodate its expanding bureaucracy and judiciary. The Manhattan Municipal Building and the judicial buildings of Foley Square, located just to the east and north, respectively, of Manhattan's City Hall, used classical forms to make a de facto civic center. The creation of this civic center embodied the values of the City Beautiful movement and has parallels in San Francisco and Cleveland.[47] The Manhattan Municipal Building (1907–1914), rechristened in honor of New York's only African American mayor, David N. Dinkins, is an imposing classical skyscraper designed by McKim, Mead & White, which was strongly based on the skyscraper that the firm had proposed for its failed bid to design Grand Central Terminal.

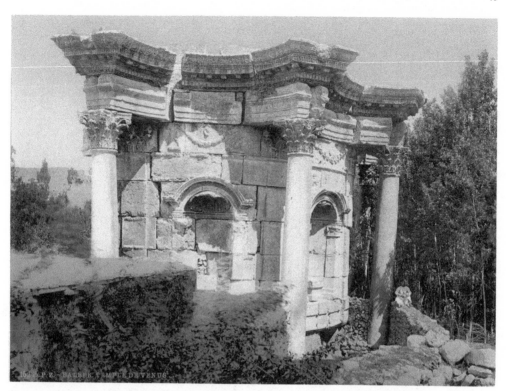

FIGURE 18. Temple of Venus, Baalbek, Lebanon, 1905.
Source: The Library of Congress.

The classical elements are concentrated at the ground level and at the very top, where its imposing crown and Adolph Weinman's sculpture *Civic Fame* form a recognizable element of lower Manhattan's skyline (Figure 19). The west-facing ground-level façade is composed of a screen of columns, at the center of which appears to be a Roman arch (with a main bay and two smaller flanking bays), clearly evoking the Arch of Constantine (Figures 20–21).[48] The arch is really a free-standing colonnade, also partly modeled on Bernini's colonnade at St. Peter's in Rome,[49] like the Manhattan Bridge's colonnade. The arch is an ingenious solution to bridge Chamber Street and provides a grand approach to the building. Above the central bay, in the architrave, two winged cupids hold a *tabula ansata* (Latin for a table with handles) inscribed with the word "MANHATTAN." Inscriptions— "NEW AMSTERDAM MDCXXV" and "NEW YORK MDCLXIV"—also grace the architrave and affirm Manhattan's position at the heart of New York since the city's inception. Shields, which symbolize New Amsterdam and the English province of New York, as well as the city, the county, and the state of New York,[50] stand in place of the captive Dacians on the colonnade's architrave. The shields also are replicated on the faux-Corinthian colonnade above the twenty-second floor.

Nestled in the arch's north and south spandrels are female and male winged victories, respectively. Over the small bays, the roundels, also designed by Weinman, evoke the *tondi* on the Arch of Constantine. In the north roundel is *Civic Duty*, while in the south is *Civic*

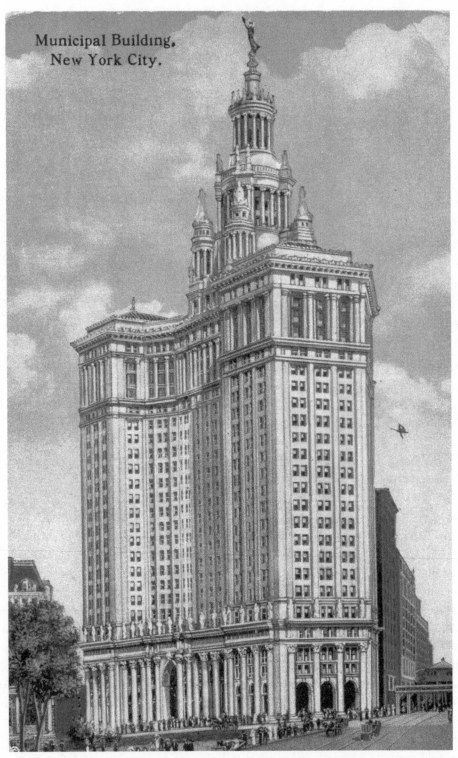

Municipal Building,
New York City.

FIGURE 19. Manhattan Municipal Building with *Civic Fame*, Manhattan, historic postcard, early twentieth century.

Source: Author's collection.

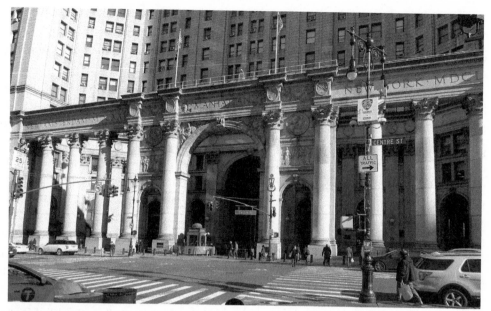

FIGURE 20. Colonnade, Manhattan Municipal Building, Manhattan, 2020.
Source: Author.

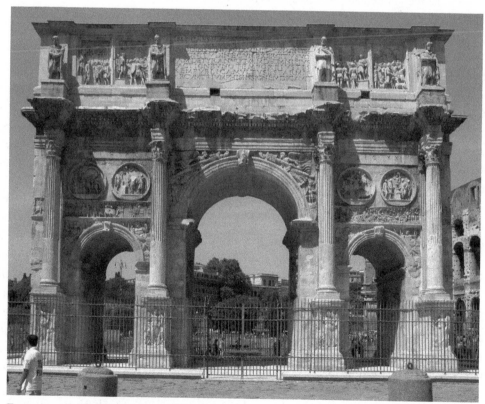

FIGURE 21. Arch of Constantine, Rome, 2016.
Source: S. Zucker (CC BY-NC-SA 2.0).

Pride, both female personifications. In the base relief, *Civic Pride* receives tribute from her citizens. Just as the shields and Corinthian colonnades provide visual unity at the building's entrance and top, *Civic Duty* and *Civic Pride* complement *Civic Fame*, who stands atop the building.

Civic Fame stands on the pedestal, composed of a tall cylinder lined by columns, flanked by four smaller column-lined cylinders. The central cylinder clearly took its inspiration from the Choragic Monument of Lysicrates (Figure 22). A *choregos*, or patron of musical performances in ancient Greece, Lysicrates had erected a monument in Athens to celebrate the first prize winner in a musical competition he had sponsored in 335/4 BCE. Having been published in *The Antiquities of Athens*, the monument was widely reproduced first in Europe and then in the United States.[51] In lieu of the monument's original Corinthian capital, *Civic Fame* stood tall, reminding New Yorkers to take pride in their city.

Turning immediately north from the Municipal Building, one reached Foley Square, where again one might be forgiven for thinking that one was in a Roman forum or Greek agora, as the space was partially lined by colonnaded courthouses. Drawing on the ideals of the City Beautiful movement, Mayor George McAneny wanted Foley Square to serve as a location for a new civic center.[52] While McAneny's vision for a civic center was scaled back, the built elements speak to the staying power of classical forms. At the heart of this complex was to be the New York County Supreme Court, which was modeled on the Colosseum, Rome's famed amphitheater.[53] While it was transformed into a hexagonal building, it retained its classical façade, with a well-decorated pediment supported by ten Corinthian columns. Directly to its south is the United States Courthouse (1933–1936), also known as the Thurgood Marshall United States Courthouse (Figure 23). Designed by Cass Gilbert and his son, its ground-level façade is dominated by a portico of ten four-story-high Corinthian columns.[54] Its simple architrave, with the inscription "United States Court House," is framed by vegetal scrolls at the north and south ends. Above this is a series of windows and the busts of four ancient lawgivers, Plato, Aristotle, Demosthenes, and Moses, who are framed in roundels, giving them the appearance of ancient coins. They seem to gaze down upon the jurors, lawyers, and judges serving and working within, reminding them to do their duty and uphold the law, as these men had done.

Set back from the colonnade, a 590-foot tower reaches into the sky. The tower closely resembles St. Mark's Campanile in Venice, one of the most recognizable buildings in the canon of Western architecture. Its tall, thin proportions made it eminently suitable for a skyscraper. The top, however, returns to the classical world for its inspiration, drawing on Vitruvius's and Pliny the Elder's descriptions of the Mausoleum of Halicarnassus as well as on Renaissance reconstructions of the famed site, one of the Seven Wonders of the ancient world.[55] This building's eclectic elements—the colonnade façade with inscriptions and busts on ground level, the campanile-like shaft that gives the building its height, and its top modeled on the Mausoleum of Halicarnassus—reflect the movement toward a more eclectic use of classical forms, so typical of Neo-Antique buildings, that occurred in the mid-to-late nineteenth century and throughout the early twentieth century.

The Manhattan Municipal Building and Foley Square reflect the lasting influence of the 1893 Columbian Exposition on architecture, especially on public architecture. While

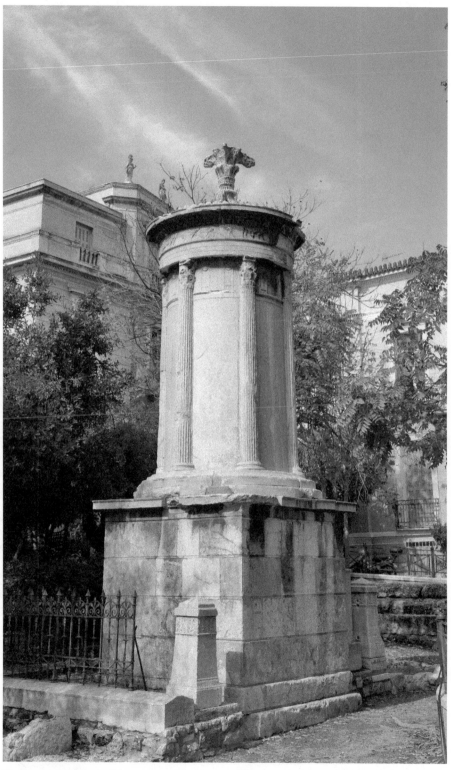

FIGURE 22. Choragic Monument of Lysicrates, Athens, 2019.
Source: Author.

FIGURE 23. US District Court for the Southern District of New York and US Court of Appeals for the Second Circuit, now the Thurgood Marshall United States Court House, Manhattan, c. 1936.

Source: The National Archives.

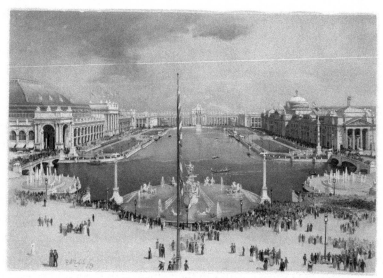

FIGURE 24. Court of Honor, Columbian Exhibition, Chicago, 1893.
Source: The Boston Public Library (CC BY 2.0).

Lewis Mumford and other critics railed against the gleaming white classical architecture of the Columbian Exposition,[56] its effects cannot be understated. The Columbian Exposition's classicizing buildings and the grand Court of Honor—with its triumphal arch, colonnades, and monumental statue of *The Republic*—led to a powerful reassertion of classical forms, especially those of imperial Rome, as the preferred modus operandi for public architecture (Figure 24). It led to a veritable explosion of plans for civic centers that used classical architecture in other cities, including San Francisco and Cleveland.[57]

The Tombs

While Greek mania was sweeping across the municipalities of early nineteenth-century America, the use of classical forms for judicial architecture was not a foregone conclusion. Located on the site of the now landfilled Collect Pond, a massive Egyptian temple-like building, which seemed more appropriate on the banks of the Nile than those of the Hudson, served as New York's Halls of Justice and Detention, better known to history as the Tombs. At the start of the nineteenth century, New York City's courts lacked a suitable meeting place, and the city's prisons, spread across several buildings in lower Manhattan, were considered an abomination by contemporaries. As early as 1824, the New York State Legislature authorized the creation of a new prison, but it was not until 1834 that Mayor C. W. Laurence recommended the construction of a modern prison to replace the decaying buildings in his annual report to the Common Council.[58] A committee, formed by the Board of Assistant Aldermen, studied the matter and presented its findings to the mayor on November 24, 1834. The report advocated the creation of a centralized prison

and state-of-the-art policing facility modeled on the Pennsylvania or Philadelphia System,[59] with a detention house, courts, and other necessary spaces.[60]

The committee, formed to select the building's design and plan,[61] took its assignment seriously and sought out expert opinions, including that of Samuel Wood, the warden of the Eastern Penitentiary (1829). Wood strongly praised the Philadelphia-based, English-born architect John Haviland, who had designed the Gothic-style Eastern Penitentiary, for his deep knowledge of prison architecture and his ability to deliver a good plan.[62] Because of his work on this prison and the Egyptian-style New Jersey State Penitentiary (1833–1836) at Trenton, John Haviland was regarded as one of America's premier architects for the construction of penitentiaries.

Haviland was invited to New York to advise the committee on the requirements of the proposed prison building. In January 1835, members of the committee traveled to Trenton and Philadelphia to study his buildings. The committee was thoroughly impressed by Haviland's practical design of the New Jersey State Penitentiary, whose design allowed the warden to corral and return inmates to their single cells quickly. The cells of the New Jersey State Prison sat behind an architectural block composed of offices. This architectural block was masked by a tetrastyle Egyptian-style portico set back between two tall Egyptian-style pylons, which gave the building an imposing street presence, as befit such a structure.[63] The reforming humanitarians and prison designers of the 1830s viewed Egyptian architecture as having a moral appeal and an ability to embody their ideals.[64] Egyptian structures were also considered to have the quality of endurance and to express hope for both this life and the next.[65] Furthermore, the committee believed that the Egyptian façade of the Trenton prison was impressive and suitable because the architecture was both economical and serious.[66]

As early as 1830, Haviland mused that he should publish a journal with designs for jails, court houses, banks, and other buildings.[67] He proposed using Egyptian columns and architectural details from the *Description of Egypt*, of which he owned a copy, for these buildings,[68] indicating that the various temples and architectural ruins in this publication were the source for the Egyptian architecture and motifs he employed. Egyptian architecture was not widely used for prison architecture in European countries. Therefore, Americans, as the scholar Richard Carrott rightly notes, must have seen Egyptian architecture as "symboliz[ing] . . . values beyond mere man-manipulated ones—those of incorruptible righteousness of law and order."[69] This usage reflects a distinctly American reception of ancient forms.

A design competition was held in 1835. Of twenty-five architects who submitted designs, five architects were awarded premiums on the basis of the percentage of their winning entries that would be included in the final design.[70] Haviland received $200, Alexander Jackson Davis and Charles Friedrich Reichardt each received $100, and Louis Dwight and Calvin Pollard each received $50.[71] Published on April 20, 1835, Document 60 announced the winners and clearly articulated the committee's opinions of the chosen style, noting:

> The style of architecture . . . is the Egyptian, and the design is from one of the most
> approved examples contained in Napoleon's Egypt. It combines great beauty with

simplicity and economy, and its massive proportions and general characteristics render it peculiarly appropriate and fit to the objects and intended uses of the establishment.[72]

The committee was particularly impressed with the "beautiful Egyptian design, with its magnificent portico by Mr. John Haviland of Philadelphia."[73] Haviland was hired to combine the designs, handpicking the best features of each submission into a masterful whole that was more than the sum of its parts. Several of Alexander Jackson Davis's surviving drawings show that his design fused Greek and Egyptian architecture.[74] While Haviland presumably adopted elements from the other four entries as per his remit, the final design must have reflected his overall vision (Figure 25).[75]

Work probably began in 1835, and the building (c. 200 × 253 feet) was constructed out of Hallowell granite and—appropriately and economically—some of the stone from the old colonial-era Bridewell prison.[76] It was completed in May 1838, and some modifications were made in 1885. It served as a one-stop policing center and prison facility; it included a sessions court, grand jury rooms, district attorney's offices, a house of detention, and debtors' quarters. It was organized around a horizontal H-plan, with its main façade along Centre Street; the cell block was located at the rear, along Elm Street, and the sessions court was in the middle, between two courtyards.[77] This plan allowed for natural light and aided the circulation of air. It also provided a suitable organization for a complex building, which needed offices and holding cells to be arranged thoughtfully and precisely.

FIGURE 25. The Tombs, Manhattan, 1860. This lithograph inaccurately depicts the portico with five columns.

Source: Author's collection.

For the Centre Street façade, Haviland crafted disparate Egyptian elements into a unified, original whole. The central feature of the Centre Street façade was a monumental portico supported by four Egyptian-style columns with large capitals of carved papyrus leaves. The shafts of the columns resemble bundled papyrus reeds, and triangular leaves were carved on the lower quarter of each column. A winged solar disc, an obvious Egyptian symbol, was located over the portico and each window. Above alternating triglyphs and metopes, a cavetto cornice, a distinctly Egyptian architectural element, ran along the building's roof line. At each end of the building facing the side streets were two small projecting Egyptianizing pavilions.

In his 1837 guidebook to New York, John Disturnell notes that the Tombs' floors were decorated in a "mosaic of an Egyptian character."[78] The columns in the entrance hall also bore "the character or [*sic*] an order taken from the colonnade of the temple of Medynet Abou," or Medinet Habu, an archaeological site in Egypt famous for its Mortuary Temple of Ramesses III.[79] He also notes that "Egyptian caviatides [*sic*] decorated the antes opposite these columns, which were highly spoken of by the French artists in Napoleon's great work on Egypt."[80]

Although the design is a pastiche of Egyptian forms unconnected to a specific structure, the Halls of Justice soon earned the epithet of "The Tombs," which brought a seriousness to the place and reflected the somber fate of those jailed within and, in theory, the swift and fair nature of the justice to be delivered. By the late nineteenth century, urban legend held that the nickname and form of the Tombs derived from the depiction of an ancient tomb in "Stevens' Travels." However, John Lloyd Stephens's *Incidents of Travel in Egypt, Arabia, Petraea, and the Holy Land* was not published until 1837, and the designs for the complex had been submitted by 1835,[81] making the chronology untenable. The origin of the nickname remains a mystery.

Like the Murray Hill reservoir, critics and the public liked the new complex. The *New York Evening Post* reported on April 1, 1837, that the Halls of Justice

> promises to be one of the handsomest of our public buildings. It is in the Egyptian style, a style well suited, by its massiveness, severity, and appearance of prodigious strength, to edifices of this kind. The thick walls used in that description of architecture, their pyramidal inclination, and the breadth and solidity of the ornament make the building appear as if destined to resist the tide and earthquakes, and the efforts of human strength.[82]

In 1852, it was still considered by the *Daily National Intelligencer* to be "not only an honor to the city and the American nation, but a perfectly unique specimen of its style."[83]

Despite the almost unanimous praise for the stylish Egyptian architecture, the building had problems almost immediately. Because of the Tombs' location on the old Collect Pond, the foundation was unstable, and four-inch cracks appeared shortly after construction finished. There was also a pervading dampness, and sewage routinely backed up through the drains.[84] It was soon woefully overcrowded.[85] In 1875, *Pomeroy's Democrat* proclaimed, "The Tombs is not a fit place in which to incarcerate the vilest wretch that lives."[86]

Despite the universal agreement that the Tombs was no longer fit for purpose, the decision to demolish the structure met some resistance. The *New-York Tribune* noted that

"many people think [the Tombs] ought to be preserved for the city as a relive [*sic*], because it is regarded as the finest example of Egyptian architecture in this country."[87] The *Oregonian* noted in 1897, "artists, architects and travelers have been most favorably impressed with the beauty of this building, sombre and grim as it is."[88] The façade in particular was acknowledged as architecturally significant. While the Tombs reflected a historically important moment in the United States' architectural history, this did not prevent its demolition, which began in 1897.

The Egyptian façade was a veneer, but a symbolically important and well-appointed one that mattered. A twentieth-century criticism often directed toward many buildings built in historical and classical revival styles was that the façade of a building did not articulate its function. This concern did not bother architects such as Haviland or those who commissioned the Halls of Justice. For them, the architecture's symbolism was as important as its functionality. The Tombs reflected moral imperatives, prison reform, and New York City's arrival as a major city with a functioning legal system.

Although the Tombs was in operation until 1897, Egyptian forms soon stopped being used for architecture associated with any aspect of the legal system. In New York City, the classical reigned supreme as early as 1860. The over-budget Tweed Courthouse (1861–1881) had a classical façade,[89] as did the Appellate Court (1900), just east of Madison Square Park.[90] Richmond County Courthouse (1913–1919), on Staten Island, used both classical and Renaissance architecture (Figure 26),[91] which was typical of Neo-Antique architecture. This courthouse replaced the 1837 third county courthouse, which was built in a Greek Revival style.[92]

Conclusions

Gulian Verplanck would have been delighted had he walked the streets of New York just a few decades after his exhortation to the genius of architecture to visit New York City. She had arrived and duly inspired architects, mayors, and aldermen to construct buildings directly modeled on those of antiquity—but not filtered through European interpretations, as the erection of the US Custom House and the Tombs affirmed. Strict archaeological accuracy was never the aim of the architects who employed Greek, Roman, or Egyptian forms; rather, it was the creation of imposing, grand, and functional buildings whose designs were informed by archaeology and archaeological publications. These buildings were proof that New York was a major metropolis and a peer of any leading European city. The framework of the Neo-Antique demonstrates that antiquity offered multiple models, not only democratic Greece and then imperial Rome. Egypt was also important, but it had a more focused remit, being used for structures that were technologically advanced, somber, and authoritative, like the Tombs, or, as we will see in Chapter 7, that had funerary associations. Egyptianizing buildings were never as popular as classical forms, perhaps because Egypt had non-Christian and non-Western associations and because Egyptian architectural forms were more difficult to modify.[93] The Founding Fathers and the American education system at this moment in time also favored the

FIGURE 26. Richmond County Courthouse, Staten Island, 2010.
Source: Jim Henderson (CC0 1.0).

historical primacy of the classics,[94] and so classical architecture held a special place. At the end of the nineteenth and start of the twentieth centuries, architects combined Grecian and, increasingly, Roman forms to make original, American structures, such as the Manhattan Municipal Building, reflecting how potent these forms could be. The Beaux-Arts tradition, which often combined Roman and Renaissance forms, demonstrated that European architecture would be an important factor for American architecture and its interpretation of ancient, especially Roman, forms. By the time Foley Square was constructed, the temple façade with symbolic sculpture had become the architectural form and norm for courts in the United States;[95] this specific appropriation would culminate in the Neo-Antique architecture of the United States Supreme Court (1935). If public architecture set the tone for New York City's built environment, and since that tone was antique and largely classical, then it is not surprising that the buildings that housed the city's economic drivers—the banks, warehouses, exchanges, and, of course, skyscrapers—would also look to ancient architecture to declare and emphasize the importance of trade and commerce to New York City, the topic of Chapter 3.

THREE

Treasuries of Old and Treasuries of New

Or did you know, even then, it doesn't matter
Where you put the US Capital
'Cause we'll have the banks
We're in the same spot

—ALEXANDER HAMILTON TO AARON BURR, *in* Hamilton, *by Lin-Manuel Miranda*

Hamilton's retort to Burr in the musical *Hamilton* underscores how financial services have always been at the heart of New York's economy. Having the banks mattered more to Hamilton than New York City being the nation's capital, since *having* capital was more important than *being* the capital. The US Custom House, discussed in the previous chapter, used Greek and Roman forms for its exterior and interior, respectively, to create a building that gave the US government's tax collection authority. It also set a tone for financial architecture in the nineteenth century; buildings that housed economic functions would primarily draw upon ancient architecture to articulate their importance to New York City, the United States, and the world. This chapter examines a number of the major types of financial or commercial buildings, including banks, exchanges, warehouses, commercial lofts, and skyscrapers. Over the course of the nineteenth century and early twentieth century, classical forms—with minor contributions from Egyptian and ancient Near Eastern architecture—were the established choice for financial architecture because of the functionality and symbolism the forms offered.

In classical antiquity, temples were the homes of gods—not a place of worship for a congregation. Temples had always housed votives, expensive gifts dedicated to the gods by petitioning humans, and they could also serve as a treasury for a city or cities. These now established facts were not well understood in the nineteenth century, and so their history as ancient treasuries is not a likely origin for the use of temples as financial or bank architecture. Rather, the survival of temples, often in ruins, made them one of the most prominent types of remains from classical antiquity. Moreover, often built in marble, temples

57

were perceived as symbolic, functional—and expensive—buildings by Americans and Europeans.

In the early eighteenth century, banks in England were originally housed in the private home of the organization's head. Unsurprisingly, Palladian classicism and its colonnaded façades, which were already associated with private architecture, served as the models for these early banks, including the first Bank of England (1734).[1] By the late eighteenth century, temple architecture was in service as the banks and exchanges of Great Britain. Sir John Soane had incorporated the tholos temple from Tivoli (near Hadrian's Villa, in Italy) into the so-called Tivoli Corner of the Bank of England, now mostly demolished, and its interiors recalled Roman temples.[2] When designing the Bank of England, Soane made drawings that depicted the bank as a future ruin, demonstrating the connection between antiquity's ruins and his design.[3] The third iteration of London's Royal Exchange (1844) had a temple portico and pediment. By the late eighteenth century, France, Russia, and German states had also embraced classical forms for their banks and exchanges.[4] These European examples established the classical idiom as the primary choice for banks and exchanges; therefore, if the United States was to compete with Europe on the international financial stage, classical architecture was required.

Banks

The US Custom House's eastern neighbor, Martin E. Thompson's Branch Bank of New York (demolished 1912), combined classical Greek elements, including a colonnade of four engaged Ionic columns that supported an adorned pediment,[5] with a tall cupola, leading scholars to describe it as both Federalist and Palladian.[6] The Federal style, which was popular during the first three decades of the American republic, could be considered as the first American interpretation of classical forms. Architects and furniture designers were heavily influenced by neoclassical—especially Georgian—designs, which were very popular in mid-eighteenth- and early nineteenth-century Britain.[7] Whatever moniker scholars have given it, it was clearly a building that looked to classical antiquity via its European interpreters. The Bank of New York (1797–1798) at the intersection of Wall and William Streets, designed by George Doolett, was another Federal-style building.[8] These two banks, along with the Custom House, set the stage for the erection of more classical banks in New York. The rapid growth of New York City's trade meant that banks, often in the form of little Grecian temples, were practically sprouting up on every corner of lower Manhattan to finance new ventures. Martin Thompson's Phenix Bank, constructed in the late 1820s,[9] was among the first banks that appropriated the form of the Greek temple (Figure 27). This austere, solidly built tetrastyle Doric temple reflects the ability of Greek forms to signify the stability and enduring nature of the Phenix Bank to those seeking a safe place to deposit their hard-earned capital.

Since the birth of urbanism, fires have always been a scourge of cities. The Great Fire of 1835 burned from December 16 to 17, decimating twenty blocks of lower Manhattan and razing between six hundred and seven hundred buildings. Such destruction was, how-

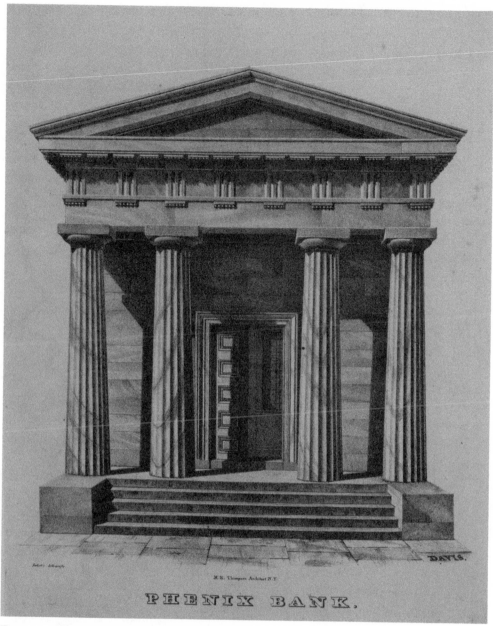

FIGURE 27. Phenix Bank, Manhattan, 1826–1829.
Source: Courtesy of the Metropolitan Museum of Art.

ever, a catalyst for an architectural rebirth. Isaiah Rogers, another leading American architect, was soon busy with commissions for new bank buildings. He designed the second building for the Bank of America, located at the corner of Wall and William Streets and completed in 1836.[10] Sitting on a slightly raised platform, this refined temple, composed of Quincy (Massachusetts) granite, had two Corinthian columns in antis and supported a simple architrave and block parapet crowned by an acroterion composed of an anthemion.[11]

The building was hailed as an "ornament to Wall Street" until its destruction in 1889.[12] Located two doors down the street was the Merchants' Bank, another Rogers commission. Constructed in 1838, it was a virtual replica of his Bank of America, although its Corinthian columns were modeled on the porch of the Tower of the Winds in Athens,[13] published in Stuart and Revett.[14] These banks rarely had sculpture in their pediments, possibly due to cost, a lack of trained artisans in the United States at this time, and a desire to cultivate an aesthetic of ruins.[15]

Sadly, the continuous redevelopment of lower Manhattan means that many of these buildings have been demolished, but these early banks set an architectural—specifically a classical—tone that would reverberate down the decades. The Greek forms that embodied the new nation's principles and dominated the early part of the nineteenth century gave way to the architecture of imperial Rome at the end of the century, when the United States emerged as an economic world power and had an overseas empire for the first time. In New York, two of McKim, Mead & White's banks exemplify the tradition of reinterpreting Roman temple architecture: the Bowery Savings Bank and the Knickerbocker Trust Building.[16]

Situated on an awkward L-shaped lot with street frontage on Bowery and Grand Streets, the Bowery Savings Bank (1893–1895) is an embellished architectural showpiece that displayed all of Stanford White's architectural brilliance (Figure 28). He developed two façades, both of whose pediments were filled by generic classicizing figures with elegant drapery and abundant garlands created by Frederick MacMonnies, White's go-to sculptor.[17] The main central banking room had double-height Corinthian columns, a vaulted coffered ceiling with skylights of Venetian glass, and walls decorated with a dazzling mix of colored marble and other luxurious materials. Anyone who banked here had clearly arrived.

The building became the Bowery's architectural anchor through its many ups and downs during the twentieth century. The savings bank eventually moved, but the building—with its polychrome marble and sculpture—was too good a venue to lie vacant for long. In 2014, after a million-dollar renovation, the bank reopened as a high-end event space for weddings, charity fundraisers, and corporate functions. It was aptly renamed Capitale, a verbal homage to its original function and its Roman architectural heritage.[18]

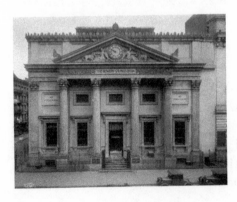

FIGURE 28. Grand Street façade, Bowery Savings Bank, Manhattan, 1893–1895.
Source: Wurts Bros. Museum of the City of New York. X2010.7.1.3361.

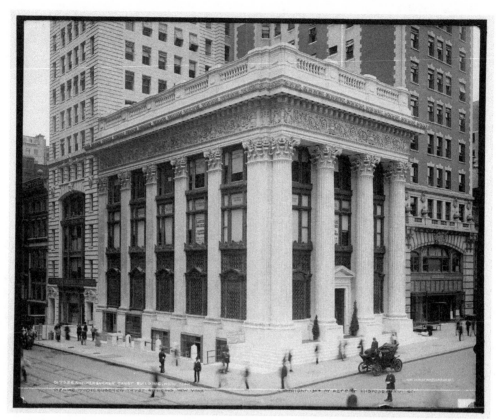

FIGURE 29. Knickerbocker Trust, Manhattan, c. 1904.
Source: The Library of Congress.

Charles T. Barney, the president of the Knickerbocker Trust, commissioned Stanford White to design a new building for the trust. White had a grand vision of a thirteen-story building occupying the highly desirable northwest corner of Fifth Avenue and Thirty-Fourth Street. A classical temple on street level would serve as the bank, and a hotel or offices would be located on the upper levels to generate income. With drawings completed and estimates in, Barney's associates withdrew their funding for the upper floors. Despite this, the lower four floors, the bank, were constructed (Figure 29). The imposing architecture of ancient Rome helped make the Knickerbocker Trust (1903) one of the most famous financial banks in New York.[19] Although the architectural critic Montgomery Schuyler identified the building's architecture as consisting of Romanized "Hellenic" forms in 1904,[20] the entablature's scrolling acanthus and Corinthian columns in reality derive from those of the famous Maison Carrée (Figure 30).[21] In the interior, the triglyphs and metopes formed a decorative cornice; coffered ceilings decorated with meanders were also used.[22] The building's classical forms and Vermont marble heralded that the Knickerbocker Trust was a secure place to deposit one's savings.[23]

Schuyler also praised the building, which he deemed a "modern classic,"[24] for its "modest" size because this meant that the bank had "scope for a really classic building, as very few building projects do."[25] He lambasted classical buildings where architects had "sacrificed

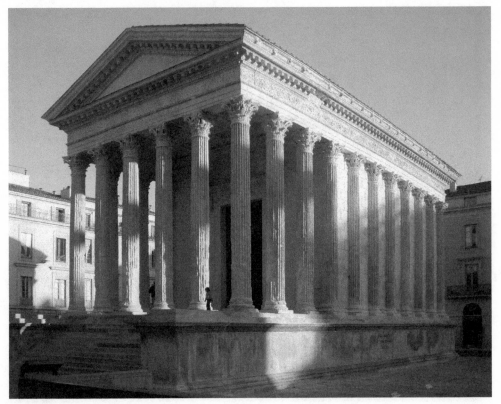

FIGURE 30. Maison Carrée, Nîmes, 2011.
Source: Danichou (public domain).

their buildings to their architecture, as, for example, by designing windowless Parthenons for the use of modern custom houses" and those buildings that merely used the classical orders as a decorative motif.[26] His comments underscore the precarious position that classical forms held in the early twentieth century.

The building's end echoed the tragic demise of Charles T. Barney. In the Panic of 1907, Barney resigned following the revelation of the misdeeds of two associates, and a run on the bank ensued. On November 14, less than a month later, Barney shot himself, at the age of fifty-six. Two days later, the *American Architect* noted coldly that the Knickerbocker bank, "so much in fashion just now, is really nothing so much as an advertisement" and that "when disaster comes, a well-rented skyscraper is a more valuable asset."[27] While the bank survived, the building only lasted intact until 1921, when a ten-story tower, also designed by McKim, Mead &White, was plopped unceremoniously atop the little temple, obliterating the richly carved entablature. In 1958, the lower floors, ironically now occupied by the Bowery Saving Bank, were modernized, and all of the bank's classical elements were stripped away, transforming the once beautiful temple into one more nondescript Midtown building. Banks in the form of classical temples (or banks that employed the classical orders) abounded in the United States and can be found in countless cities, from Charleston and St. Louis to Cleveland and San Francisco.

Warehouses and Commercial Lofts

Warehouses and commercial lofts were generally designed as highly functional buildings, and their exterior aesthetics were of secondary concern at best. That said, a few early New York warehouses from the 1820s and 1830s, such as 207–11 Water Street (1835–1836), 3 Coenties Slip (1836–1837), and the Arthur Tappan Store (1826, demolished) at 122 Pearl Street,[28] were built using Tuscan capitals.[29] The use of classical elements at Tappan's Store and at these other buildings helped them distinguish themselves from the competition (Figure 31). The Tuscan order's ancient associations with utility and strength were appropriate for warehouses.[30] Decorating warehouses and lofts was never widely embraced in New York, even when the city's industrialization reached a fever pitch. However, two buildings—the Austin, Nichols and Company Warehouse and 130 West Thirtieth Street, a commercial loft, both designed by Cass Gilbert between 1914 and 1927—used ancient architectural forms and sculptural elements.

Austin, Nichols and Company was a leading importing and manufacturing wholesale grocery business. Having outgrown their warehouse in Tribeca,[31] their new massive, hitech, six-story warehouse with piers, freight elevators, conveyor belts, and railway tracks was located on Brooklyn's waterfront at 184 Kent Avenue in Williamsburg and went into operation in 1915 (Figure 32). For the cost of $1 million, Cass Gilbert designed the building, which the architectural critic Arthur J. McEntee described as "an excellent example of the modern adaptation of Egyptian architecture to present requirements of commercialism."[32] The Egyptian architectural qualities of the warehouse are evident in its undecorated, distinctive cavetto cornice and its monumental proportions, which Gilbert saw as essential to its simple elegance.[33] Le Corbusier, Walter Gropius, and other European architects identified the warehouse and other similar industrial buildings as an inspiration for the development of modernism,[34] demonstrating that ancient forms continued to spark innovative architecture. By hiring Gilbert, a behemoth in American architecture who had just completed the Woolworth Building (1913), Horace Havemeyer, who financed the building, brought prestige to the Austin, Nichols and Company brand.

Gilbert, an architectural magpie, also used the artistic and architectural forms of the ancient Near East for a commercial loft (1927–1928) that he designed at 130 West Thirtieth Street, in the heart of Manhattan's garment district. In this neighborhood, developers speculatively built lofts with flexible space for manufacturing and sales.[35] Cass Gilbert's involvement brought the project cachet and helped attract tenants,[36] as did his unique deployment of ancient Near Eastern art and architecture.

130 West Thirtieth Street utilized architectural setbacks, as required by the 1916 zoning law, giving the building a ziggurat-like appearance.[37] Ziggurats are the tower-like, step-pyramid platforms of ancient Mesopotamia that served as a base for a temple or shrine. Hugh Ferriss, a delineator and architect working in the 1920s, noted that their form was a natural model for skyscrapers, especially for those that used setbacks.[38] The building's six setbacks were each decorated with glazed terra cotta friezes with mythical Neo-Hittite griffins[39] and Syro-Hittite sphinxes (Figure 33).[40] At the corners of some of the friezes stand images of Lamashtu, the most feared demon of ancient Mesopotamia.[41] These unique,

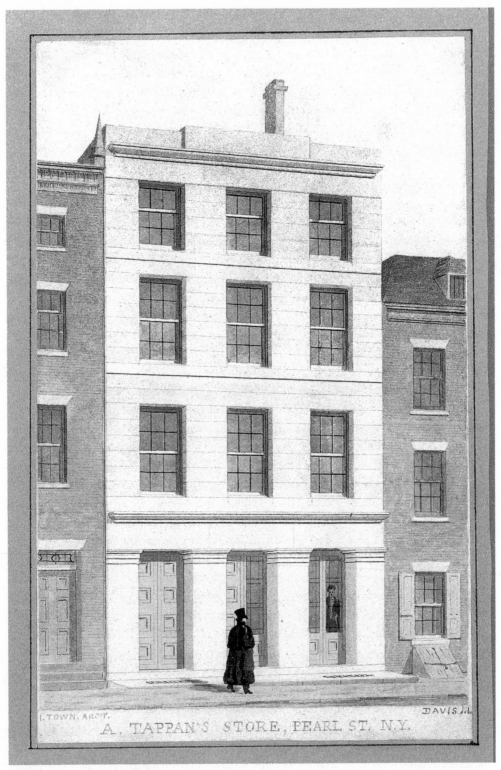

FIGURE 31. Arthur Tappan's Store, Manhattan, 1826.
Source: The Metropolitan Museum of Art (CCO).

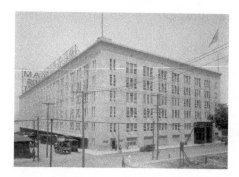

FIGURE 32. Austin, Nichols and Company Ware-
house, North Third Street, Brooklyn, 1915.
Source: Wurts Bros. Museum of the City of New York.
X2010.7.1.4502.

polychrome tiles, together with the setbacks, articulated the building's façade and success-
fully differentiated the top of the building from its surroundings.

This strategy was also employed on the street level of 130 West Thirtieth Street via
the deliberate positioning of bas-reliefs over the main and service entrances. Over each
entrance, there is a terra cotta relief of a hunting scene, where two male figures in a char-
iot shoot arrows at deer (Figure 34).[42] While some scholars have interpreted these reliefs
as being based on those from the North-West palace of Ashurnasirpal II at Nimrud (883–
859 BCE),[43] the more likely sources are Neo-Hittite reliefs. The Louvre has a nearly iden-
tical scene, which came from the kingdom of Milid (Malatya) in southeastern Anatolia
and northern Syria and dates from 1200 BCE.[44] Two roaring lions, also a symbol of royal
authority and the guardians of royal and religious spaces,[45] project outward from the build-
ing's wall and frame each relief. These two-tone reliefs, so different from the rest of the
street-level façades on West Thirtieth Street, ensure that the hurried pedestrian registers
the distinctive building.

Although Gilbert did not explain his selection of these motifs, his words give us a hint:
"I find beauty in so many different things that I like to develop a subject in the style which
seems best adapted to the purpose."[46] The novelty of ziggurat setbacks, Syro-Hittite
sphinxes, and Neo-Hittite griffins were striking in New York's architectural landscape.
The clean lines and more abstract aesthetic of the two-toned terra cotta tiles embodied
the aesthetics of Art Deco, the artistic style that was emerging in the 1920s, giving the
building an undeniably more modern look. In the early twenty-first century, the building
was converted into condominiums, and the building rechristened "The Cass Gilbert" to
attract buyers.

Sir Austen Henry Layard's excavations unearthed the Neo-Assyrian sites of Nineveh
and Nimrud in the mid–nineteenth century. His finds, including monumental *lamassu*,
have been on display at the British Museum since 1849. The *lamassu* is a mythical human-
headed winged bull or lion who protected the important doorways in Assyrian palaces.
Layard's publications and the Nineveh court at the Crystal Palace in London popular-
ized these remains.[47] By the end of the nineteenth century, major sites in the ancient
Near East, including Susa, had been excavated by the French.[48] The mythical Hanging
Gardens of Babylon and the Tower of Babel had long fascinated Europeans, formed the
subjects of paintings, and even appeared on the silver screen in D. W. Griffith's *Judith*

FIGURE 33. 130 West Thirtieth Street, Manhattan, 2016.
Source: Author.

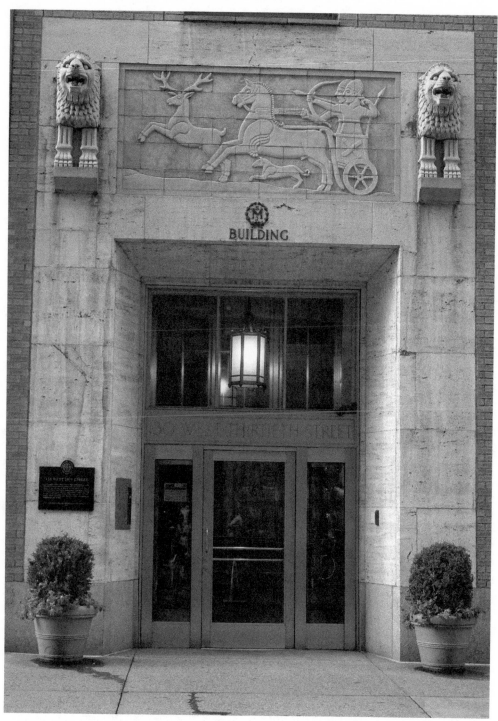

FIGURE 34. Entrance, 130 West Thirtieth Street, Manhattan, 2017.
Source: Author.

of *Bethulia* (1914) and *Intolerance* (1916).[49] Clearly, the art and architecture of the ancient Near East were circulating in the artistic milieu in the United States and Europe at this time.

The First and Second Merchants' Exchanges

Trade was at the heart of New York's economy, and exchanges were the venues where merchants could buy and sell goods and stocks. Both the first and second Merchants' Exchanges drew upon classical forms for their architecture and further established that classical forms were appropriate for financial architecture.[50] The first Merchants' Exchange, the first purpose-built exchange in the city, was erected on the south side of Wall Street between William and Hanover Streets between 1825 and 1827 by Martin E. Thompson and Josiah Brady (Figure 35). Like many buildings of this era, it drew on classical elements from disparate sources. Its towering Federal-style cupola owes a clear debt to contemporary English architecture, especially to Francis Goodwin's Old Town Hall in Manchester (1822–1824).[51] For the main two-story tetrastyle portico, Thompson employed the Ionic order of the temple of Athena Polias (fourth century BCE) in Priene, Ionia, which was illus-

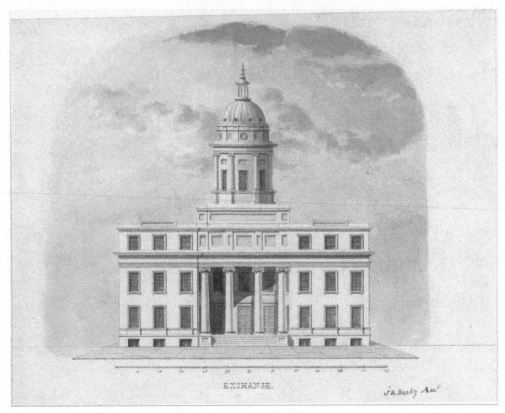

FIGURE 35. First Merchants' Exchange, Manhattan, c. 1826.
Source: The Metropolitan Museum of Art (CCO).

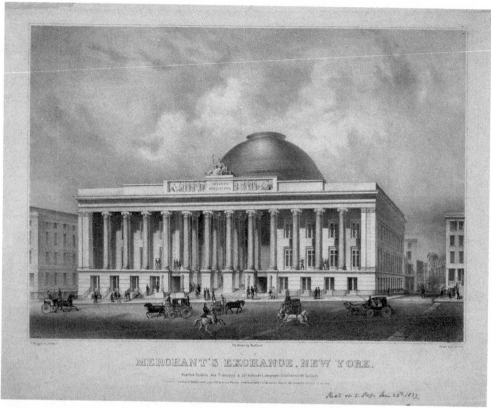

FIGURE 36. Second Merchants' Exchange, Manhattan, 1837.
Source: The Library of Congress.

trated in the second volume (1787) of *The Antiquities of Athens*.[52] Within the first Merchants' Exchange, two large rooms for the trading of goods each had a spacious apse, framed by Ionic columns.[53]

The Great Fire of 1835 destroyed the first Merchants' Exchange. Isaiah Rogers was then tasked with building the second Merchants' Exchange (1836–1842) at 55 Wall Street, where it would occupy the same footprint. A monumental Ionic colonnade of twelve columns of Quincy granite composed the Wall Street façade (Figure 36).[54] The interior was organized around a large hall with a 124-foot-tall dome with an oculus.[55] As at the Custom House, a Roman dome was fused with Greek architecture.

The façade of the second Merchants' Exchange, which only survives in nineteenth-century lithographs, had one of the earliest symbolic sculptural programs in New York City. A central freeze was positioned above the main entrance. Above this frieze sits an enthroned, robed female personification. She clutches a staff in her right hand, accompanied by a cornucopia, a globe with a branch, an eagle, and a parcel, alluding to the goods and services to be traded within. Although she is not identified, she is likely Tyche, the classical goddess of fortune, who was often associated with a city's prosperity.[56] Tyche became popular in the Hellenistic era, when she came to be associated with fate and the idea that a predetermined design or invisible hand was directing the outcome of men, cities,

and empires. Such an association is fitting: New York was destined for greatness through her commercial pursuits.

Surveying all below her, she appears to bless the transactions made within the exchange. The inscription reads "Erected/MDCCCXXXVIII" (1838) and is flanked by sculptural friezes. On the left is a crowned, lounging Neptune/Poseidon-like figure with a trident, attended by a series of classically robed figures, and on the right, toga-wearing figures attend a Ceres-like figure, who holds wheat sheaves. A steamship sails in the background. Although the specific details are lost, the personification and sculptural friezes clearly told the story of the exchange and indeed of New York—of how trade, geographic opportunity, and agricultural bounty had made the city rich. Underscoring this symbolism was the fact that the Merchants' Exchange was also home to the New York Stock Exchange until 1854, and the retail outlets of several merchants and insurance companies occupied offices that could be accessed directly from the street, thereby facilitating multiple types of transactions. This design is in keeping with contemporary European trends in the design of exchanges; the Paris Bourse (1808–1826; designed by A. T. Brongiart) and the St. Petersburg's exchange (1804–1816; designed by Thomas de Thomon) both had a colonnaded façade that hid a trading hall.[57] New York's Merchant's Exchange had an architecture clearly recognizable to European merchants, heralding the city's arrival as a cosmopolitan metropolis.

The Merchant's Exchange was only housed here until 1862, when the United States leased the building and remodeled it for use as the Custom House, which function it served until the 1890s. James Stillman, the president of First National City Bank, purchased 55 Wall Street for $3.265 million in 1899.[58] The First National City Bank, first known as the City Bank of New York and later as Citibank, was formed in the wake of the demise of the First Bank of the United States. One of the most powerful banks of the late nineteenth century, in the 1920s it became the first bank to hold $1 billion in assets.[59]

The public fretted over whether Stillman would demolish the much-loved building. Allaying the public's fears, he acknowledged that the building was an architectural masterpiece and would therefore be an "outward and visible sign of power and combination" for his bank.[60] However, it would need modifications. To achieve an architectural vision commensurate with the bank's stature and vast holdings, Stillman enlisted McKim, Mead & White. Like Stillman, the architects noted that they had "selected a classical type as best suited to our purpose";[61] classical forms were practical and symbolic. On the exterior, a Corinthian colonnade was superimposed above the original Ionic colonnade (obliterating the frieze and sculpture), recalling the stacked orders of Rome's Colosseum, the Roman fora, and the sixteenth-century Palazzo Thiene Bonin Longare in Vicenza.[62] The building's interior was demolished, and a completely new banking hall was created. Five upper stories were also added.

The building underwent continuous changes during the twentieth century. In 1992, the building became vacant when Citibank moved out of what the *New York Times* called "a Temple of Capitalism."[63] Yet the classical architecture still afforded the building an elevated status. In the 1990s, the bank was reborn as Cipriani Wall Street. Run by the

Cipriani family, known for their exclusive dining and event establishments, the former central banking hall was converted into a venue for parties, weddings, and other events. The upper five stories became an upscale hotel and full-service apartment complex.

The New York Stock Exchange

Arguably, there is no exchange more famous in the world than the New York Stock Exchange. The proud display of a corporate banner against the backdrop of the six Corinthian columns of the NYSE announces that the company is being listed on the exchange (Figure 37). Its proud owners and key employees will ring either the opening or closing bell. The NYSE is the undisputed symbol of Wall Street and of New York's place as the United States' financial powerhouse and a global leader among cities in finance, commerce, and exchange.

Constructed between 1901 and 1903, the New York Stock Exchange's new building was defined by a monumental Corinthian colonnade and pediment filled with classical sculpture. The massive building imbued the NYSE with authority, reflecting its view of itself and its role in the economy, and, as importantly, it provided the exchange with the trading floor it required.[64] The architectural origins of the exchange were far humbler. As early as 1725, wheat, tobacco, slaves, and securities were traded at the foot of Wall Street. In 1792, stock dealers, auctioneers, and brokers started meeting under a buttonwood tree at 68 Wall Street. In that same year, the Buttonwood Tree Agreement was reached, and the NYSE was formally incorporated. The exchange had a peripatetic existence during the nineteenth century. It was first housed in the Tontine Coffee House at the corner of Wall and Water Streets in 1793. In 1827, it moved into the Merchants' Exchange. Only in 1865 did the NYSE come to its current location on Broad Street, when a purpose-built French Second Empire style building was erected.[65] As the NYSE became a more and more important center of finance and securities exchange by the end of the nineteenth century, the old Broad Street building became increasingly inadequate.

George B. Post's Corinthian temple was selected in a competition. Post had designed a series of important industrial buildings, office buildings, and exchanges, including the Montreal Stock Exchange, so he knew how to produce a design that would meet both the functional and symbolic needs of the exchange. The façade is a modified version of a Corinthian temple, similar to that of the Maison Carrée (see Figure 30). The Corinthian order was the defining order of Roman architecture and was popularized under Augustus, the first Roman emperor. While one classical order might seem interchangeable with another, the decision to use the Roman Corinthian order for the NYSE reflects American architects' embrace of Roman forms, as opposed to Greek, during the late nineteenth and early twentieth centuries. By the start of the twentieth century, the ascendant United States had an economic and territorial empire. The narratives around empires and their inevitable decline, which had so worried early Americans, now had shifted to a narrative of American exceptionalism and of the glory of empire.[66] The broad shift from Greek to Roman architecture reflects this change. In the case of the NYSE, the high podium

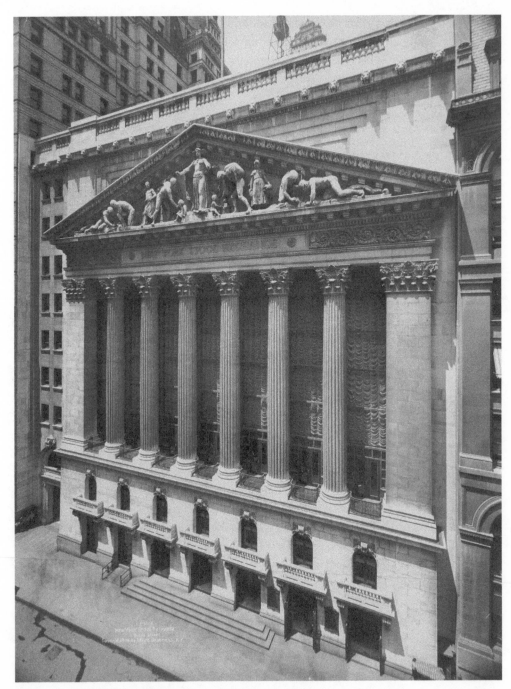

FIGURE 37. New York Stock Exchange, Manhattan, c. 1908.
Source: The Library of Congress.

and façade of a Roman temple were retained. The traditional temple's staircase was re-placed by street-level entrances and internal staircases, good examples of how modifica-tions to the classical forms were necessary. Behind the façade's Corinthian columns was a massive glass curtain wall (96 × 50 feet) that provides natural light and ventilation for the trading floor (138 × 112 feet; 80 feet high).[67]

While the New York Stock Exchange is an iconic building, the pedimental sculpture, created by John Quincy Adams Ward and Paul Wayland Bartlett, is virtually unknown. New Yorkers are too preoccupied with life to glance up from their phones, and the tour-ists are too busy taking selfies to notice the sculptural composition, titled *Integrity Pro-tecting the Industries of Man*. Ward designed the overall composition in 1903, and Bartlett carved the figures between 1908 and 1909.[68] At the center is Integrity, sometimes called Business Integrity, with her arms outstretched. Two groups of male and female figures flank her, and two small children sit at her feet. On the left, a slim figure and a muscular giant, nearest to Integrity, personify Electric Power,[69] and in the south corner, two other male nude figures, who represent Scientific and Mechanical Appliances,[70] appear to be sur-veying the ground or laying out a building.[71] On the right, Agriculture and Mining are personified.[72] A nude farmer bears a backbreaking load of grain. The nudity gives the farmer and the other figures a heroic quality, and, like the heroes of Greek myth, their toil is celebrated. To his right is a modestly dressed young woman, whose hand rests on the head of a magnificent ram, signifying woman's role in the economy. In the north cor-ner of the pediment, two muscular male nudes explore the ground for minerals, trying and testing the surface in search of hidden wealth below. The words "NEW YORK STOCK EXCHANGE" are inscribed on the entablature, framed by acanthus and leaves. This highly symbolic composition places the NYSE at the heart of the US economy; it would provide the capital necessary for the United States' new industries, and it would enable men, women, and children to prosper. Like Integrity, the NYSE is principled and honest. While this figure and composition might seem ironic in the wake of the Great Recession, it reflects the attitude and belief that many Wall Street bankers had at this time.

Writing for the *Architectural Record* in 1901, Percy Stuart thought that the building re-flected the new and increasing prosperity of the United States and proclaimed that the NYSE

> will be the first great commercial edifice to be built in New York in the twentieth century, a fitting precursor of an age destined for great buildings. It will represent the highest engineering achievements of modern construction; and it will contain architectural features of a unique and impressive character. In fine, it will be a monument typical of this era of great commercial buildings, and illustrative of the ruling tendencies of the American people.[73]

Commercial success was a force that allowed America's democracy to flourish; such a build-ing as the NYSE celebrated this. In his broadly positive review of the building, Russell Sturgis, a major architectural critic at the time, noted:

> So far we have accepted the front as a piece of admittedly neoclassical academic work, but there are one or two points on which, for better or worse, the academic system has been

abandoned; and first, to name an instance of such breaking of rules, the result of which is triumphantly good, let us consider the treatment of the capitals which crown the great antae.[74]

Sturgis's review foretells the changes that would define the architecture of twentieth-century New York: the abandonment of classical and other forms of historicizing architecture. Nowhere is this more evident than in the development of the skyscraper, often considered the quintessential New York building.

Skyscrapers

The skyscraper, made possible by steel and the elevator, was an excellent solution to the lack of space in cities, especially on the small island of Manhattan. Early skyscrapers were often compared to columns. The architect Louis Sullivan, a leading advocate of the skyscraper, observed in 1896 that while the formal comparison of the skyscraper to a tripartite column's division of a base, shaft, and capital often held true, the skyscraper did not derive its form from the classical column.[75] Much to Sullivan's dismay, many of the skyscrapers erected between the 1880s and 1920s in New York City were much like the shorter buildings that they overlooked, that is, utilizing a range of historical—classical, medieval, and Renaissance—architectural forms.[76] The Bankers Trust Building (1912) and the Fred French Building (1927) allow us to chart the changing role that ancient forms played in these buildings and ultimately the decline of ancient architecture and decoration in skyscrapers. While classical forms were rejected as decorative models for skyscrapers by the 1930s, when the European International Style, which embraced modernism, gained traction with architects, classical architecture's principles of proportion and ratio would emerge as fundamental to the design of some of New York's most important skyscrapers, including the Seagram Building (1958).

BANKERS TRUST BUILDING

Located at 14–16 Wall Street, across from the New York Stock Exchange and next to the old Custom House, the Bankers Trust Building embodied many of the principles of early skyscrapers; it met the functional and symbolic needs of its primary occupant, the Bankers Trust, through a deft use of classical architecture (Figure 38). Built by the legendary New York firm Trowbridge & Livingston, the building combined classical and Renaissance forms while using the most technologically advanced systems[77] to create what was briefly the world's tallest building in 1912 (construction started in 1910).[78]

The 539-foot skyscraper had a tripartite division. The four-story granite base[79] is composed of a colonnade of three-story-tall, engaged Ionic columns that sit on a stylobate. The base's architectural order derived from the Ionic columns of the Erechtheion, one of the most widely reproduced classical buildings. It is decorated with Greek fretwork that alternates with belt courses that support a cornice with rosettes and lion heads.[80] The col-

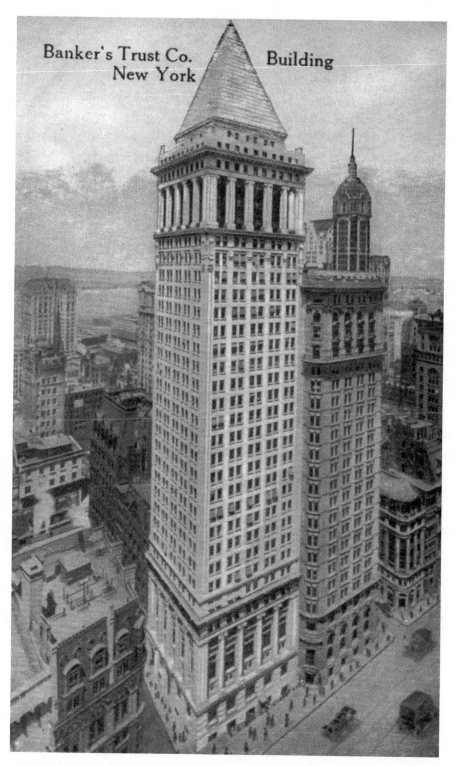

FIGURE 38. Bankers Trust Building, Manhattan, historic postcard, early twentieth century.

Source: Author's collection.

onnade gave way to a plain curtain-wall shaft twenty-one stories tall,[81] whose austere, granite façade conveys a sense of "lithic solidity," in the words of the architectural historian Eric Nash.[82] While the shaft of the building recalls the campanile of St. Mark's in Venice,[83] the details are overwhelming classical.

Topping the shaft is a five-story colonnade of engaged Ionic columns in antis. It serves as the base for a one-story setback penthouse and the building's signature seven-story stepped pyramid. The *New York Architect* reported that the top colonnade is supposed to have derived from a portico at "Palitiiza" in Macedonia;[84] however, this is not a site that I have been able to identify. Therefore, this is yet another example of claiming a connection to a classical site and architecture to augment or inflate the status of a building.

The stepped pyramid was modeled on one of the Seven Wonders of the ancient world, the Mausoleum of Halicarnassus (c. 352 BCE), the grand tomb of King Mausolus of Halicarnassus (now Bodrum), in Asia Minor. The Mausoleum did not weather the vicissitudes of time well. It is best known from ancient sources such as Vitruvius and, in particular, Pliny the Elder, whose detailed description (c. 75 CE)[85] has provided rich fodder for architects and artists since the Renaissance. The rectangular Mausoleum had a perimeter at ground level of c. 453 feet.[86] Standing c. 146 feet tall, it was composed of three main sections: a high podium, on top of which was a colonnade of thirty-six columns, known as the Pteron; a pyramid-shaped roof, with twenty-four steps, topping the colonnade; and on top of this a marble quadriga, created by Pythis.[87] According to Pliny and Vitruvius, it was adorned with statues executed by famous Greek sculptors.[88]

The roof and colonnade collapsed in an earthquake; however, the ruins were reasonably intact until 1494, when the Knights Hospitallers used stones from the Mausoleum to fortify their castle of St. Peter at Bodrum; by 1522, most of the Mausoleum had been cannibalized as building material. Although the superstructure of the Mausoleum was effectively gone, its identification as one of the Seven Wonders of the ancient world meant that it held great appeal to architects and artists. In 1856, Charles Newton undertook the first systematic excavations. Most of the sculpture he recovered is now in the British Museum,[89] but there was not enough archaeological evidence to reconstruct the Mausoleum's architecture with any certainty.[90] The Mausoleum thus became an archaeological palimpsest that could be reconstructed in endless variations. The tallness of its famous pyramid-shaped roof—an ancient tall building—made it an ideal ancient model for the newfangled skyscraper.

The stepped pyramid provided a visually striking terminus for the Bankers Trust Building, while also being highly functional. The pyramid housed storage space, a water tank, records, and part of the elevator's mechanics.[91] The design was celebrated almost immediately; *Cassier's Magazine* wrote:

> The whole structure—pyramidal cap, heavy colonnade, regular body, with accurately
> placed and numerous openings and basal portion with its colonnade—presents a beautiful
> and impressive appearance, free from ornate decoration. The tower makes it appeal to our
> approbation for the simple and the substantial.[92]

Cassier's misidentified the pyramid as Egyptian in inspiration.[93] *Cassier's* mistake—confusing one ancient prototype with another—was not uncommon,[94] and it reflects the point that sometimes a connection to antiquity and ancient architecture was as important as the ac-

curacy of that identification. While the architect may have made a purposeful choice, the man—even the well-educated man—on the street did not always get such specific references; nevertheless, he saw such ancient architecture as prestigious.

The building was a critical and design success, and its form was widely replicated. The 480-foot-tall Standard Oil Building (1922) that was erected at 26 Broadway at Bowling Green has a stepped-pyramid roof topped by an urn. The addition to the old AT&T Building at 195 Broadway also has a smaller stepped-pyramid roof, which rested on a temple base inspired by the Temple of Athena Nike in Athens.[95] Outside of New York City, Cass Gilbert took inspiration from the Mausoleum of Halicarnassus and the Bankers Trust Building for the Union Central Life Insurance Company Building (1911–1913) in Cincinnati.[96] At 495 feet tall, it was one of the tallest buildings erected outside of New York City and was intended to identify Cincinnati as a regional center for the insurance sector.[97] The S. W. Strauss & Company Building (1924) in Chicago and the Foshay Tower (1927–1929) in Minneapolis both had stepped pyramid tops. Postmodernists were also inspired by the building's step-pyramid roof. In 1998, Kevin Roche John Dinkeloo and Associates designed the new Morgan Bank Headquarters at 60 Wall Street,[98] whose top recreated columns in glass, like those on the Bankers Trust Building, and the Museum of Jewish Heritage—A Living Memorial to the Holocaust (1997), which has a pyramidal structure.

The highly functional main banking room of the Bankers Trust Building had Greek details, and reportedly the column capitals were modeled on those from the Temple of Apollo at Bassae.[99] The Greek motifs were considered to provide elegant, clean lines that dignified the interiors and gave them a business sensibility.[100] The lobby was decorated with a series of symbolic paintings depicting different sectors of the economy, including agriculture, manufacturing, and mining, much like at the New York Stock Exchange.[101] An L-shaped extension was placed around the building in 1931–1933.

Just as the New York Stock Exchange's façade and pedimental sculpture symbolized the NYSE's centrality to the US economy, the Bankers Trust Building embodied the solidity and strength of the Bankers Trust Company. The Bankers Trust adopted their building's pyramid as its trademark and logo until the 1980s, and their advertising featured the building and the tagline "A Tower of Strength" (Figure 39).[102] The building had literally become a symbol of the honesty and dependability of the Bankers Trust Company, giving physical form to an abstract idea. Unsurprisingly, other financial and real estate companies realized that architecture could not only house their offices but could symbolize a company's ideas and aims. Nowhere is this better articulated than in the architecture and decoration of the Fred French Building.

THE FRED FRENCH BUILDING

Motifs that drew upon the traditions of the ancient Near East and the classical world could also be found on one of the most prominent office buildings erected in the late 1920s: the Fred French Building. Following the completion of Grand Central, the area immediately around the terminal became highly desirable, and office buildings sprang up. Fred French, who developed Tudor City, a complex of brick residential towers dressed in another historical style to the east of Grand Central Terminal,[103] was a key figure in the area's

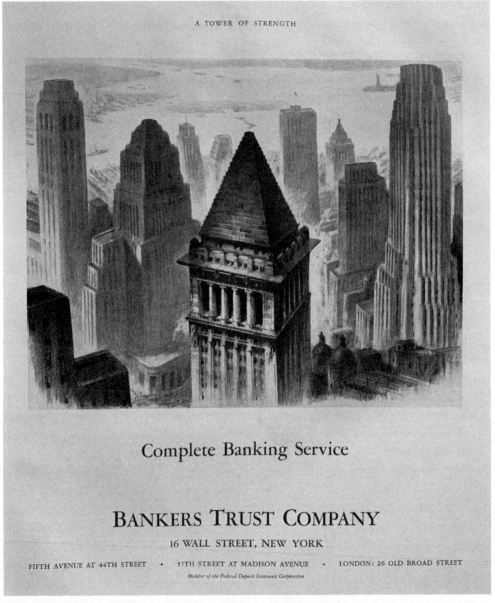

FIGURE. 39. "A Tower of Strength" advertisement, twentieth century.
Source: Author's collection.

development. Between 1925 and 1927, he erected his headquarters at Forty-Fifth Street and Fifth Avenue. French's unabashed promotion of the building's architecture through the *Voice*, the Fred French Company's magazine, resulted in the swift occupation of the building's rental space and ensured that the building was almost immediately a financial success. Like the Bankers Trust building, the Fred French Building featured prominently on the masthead of the *Voice*.[104]

The French Building had an interesting top and setbacks, which used bright polychrome terra cottas, as well as two daring lobbies and street-level façades with rich ornamentation,

inspired by the diverse traditions of the ancient Near East.[105] Fred French's in-house architect, H. Douglas Ives,[106] worked with the firm Sloan & Robertson,[107] who served as consulting architects on the project, to erect the skyscraper. Ives noted that they "felt we might safely adapt these Assyrian or Chaldean forms of ornament which were peculiarly suitable to the flat surfaces" of the French Building.[108] For his design, Ives referenced the polychrome Tower of the Seven Planets, another name for the Tower of Babel,[109] and observed that setbacks would permit planted terraces, like the Hanging Gardens of Babylon.[110]

Ives called the style "Mesopotamian." Reportedly, he had originally considered Gothic or Romanesque but changed his mind because such styles, as he thought, needed "projections such as cornices and depth to the reveals of openings in order to be effective."[111] The 1916 zoning law prohibited projections of more than eighteen inches from a façade, thereby preventing architects from creating monumental cornices and projecting sculpture,[112] and it encouraged the use of setbacks. The lack of projecting cornices meant that reliefs would be a more effective type of decoration on the new flat façades of the building's top, opening new decorative possibilities.

Colored tiles, which always had an important place in the architecture of the ancient Near East, figured prominently here.[113] The polychrome tiles of Babylon's Ishtar Gate and Layard's publications of Nineveh, some of which showed the palatial interiors in bright colors,[114] ensured that the colorful nature of ancient Near Eastern art was emphasized. On the north and south façades of the building's top are identical polychrome faience reliefs that center on rising suns, symbolizing progress, flanked by winged griffins, symbolizing watchfulness and integrity (Figure 40).[115] Separated from the sun and griffins by Corinthian columns are two golden beehives, each surrounded by five bees. Since 29 BCE, when the fourth book of Virgil's *Georgics* was written, bees have been perceived as hardworking laborers, and so for the French Building they likely symbolize thrift and industry. The reliefs' high, glossy finish and bright colors—yellow, red, orange, and green—made the top of the Fred French building stand out in New York's Midtown skyline, especially when sunny. The building's crown was also illuminated,[116] giving the building a prominent position in the cityscape at night. The head of Mercury, the god of commerce, appears on the building's east and west sides. The building was the first nonresidential application of the French Plan and the cooperative ownership plan.[117] Thus, on top of this building, the artistic forces of classical antiquity and the ancient Near East had joined forces to bless French's success as a developer and to proselytize for the French Plan.

On the street level, the building's two lobbies and decorated façades are unique in this bustling part of Midtown. The Fifth Avenue entrance has gilt-bronze doors decorated with winged griffins, and the elevators each have eight reliefs of either women or bearded genies, symbolizing industry, commerce, finance, and construction, that is, the business concerns of Fred French (Figure 41).[118] The motifs in the lobby include Assyrian palmettes, lotus flowers, lions, chevron bands, merlons (crowsteps), winged bulls, and volutes.[119] Double bull capitals from the palace of Darius the Great in Susa, one of which is now in the Louvre, are reproduced in miniature and flank the revolving doors used to enter the Fifth Avenue lobby.[120] The lobby and main entrance on Forty-Fifth Street had a similar multicolor painted ceiling, elaborate cornices, and wall fixtures, as well as gilt-bronze doors with

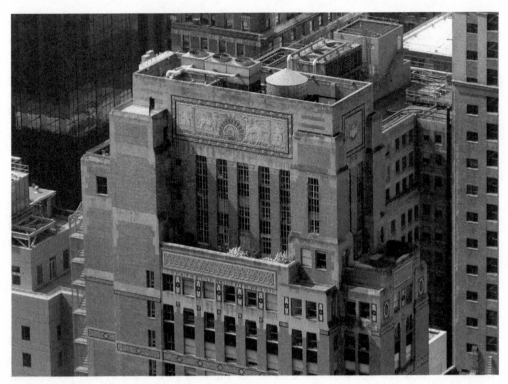

FIGURE 40. Fred French Building, Manhattan, 2014.
Source: Chris Sampson/Wikimedia Commons (CC BY 2.0).

twenty-five inset panels of women and bearded Mesopotamian genies.[121] This entrance has jambs and lintels decorated with similar motifs from the ancient Near East, including ox-head capitals atop scrolls. The office floors did not feature any ancient motifs and were designed to suit the tenants' needs.

Writing for the Landmarks Preservation Commission, Amy Galanos and Janet Adams identified the building as "proto–Art Deco" and saw the building as marking a transition from historicism to modernism in the design and decoration of skyscrapers.[122] The building's use of tiles as architectural decoration on its top, as well as the street-level decoration, underscores this transition. The Fred French Building also embodies the eclectic nature of many Neo-Antique buildings: It purposefully combined two different ancient styles together in its architectural decoration. While the bull capitals, *lamassu*, and genii distinguished the building's street-level façade and setbacks of the ancient Near East proved a useful architectural model, the building's crown amalgamated the griffins of the ancient Near East with Mercury and the industrious bees of the classical world. The use of ancient Near Eastern and classical elements aimed to attract tenants as well as publicize the benefits of the French plan. It also articulated the success of the self-made Fred French to anyone who strolled Fifth Avenue or who had a view from a neighboring skyscraper. The Bankers Trust, previously discussed, also did this—fusing Venetian forms with Hellenistic and Greek architecture to create an original and much-copied building.

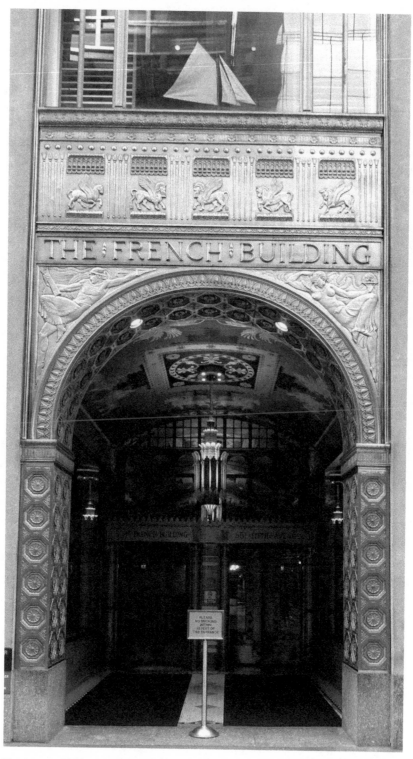

Figure 41. Fifth Avenue exterior and entrance, Fred French Building, Manhattan, 2017.

Source: Author.

Modernism and Its Debt to Classical Architecture: The Seagram Building

Modern architects relegated the anthropomorphic versions of Industry, Commerce, and other personifications to the annals of art history because they deemed such sculpture derivative. Likewise, the architecture that supported it, such as a Grand Central Terminal, was seen to be a bit of a sham by architects; Grand Central was supported by steel, not built of stone or brick. However, the fundamental principles of classical architecture—which emphasized portion, ratios, and order—emerged as critical elements of the design and thought process of the leading modernists.[123] Le Corbusier, for example, was drawn to and inspired by the rationalism and proportional principles of classical architecture, which inform some of his most important works, like the Villa Savoye.[124] He even compared modern machines to the Parthenon and pictured them together in his *Vers une architecture*.[125] Nowhere is this modern interest in ancient forms more evident than in the masterful Seagram Building, located at 375 Park Avenue, designed by Ludwig Mies van der Rohe with Philip Johnson and constructed between 1956 and 1958 (Figure 42).[126]

Designed by Mies at the behest of Phyllis Lambert, the building served as the New York headquarters for Joseph E. Seagram and Sons, Canada's leading distilling and liquor-distributing firm, run by Samuel Bronfman, Lambert's father. Considered a modern architectural masterpiece—Lewis Mumford called it the "Rolls-Royce" of architecture[127]—the design of the building undeniably draws upon the principles of classical architecture, which Mies had long embraced.[128] Lambert noted that his "ingenious and deceptively simple solution is comparable to the use of the Greek orders."[129] Just as the Greeks and Romans used a system of proportions and ratios to erect their temples,[130] Mies deployed a proportional system of three to five bays to form his elegant tower.[131] The Seagram Building is like an ancient Greco-Roman temple; set back one hundred feet from Park Avenue,[132] it has an elevated plaza, just as a temple has a temenos before it. Here pedestrians and light replace worshipers and an altar. One has to walk up steps, like one was going to enter a temple. The lobby is flanked by black steel pillars, just as a colonnade would flank a temple to Zeus. To enter the lobby, one passes through four pillars—akin to the porch of a hexastyle temple. As the architectural historian Franz Schulze noted, "the very axiality of the plan, underscored by the centrally hung entrance canopy, lent a psychic formality to the act of entry, as if the building were a classical edifice."[133] At first glance, the design of the Seagram Building appears to have little to do with any aspect of classical architecture; however, a closer examination demonstrates that Mies's masterpiece had a different—but highly significant—engagement with Roman architecture, specifically the implementation of the design principles of Greco-Roman architecture.

Conclusions

The architects and owners of New York's commercial and financial architecture consistently appropriated ancient forms in the nineteenth and early twentieth centuries. These forms not only worked well for the various purposes required (bank, exchange, skyscraper,

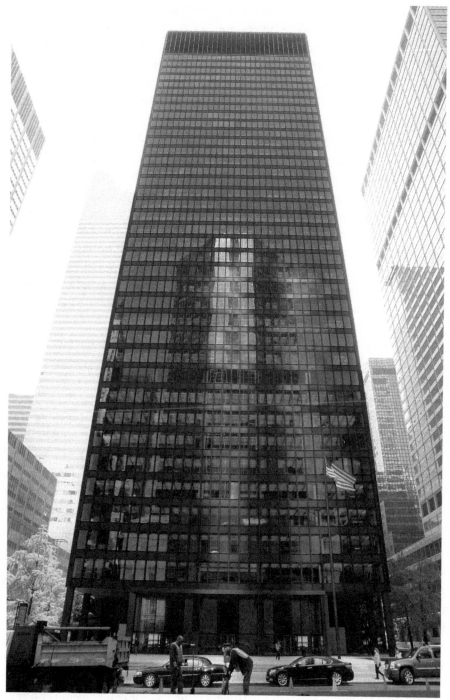

FIGURE 42. Seagram Building, Manhattan, 2008.
Source: Noroton (public domain).

or warehouse), but ancient architectural forms could encapsulate the values that many of these buildings' owners wanted to convey: solidity, strength, endurance, and confidence. Banks were fortress-like temples with secure vaults. The warehouses mostly used simplified forms and lines, although buildings like the Arthur Tappan Store; the Austin, Nichols and Company warehouse; and 130 West Thirtieth Street used the architecture and sculptural traditions of ancient Egypt and the ancient Near East to stand out from the commercial crowd. New York's exchanges used classical forms to enclose their trading floors and used classical sculpture to symbolize the goals and standing of the exchanges—from the Tyche-like figure on the 1838 Merchants' Exchange to Integrity in the pediment of the New York Stock Exchange. Skyscrapers were functional, serving the needs of the banker, trader, and salesmen, but they were also highly symbolic. The Bankers Trust Building was a "Tower of Strength," while Mercury, the *lamassu*, and the bees advertised the Fred French plan. Despite the careful selection of ancient forms by architects, sometimes architectural critics and contemporary accounts of these buildings identified the wrong ancient model, suggesting that the symbolism and status conveyed by ancient forms was sometimes more important than accuracy. A New Yorker in the know recognized that classical forms could mean strength, status, and success even if they did not know from which exact building the classical forms derived.

In the twentieth century, classical architecture gave way to more abstract architectural forms, as architects and designers pushed for original forms no longer grounded in historical architecture. Yet certain elements, especially in sculpture, would endure, and many classical subjects were rendered in modern form, as seen in the statues *Prometheus* and especially *Atlas* at Rockefeller Center[134] and in the work of some of Europe's most famous artists, including Giorgio de Chirico, Pablo Picasso,[135] Fernand Léger, and Francis Picabia.[136] While the use of overt ancient forms were curtailed in New York's architecture, the principles of classical architecture, specifically the use of proportion and ratios, continued to influence modernism, as is evident at the Seagram Building. Postmodern architecture also returned to classical forms, but in a playful, distinct way. The broken pediment of the postmodern 550 Madison Avenue, designed by Philip Johnson for AT&T in the 1980s, serves as a distinctive top that distinguishes the building in the forest of Midtown skyscrapers. It also has an arcade, akin to an ancient portico or colonnade, on the street level. Likewise, the work of Kevin Roche John Dinkeloo and Associates in lower Manhattan is a reminder that ancient architecture continues to be used because it can be readapted again and again.

Thus far, we have seen how ancient art and architecture—from classical myth to ancient town planning and temple architecture—could be adapted for aqueducts, reservoirs, banks, borough halls, custom houses, and even skyscrapers in New York City. It comes as no surprise that buildings associated with art, culture, and learning would also appropriate the timelessness of ancient architecture to form New York's museums, universities, libraries, and even zoos, as we will see in the next chapter.

Modern *Museions*

In the 1820s, New York City was bursting at the seams, expanding northward up Manhattan in line with the Commissioners' Plan of 1811. DeWitt Clinton's Erie Canal connected New York City to new markets and the agricultural produce of the Midwest, helping fuel the city's economic boom. But Clinton had the foresight to realize that for a city to be a proper city, let alone a world-class metropolis, it also needed cultural institutions, universities, and museums—the modern descendants of the ancient *museion*, a building associated with the nine muses. Therefore, when the inmates of the Chambers Street alms house were relocated near Bellevue, the building was rechristened the New York Institution of Learned and Scientific Establishments in 1816, and several leading educational and cultural institutions moved in.[1] Shortly thereafter, the artist John Vanderlyn asked them to exhibit *Ariadne Asleep on the Island of Naxos*, his painting of a reclining nude. Horrified, the leadership of the institution firmly declined to display this risqué work, which they deemed an affront to the standards of propriety.[2] Vanderlyn took matters into his own hands, raising funds from prominent members of society, including the Astors, to build the Rotunda, New York's first art gallery, directly to the east of the alms house, a clear rebuff to those who had rejected him (Figure 43).[3]

Built in 1818, the Rotunda's dome and portico was undeniably influenced by Rome's Pantheon.[4] While the building lacked a double pediment, the façade was composed of a rectilinear triangular pediment with a Doric portico—not the Corinthian order used in the original. Behind this was a vertical stacking of a rectangular Doric entablature and dome, both features of the Pantheon. Two niches set between Doric columns framed the

FIGURE 43. Rotunda, Manhattan, 1827.
Source: The Metropolitan Museum of Art (CC0).

door. In the left niche, a figure in classical robes looks at a bust on a column, while in the right niche a classical male nude places his hand on his hip and stretches out his hand, much like the Apollo Belvedere, one of antiquity's most famous sculptures. For New York City's first art gallery, only the most fashionable and culturally prestigious architecture would do, and that was classical. The choice of the Pantheon belies what we might expect:

It is not Greek architecture, which had directly inspired so much of the United States' architecture at the time. But the Pantheon, which had already been reinterpreted at Thomas Jefferson's Monticello and at the University of Virginia, had cultural cachet.

The Rotunda served as an art gallery until the late 1840s. Demolished in 1870,[5] it is now no more than a footnote in the history of classical architecture in early nineteenth-century New York, but it speaks to how classical art and architecture were not only popular but fundamentally connected to the conceptualization of museums and cultural institutions in the United States. After the Civil War, classical culture shifted from a major aspect of civic culture to being a symbol of high culture, and classics became a key element of elite learning.[6] Paralleling this development, classical architecture emerged as the primary architectural language for elite cultural institutions, museums, and universities, often replacing (although not exclusively) the widely used Gothic and Romanesque architecture. This chapter examines why the Metropolitan Museum of Art, the Brooklyn Institute of Arts and Sciences (renamed the Brooklyn Museum), the American Museum of Natural History, and the New York Zoological Society (better known as the Bronx Zoo) engaged with and appropriated classical—especially Roman—architecture. Columbia University, New York University, and City College also reinterpreted classical forms for key buildings on their campuses, as did New York City's public libraries.

The Metropolitan Museum of Art

The Metropolitan Museum of Art has a monumental presence along Fifth Avenue, anchoring Museum Mile. Its Fifth Avenue façade appears to be a unified image of classical perfection, but the museum's architecture is in fact an amalgamation of wings, additions, and perpetual transformations.[7] It would take several attempts for the Met to achieve classical perfection or, indeed, something classical at all.

The Met was incorporated on April 13, 1870. It was housed in temporary quarters until 1880, when the first museum building opened, located within Central Park. Designed by Calvert Vaux, the co-designer of Central Park, and Jacob Wrey Mould, a student of Owen Jones, the famed British designer, the building was an unattractive and critically derided high Victorian Gothic hodgepodge (Figure 44);[8] the art critic James Jackson Jarves called it "fit for only a winter garden or a railway depot."[9]

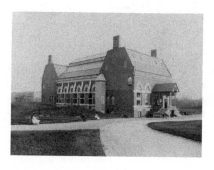

FIGURE 44. Wrey and Mould building, Metropolitan Museum of Art, Manhattan, c. 1900.
Source: Museum of the City of New York. Photo Archives. X2010.11.4938.

In December 1880, the museum's executive committee decided that an extension was necessary, and classical forms, especially Roman ones, were on the ascendency in American architecture. Theodore Weston and Arthur Lyman Tuckerman designed and erected the second, north wing of the museum between 1880 and 1894. Weston's design—with its large rounded arches, like those of Roman baths, and columns with mansard roofs—was classical and French in inspiration. Several trustees pushed for the inclusion of classical elements, including relief panels inspired by the Parthenon friezes on the new wing's main façade.[10] By January 1886, when construction finally started, the new building's budget had already ballooned out of control, so the classical details were omitted. The new building opened on December 18, 1888, to decidedly mixed reviews. *Harper's Weekly* wrote, "All who are familiar with the complete design of the late WREY MOULD must regret that it has been thrown aside to be replaced by the present squat and heavy structure."[11]

In 1894, the board finally turned to its trustee Richard Morris Hunt to design the Met's next iteration. Educated at the École des Beaux-Arts and having designed the Administration Building of the Columbian Exhibition of 1893, he was the elder statesman of American architecture. Hunt devised a master plan for the museum that incorporated the older buildings and situated the museum's main entrance on Fifth Avenue.

The Fifth Avenue façade is a hymn to the power of classical, especially of Roman imperial, architecture. Forged of steel and Indiana limestone, its exterior was composed of three monumental arches flanked by pairs of columns, which effectively created three triumphal arches (Figure 45). The enormous thermal windows provided extensive natural light. Behind the Fifth Avenue façade is the Great Hall, which has three massive Guastavino domes,[12] which the sculptor Augustus Saint-Gaudens likened to the Baths of Caracalla.[13]

The east façade was supposed to include thirty-one pieces of sculpture. But after Hunt's untimely death in July 1895, it was curtailed. The texts for the three attic panels were eliminated, and the number of keystone heads was reduced to the placement of a head of Athena over each of the three windows. In each spandrel only two portrait medallions remained. The six medallions each include a portrait of a celebrated Old Master—Bramante,

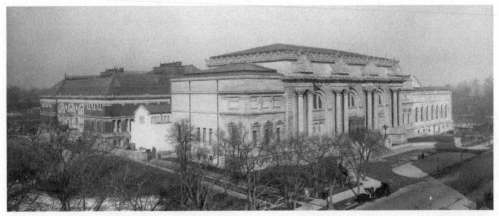

FIGURE 45. Metropolitan Museum of Art, view from the southeast, 1909.
Source: The New-York Historical Society.

Michelangelo, Raphael, Rembrandt, Velázquez, and Dürer. Only four caryatid figures—Painting, Sculpture, Architecture, and Music—were placed on the wings, and they separate the undecorated relief plans.[14] The crowning glory of the façade was to be four monumental allegorical sculptural groups, embodying the Egyptian, Greek, Renaissance, and modern eras, located atop the pairs of Corinthian columns. Because of financial constraints, the works were never executed, and the blocks of stone remain uncarved.

Overall, the museum design was admired and set the tone for subsequent classical additions to the museum. From 1904 to 1926, McKim, Mead & White served as the museum's architects, and they added five exhibition wings, including the classicizing wings J and K. Wings J and K are located directly to the south of Hunt's main block. Edward S. Robinson, formerly the museum's curator of Greek and Roman art, became director of the museum in 1910, and so, unsurprisingly, classical art was given prime Fifth Avenue real estate in Wings J and K. Robinson saw the new classical galleries as an "opportunity for expansion somewhat in proportion to their growth in size and importance."[15] Classical art would become one of the museum's most valued collections.[16]

Wing J, rechristened the Mary and Michael Jaharis Gallery in 1999, was composed of a long hall with a coffered barrel vault ceiling, like that of a Roman basilica. From Wing J, one approached Wing K. Writing on April 8, 1922, to McKim, Mead & White from Rome, Robinson recommended that "the court in the middle of Addition K shall be treated as a Greek or Pompeian peristyle, with a garden in the centre, in which sculpture and other works of classical art could be exhibited."[17] He sent drawings prepared by the faculty and students of the American Academy in Rome, a research institution dedicated to the support of historical, archaeological, artistic, and architectural studies, as a reference. Rather than replicating a known house, the Pompeian court was, in Robinson's words, "composed of homogeneous elements from different sources, the colors being copied from the originals in Pompeii and the neighboring towns" (Figure 46).[18]

Robinson wanted to plant the garden with Pompeian plants and consulted with Dr. C. Stuart Gager, the director of the Brooklyn Botanical Garden. However, the recreation of an accurate Pompeian garden proved impossible. Italian cypresses could no longer be imported into the United States; red cedars had to do. Other plants, Robinson bemoaned, "refused to do their archaeological duty by promptly fading away." As a result, the garden was planted to create "a general effect which may be described as approximately correct, in hope of doing better as we gain in time and experience."[19] Robinson drew on actual archaeological knowledge of ancient Pompeian domestic architecture, Pompeian gardens, and the display of ancient art for the galleries. About the design, Robinson mused:

> Some of our original sculptures have been set up along the paths and in the beds of the garden, and the colonnade is also utilized for exhibits. . . . Perhaps this is the place to say that in the creation of this court a threefold intention has been kept in mind: first, to show Greek and Roman works of art in something like the setting and atmosphere in which they were seen in antiquity; second, to illustrate the important part that color played in classical architecture; and third, to offer the visitor some place where he can find distraction from the customary routine walk through gallery after gallery, where he can rest and meditate undisturbed by any sound save the tranquil splashing of water.[20]

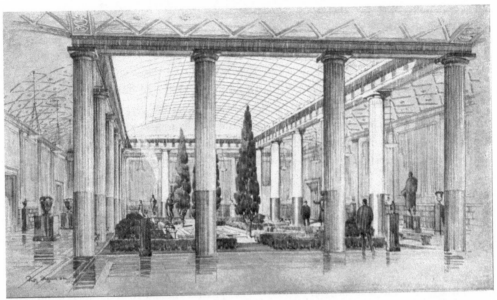

FIGURE 46. Pompeian Court, Wing K, Metropolitan Museum of Art, Manhattan. Sketch by McKim, Mead & White, 1926.

Source: The Metropolitan Museum of Art.

In this installation, architecture, art, and nature worked in concert to create an immersive or hyperreal viewing experience for the museum visitor, creating a sort of virtual or augmented reality avant la lettre.[21]

The classical galleries occupied this premiere location for less than twenty-five years. Francis Henry Taylor, who was appointed director in 1940, converted the grand court of Wing K into a dining room.[22] The galleries would not recover from this demotion until the 1990s, when classical art regained its position as one of the museum's premier departments. The court was renovated and renamed the Leon Levy and Shelby White Court, opening to the public in April 2007. Although the garden was not reinstated, the double-height courtyard with its skylight gives the space an atrium-like quality that makes the court once again a glorious location in which to linger and learn about ancient art.

The Brooklyn Institute of Arts and Sciences

Across the East River, there was another institution—the Brooklyn Institute of Arts and Sciences—and in the 1890s another city—Brooklyn (then the fourth-largest American city)—with even greater ambitions and a desire to outdo the Met and Manhattan. The institute had its origins in the Apprentices' Library, founded in 1823. More than just a library, it had books, maps, drawing materials, and tools and was intended to provide the working man with a general education.[23] The library was first housed in the classical-style Brooklyn Lyceum, on Washington Street,[24] whose name derived from Aristotle's *gymna-*

sium, or philosophical school. In 1843, as the scope of the library expanded, it was renamed the Brooklyn Institute.

The institute languished until the 1880s, when Gen. John B. Woodward made its renewal his pet project. He hired Franklin W. Hooper as the new director in 1889, and he focused on setting up new departments and absorbing many of Brooklyn's scientific and educational societies.[25] The institute was reincorporated as the Brooklyn Institute of Arts and Sciences by New York State in April 1890. With such ambitions, the institute clearly needed a new building.[26] The supporters of the institute conceived of it as unique, because it would combine the arts and sciences in a truly encyclopedic manner.[27] The Brooklyn Institute was to be located by the Mount Prospect Reservoir, on the edge of Prospect Park and to the east of Grand Army Plaza. The Brooklyn Botanic Garden and the main branch of the Brooklyn Public Library would be located nearby.

The trustees held a design competition for the building. The *Brooklyn Eagle* reported that "the style of the architecture is classic," as stipulated by the trustees.[28] In the second round of the competition, sketches were submitted and judged blindly, and McKim, Mead & White's archaeologically informed design was selected. Their design featured a main entrance with an Ionic hexastyle portico with capitals patterned after those from the Temple of Apollo at Didyma,[29] which had been excavated in the mid–nineteenth century. The Propylaea at Eleusis, where excavations had commenced in 1882, provided a model for the other capitals of the institute.[30] In the *Brooklyn Eagle*, the Columbia professor A. D. F. Hamlin, also one of the competition judges, proclaimed, "The museum carried out after this design will constitute a monument such as no city in the Union, outside of Washington, possesses, in its combination of size, situation, usefulness, dignity and beauty."[31] The building would physically embody Brooklyn's prominence as a city.

Construction started in September 1895, and the institute was designed so it could be built in stages but not appear unfinished (Figure 47). The northwest wing was constructed first and centered around a pavilion with a Guastavino dome, which clearly evoked the Pantheon's vertical stacking. A grand staircase was added to the Eastern Parkway façade in 1906, when it became apparent that the main entrance, originally planned for Flatbush Avenue, would not be erected. Most of the intended wings of the institute were never completed.

Commissioned to design the institute's sculptural program in 1896, Daniel Chester French was formally selected to design the pedimental sculpture in 1906, after sufficient funds were raised. French's program gave physical form to the institute's truly encyclopedic ambitions. Completed in 1914, the classically robed personifications of *Art* and *Science* (on the left and right, respectively) are enthroned in the pediment of the Eastern Parkway façade (Figure 48). On the left, *Painting*, *Sculpture*, and *Architecture* are personified, and on the right are *Geology*, *Astronomy*, and *Biology*.[32] In the right corner, a sphinx symbolizes knowledge; in the left corner a peacock symbolizes beauty.[33]

Thirty sculptures added in 1909 adorn the museum's façades. Designed by French, the leading sculptors of the day carved them. The male and female personifications represent the universal scope of the museum's collections and intellectual endeavors. They ranged from canonical figures, such as the *Roman Statesman* and *Greek Sculpture*, to those not

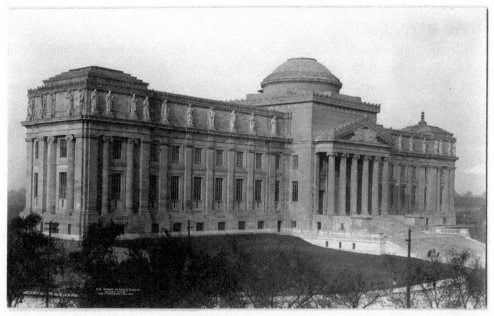

FIGURE 47. Eastern Parkway façade, Brooklyn Institute of Arts and Sciences (later the Brooklyn Museum), 1910. The pedimental sculpture has not yet been placed.
Source: The New-York Historical Society.

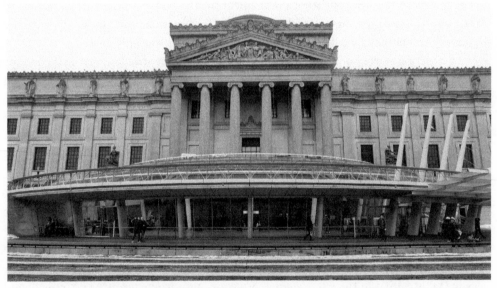

FIGURE 48. *Art* and *Science*, pediment, Eastern Parkway façade, Brooklyn Institute of Arts and Sciences (later the Brooklyn Museum), 2015.
Source: Barney Bishop (CC BY-ND 2.0).

normally included, such as the *Genius of Islam*, *Indian Literature*, *Chinese Philosophy*, and *Japanese Art*. While the sculptures were more inclusive than the Met's, reflecting the broader scope of the Brooklyn Institute, the architectural and sculptural language of classical antiquity was still regarded as the most potent for expressing the institute's ambitions. The deployment of classical forms continued within the structure; the original entrance hall was composed of a two-story Doric colonnade. It was decorated with casts of the Parthenon frieze, and casts of famous ancient statues, including the Prima Porta Augustus, were displayed here. Casts were considered to be the most accurate way to reproduce and understand ancient sculpture until the advent of photography, and in the nineteenth century they were considered essential to any museum collection.[34] But the glory, classical or otherwise, of the institute was not to last. Almost as soon as construction began, Brooklyn was incorporated into the new megacity of Greater New York. Almost immediately, the institute was playing second fiddle to the Met by virtue of the fact that it was not in Manhattan.[35]

Philip N. Youtz became the museum's acting director in 1934 and oversaw a series of major changes. He reduced the number of departments, transforming the institute into a fine arts museum and renaming it the Brooklyn Museum. Under his leadership, the main staircase, which was in poor condition, was removed in 1934–1935 as part of the WPA works under the direction of William Lascaze, a modernist architect. Removing the staircase, ostensibly to make the museum less intimidating to the average Brooklynite, fundamentally altered the building's aesthetic unity.

By 1900, the classical language of architecture, supported by the widespread training of American architects at the École des Beaux-Arts, the Chicago's 1893 World Fair, and the City Beautiful movement, was the default choice for New York's cultural institutions. The New-York Historical Society's new building, completed in 1908 by York & Sawyer, used both Greek and Roman architectural elements on the building's façade and in its library.[36] Other complexes, like Audubon Terrace, were clearly influenced by the ideas of the City Beautiful movement and Renaissance classicism.[37] Other major American cities also used classical architecture for their art museums, including the St. Louis Museum of Art (1901–1904), designed by Cass Gilbert and heavily influenced by Roman imperial baths, and the Cleveland Museum of Art (1913–1916). The classicizing Baltimore Museum of Art (1927–1929) and National Gallery (established in 1937) were both designed by John Russell Pope.

The use of classical architecture for museums had long been established in Europe; many of the earliest collections housed in European museums were of classical sculpture, and so the classical idiom was a fitting architectural stage for such works. Kassel's Museum Fridericianum (1769–1777), Munich's Glyptothek (1830) and Staatliche Antikensammlungen (1848), the Vatican's Museo Pio-Clementino (c. 1773–1780) and Braccio Nuovo (1806–1823), and Madrid's Prado (1784–1811) all used classical architecture.[38] In Britain, the British Museum (1823), the Ashmolean (1841–1845), and the Fitzwilliam (1837–1843) followed suit. For New York and other American cities to compete on the cultural world—albeit European—stage, museums with classical architecture were needed.

Temples to Monkeys, Birds, and Lions:
The Architecture of the New York Zoological Society

The New York Zoological Society,[39] better known as the Bronx Zoo, is a beloved institution. Countless New Yorkers have warm childhood memories of watching pandas visiting from China or riding the monorail to gaze upon Africa's mightiest animals safely from above. The origins of the New York Zoological Society, like so many of New York's cultural and educational institutions, were grounded in the ideals of the Progressive Era,[40] where education was seen as a means to improve the lives of Americans. New York's first "zoo" was the Central Park Menagerie, which started life in the 1860s as a dumping ground for unwanted animals, eventually housing twenty-two black swans, a bear cub, and Mike Crowley, the first chimpanzee ever shown in the United States.[41] A visit to the menagerie, which the affluent residents of Fifth Avenue considered to be a nuisance, was a popular outing for New York's working classes.

The conservation of the American landscape and wildlife emerged as an important concern in the collective conscience of leading Americans by the 1870s. In December 1887, Theodore Roosevelt and ten friends founded the Boone and Crockett Club. The club members, eventually totaling one hundred, were big-game hunters who wanted to protect game and establish game reserves in the United States,[42] lest countless species go extinct from overhunting. They started to work on legislation to regulate and limit hunting (in some cases), and they focused on creating a zoological park in New York City so that Americans could learn about the nation's animals.[43]

In April 1895, the New York State Legislature incorporated the New York Zoological Society. Within a month, the first board of managers was selected, many of whom belonged to the Boone and Crockett Club,[44] and an executive committee was formed. In November 1895, the committee was presented with designs for a free, three-hundred-acre zoological park containing North American and exotic animals.[45] The park aimed to ensure, in the words of the society, that "no civilized nation should allow its wild animals to be exterminated without at least making an attempt to preserve living representatives of all species that can be kept alive in confinement."[46] The park, originally consisting primarily of wooden structures, opened to the public on November 8, 1899. In the first year, 525,000 people visited.[47] By 1909, there were 4 million annual visitors.[48] To sustain such visitor numbers and house the animals properly, more permanent structures were required.

The zoo's first director, William Temple Hornaday, envisaged a small cluster of buildings around a formal court, linked together by a uniform design, as early as 1897.[49] The Baird Court, named for Spencer Fullerton Baird, the renowned naturalist and second secretary of the Smithsonian, was the heart of the complex. The elegant, symmetrical court was lined by four temple-inspired brick buildings that served as animal houses and administrative offices, almost all of which were designed by the firm of Heins and La Farge. At the south, the elephant house, a monumental Beaux-Arts creation, served as the court's architectural anchor. The influence of the City Beautiful movement and its predilection

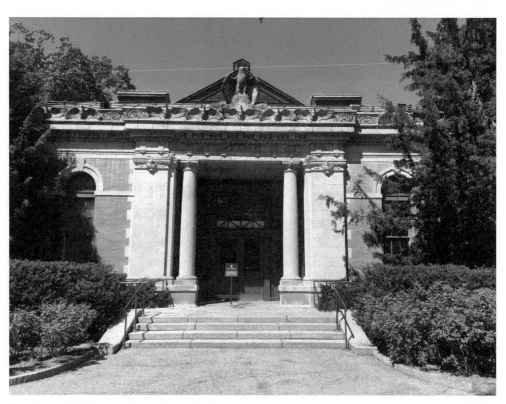

FIGURE 49. Bird house, Bronx Zoo, the Bronx, 2018.
Source: Author.

for classical forms are evident at the Baird Court,[50] which was renamed in 1989 in honor of the philanthropist Brooke Astor. Because contemporary accounts and the zoo's archives are silent about the choice of temple architecture for the animal houses, one must assume that classically inspired architecture and sculpture was deemed to be appropriate for New York City's first real zoological park, where scientific, conservation, and educational ideals came together.

From a series of classical stone pediments and cornices, where gods, Amazons, and heroes normally lurked, instead a visitor might be surprised to find baboons, cockatoos, owls, and lions. On the Large Bird House (1905), an eagle, the most American of birds, stands regally above the south entrance and a cornice filled with cockatoos spreading their wings in a proud display. Little owls peer out from the capital columns that flank the Bird House's entrance (Figure 49). In the pediments of the Lion House (1903), male and female lions lie prone, with sweetly intertwined paws, in an anthropomorphic gesture of affection. The cornice decoration includes the heads of large cats. The baboon finials atop the Primates (or Monkey) House (1901) were modeled on two actual hamadryas baboons, and monkeys cheekily leap and bound in the building's cornice, their playful nature captured in stone.

The New York State Memorial to Theodore Roosevelt at the American Museum of Natural History

Founded in 1869, the American Museum of Natural History is one of the United States' preeminent scientific institutions. After the museum outgrew its original location in the Central Park Arsenal, its trustees secured land on Central Park West between Seventy-Seventh and Eighty-First Streets for its first permanent home. From 1874 to 1890, the museum's architecture was built in medieval styles. The Vaux and Mould–designed building on West Seventy-Seventh Street is one of the city's best examples of the Romanesque Revival style.[51] The use of medieval forms demonstrates that the use of classical architecture was not a foregone conclusion but a choice. When the museum wanted to expand again, this time along Central Park West, in the early 1920s, Henry Fairfield Osborn, the president of the museum, asked Trowbridge & Livingston to design a more classical façade. At its center was to be a prominent new entrance that would also serve as the New York State Memorial to Theodore Roosevelt.

Teddy Roosevelt was a larger-than-life figure. In addition to serving as governor of New York State and later US president, Roosevelt was also an explorer, naturalist, and conservationist. Roosevelt's father was one of the founding members of the museum, and the younger Roosevelt had led an expedition to South America for the museum. Roosevelt's interest in hunting was tied to his belief in the conservation of the fauna, flora, and natural beauty of the United States. Therefore, a memorial associated with New York's leading scientific museum was fitting.

In 1920, the New York State legislature established a commission to investigate and report on possible state memorials to Roosevelt.[52] Debating where to erect the monument and what forms it might take, the commission rejected a "conventional Greek mausoleum" because it "did not seem to figure the memory of the man who was at once a statesman of worldwide repute and an explorer, writer and naturalist of the first rank."[53] Instead, a Roman triumphal arch and an accompanying hall, which could serve as the new main entrance to the American Museum of Natural History, was selected.[54] Clearly, only a specific architectural quotation would do; the arch had honorific and triumphal qualities and thus was appropriate to this famous and revered American. In 1925, a competition was held for the memorial's design. Much to the distress of Trowbridge & Livingston, who had already prepared extensive drawings that included a triple arch for the Central Park West façade,[55] John Russell Pope's design, modeled on the Arch of Constantine, was selected on June 2, 1925 (Figure 50).

The memorial, dedicated on January 19, 1936, was composed of a plaza, the arch that would serve as the museum's new monumental entrance, and the memorial hall. The lower level of the memorial hall, which was decorated with coffered ceilings and Doric columns, provided access to the new subway station. Writing in 1928, Osborn noted:

> Going back to the days of the Roman Empire, when great buildings and great men shared honors equally, the architect found his inspiration for the façade in the triumphal arches of those brilliant times. . . . This triumphal motive [the arch] . . . not only symbolizes the great spirit of Theodore Roosevelt, but echoes the dignity and majesty of the state and nation.[56]

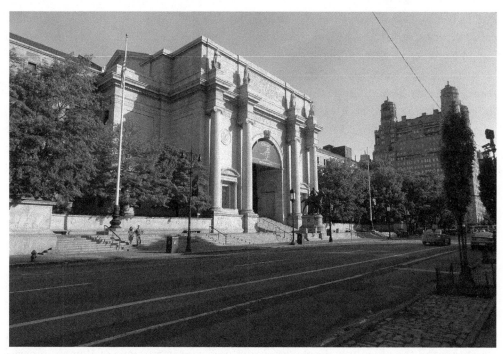

FIGURE 50. New York State Memorial to Theodore Roosevelt, American Museum of Natural History, Manhattan, 2018.
Source: Author.

As a form, the Roman arch could be reinterpreted to be part of New York's infrastructure (like the Manhattan Bridge), part of a museum, and, as will be discussed in Chapter 8, part of the city's culture of commemoration and collective memory.

The arch clearly reinterprets the Arch of Constantine (see Figure 21). Atop the Ionic columns, replacing the six Dacians to be found on the Roman original, stand John James Audubon, Daniel Boone, Meriwether Lewis, and William Clark. These men rank among the great explorers and naturalists of nineteenth-century America, in whose footsteps Roosevelt had followed. In the attic an English inscription explains the function of the monument, while in the register below are the words TRUTH, KNOWLEDGE, and VISION, Roosevelt's virtues, which one could hope to acquire should one visit the museum and imbibe all of what it had to offer. Between the columns are the seals of New York State and New York City.

Rather than being placed atop the arch, an equestrian statue of Roosevelt by James E. Fraser stands in the center of the plaza. Roosevelt, robust and masculine, appears as if he is ready to resume his role as the leader of the Rough Riders or as an explorer of distant Amazonian jungles. His dominant position is enforced by the two seminude figures flanking him. Osborn identifies them as an "American Indian" and an "African."[57] Such depictions are deeply problematic and frankly racist. However, in the 1930s, Roosevelt's elevated position exemplified the idea of the white man's burden of bringing civilization to savage lands. The presence of these figures is an overt reminder of the United States' imperialist

tendencies and of Roosevelt's policy to "speak softly and carry a big stick." The marble plaza is carved with bas-reliefs of exotic animals from the lands Roosevelt explored, which could be interpreted as another form of colonialism. In 2019, the American Museum of Natural History examined the troublesome nature of these figures through the exhibition *Addressing the Statue* (opened in August of that year). This exhibit discussed the legacy of the statue, Roosevelt's achievements as a president as well as his own racism, and the museum's past exhibitions on eugenics, and asked visitors, academics, and community leaders to share their views on the statue.[58] The exhibition aimed to prompt debate and discussion about many of the divisive issues about race and colonialism that the United States still faces. In the wake of the killing of George Floyd on May 25, 2020, and the Black Lives Matter movement, the museum decided to remove the statue, which is technically owned by the City of New York, to a location to be determined. The museum chose to remove the statue, according to its president, Ellen V. Futter, because of the statue's "hierarchical composition"—not because of Roosevelt as an individual. The museum will continue to honor Roosevelt, because he was, in Futter's words, "a pioneering conservationist," and plans to rename its Hall of Biodiversity in Roosevelt's honor.[59]

From the arch, one entered the stunning Memorial Hall (67 × 120 feet) (Figure 51).[60] Like so many grand buildings of its era, the fingerprints of the Baths of Caracalla, or at least those of the ubiquitous École des Beaux-Arts reconstructions of Roman imperial baths, are apparent. The hall had a lofty hundred-foot-high coffered ceiling with large clerestory lunette windows. The interior decorative program was a visual mélange of inscriptions and murals. The east and west walls were decorated with eagles, and quotations were inscribed under four of Roosevelt's aphorisms, entitled "YOUTH," "MANHOOD," "THE STATE," and "NATURE," which exhort future generations to make meaningful contributions to society. Corinthian columns adorn the walls. William Andrew Mackay's 1935 murals on the north, south, and west walls respectively depict three key events in Roosevelt's career: building the Panama Canal; his negotiation of the 1905 Treaty of Portsmouth, for which he received the Nobel Prize, making him the first American to win this prize; and his 1909–1910 expedition to Africa.[61]

The Theodore Roosevelt Memorial is visually jarring against the museum's earlier Romanesque architecture. But Pope's design was so powerful that Osborn wrote that "instead of becoming a portion of the American Museum of Natural History, the Museum would become a part of the Memorial."[62] While Osborn's words might persuade some, Lewis Mumford, writing in the "Sky Line" column of the *New Yorker*, was having none of it. He lambasted the Roosevelt Memorial with his caustic wit: "This Classic monument, so painfully, so grotesquely inappropriate, so defiantly out of the picture of the Museum itself, will never look better than it does now. Today one can swallow it as sheer ghastly fantasy, but when it is completed it will be only pompous bad taste."[63] His sentiments reflect the growing disquiet with classical forms and herald their demise. However, the use of a triumphal arch for the memorial exemplifies how Roman forms were still considered suitable for museum architecture. In the 1920s and 1930s, they could still reaffirm the museum's status as an elite institute of scientific learning and commemorate a great president and American.

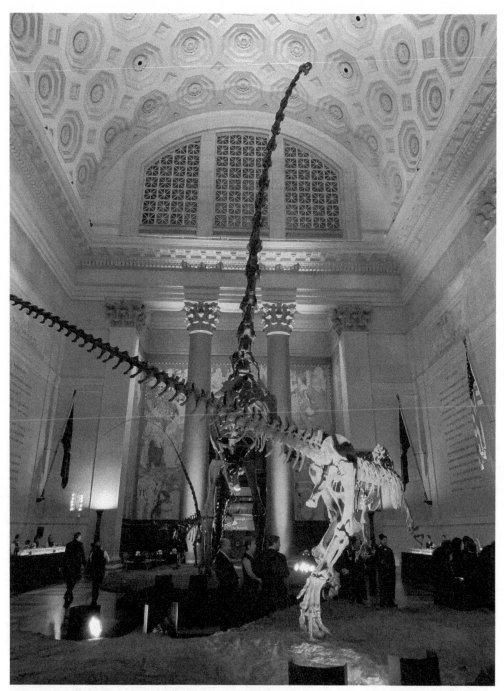

Figure 51. Memorial Hall to Theodore Roosevelt, American Museum of Natural History, Manhattan, 2018.

Source: Author.

Pantheons and a Stadium: The Architecture of New York's Universities

In the wake of the Columbian Exhibition and its emphasis on classicism and the classi-cally referenced forms of the Beaux-Arts movement,[64] New York University (formerly the University of the City of New York) and Columbia University both appropriated the lan-guage of classical architecture—specifically that of the Pantheon—for their main librar-ies, the architectural heart of each university's new campus.[65] Classical forms also had a unique expression in Lewisohn Stadium of City College, New York City's leading public university, which sought to compete with its private and better-funded neighbors through innovative architecture and a new campus.

DUELING PANTHEONS: NEW YORK UNIVERSITY VS. COLUMBIA UNIVERSITY

Few buildings are more important in the canon of Western architecture than the Pan-theon (Figure 52). Often considered to be the greatest Roman building ever erected,[66] the first Pantheon was built by Marcus Agrippa during Emperor Augustus's reign (r. 27 BCE–14 CE). Due to fire, it was rebuilt continuously throughout antiquity, with the most important reconstruction occurring during the reigns of Trajan and Hadrian.[67] The purpose of the building remains elusive; it may have housed statues of the imperial

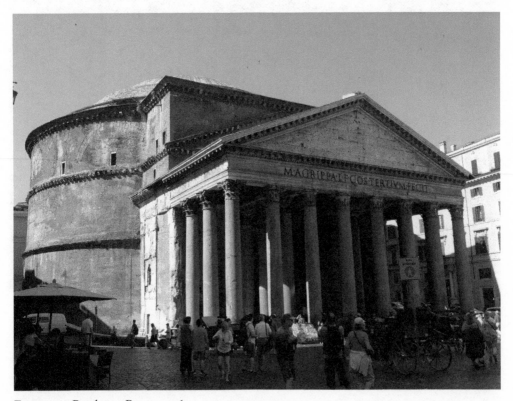

FIGURE 52. Pantheon, Rome, 2016.
Source: D. Mladenović.

family and certain gods.[68] The lofty interior was dominated by a vast dome, designed around a perfect circle with a diameter of 150 Roman feet with elaborate *opus sectile* (inlaid marble mosaic) flooring and wall decoration, composed of marble brought from across the Roman Empire (Figure 53). The Pantheon's porch had an outline of a taller pediment, creating its signature visual stacking effect of a double pediment and dome. While

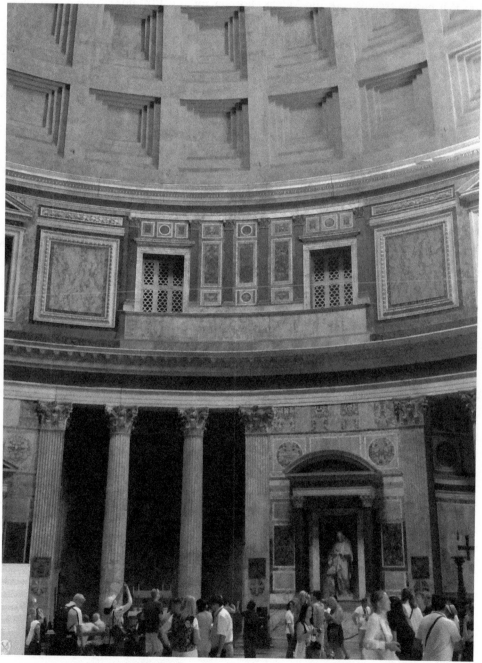

FIGURE 53. Pantheon, interior, Rome, 2016.
Source: D. Mladenović.

scholars still debate the significance of the double pediment, date, construction techniques, and other aspects of Pantheon,[69] these academic concerns were not of primary importance to later architects, who treated the Pantheon as an architectural palimpsest.

As early as the sixteenth century, Italian architects, most notably Andrea Palladio, were experimenting with the form of the Pantheon in their buildings.[70] Thomas Jefferson, who owned at least one copy of *The Architecture of A. Palladio*, was the first to repurpose the Pantheon's architecture for Monticello and for the Rotunda at the University of Virginia. Through its reinterpretation in the architecture of Palladio, Jefferson, and others, the Pantheon was imbued with a sophisticated air of classical and European culture as well as with architectural and academic prestige. Therefore, when Stanford White and Charles McKim were both commissioned in the 1890s to design libraries for New York University and Columbia University, respectively, they both turned to the Pantheon as their model.

Stanford White's Gould Memorial Library was to be the centerpiece of Henry Mitchell MacCracken's new uptown University Heights campus in the Bronx, where MacCracken was relocating most of the undergraduate programs of the recently rebranded New York University (Figure 54). The building was named in honor of Jay Gould, the robber baron infamous for manipulating stocks, thanks to a large benefaction made by his daughter Helen Miller Gould Shepard. The library is a glorious reinterpretation of the Pantheon. It has a double pediment and an interior decorated with green Connemara marble columns and Tiffany glass. A glorious, golden dome decorated with Dutch metal springs from a walkway where statues of the muses and Mnemosyne, the personification of memory and mother of the muses, gaze down (Figure 55).[71] Inscriptions from Milton and the Bible and the names of great philosophers, scholars, scientists, and poets line the interior's walls to inspire the young undergraduates to the greatest heights of scholarship.

Flanking the library on its western side is the Hall of Fame of Great Americans, a long portico. In the Hall of Fame, students, scholars, and the general public can walk and gaze upon the busts of great men and women whose contributions to the United States had been deemed so important that they had been elected to be included here. Constructed of Roman brick and aggrandized with pediments, the Halls of Languages and Philosophy complement the library and Hall of Fame and together form a campus where classical architecture bestowed cultural and academic status upon NYU. The power of these forms reverberated over a hundred years later. The "starchitect" Robert A. M. Stern designed a new library (completed in 2012) for the campus, now that of Bronx Community College, the City University of New York. He used the same color brick and architectural details as the Gould Memorial Library, demonstrating that the effect and appeal of the library's Roman architecture endure.

Almost simultaneously, Charles McKim, White's partner, designed the Low Library at Columbia University (Figure 56).[72] McKim was involved in Columbia's architectural school, where he had endowed a traveling fellowship, so it was unsurprising that he was selected to design Columbia's new library. Seth Low, the ambitious president of Columbia and later mayor of New York City, underwrote the construction costs and dedicated the library in honor of his father. Low and Columbia were in direct competition with Mac-

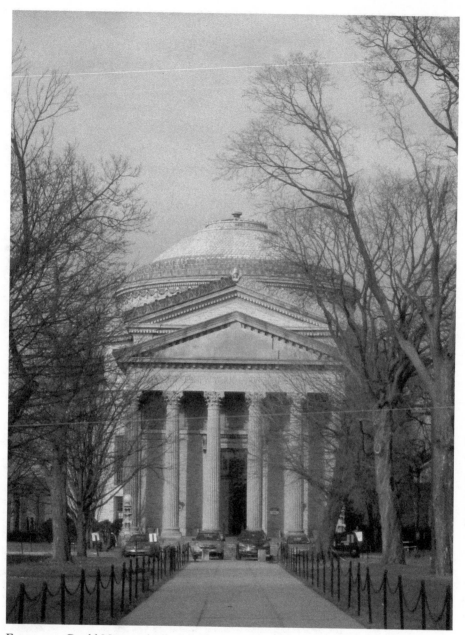

FIGURE 54. Gould Memorial Library, New York University (now Bronx Community College, City University of New York), the Bronx, 2016.
Source: Author.

Cracken and NYU for academic prestige, students, and donors. Like MacCracken, Low risked his reputation on the successful migration of Columbia from Midtown Manhattan to a new campus in Morningside Heights.[73]

In the Low Library, the Pantheon's dome was deployed alongside the architecture of Roman porticos and public bath buildings, a combination that may have resulted from the

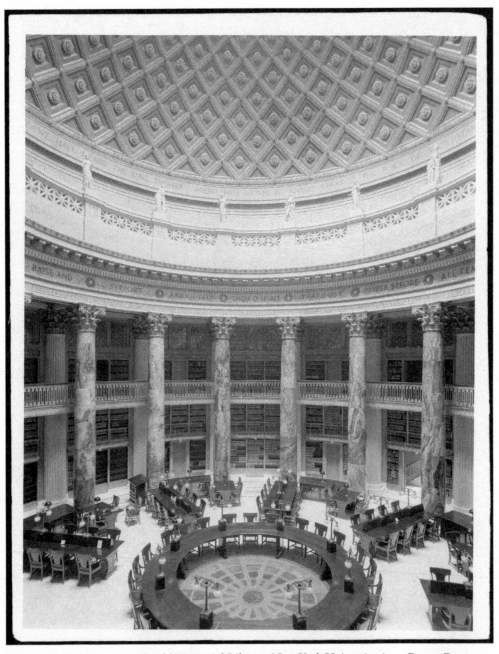

FIGURE 55. Reading room, Gould Memorial Library, New York University (now Bronx Community College, City University of New York), the Bronx, 1905.

Source: Wurts Bros. Museum of the City of New York. X2010.7.1.635.

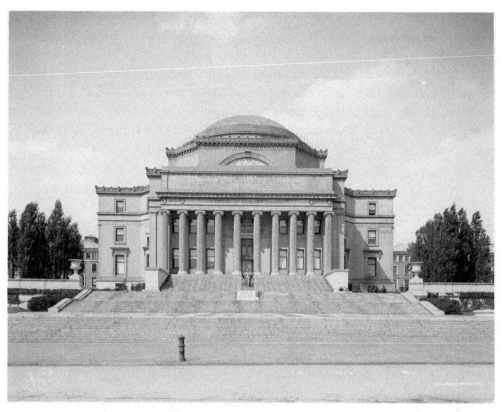

FIGURE 56. Low Library, Columbia University, Manhattan, c. 1905.
Source: Courtesy of the Library of Congress.

influence of the Columbian Exposition of 1893.[74] The façade is composed of a wide de-castyle portico, which supports an entablature where an inscription details Columbia's long history. A statue of a seated, robed woman, *Alma Mater*, executed by Daniel Chester French, is located in front of the library, another appropriation of classical ideals and sculpture.

The interior was built on a Greek-cross plan with a central rotunda that served as the great reading room. Four large Roman thermal windows provide natural light. The ceiling was blue, like the night sky, and a globe hung from it to emulate the moon. Of the sixteen figures intended as decoration, only four were erected. The blue and gray interior of the Low Library is mute and subdued compared to the rich golds and greens of the Gould Memorial Library's reading room.

The Low Library worked poorly for its purpose. As Lewis Mumford quipped, it has "ample space for everything except books."[75] The symbolic academic center of Columbia was soon denuded of books and transformed into an event space. In the early 1930s, the new Butler Library was erected across the quad to serve as Columbia's primary library. The north façade of Butler was composed of a monumental Ionic colonnade, like a stoa where Greek philosophers strolled while debating with students, and its entablature was

inscribed with the names of Roman and Greek historians, philosophers, and statesmen, to serve as exempla for Columbia's students. The rest of the McKim-designed campus that sprung up around the Low Library, Butler Library, and *Alma Mater* was composed largely of brick structures with classical pediments and entablatures, bringing visual coherence to the campus and affirming its classical nature. While the Gould Memorial Library architecturally outshone the Low Library, Low's gamble on Columbia's relocation to Morningside Heights was much better than MacCracken's bet on the Bronx. In 1973, NYU was forced to sell the uptown campus due to financial difficulties.

LEWISOHN STADIUM AT CITY COLLEGE

Founded as the Free Academy, City College provided a free college education to some of New York City's brightest but poorest students. By the 1870s, it had outgrown its James Renwick–designed building at Twenty-Third Street and Lexington Avenue.[76] Like NYU and Columbia, City College wanted a more bucolic, spacious location for its campus and moved to the area known as Hamilton Heights in upper Manhattan. The architectural core of the new campus was a series of George B. Post–designed Gothic buildings.

Given the increasing popularity of college athletics, John Finley, a classicist and the third president of City College, decided that the college needed new athletic facilities. He convinced the city to give him a small park between 136th and 138th Streets and between Amsterdam and Convent Avenues and some funds toward grading the land.[77] Finley also persuaded Adolph Lewisohn, a German immigrant and self-made millionaire, to underwrite the stadium, which would be named in his honor. The architect Arnold W. Brunner started constructing the stadium in 1913 and completed it in 1915.

The stadium was composed of a single level of seating that looked upon a large open field. An austere Doric portico lined the top of the seats. Simple roundels in the entablature aligned with each column. At each end of the seats were two Doric pavilions, which later served as offices (Figure 57). The stadium's design was Finley's idea. During the June 1915 dedication of the stadium, he noted that

> this structure has the outlook of the theatre near St. Onofrio [on the Janiculum Hill], but it has the sweep of the ellipse of the Coliseum, and it has, as I recall, the diameter dimension of the great theatre at Epidauros. Many years ago I heard a lecture on this theatre and was greatly encouraged in the planning for the City College theatre or stadium.[78]

While the stadium was not a proper theater or amphitheater,[79] it was clearly inspired by the entertainment venues of antiquity while remaining something other than a mere copy of an ancient model. Appropriately, the stadium's inaugural event was a staging of Euripides's *Trojan Woman*, and Shakespearean productions followed. The college immediately put the stadium to use, regularly hosting football games and athletic competitions. The stadium also housed City College's graduation ceremony, where leading politicians and Martin Luther King Jr. gave commencement addresses. Like NYU's Hall of Fame, the stadium was always intended to serve the public; Lewisohn noted in the *New York Times*:

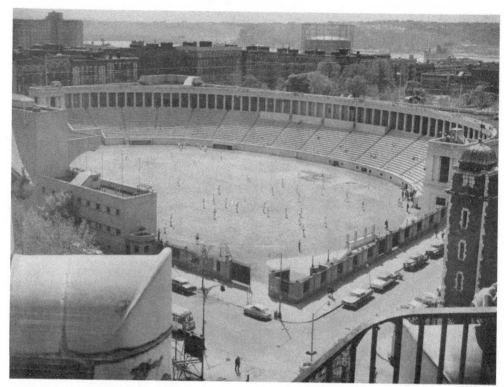

FIGURE 57. Lewisohn Stadium, City College, Manhattan, 1961. The "Marathon Stone" is displayed in the middle of the seating.
Source: Courtesy of the City College Archives.

> I would like to see the Stadium, busy from morning to evening, Sundays and holidays included. Of course, the City College students have to use it for instruction; I would like to have it for the benefit of everybody—for all of the people of the city—if possible. . . . While it is the City College Stadium, it is also going to be the Stadium of the City of New York.[80]

Until it was razed in 1973 (and replaced by the North Academic Center), Lewisohn Stadium was, in the opinion of the *New York Times*, the working man's "outdoor Carnegie Hall . . . with the patrons in shirtsleeves and work pants."[81]

In 1923, City College received an inscribed funerary stele, which Finley called the "Marathon Stone." It was erected in c. 350 BCE and stood along the route that a runner reportedly took from Marathon to Athens to announce the victory of the Greeks over the Persians, but the stele has no *actual* connection to this event.[82] Finley had seen it while retracing the route of the famous run in Greece and managed to persuade the Greek government to give the stele to the college. It was unveiled during a grand ceremony and placed at the exact middle of the stadium. In the 1990s, the Metropolitan Museum of Art offered to exhibit the stone, which had been languishing in a basement since 1973; it is displayed in Wing J today. For City College, nicknamed the "Harvard of the Proletariat," the display of the "Marathon Stone" in the classical stadium at its new uptown campus was a

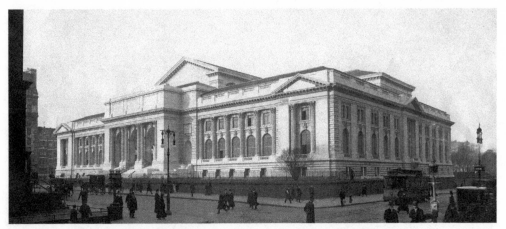

FIGURE 58. Main branch, New York Public Library, under construction, Manhattan, 1907.
Source: Courtesy of the New York Public Library.

physical way that Finley could demonstrate that City College was the equal of its more socially prestigious rivals.

Public Libraries

The adaption of classical forms for campus libraries was paralleled in the public libraries across the city and would culminate in the creation of the main (Forty-Second Street) branch of the New York Public Library, which was renamed for Stephan A. Schwarzman's $100 million gift in 2008 (Figure 58). Built by Carrère and Hastings between 1902 and 1911, the Forty-Second Street New York Public Library was one of the city's crowning achievements. It reflected a core belief of the City Beautiful movement—that public institutions should and could improve the lives of its citizens.[83] Again, Carrère and Hastings turned to the architectural language of the classical world, as filtered through a Beaux-Arts lens.

The main entrance is modeled on the Arch of Constantine. The entrance of the library is a triple-bay triumphal arch with decorative Corinthian columns, a rich sculptural program, and inscriptions. The inscription in the entablature reads "THE NEW YORK PUBLIC LIBRARY." The inscriptions in the attic celebrate the collections of John Jacob Astor and James Lenox[84] and a $2.5 million benefaction from the former New York governor Samuel J. Tilden,[85] which helped establish a single public library. These inscriptions are separated by six female statues, who are aligned directly above the Corinthian columns. These personifications represent History, Drama, Poetry, Religion, Romance, and Philosophy.[86] Although less famous than the lions resting below them, these statues embody some of the subjects that could be investigated by a keen New Yorker within the library. One entered the main entrance to find oneself within a vaulted ceiling of marble (fixed into a hidden steel construction), which recalled the vaulted interiors of Roman baths. The

wings are decorated with columns and featured pediments at the Fortieth and Forty-Second Street ends along Fifth Avenue. As discussed in Chapter 1, the library replaced the Egyptian-style Murray Hill Distributing Reservoir, which had fallen out of fashion.

In 1901, Andrew Carnegie gave $5.2 million toward the construction of branch libraries across the city; his gift prompted the New York State Legislature to create a system of free public lending libraries. Many of these libraries, including the Yorkville Library at 222 East Seventy-Ninth Street, the first branch library constructed, were in a Palladian style.[87] This style, itself a creative reinterpretation of classical forms, underscores the potency of classical architecture, here refracted through the lens of Renaissance and early modern Italian architecture, for libraries.[88] Carnegie would also support the construction of libraries across the United States.[89] Many of these libraries employed classical-inspired forms, including those erected in Oklahoma, Florida, St. Louis, Charlotte (North Carolina), Washington, DC, and, of course, Pittsburgh.

Conclusions

Like the designers of commercial structures, the architects of museums and cultural institutes took a modernist turn in their mid-to-late-twentieth-century structures, producing masterpieces like the Guggenheim. Yet engagements with the architecture of the classical world are still evident. Lincoln Center, like the Seagram Building, still harks back to ancient architectural principles. At the heart of Lincoln Center is an elevated plaza. Like the plaza of the Seagram Building, discussed in the previous chapter, that of Lincoln Center is like the *temenos* of a classical temple or the bounded precinct of a planned Roman forum, and it is organized around a strong cross-axis alignment. The concrete pillars and porticos of the Metropolitan Opera House, David Geffen Hall (formerly the Philharmonic Hall), and the David H. Koch Theater (formerly the New York State Theater) seem to take their order and form from the precepts of classical architecture, just as the Seagram Building does.

Undoubtedly, one of the most prolific appropriations of ancient architecture in nineteenth- and twentieth-century New York City was for its museums, libraries, universities, and zoos. Even though it was often associated with the elites in Europe, classical culture played an important part in the development of the early United States, its intellectual, political, and civic life, as Caroline Winterer's groundbreaking work has demonstrated.[90] However, in the late nineteenth century, classical culture and architecture become increasingly associated with elite or high culture, and such architecture could serve as outward symbols of the elevated status of New York's cultural and educational institutions.[91] Such uses also reflected the values of the City Beautiful movement, which saw architecture and art as being crucial to bettering the lives of city dwellers, and indeed, these buildings did improve the lives of New Yorkers.

The Low Library symbolized Columbia's position as a premier educational institution.[92] Just as the Gould Memorial Library was situated at the center of NYU's campus, the Low Library was centrally positioned in Columbia's campus, atop an elevated platform. Both

libraries are conceptualized as memorials for deceased men, serve as the focal point of their respective campuses, and are positioned far above the uncouth and ill-educated city. The president of City College, the young upstart among New York's institutions of higher learning, used classical forms at Lewisohn Stadium and the prominent display of the "Marathon Stone," a genuine archaeological object, to assert that it was the peer of these older established universities.

At the same time, ancient architecture—from the imperial baths to the Pantheon—and architectural sculpture were flexible, allowing turn-of-the-twentieth-century architects and museum directors to tell the tales they wanted to tell. For the Brooklyn Museum, the sculpture boasted that the museum was *actually* an encyclopedic museum of art and science, unlike the Met. The triumphal arch of Rome allowed the American Museum of Natural History to trumpet its relationship to Teddy Roosevelt and advertise its scientific contributions to the city and world. Many of the men who oversaw these projects or funded them were members of New York City's old elite or beneficiaries of the new money that poured into the city after the Civil War, creating the glittering and glamorous world that Mark Twain would disparagingly name the Gilded Age. Their wealth not only funded these key cultural institutions but also paid for the stunning mansions that were erected throughout New York City. Many of these palatial residences included rooms decorated with ancient art and interior décor, especially that of Pompeii, the topic of the next chapter.

Togas at Home

Just as classical and Egyptian architecture held a preeminent position in the creation of much of New York City's public-facing architecture—banks, museums, libraries, courts, and civic buildings—during the nineteenth century, the art, architecture, and decorative motifs of antiquity also permeated New Yorkers' homes. During the first half of the nineteenth century, many townhouses incorporated elements of the Greek Revival style. After the Civil War, the bluebloods of New York City and the newly moneyed classes of America forged from the steel, oil, and railroads of the rapidly expanding nation utilized the art and architecture of antiquity to decorate some of the interiors of their vast mansions. Pompeian rooms and other ancient-inspired interiors became de rigueur in the mansions of Gilded Age New York.

This chapter examines the cultural and artistic trends behind the popularity of ancient décor, architecture, and art in New York's domestic architecture. This is the first of a trio of chapters that explores how antiquity was reinterpreted in private or quasi-private spaces in New York. The chapter after this one considers two restaurants with ancient-themed interiors where New Yorkers socialized and dined. Moving on to the places New Yorkers inhabited after death, a third chapter examines classical and Egyptian tombs in Green-Wood and Woodlawn cemeteries, New York's most prestigious burial grounds.

Domestic Architecture and the Greek Revival Style in New York City

In the late eighteenth century, houses quickly became important status symbols and a key mechanism for the display of wealth, status, and leisure time.[1] Houses were transformed from simple, multifunctional, single-room dwellings into larger residences whose rooms had specific purposes. By the mid–nineteenth century, a respectable middle-class house had a parlor, a symbol of refinement. Because Americans lacked an architectural language of grandeur and nobility,[2] the elite and middle classes of the United States turned to European, especially British aristocratic, elites as models for their behavior and homes,[3] and especially to the parlor. The parlor, a reception space that derived from the aristocratic and royal courts of Europe, became a setting for formal entertainments and the display of the family's decorative possessions. Dining rooms, sitting rooms, music rooms, and libraries all started to appear. These distinct rooms implied a different type of living and signaled the advent of leisure time. The rooms' furnishings demonstrated that the owner did not need to work, even though such rooms could only exist through successful business endeavors[4] or inherited wealth.

From about 1820 onward, the homes of New York's elite and new middle class—typically townhouses—were aggrandized on the exterior with the addition of a portico supported by Ionic, Doric, or Corinthian columns over the main entrance. Townhouses in Boston and Philadelphia also embraced this strategy.[5] By the second half of the eighteenth century, London's streets were also increasingly filled with elegant townhouses with classical decoration designed by Robert Adam. During the Regency period (1811–1820), John Nash's classical houses, erected around Regent's Park, were hugely influential on domestic architecture. A parlor created in the Greek Revival style with the most up-to-date furnishings ennobled the interior. And in New York City, just as Greek architecture provided civic and financial leaders with an architecture of authority for their banks, custom houses, and capital buildings, the Greek Revival style provided homeowners with an architectural language that reflected the patriotism and political values of the young republic and its ideals of beauty.[6] Greek Revival architecture was also flourishing in the domestic architecture of other parts of the United States. In the South, temple façades and their highly recognizable porticos were being deployed in grand plantation homes in Georgia and North Carolina as well as in the town houses of important southern cities, for example, Charleston.[7]

The rowhouses built in the early 1830s on the north side of Washington Square Park are fine examples of the style. As the setting of Henry James's famous novel *Washington Square*, they are constructed of crisp red brick, with slim white Ionic or Doric columns supporting the small porticos that add a modest grandeur to their entrances. Rectangular or triangular pediments top the windows. Five blocks away, out of place amid the shiny new apartment buildings that now crowd Astor Place, La Grange Terrace, on Lafayette Street, designed by the talented Alexander Jackson Davis[8] and built by Seth Geer between 1832 and 1833, marks an intensification in the appropriation of ancient forms in residential architecture (Figure 59). Named for La Grange, General Lafayette's country estate outside Paris, nine townhouses formed an early rowhouse development in New York. The

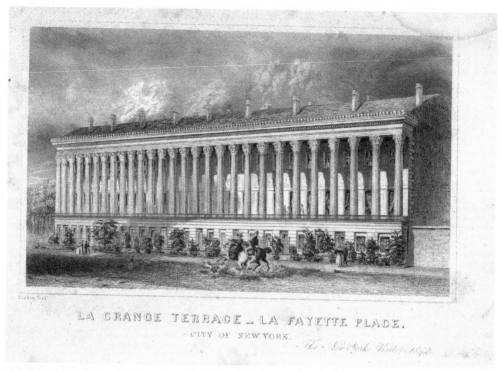

LA GRANGE TERRACE — LA FAYETTE PLACE.
CITY OF NEW YORK.

FIGURE 59. La Grange Terrace, Manhattan, 1842.
Source: Courtesy of the New York Public Library.

four surviving façades give a good idea of the impression these homes must have made when they stood new, in a long stately parade. They were united behind a single façade with an unbroken colonnade of twenty-eight Corinthian columns, mounted atop a ground-level story that was identified as being "of the Egyptian order."[9] The columns were carved from white Westchester marble, reportedly cut by the inmates of Sing Sing prison, thirty miles up the Hudson and later infamous as the home of the electric chair. Bordering on swaths of undeveloped land owned by John Jacob Astor, it was initially considered too far north and east to be fashionable ("two miles out in the country," sniffed one architecture critic),[10] but its elegant design soon attracted prestigious buyers.[11] Astor himself lived here and later built his library across the street, now the Public Theater. Washington Irving lived a few doors down with his friend Irving Van Wort, giving the neighborhood an artistic flair.[12] Within a decade, Astor Place was a tony neighborhood, and fine homes were being built at a rapid pace.

If you arrived at one of these townhouses as a guest in 1835, you would have entered the street door and walked up an indoor staircase to the parlor, unlike most townhouses, with an outdoor stoop rising to a small porch. The raised parlor was modeled on the *piano nobile* characteristic of European aristocratic residences. The capitals on the columns of the façade are thought to be "exact replicas of the Corinthian motive in the well-known Choragic Monument of Lysicrates in Athens," which a trained eye at the time would have recognized from the pages of Stuart and Revett's *The Antiquities of Athens* (see Figure 22).[13]

"The entire wealth of all antiquity formed the storehouse" that these styles drew on, Matlack Price explains. He also observes that antiquity was a visual treasury "of which the sudden interest in classical archaeology and the wonderful discoveries of the savants at that time had thrown open the doors."[14]

In 1836, *The Ladies Companion* declared, "There is no city in the Modern World, judging from the rapidity with which splendid structures are continually erected, that has made greater progress toward the appropriate magnificence of a great metropolis, than New-York." These superb rowhouses, considered "most imposing and magnificent,"[15] were a sign that New York City had arrived. The Corinthian colonnades evoked the traditions of ancient democracy, and the name La Grange recalled the Revolutionary War hero Lafayette. Together these elements gave the townhouses European and classical airs while also alluding to the foundation of the United States and the ideals of the new republic.

The Tredwell Home

Just around the corner from Colonnade Row, as the LaGrange houses were sometimes called, a narrow, four-story red-brick house stands. Few historic homes have survived the continuous redevelopment of the city, but the townhouse at 29 East Fourth Street stands out for its use of classical forms in its interior. The Tredwell Home, now known as the Merchant's House Museum, was built on speculation two blocks north of Bond Street, New York City's most exclusive neighborhood in 1832. Seabury Tredwell, a flourishing merchant who imported hardware from England, bought the house for the considerable sum of $18,000 in 1835, and it remained in the family until 1933.

Behind a late-Federal-style exterior, the Tredwell house hides two noteworthy Greek Revival rooms, the front and rear parlors, and Greek Revival motifs decorate the rest of the house, too. Just inside the front door, the main vestibule has a central ceiling medallion of acanthus, announcing this as a most fashionable residence. From the vestibule, a visitor would enter the double parlor. The focal points of the house's social life, the front and rear parlors are the best decorated spaces in the Tredwells' home. The large parlors (twenty-five feet long)[16] are divided by mahogany pocket doors that slide into the wall behind a grand pair of Ionic columns. The columns' capitals are modeled on those of the Erechtheion, another Athenian monument known through publications like *The Antiquities of Athens*.

The ceilings and moldings of the parlors are decorated with ancient-inspired motifs. In each of the parlors a light fixture hangs from a central, circular ornamental plaster medallion. Over five feet in diameter—larger than most contemporary medallions[17]—they are composed of a center of acanthus-like oak leaves framed by a circular band of wave motifs and then an exterior band of acanthus leaves. The wall cornice is decorated with egg-and-dart, lamb's tongue, and other floral motifs. With their choice of Greek Revival interiors, the Tredwells signified that they were fashionable New Yorkers.

While only the richest Americans could travel abroad at this time, pattern and building books were widespread,[18] and these made classical designs accessible to a much wider

group of patrons, including those like the Tredwells. Asher Benjamin's *American Builder's Companion* (1811) and *The Practices of Architecture* (1833), as well as Minard Lafever's publications—*The Young Builder's General Instruction* (1829), *The Modern Builder's Guide* (1833), *The Beauties of Modern Architecture* (1835), *The Modern Practice of Staircase and Handrail Construction* (1835), and *The Architectural Instructor* (1856)—are some other well-known examples. In fact, some of Minard Lafever's designs may have served as the direct inspiration for decorations in the Tredwell house.[19] Along with the meticulously engraved plates that provided a visual catalogue of motifs, these books offered detailed instructions for how to incorporate classical orders and motifs into the design of a room.

The double parlor allowed the Tredwells a flexible space for entertaining. The front parlor had a piano for more formal engagements, while the back parlor was more intimate.[20] When a larger gathering was planned, the sliding doors could be opened to provide a grand space for a dance, family wedding, or New Year's Day reception, when men would call upon one another. These interiors were enhanced with carefully chosen furnishings and objects, such as Wedgewood tea sets, whose decorations were often based on ancient cameos.[21] The Tredwells displayed exactly the sort of possessions expected of successful merchants: Greek Revival–style furniture (replaced in the 1850s by a Neo-Rococo suite), a piano, gilt-framed mirrors, silk brocade curtains, imported carpets, and paintings.[22] The goal was not to be exceptional but to fit in. The furnishings that graced the parlors of the Tredwell home all signified that they were cultured Americans who understood beauty and possessed good taste. Again, the classical motifs also signaled that the owners were patriotic proponents of the young republic's democratic ideals.

Residences in New York City after the Civil War

The construction of grand homes in New York accelerated after the Civil War. America's richest citizens saw their homes as a means to display their wealth while also evincing the sort of taste and refinement that might distance them somewhat from the commercialism that generated the fortunes that funded such residences. Now as wealthy as European aristocrats or industrialists, America's new and old elites displayed their status by building monumental residences where they could entertain extravagantly.[23] By the 1880s, affluent men and women displayed their economic wealth by showing off imported objects in themed rooms that demonstrated that they were cosmopolitan, sophisticated, cultured, and appreciated the artistic productions of other cultures.[24]

The proliferation of period and themed rooms was given a boost by the Aesthetic Movement, which dominated interior decoration in the United States at the end of the nineteenth century. As an artistic movement, it emphasized the beautification of the home via interior spaces in which fine and applied arts were closely integrated.[25] Disdaining mass-produced furnishings, designers and artisans crafted original pieces for patrons whose tremendous wealth could underwrite exceptional interiors. Themed rooms imitated European models such as the Italian Renaissance palazzo or the Tudor hunting lodge. Before long, decorators looked to more exotic sources of inspiration, including pre-Columbian

Mesoamerica and "Oriental" styles, which ranged from "Moorish" and Turkish to Chinese and Japanese.[26] Classical antiquity was perceived as the font and forebear of European culture and, as such, exerted a powerful and long-lasting appeal. After the Civil War, familiarity with classical culture and learning shifted away from having a widespread, if not always deep, presence in America's civic culture to being a hallmark of high culture.[27] Knowledge of ancient art, texts, and archaeological sites signaled that one was culturally elite and sophisticated. Having an ancient-themed room was a physical manifestation of one's knowledge, education, and wealth.

Pompeian Rooms in New York City

In the late nineteenth and early twentieth centuries, the Pompeian room was one of the most popular domestic reinterpretations of classical antiquity, as Marden Nichols's pioneering work has shown.[28] The rediscovery of Pompeii and Herculaneum in the mid–eighteenth century and the subsequent publication of the archaeological excavations there were hugely influential. Wall paintings, the perceived opulence of the sites, and the widespread availability of objects from the Bay of Naples after the start of the nineteenth century meant that domestic architecture—specifically the houses of Pompeii, villas on the Bay of Naples, and the Villa di Papyri at Herculaneum—captured the imaginations of Europeans and later Americans. As early as the 1780s, Pompeian rooms appeared in British stately homes, with the first being in Packington Hall, Warwickshire.[29] Leading figures such as Sir John Soane, the architect of the Bank of England, constructed rooms inspired by antiquity—in his case, the breakfast room in his famous townhouse at no. 12–14 Lincoln's Inn Fields and the library and breakfast room at his country estate Pitzhanger Manor,[30] whose decoration was partially based on the frescoes from the Villa Negroni, Rome.[31] Pompeian rooms, with decoration and furnishings inspired by antiquity, soon became favorites among elite and aristocratic homeowners and for social aspirants like Soane. The son of a builder, Soane, who taught himself Latin, defined himself as one of the *homines novi*, using the Roman term for the "new men," like Cicero, who lacked a patrician pedigree and ascended to prominence from a modest background.[32]

Pompeii was in fashion for the better part of a century. Edward Bulwer-Lytton's bestselling 1834 novel *The Last Days of Pompeii* included vivid descriptions of the fictional house of Glaucus, which was modeled on the House of the Tragic Poet (IV.8.5), an actual house in Pompeii celebrated for its sumptuous wall paintings.[33] The presence of a Pompeian court in London's Crystal Palace further established Pompeii in the minds of the public, designers, artists, decorators, and tastemakers, who brought the Pompeii craze to the United States.[34] By the second half of the nineteenth century, the Pompeian room, as Marden Nichols observes, became "a central feature of the tycoons' palaces . . . and thus a product of the quest to forge a pseudo-aristocracy for the super-rich."[35] As the financial center of the United States, New York City was home to a bumper crop of the nouveau riche, who built sprawling, lavish mansions in which Pompeian rooms featured prominently.

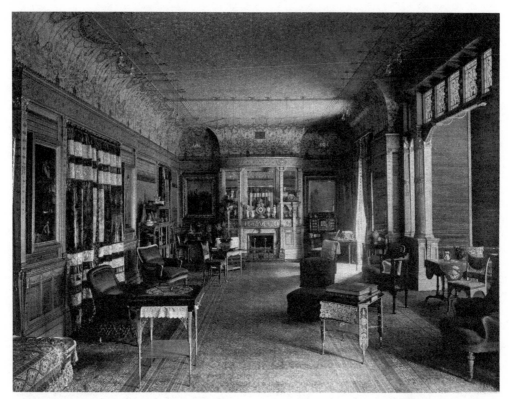

FIGURE 60. Pompeian drawing room, Morgan residence, Manhattan, c. 1880–1882.
Source: Public domain.

The fad even swept up J. P. Morgan, the banker who was so wealthy that he once bailed out the US Treasury. Morgan's brownstone mansion at Madison Avenue and Thirty-Sixth Street included a drawing room designed, decorated, and furnished with Pompeian inspiration (Figure 60).[36] "Nothing like it can be seen in Pompeii, nor in that excellent example of Pompeian decoration, the house of Germanicus,[37] at Rome," George W. Sheldon noted in his 1883 book *Artistic Houses.* Furthermore, he observed:

> A breath from the Graeco-Roman epoch of Italia seems to have left its faint impress on
> the walls, or rather its faint fragrance in the atmosphere. . . . No slavish copying of another
> dwelling or another period, ancient or modern, and no demonstrative self-assertion;
> but only a mild gayety of expression amid the aroma of perfect taste.[38]

Part of the banker's opulent townhouse is open to the public, in the form of the Morgan Library, but the Pompeian drawing room was destroyed when the rest of the mansion was demolished in 1928 for the construction of the library's annex.[39]

Designed by Christian Herter, a premier interior decorator, the room was not a wholesale adaptation of a Pompeian interior; as Sheldon observed, there were "suggestions" rather than a systematic "imitation" of Pompeian elements, which were mixed with other exotic touches. The room's walls were divided by red pilasters whose color matched the frieze

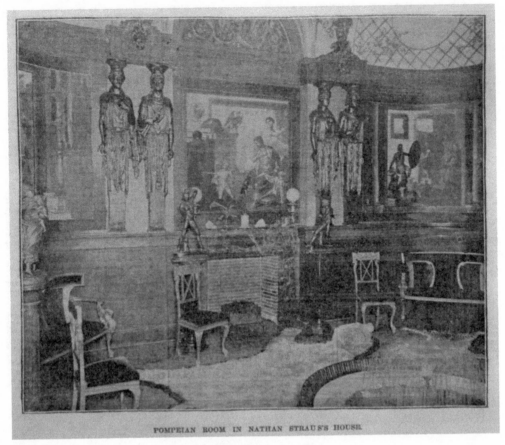

POMPEIAN ROOM IN NATHAN STRAUS'S HOUSE.

FIGURE 61. Pompeian room, Straus residence, Manhattan, 1903.
Source: Public domain.

and were upholstered in "Japanese stuffs worked in silk and gilt thread." Japanese fabrics were used on the *diwan* (a low sofa common in the Middle East) and other furniture and on cushions "with old Persian embroidery."[40] Old Master paintings hung against this artistic bricolage. The eclectic nature of Morgan's drawing room is typical of its era and of the Neo-Antique; elements of ancient art and architecture were thoughtfully combined with artistic, architectural, or decorative elements from other periods and/or geographic locales to create original interiors.

Other Pompeian rooms were constructed with an approach that prized historical accuracy. Nathan Straus, the department store magnate who owned Macy's, had an accurate Pompeian room in his mansion (Figure 61).[41] Photographed in 1903, the walls of the room were decorated with mythological scenes borrowed directly from houses excavated in Pompeii, including Thetis visiting Hephaestus's forge, from the House of Paccius Alexander (IX.1.7; Museo Archeologico Nationale di Napoli, Inv. 9529), and two scenes from the House of the Vettii (VI.15.1): Hercules strangling two serpents and the punishment of Ixion. Water splashed in a fountain of black basalt, and animal skins were arranged on mosaic floors. Reproductions of ancient sculpture and practical objects were faithfully ex-

ecuted for Straus under the supervision of the president of the museum of Naples[42]—an indicator of the premium placed on authenticity in the creation of some of these interiors. Indeed, the decorative scheme was *too* authentic for some critics, who took exception to its deep, saturated colors, which contemporary commentators observed were genuinely typical of Pompeii.[43]

William H. Vanderbilt's Triple Palace, on Fifth Avenue, composed of three nearly identical mansions built for Vanderbilt and his two married daughters, was another Herter Brothers project.[44] Completed in 1879, it had ancient-inspired interiors, including a Pompeian atrium and Pompeian bathroom replete with female figures and cupids.[45] While no descriptions or images of the Pompeian bathroom survive, one can imagine chubby little cupids frolicking on a ceiling frieze or serving as faucets. In the summer of 1914, John D. Rockefeller Jr. selected Francis Newton to paint Pompeian murals in his nine-story mansion at 10 West Fifty-Fourth Street, perhaps taking his inspiration from the newly installed Boscoreale rooms at the Met, which showcased Pompeian trompe-l'oeil wall paintings.[46] These rooms reflect the talents and tastes of America's first wave of professional interior designers, many of whom were European born.[47] The Herter Brothers and their competitors, Pottier & Stymus, were key tastemakers and helped spread Pompeian motifs and works of art in these ornate interiors.[48]

Solidly installed in the grandest homes of Gilded Age New York, Pompeian rooms nevertheless teetered on contemporary fault lines around wealth and the nascent American empire, with its rapid rise and anxieties about a future fall.[49] Pompeii never shed the associations of its excesses and famous demise: It symbolized decadence, overindulgence, and even effeminacy at its zenith,[50] as well as the notion that the newly rich lack good taste, all of which contributed to its destruction in a volcanic fury.[51] Indeed, Pompeian interiors could border on dubious or outright deplorable taste. In 1878, Harriett Spofford expressed her doubts about the Pompeian style, writing that "it takes a princely fortune to venture on the Pompeian, and to do it in character."[52] Yet fear of steep costs—or charges of flamboyance—did not dampen the enthusiasm for Pompeian rooms in New York, where they were embraced by Morgans, Vanderbilts, and Rockefellers. Across the United States, Pompeian rooms could be found in the houses of other Gilded Age millionaires: Leland Stanford had one in San Francisco, William T. Walters in Baltimore, and the Doheny family in Los Angeles.[53] But it was in New York that the style flourished most exuberantly, and arguably there was no specimen anywhere to equal the truly extraordinary Greco-Pompeian music room of Henry G. Marquand.

The Mansion and Greco-Pompeian Music Room of Henry G. Marquand

After selling his stake in the St. Louis, Iron Mountain & Southern Railroad for $1 million in 1880, Henry G. Marquand poured his money into philanthropy, supporting the Metropolitan Museum of Art as a trustee and as its second president, and nurturing his lifelong love of music. In his own extensive art collection, he favored Old Masters and living British artists, whom he commissioned for new works. To house his treasures, Marquand

FIGURE 62. Henry G. Marquand residence, Manhattan, 1905.
Source: The Metropolitan Museum of Art (CCO).

needed a monumental Manhattan residence. In 1881, he commissioned his friend Richard Morris Hunt—who had already built him a summer home in Newport, Rhode Island—to design a palatial residence for him at the northwest corner of Sixty-Eighth Street and Madison Avenue.[54] As an expression of Marquand's taste and culture, this home would serve as the stage for his public "transformation from 'capitalist' to 'philanthropist.'"[55]

Sprawling along 175 feet of East Sixty-Eighth Street, the residence was composed of a four-story mansion with two other buildings. Built of red brick and sandstone, it combined French Gothic and Renaissance styles and was completed in 1884 (Figure 62).[56] The interiors exemplified the values and craftsmanship of the Aesthetic Movement and were designed to awe and impress. Passing through a vestibule and a Renaissance-style entrance hall, a visitor would come next to a grand, baronial hall, a conspicuous display of non-functional space.[57] The entire ground floor was effectively a quasi-public space, used for socializing, dining, and entertaining. From the hall, a guest might turn to the left, into an elegant Japanese living room decorated with custom-made, embroidered Japanese silk. Here one could admire Marquand's collection of Japanese and Chinese bronzes, lacquers, ivories, and other objects before continuing into the adjacent English Renaissance dining

room. The Greco-Pompeian music room occupied prime real estate opposite these rooms, sharing the ground floor with a Moorish-style smoking room and a conservatory.[58] Upstairs, in the family's private quarters, a masculine mahogany-and-leather-paneled library nestled alongside bedrooms that took their decorative inspiration from Byzantine Ravenna and Versailles's Petit Trianon.[59]

Teams of French, English, and American designers, including Louis Comfort Tiffany, worked on the interior, as did leading artists including John La Farge. Each room was stylistically harmonious in its own unified composition and style, but moving to the adjacent room might entail a stylistic journey across centuries or continents. The overall effect of these differently styled interiors was considered highly successful by members of the American Institute of Architects, who toured the property with Hunt on December 2, 1886.[60] The residence was a conspicuous showcase of Marquand's wealth, cultural sophistication, travel experiences, and art collecting[61]—and its crown jewel was the Greco-Pompeian music room.

A great lover of music, Marquand regularly attended the opera with his wife, Elizabeth. Being an original box holder at the Metropolitan Opera House was prestigious. Simultaneously, though, it identified Marquand as one of the city's nouveau riche because it indicated that he had not been able to buy a box or seats in the well-established Academy of Music.[62] But for Marquand, the box at the opera was not merely a feather in his cultural cap or an expensive place to nap. Music genuinely played an important part in his life. A violin had brightened his long days at boarding school.[63] As an adult, his love of music became one of his principal philanthropic interests; he sponsored the conductor Theodore Thomas's program for the New York Musical Festival in 1882 and Thomas's efforts to start an American School of Opera in 1885.

Marquand enjoyed music at home, too—and for a tycoon of his era, that meant hosting live musicians. In the 1880s and 1890s, the homes of the wealthy commonly included a music room.[64] Musicales, private concerts held in the afternoon or evening by professional or amateur musicians, had been a staple of elite social life in the United States since Marquand's childhood. Marquand and his wife hosted private concerts and society musicales, which were considered major social events and were reported in the press. It is not surprising that his music room was the most artful of all of the rooms in the mansion.

At about eight hundred square feet, the Greco-Pompeian music room was the largest of the house's formal rooms.[65] Marquand was very involved in its design, collaborating with the Anglo-Dutch artist Lawrence Alma-Tadema, who wove together different threads of artistry like a conductor marshaling the instruments of his orchestra. The setting was designed to provide an immersive sensory experience, with custom-made art and furniture complementing the music. Marquand's association with Alma-Tadema had begun in late 1881 or 1882, with the purchase of *Amo Te, Ama Me*, a small oil painting depicting a Roman girl shyly courted by a youth on a white marble bench by the sea. In 1882, Marquand commissioned Alma-Tadema to paint a larger piece, which would be named *A Reading in Homer*. Marquand was probably familiar with the elaborate interiors that Alma-Tadema had designed for his own home, Townshend House, in Regent's Park, London, and may

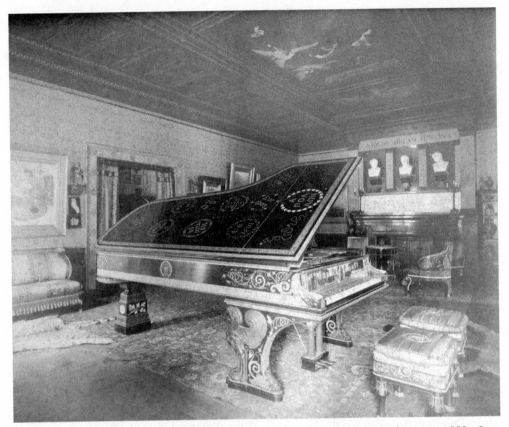

FIGURE 63. Greco-Pompeian music room, Henry G. Marquand residence, Manhattan, c. 1888–1890. *Source*: Courtesy of the Nassau County Department of Parks, Recreation, and Museums, Photo Archive Center.

have visited there on one of his trips to that city.[66] By early 1884, he had asked Alma-Tadema to design the music room and its piano and furnishings.

This room, sometimes called the "Greek music room" by scholars, is really better thought of as Greco-Pompeian, as it combined Greek- and Pompeian-inspired décor (Figure 63). As Kathleen Morris observes, "the forms and designs of the music-room furniture drew inspiration from a wide range of ancient precedents, freely adapted to the objects' functional requirements in the context of a modern parlor and music room."[67] In 1885, the room was described as "Greek, rendered, with Mr. Alma-Tadema's special mannerism, which somewhat resembles the modifications, prevailing in Pompeii, under Roman influences in Magna Graecia."[68] The room's design thus reflected the contemporary idea that much of Greek art was transferred to Rome by way of Pompeii.[69] Rather than copying a single ancient model, the Greco-Pompeian music room drew upon a variety of different ancient models to create a distinctive hybrid—and Neo-Antique—space.

Though Marquand's mansion no longer survives, the music room is well documented in photographs and contemporary accounts. The silver-gray silk wall coverings that Alma-Tadema designed for the room afforded a simplicity uncommon in this period,[70] allowing

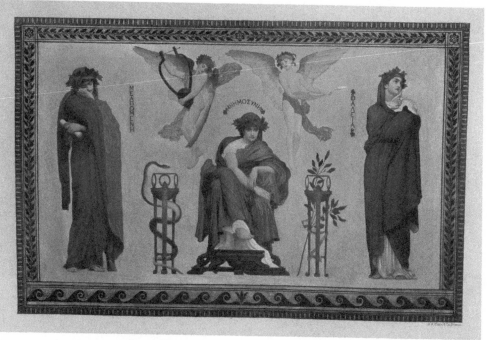

FIGURE 64. Tripartite ceiling painting (1886), by Frederic Leighton, Greco-Pompeian music room, Henry G. Marquand residence, Manhattan.
Source: Public domain.

the carefully selected art, objects, furniture, and piano to draw the eye and set the tone. Frederic Leighton, one of the most esteemed British painters of the day, was commissioned to create a tripartite painting for the ceiling (Figure 64).[71] Melpomene and Thalia, the muses of tragedy and comedy, and Mnemosyne, the personification of memory and the mother of the muses, appeared in the central panel. The two flanking panels depicted a Bacchante dancing with a faun and a maiden attended by a cupid.[72] Scholars have identified them as Terpsichore (muse of dance) and Erato (muse of erotic poetry), respectively.[73] Leighton, like Alma-Tadema, was purposeful in his choices, explaining in January 1886, "I have thought that in a room dedicated to . . . the performance of music the muses will [be] the proper presiding spirits in as much as with the Greeks music & poetry always went hand in hand."[74] The painting was exhibited at the Royal Academy and the Liverpool Autumn Exhibition in 1886. Display in these prestigious public venues brought critical acclaim and status to the painting before it arrived in Marquand's home.

Alma-Tadema's *A Reading from Homer* hung on the wall to the right of the room's main entrance (Figure 65).[75] In the painting, an audience of three youths and a young woman listen intently to a dramatic recitation of epic poetry, an apt reminder to guests in the music room to be attentive listeners. The upper register of walls was decorated with marble reliefs carved by the Spanish sculptor Mariano Benlliure y Gil, depicting foot races and a chariot race.[76] The relief occupying the prominent place over the fireplace mantel showed a Bacchanal. Above it perched three replicas of antique busts (see Figure 63) and a quotation from Aeschylus's tragedy *Agamemnon* (line 306), written in Greek. "A mighty beard

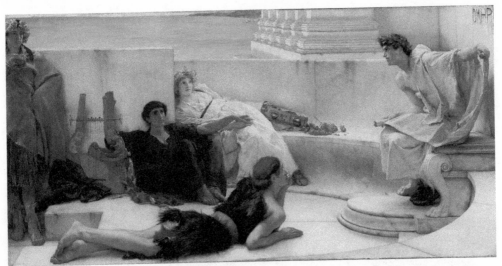

FIGURE 65. *A Reading from Homer* (1885), by Lawrence Alma-Tadema, Greco-Pompeian music room, Henry G. Marquand residence, Manhattan.
Source: Courtesy of the Philadelphia Museum of Art / Google Art Project.

of flame," the inscription reads,[77] alluding doubly to the fireplace below and to Clytemnestra's description, in the play, of a flaring beacon carrying home the news that the Greeks had defeated Troy.[78] Another relief by Benlliure y Gil was located in the alcove that led to the conservatory,[79] above a life-size marble statue, *L'inspiration*, by Jean Gautherin, depicting a classically idealized young woman playing a harp. Commissioned by Richard Morris Hunt and displayed at the 1887 Paris Salon before being shipped to New York,[80] this sculpture, like Leighton's painting, had the sort of prestigious public profile that would reflect well on its owner.

The striking music cabinet, designed by Alma-Tadema, drew heavily on classical architecture (Figure 66). The third and topmost tier of the shelving supported a miniature temple, like a Roman *aedicula*, or shrine, used to display ancient sculptures and high-quality reproductions. The capitals and bases of the *aedicula*'s Ionic columns were made of ivory; the cabinet was decorated with precious materials including mother-of-pearl, abalone, and marble. Alma-Tadema had first visited Pompeii in 1863, and he had amassed an extensive library of books, drawings, and photographs of Pompeii and antiquities housed in the Naples Museum. One such item was a household shrine, or *lararium*, in the form of a miniature temple, from the House of Epidius Sabinus in Pompeii (IX.1.20).[81] This small shrine found its way into a few of the artist's paintings and seems likely to have inspired the top of the music cabinet. The room's other cabinetry was designed to display Marquand's collection of ancient Attic and Etruscan ceramics,[82] which included a black-figure amphora attributed to the Pasikles Painter (520–510 BCE), depicting Apollo playing the lyre[83]— the epitome of classical images for the art of music making. Cast reproductions, purchased on the advice of Frederic Leighton, included the *Dancing Faun from Pompeii* from the House of the Faun (VI.12.3) and a *Narcissus*.[84] Arranged atop the music cabinet or by

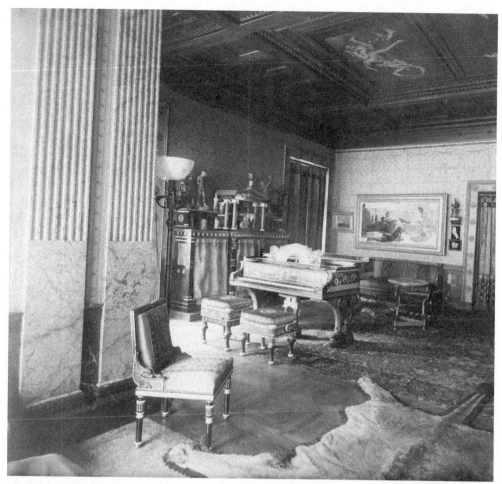

FIGURE 66. Music cabinet, Greco-Pompeian music room, Henry G. Marquand residence, Manhattan, c. 1888–1890.

Source: Courtesy of the Nassau County Department of Parks, Recreation, and Museums, Photo Archive Center.

the fireplace, they brought vibrancy to the room, with the *Faun* almost seeming to dance to the music that would regularly fill this room.

Classical motifs carry over into the room's furniture, which included three straight-back settees, two curved settees, four side chairs, two barrel-arm chairs, two side tables with round onyx tops, and two footstools (now lost)—all made by Johnstone, Norman & Co.[85] Some of the furniture, such as the side chairs, was based directly on ancient proto-types. The design on the sides of the footstools was derived from the back of a Pompeian chair.[86] In the decoration of the furniture, Greek or Greek-inspired designs ran riot.[87] A fish-scale motif and other ancient designs were used in the fabrics of the furniture and in the room's curtains, portieres, and tapestries. Other designs were taken from major pub-lications, like the 1868 edition of Owen Jones's *Grammar of Ornament* and William Zahn's 1849 design book.[88] The use of an ebony veneer on the furniture, with lighter inlays of

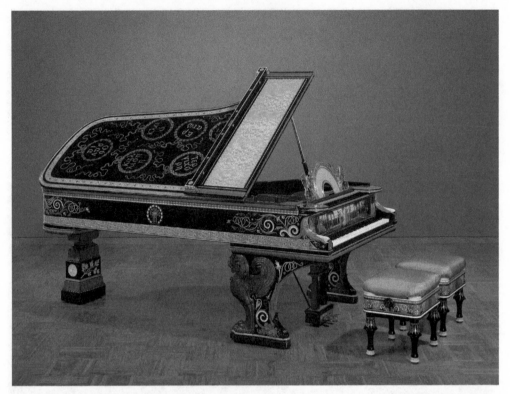

FIGURE 67. Model D pianoforte and stools (1884–1887), Greco-Pompeian music room, Henry G. Marquand residence, Manhattan, 2016.
Source: Courtesy of the Clark Art Institute (clarkart.edu).

gleaming ivory or abalone, was evocative of "the dark ground of Etruscan and red-figured Attic vases."[89]

Amid this welter of rich decorative detail, the room was undeniably dominated by its one-of-a-kind, custom-made grand piano (Figure 67). Built by Steinway & Sons in New York, the size-D cherry-wood case was then shipped to London in 1881, where Johnstone, Norman & Co. painstakingly added the decorative work designed by Alma-Tadema. The lid of the instrument was inlaid with the names of Apollo and the nine muses, in Greek, framed by laurel wreaths. This is a fine example of how the room's decorative program aimed for an immersive quality: Wherever one looked—down at the piano, up at Leighton's painted ceiling—the eyes settled on unifying reminders of the creative power of the muses.

Set into the piano's tail (the curved tip end, far from the keyboard) was a silver-plated brass plaque engraved with a lyre accompanied by the single Greek word *kalos*: "beautiful." Echoed on the coverlets of the piano stools and the central curtain of the music cabinet,[90] this one-word motto encapsulated the notion that animated Alma-Tadema's design for the room and the ideal that his patron wished to espouse: Railroads and commodity trades might foot the bills, but music and art were the fit pursuits of a soul aspiring to beauty. Though Alma-Tadema blended and transformed classical models freely, he sought

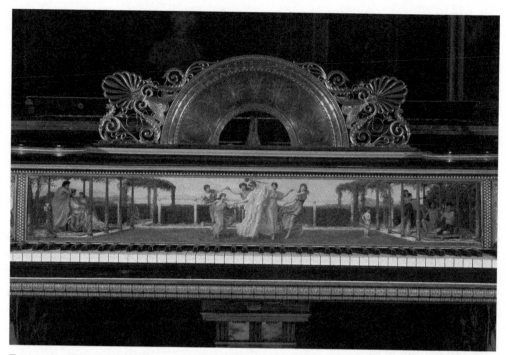

FIGURE 68. *The Wandering Minstrels* (1887), by Edward Poynter, fallboard, pianoforte, Henry G. Marquand residence, Manhattan.
Source: Courtesy of the Clark Art Institute (clarkart.edu).

authenticity in even the smallest details of his Pompeian-influenced design. The legs of the piano provide a good example: They are loosely based on the griffin table supports from the House of Gaius Cornelius Rufus (VIII.4.15) in Pompeii, of which he had a photograph and also included in some of his paintings.[91] Even the fall board, the hinged cover that closes to protect the keys, was decorated appropriately. The artist Edward Poynter adorned it with an idyllic scene of musicians and frolicking dancers set in a Roman maritime villa, entitled *Wandering Minstrels* (Figure 68).

With the elements of design and décor all working together to transport guests from Manhattan's Upper East Side to a seaside villa on the Bay of Naples to experience classical antiquity's reverence for music and poetry, the room was an elaborate leisure space that affirmed Marquand's own love of music and his taste, status, and cultural attainments. But such a concert cannot go on forever, and in the case of Marquand's Greco-Pompeian room the moment of artistic glory was fleeting.

It took three and a half years to decorate the furniture suite. When the piano and suite were finally completed, they were publicly exhibited in London, and even the Prince and Princess of Wales viewed them in July 1885.[92] By 1887, when the piano was ready to be shipped to the United States, it was a topic of much discussion—and criticism—in the press. The piano was obscenely expensive. The *New York Times* reported that the piano and stools had cost $46,590 (excluding a $4,000 design fee for Alma-Tadema);[93] the *San Francisco Bulletin* put the cost at $50,000. Adjusted for inflation, this would be close to $1.27 million in

2017.[94] In May 1888 *Decorator and Furnisher* called it a "remarkable example of lavish expenditure."[95] It had become a symbol of frivolous excess on the part of Marquand and his peers.[96] To add insult to injury, once the piano was delivered to Marquand's mansion on November 18, 1887, only Marquand and his guests could enjoy it.

Marquand hosted a steady program of events in his music room throughout the 1890s. Then, in the last few years before Marquand's death in 1902, the family experienced a series of financial reversals that shook it to its core.[97] The worst came in 1901, when the brokerage firm of Marquand & Co., which his son Henry ran, had to be bailed out, at a huge cost. After Marquand's death, none of his heirs wanted to keep up the palatial house. Its sumptuous furnishings and fixtures were sold at a highly anticipated auction in January 1903.[98] The auction raised $706,019.75, far surpassing the appraised value of $206,400. The fabulous custom-designed piano, however, sold for only $8,000, and the rest of the room's suite of furniture brought in just $5,700, a meager fraction of their cost.[99] What a folly they now seemed. The piano's artistic value was finally vindicated in 1997, when it was sold at Christie's for £716,000 ($1.2 million) to the Clark Art Institute in Williamstown, Massachusetts.[100] The piano thus regained its position as a cherished work of art available for public enjoyment. The house was also sold, and it was eventually demolished to make way for an apartment building[101] called the Marquand, the only legacy of the mansion that remains today.

While the Marquand music room and its stunning piano, collection of art, and suite of furniture only existed together for less than twenty years, they showcased the potency of antiquity as a flexible reference point for patrons and designers. Eclectic and original, it was an exceptional example of an ancient interior. Its success as an artistic accomplishment was due to Alma-Tadema's deep knowledge of classical art, architecture, and design married to the vision, support, and intelligence of Marquand, an excellent patron. Concerts were not the only performances that unfolded in the music room; here one could witness, as Melody Barnett Deusner observes, "the true complexities of Gilded Age taste, behavior, and aspiration playing out in remarkably revealing configurations."[102] Like other Pompeian rooms, it sat balanced precisely and precariously on the tensions of the age, prompting questions about the function of art, whether art should be public or private, and the purpose of extraordinary wealth.[103]

Aspirational Antiquity: Décor and Design for the Middle Classes

The United States' well-developed middle class aspired to emulate the upper classes—especially in the decoration of their homes. The desire in the late nineteenth century to own ancient-style objects was a continuation of the adoption of ancient art and architecture that had started in the 1830s and 1840s with the Greek Revival details and interiors that graced the townhouses of New York's developing mercantile class. In the late nineteenth and early twentieth centuries, only a select few, like Marquand, Morgan, Straus, or Rockefeller, could purchase genuine ancient statues, original works of art by Alma-Tadema and Leighton, or custom-made furniture. The newly formed middle classes of the United

States could, however, afford mass-produced reproductions of ancient sculpture, *objets d'art*, and furniture.[104] While designers created Pompeian interiors for their wealthy clients, magazines like *Art Amateur*—a Gilded Age precursor of *Martha Stewart Living* or *Better Homes and Gardens*—offered upwardly mobile readers advice on ancient-style color schemes and furnishings[105] as well as explanations of how ancient and contemporary mosaics were created.[106] Greek- and Roman-style furniture, fixtures, and fittings could be purchased for the home, at prices the prosperous middle-class homeowner could afford.[107] Ancient works of art were reproduced, with copies of *Winged Victory*, Greek vases, and Pompeian objects among the most popular.

Contemporary paintings with ancient themes were also widely reproduced, often as engravings.[108] Paintings by the celebrated French artist Jean-Léon Gérôme were popular. One such was *The Christian Martyrs' Last Prayer*, originally commissioned in 1863 by William T. Walters, whose Baltimore mansion, as briefly noted earlier, contained a Pompeian room. Alexander von Wagner's *Chariot Race* (1893) was quickly reproduced as an engraving that was hung in homes and schools.[109]

Apartment Buildings: Classical Forms in the Sky

Just as quickly as they'd been built, the New York City mansions of the Gilded Age millionaires—and their Pompeian rooms—were torn down, and elegant apartment buildings rose in their place. Erected in the early decades of the twentieth century, they offered privacy, separation from the masses, and services, such as a communal kitchen, which the new generation of moneyed New Yorkers valued more than grand, vastly expensive mansions with large staffs. These apartment buildings also engaged with antiquity, but in a more decorative way.

When the San Remo was built in 1929–1930 at 145–146 Central Park West between Seventy-Fourth and Seventy-Fifth Streets (Figure 69), it took the name of an earlier San Remo, an apartment hotel located in the same neighborhood. Many such apartment blocks were replaced with taller, grander apartments in the late 1920s and early 1930s, partially in response to the Multiple Dwelling Act of 1929, which permitted the construction of taller buildings with towers. The Dakota, the Majestic, and the El Dorado were some of the new crop that sprung up in those years on the Upper West Side.

Advertised in the *New York Times* in 1930 as "The Aristocrat of Central Park West"[110] and designed by Emery Roth, its architecture is best described as evoking the late Italian Renaissance.[111] Atop the San Remo's two symmetrical ten-story towers, however, are two elaborate circular temples that crown the building and distinguish it from neighboring structures. They evoke that mainstay of architects—the ancient Greek Choragic Monument of Lysicrates[112]—which we have already seen surmounting McKim, Mead & White's Municipal Building (see Figures 19 and 22).

The harmonious marriage of the Italian Renaissance with a classical temple is a testament to Roth's skill as an architect.[113] It also embodies how American architects were open to blending disparate influences. As vastly different as these towering new uptown

FIGURE 69. The San Remo apartment building, Manhattan, 2020.
Source: Author.

apartments were in scale from the dwellings fashionable New Yorkers had built for themselves a century earlier, classicism continued to serve some of the same purposes. Just as the Greek columns of La Grange Terrace or the Greek Revival rowhouses on Washington Square had identified them as sophisticated, high-status residences, the San Remo's Choragic towers served as outward markers of architectural elegance that could be used to lend distinction to broad, tall apartment buildings that might otherwise run the risk of being drably similar to one another.

Conclusions

From the earliest days of the republic, ancient architecture and decorative motifs permeated American domestic architecture. The first wave, during the peak of the Greek Revival in the 1830s and 1840s, was largely limited to adding a portico, incorporating classical columns, or placing another architectural detail as an accent. Furnishings with ancient designs allowed homeowners to bring a touch of Greek-themed styling indoors, as well. These classical touches embodied the ideals of a nascent republic that saw itself as the inheritor of Athenian democracy.

With the creation of huge fortunes during the Industrial Revolution and the emergence of the United States as a new force on the international stage, antiquity remained a reference point, but with a difference. Rome and Pompeii, which had been the primary model for domestic interiors in Europe for almost a century, became extremely popular in the United States, replacing the Greek forms that had been preferred in the earlier part of the nineteenth century. Europe continued to serve as an intermediary or conduit through which tastes and techniques for deploying classical art and architecture passed to American designers and consumers. The first wave of decorators included many who were born in Europe. For homegrown artists and architects, studying in Europe was an indispensable part of their training. Indeed, even for the well-heeled nonspecialist, the sophisticated young man or, more rarely, young lady, a trip to Europe was a prestigious training in good taste—as Henry James recorded so well in his tales of Americans abroad on the Grand Tour. The fad for Pompeii reached New York by way of France and England. The miniature columns and Greek keys that could grace chairs, cabinets, and clocks also came by way of Empire style *arts décoratifs* from France.

Just as having a Pompeian room or an eclectic Neo-Antique room signified that one belonged to New York's elite, owning a mass-produced reproduction of an ancient sculpture or an engraving with an ancient theme and decorating one's parlor with ancient furniture (after the suggestions found in *Art Amateur* or the like) affirmed that one belonged to the middle class. While it seems that architectural engagements with antiquity were a major tool of the affluent—whether inherited or newly made—to display their elite status, the middle classes also saw the art and architecture as a means for expressing their social and financial status. The working classes also took an interest in antiquity, but primarily in the form of popular entertainments and spectacles—such as the eruption of Pompeii on Coney Island—staged by P. T. Barnum, the Kiralfy brothers, and others.[114] Every segment of New York's population engaged with antiquity—each in their own way.

When tall apartment buildings started to be erected, the power of ancient architecture endured, in yet another form, as the outward signal of high-status architecture, similar to the Ionic and Doric columns that graced the townhouses along Washington Square. The distinct and changing ways that antiquity was brought home to New York's domestic architecture were allowed by the shifting, fluid nature of antiquity,[115] as embodied in ancient designs, which made it an appealing and endlessly adaptable resource for designers and patrons. This meant that each patron or designer could make informed, specific choices about what architectural aspect of antiquity to reinterpret.

The prestige and popularity of Pompeii and the ancient world was not limited to the music rooms or libraries of the rich and prominent but could be seen in the etchings that hung in the parlors of socially aspirational homeowners in the second half of the nineteenth century. Roman- or Pompeian-inspired interiors were contested, complex spaces; they never shook their undertones of luxury and debauchery, which is why they and other antiquity-themed interiors also played an important role in some of Gilded Age New York's racy, late-night dining establishments: the turn-of-the-century "lobster palaces."

Dining Like Nero

Stanford White frequented them with the showgirl Evelyn Nesbit, his beautiful underage mistress, and his other conquests. Edith Wharton would have looked down her nose at them, and her respectable characters, like Newland Archer, would never have been caught dead in them. But by the 1890s, everyone was talking about the "lobster palaces," the new restaurants that started appearing along the Great White Way, or Broadway,[1] around Forty-Second Street and Longacre Square, which would later be renamed Times Square. From 1890 through the 1920s, the proprietors and designers of the lobster palaces aimed to attract the newly minted millionaires and New York's fashionable, flashy young set to their establishments, appropriating and reinterpreting the art, architecture, and design of ancient civilizations to create over-the-top immersive dining experiences. Two of the best-known establishments, Murray's Roman Gardens (1906) and the Café de l'Opéra (1909–1910), both designed in large part by Henry Erkins, achieved their gaudy splendor by drawing on a mix of Pompeian, Roman, Greek, and Egyptian influences (in Murray's case) and ancient Near Eastern motifs (in the case of the Café de l'Opéra).[2]

The Development of the Lobster Palaces

Taverns were the hotbed of social and political movements—including the Revolution—in late eighteenth-century America. During the nineteenth century, they began to be supplanted by restaurants as the primary venues for dining, social interaction, and deal making

in New York City. New York's elite, who once only entertained at home, shifted some of their socializing to restaurants like Delmonico's and hotels like the Waldorf-Astoria, where the established bluebloods of New York society and new millionaires could dine.

Hotels and restaurants were quasi-public spaces,[3] which theoretically anyone could frequent. In reality, however, wealth and status determined entry.[4] One had to have the right, fashionable (and expensive) clothes—black tie or an evening gown; the funds to afford a lavish meal of lobster and champagne; and the time to spend on a late-night meal and the inevitable hangover that followed. The public spaces of hotels, like Peacock Alley of the Waldorf-Astoria, were stages where affluent men and finely attired women could parade on their way to dinner.[5] The rapid turnover in New York's economic elite and the creation of new wealth also meant that at the start of the twentieth century the opportunity to display one's new or old wealth—by dining in restaurants with one's peers or with the people one aspired to count as peers—was critical to affirm one's social status.[6] As the food historian Cindy Lobel argues, restaurants "provided a staging ground for social interactions and stratification, for gender mores and conventions, and for the working out of social relationships and public behavior in the increasingly complicated metropolis."[7] They were central to reinforcing social hierarchies and attempting to challenge them. New York's population was changing dramatically at all levels. New tycoons and lowly immigrants were altering the established social ranks that New York's bluebloods had long controlled.

The development of new restaurants such as the lobster palaces was partially due to the rapid accumulation of wealth in New York, the United States' financial capital.[8] In 1888, Henry Clews, a Wall Street Banker, noted that New York was the magnet that drew people from all across the United States, just as Rome had been for its empire and London was for the Continent.[9] In 1892, 1,368 millionaires and their families lived in New York City; by the late nineteenth century, 70 percent of major American corporations and sixty-nine of the nation's 185 trusts had their headquarters there.[10] This flood tide of new wealth meant that New York's old moneyed families relied on social activities and engagements as a means to display their prestige and cultivation and to distinguish themselves from new money and hoi polloi.[11] The wealthy old establishment, epitomized by Mrs. Astor, who together with the socialite Ward McAllister invented the exclusive notion of "The Four Hundred" (the number of the grandest New Yorkers who fit in her ballroom for her celebrated annual fête), tried to control entrée into the "right" social circles, but by the 1890s their power was waning. The sons and daughters of Mrs. Astor and her high-society peers sought out restaurants for their festive dining and did their most visible socializing in restaurants.

The shift from the home to the public spaces of restaurants and hotels was in full swing by the 1890s, by which time these venues offered the same service and cuisine as an aristocratic home. The restaurant that defined culinary sophistication in nineteenth-century New York was Delmonico's, founded by the Swiss brothers Peter and John Delmonico in 1827.[12] It was the first restaurant in New York to offer French food and an extensive menu in a grand setting.[13] Delmonico's was not alone; refined hotels and restaurants including the Waldorf-Astoria, Martin's, Sherry's, the Holland House, the St. Regis, the Savoy, and

others all opened along Fifth Avenue.[14] Dining in one of these establishments meant that one had arrived socially. But the elegant, formal restaurants and hotels on Fifth Avenue were evidently a bit stuffy for the younger, faster crowd, who chafed under the social norms of their elders. A different sort of restaurant began appearing along Broadway in the Thirties and Forties, as alternatives for dining after attending the theater. Among them were the lobster palaces. With their more morally and socially permissive atmosphere, their late-night after-theater dining, and their ostentatiously luxurious décor,[15] these lobster palaces aimed to provide what we would recognize today as an immersive, multimedia dining experience. Many had Pompeian-themed rooms, as did the finer hotels of the era. The Hotel Waldorf (which William Waldorf Astor built in 1893 to put his famous aunt's mansion in the shade, metaphorically and quite literally) had a Pompeian suite painted in yellow and red.[16] The Astor Hotel (which Mrs. Astor built right next door in 1904 to spite her nephew) had a Pompeian billiard room with mosaic floors, richly painted red walls, and custom-made tables.[17]

The Pompeian rooms in hotels and restaurants, as Marden Nichols argues, "provided social aspirants with entrée into the type of interiors their superiors enjoyed at home."[18] The influence of the Marquand music room and the Pompeian rooms discussed in the previous chapter was evident in the conceptualization and aesthetics of these spaces. While one might not be able to afford one's own Pompeian room, one could experience the luxury and opulence of antiquity any night of the week in one of the lobster palaces.

Shanley's, a well-established lobster palace (on Broadway between Forty-Second and Forty-Third Streets), had a Roman Court, which was used for private dinners and functions. Charles Rector, a successful restaurateur from Chicago, opened Rector's in 1899 on Broadway between Forty-Third and Forty-Fourth Streets and in 1914 likewise added a Pompeian Room that could accommodate up to 150 people for hosting private dinners and functions.[19] Its Pompeian decoration embodied the hypermasculinized atmosphere of the lobster palaces, which were essentially places for men to parade themselves and their female guests. Pompeii had traditionally been associated with decadent living, so a Pompeian theme was a perfect vehicle for the erotic undertones of New York's first late-night date spots.[20] The focal point of the room was a fountain, where a statue of a curvaceous nude woman stood under a pavilion and poured water into a basin. The rest of the decoration was less showy. The walls were painted to look like third-style Pompeian wall paintings,[21] and the flooring either mimicked the geometric patterns of *opus sectile*, the inlaid marble flooring found in Roman buildings, or normal mosaic flooring. Lighting fixtures fastened on the room's pillars evoked the ancient bronze lamp stands found in the House of Pansa (VI.6.1) in Pompeii,[22] and Roman-style tripods provided other lighting. Not content to be limited to antiquity, the designers of Rector's Pompeian Room also threw in fleur-de-lis patterns and imaginary creatures derived from eighteenth-century French aristocratic interiors.[23] As we saw with Marquand's music room and J. P. Morgan's Pompeii room, European interiors were a key lens through which such rooms interpreted antiquity.

The Pompeian dining room in the Hotel Whitehall, which opened in 1927, located at Broadway and 100th Street, was in operation as late as 1934. Its walls were adorned with poorly executed murals of men and women dining, painted in the style of the *megalographia*

(large-scale paintings) found in villas on the Bay of Naples, like those from Room H of the villa at Boscoreale, which the Metropolitan Museum of Art acquired in 1903, or the famous red room (*oecus* 5) of the Villa of Mysteries outside Pompeii.[24] In these two rooms, we encounter three putative elements of Pompeian home and villa décor that made them so appealing to the designers of lobster palaces: sex, gluttony, and luxury.

These themes reached their crescendo in Murray's Roman Gardens and the Café de l'Opéra, where antiquity was not confined to one themed room within a larger establishment but ran riot in a broadly reconceptualized form as the decoration of the whole restaurant. Pompeii and Rome remained central to the design, but the art and architecture of Egypt, used primarily in funerary architecture by this time (discussed in the next chapter) and other more novel and less commonly imitated ancient civilizations—those of the ancient Near East—were also brought in. These restaurants embody a core principle of the Neo-Antique—that different architectural and artistic elements could be purposefully mixed together to create highly original, new spaces. At a time when many lobster palaces and hotels had Pompeian-themed rooms, a restaurateur might understandably feel pressured to go bigger and better, to distinguish his establishment from the competition. Appropriating a different historical tradition was one way to do that.

Murray's Roman Gardens

The Irish American restaurateur John L. Murray built Murray's Roman Gardens[25] at 228–232 West Forty-Second Street between Seventh and Eighth Avenues,[26] using Roman art, architecture, décor, and landscaping from villas on the Bay of Naples, houses in Pompeii, and Nero's Rome, in an exuberant mix with elements pulled from Greek and Egyptian art and architecture, to create a three-story, all-enveloping dining extravaganza that promised to transport diners back to the luxury of antiquity. Murray's Roman Gardens is long gone—but descriptions in contemporary publications, including the restaurant's original 1908 publicity pitch, a forty-three-page swan song in the first issue of an intended *New York Plaisance: Illustrated Series of New York Places of Amusement*, tell much of the story of how the architect Henry Erkins and his team of artists and artisans reinterpreted antiquity to create Murray's flamboyant interiors.

The vision for the restaurant seems to have come from Erkins, who designed everything down to the furnishings. After training as an architect, Erkins traveled to China, Japan, India, and, of course, Europe.[27] Back home at 10 East Thirty-Third Street in New York, he ran a business that manufactured interior fixtures and cast-concrete and plaster garden furnishings—mastering techniques that he put to good use in shaping the interior at Murray's. Erkins's extensive experience designing and decorating upscale homes[28] is a good reminder that the design of sumptuous restaurants was closely connected to the creation of domestic interiors and looked to them for inspiration.[29]

Like the work of most ambitious artists—in antiquity or the present—Erkins's vision could only be achieved through the support of a discerning and deep-pocketed client. The elaborate sales-pitch brochure praises the proprietor as "a liberal and discriminating pa-

tron of the beautiful in art and an enthusiastic believer in the intelligence and appreciation of the class of New Yorkers whose patronage he seeks." Together, Murray and Erkins were pleased "to provide the Empire City with an establishment that will be reckoned as one of its attractions by all whose inclinations are towards the beautiful."[30] The publicist's prose spares no hyperbole, but its basic claim is clear: Through Erkins's vision, Murray's money, and their collective good taste, New York was graced with the miracle that was Murray's Roman Gardens.[31]

Thanks in part to the new restaurant, Charles Bevington, the author of the publicity piece, notes, "it is also possible, within the limits of this youngest of the world's metropoli, to become familiar with the beauties of ancient art in their original form." Bevington enthuses:

> At his very doors, in the city's theatre and hotel section . . . he can be transported . . . back into ancient Rome and can feast his eyes on an artistic and authentically exact reproduction of the most beautiful features of Rome's most ornate houses, of the palaces, villas and pleasure resorts of her wealthiest and most cultured citizens.[32]

Murray's Roman Gardens asserted that New York could compete with world-class cities like London, Paris, or Rome. Indeed, the publicity article claimed that Erkins's simulacrum of antiquity was better than the real thing: Murray's Roman Gardens could teach New Yorkers about antiquity without them ever having to leave the island of Manhattan "to visit the exhumed ruins of Pompeii, the excavations made on the sites of Nineveh or Babylon or the palm-fringed banks of the old Nile."[33] It flatteringly positioned New York as not only as the inheritor of the classical past but also as its best interpreter and improver. The publicity write-up asserted that the restaurant was a

> realistic reproduction, largely from the originals in the form of direct copies, casts, etc., of the decorative features of the homes of one of the most lavishly luxurious of the world's ancient peoples—the Romans of the Caesarian period—as adapted to the embellishment of a modern place of entertainment.[34]

Thus, one of Murray's claims to fame was that its depiction of antiquity was genuine—a "reconstruction, from original models and authentic records." The fact that casts and copies were seen as legitimate representatives of classical antiquity reminds us that Americans were accustomed to experiencing the classical past filtered through intermediaries.[35] For Americans unable to afford a trip to Rome or Greece, the books, photographs, and, most importantly, casts, which were held in most prominent museums by the end of the nineteenth century, were considered excellent substitutes.[36] Sometimes the mediation involved several layers. For all the talk of casts and "direct copies," the publicity write-up acknowledges that the appeal of Murray's Roman Gardens was based in part on the lush descriptions in Edward Bulwer-Lytton's bestselling 1834 novel *The Last Days of Pompeii*, which had indeed been highly influential on the development of Pompeian-style interiors in England and the United States.

Bevington's celebration of the luxurious nature of Pompeii and Rome is evident in his description of Murray's Roman Gardens. Nero, the quintessential "bad" Roman emperor,

who, among other things, murdered his mother, Agrippina, and forced Seneca the Younger to commit suicide, was praised:

> Nero ruled over Rome when its wealth and luxury were at their zenith. Although he is reported to have been an indifferent spectator of the burning of a considerable portion of the town [in 64 CE], it is shrewdly suggested that he was interested rather in the opportunity the conflagration offered for improvements than in the loss it entailed.[37]

While modern scholars agree that Nero was indeed an architectural pioneer, as attested by the remains of his sprawling Domus Aurea ("Golden House") on the Oppian Hill and spectacular recent discoveries including the famed rotating dining room on the Palatine Hill,[38] he remains a problematic historical figure, to say the least. Erkins and Bevington overlook Nero's notorious cruelty, impulsiveness, and despotism to rehabilitate him as an emperor with excellent taste and artistic vision under whom Rome reached a luxurious architectural and artistic zenith.[39] It was a sentiment they clearly expected to be shared by New Yorkers: The text boasts that Murray's was designed "for the pleasure and delectation of the people in one city in the new world where such luxury and elegance are likely to find appreciation."[40]

Since the founding of the United States, the decline and fall of the Roman Empire had been a subject of great interest for Americans.[41] Until the late nineteenth century, imperial Rome was looked upon with fear and worry by Americans, lest Americans fall into the same traps and thus experience inevitable decline. With the overseas territories gained during the Spanish-American War of 1898 and its vast mercantile interests, the United States had become an empire, and so the Roman Empire became an appealing model for emulation. This new attitude toward the Roman Empire was supported by the widely held belief that the United States was historically exceptional and would be exempt from the decline that all previous empires had undergone.[42] Manifest Destiny, the idea that God had intended the white colonists to settle the United States, fueled America's westward expansion; it also sanctioned its empire, which was just and, in the words of the historian Margaret Malamud, "divinely guided."[43] At the start of the twentieth century, Rome—its styles, the mystique around its history, the things it stood for in the popular imagination—could therefore be consumed in the United States as a form of "imperial pleasure" without an accompanying fear of decline.[44] New York was now seen as a new Rome, and Pompeii was recast as the ancient equivalent of Newport, Rhode Island,[45] with Newport's famed "cottages"—the ironically named summer retreats of the ultrawealthy—finding parallels in the houses of Pompeii and villas on the Bay of Naples.

In looking to Rome's era of empire as opposed to its earlier centuries as a republic, when it was reputedly a more modest, restrained, clean-living, and virtuous civilization, the designer of Murray's Roman Gardens is clear about which Rome he wanted to evoke for his patrons. Erkins was embracing a classicism focused on excess, luxury, and wealth, not one that sought to emulate and lay claim to the upstanding values, political liberties, and other aesthetic and philosophical refinements that earlier centuries of Europeans and Americans admiringly attributed to Greece and Rome. Even while making its boldest claims for

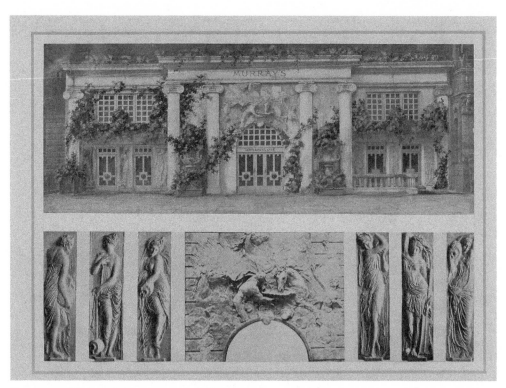

FIGURE 70. Main entrance, Murray's Roman Gardens, Manhattan, 1908.
Source: Public domain.

authenticity, the publicist's article is clear in announcing Erkins's goal as "the reconstruction, from original models and authentic records, of the artistic splendor and ornate surroundings of a Roman residence, at the period of the Imperial city's greatest opulence and magnificence."[46]

Even in the competitive landscape of Broadway, Murray's elegant façade served as an enticing advertisement both to draw the diner in and to prepare him or her for the building's interiors (Figure 70). Inspired by the hotel of "Cardinal de Rohan, Paris,"[47] which was constructed in a French Renaissance style, itself a classicizing style, the façade had many classical sculptural elements, based on Robert Le Lorrain's *Les Chevaux du Soleil* (1737) and Jean Goujon's *Fontaine des Innocents* (1547–1550), both in Paris. Inside, the guest stepped into a foyer embellished with gold, black, and polychrome mosaics (Figure 71). Palms and ivy vines continued the vegetal decoration from the façade. The first wall painting to greet the diner was a copy of Sir William Reynolds Stephens's *Summer* (1891).[48] By replicating this well-known British painting (and others), which hung in many a grand home in England and the States, Erkins injected the cultured world of the aristocratic home into Murray's. The scene and the season represented in the painting are carefully chosen: Five women lounge, luxuriating in the steamy heat of summer (*aestas* in Latin, inscribed right above the central figures) and allude to the luxurious, decadent interior that awaits a guest.

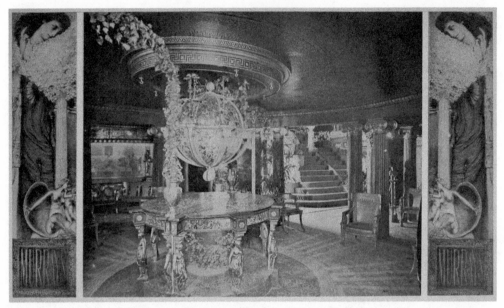

FIGURE 71. Foyer, Murray's Roman Gardens, Manhattan, 1908.
Source: Public domain.

At the center of the foyer there appears to be a table supported by bare-breasted cary-atids, above which hovered an enormous glowing polychrome glass mosaic globe. The pub-licity write-up boasts, however, that

> the ordinary observer would hardly notice, in bestowing a casual glance on this beautiful ornament, that the globe, as well as the table over which it is poised, are the product of an optical illusion skillfully carried out by an arrangement of mirrors of crystal clearness. . . . It is indeed almost impossible to discover where substantial form ceases and reflection begins.[49]

Mirrors were central to the decoration of Murray's; they were inexpensive, easy to install, and, as Erkins noted, "quadruple everything in the court."[50] Illusion was at the heart of Erkins's design for Murray's: The guest would move in a delicious haze, uncertain where physical reality and artistic form began or ended. From the entrance foyer onward, it was all of a show of mirrors, light, and artistry.

From the foyer, a grand staircase rose to the main dining room, the Interior Court, where one could dine like Nero. Having come inside from the bustle and grime of Mid-town Manhattan, a dinner guest would have been surprised and delighted to find himself instead in a lavish Roman garden. Although Erkins identified this space as an atrium—a Roman house's central room, with a high ceiling partially open to the sky—he noted that his aim was "to reproduce the garden of a villa at Pompeia, the Newport of Rome, be-decked with sculpture, statuary and various trophies of victories, such as a Roman general would build on his return from his conquests."[51] Indeed, Erkins continued, "the whole scheme of decoration is to convey an outdoor effect; festoons of vines with flowers and foliage wall [*sic*] in this room, while the ceiling is decorated and lighted to represent the

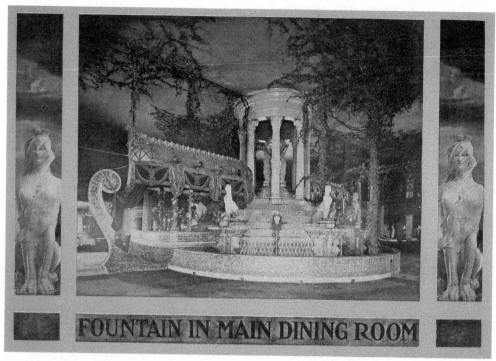

FIGURE 72. Main dining room, Murray's Roman Gardens, Manhattan, 1908.
Source: Public domain.

deep blue eastern sky with interstices through which twinkle electric stars."[52] A Roman garden offered even more opportunity for artistic creativity and fantasy than an atrium because nobody could say exactly what it should look like: In 1908, no Roman garden had been systematically excavated.[53]

In the center of the dining room was a huge fountain fashioned in the shape of a Roman barge, of the sort that the emperors Nero and Caligula favored when boating on the Bay of Naples (Figure 72).[54] Set within the barge was a tholos, a small temple fashioned of columns set in a tight ring.[55] Four female sphinxes with pert breasts guarded the perimeter of the tholos; the pert breasts are characteristic of the mythical creature that the ancient Greeks had borrowed from the ancient Near East. Jutting up next to the barge-fountain was a tall column topped with an eagle. Such columns were honorific or triumphal monuments that were erected in the public spaces of Roman and Greek cities, not in the private garden of a Roman villa or house.

As much as Murray's Roman Gardens insisted on its authentic Romanness, the main dining room was not, strictly speaking, simply a Roman or Pompeian room. It was a fanciful hybrid merging indoors and out and drawing decorative inspiration from famous ancient Mediterranean civilizations across a range of centuries. Ancient Greece was well represented in the architectural elements that framed the balcony-level dining gallery of the double-height room. There were Ionic columns and balustrades decorated with galloping horses and swift-moving chariots copied from the Parthenon's famous Panathenaic frieze,

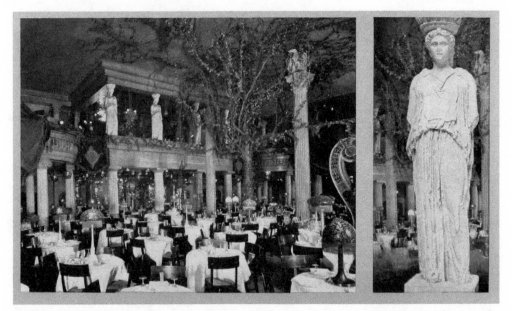

Figure 73. Column with eagle and caryatid-supported balcony, Murray's Roman Gardens, Manhattan, 1908.
Source: Public domain.

designed by Pheidias (see Figure 4). A frieze of dancing women holding hands appears on another curved balcony. The caryatids—columns carved in the shape of sturdy women—that hold up the ceiling on the balcony level are instantly recognizable borrowings from the Erechtheion, the famous temple situated next to the Parthenon on the Acropolis in Athens (Figure 73). These architectural elements are not Roman by any stretch, but they contribute to the overall fantasy of antiquity.

Here, disparate, ancient elements were borrowed widely and combined in a purposeful way. Erkins acknowledged this hybrid use of antiquity and offered the claim that his eclecticism itself was an authentically Roman aesthetic strategy: "The whole atmosphere of the room and the decorative effects are suggestive of ancient Rome during the period of its greatest luxury, when the sublimity, mystery and grandeur of Egypt and the refinements of Greece contributed to the adornment of the Roman Palace."[56]

Wall paintings filled in a "background recalling . . . a vista of the Bay of Naples."[57] The painted landscape of trees, sea, and hills were meant to give the customer the sense of sitting in a pergola in the gardens of his villa, surveying his domain and the beautiful Roman countryside. Other wall paintings in Murray's enhanced the immersive nature of the decorative scheme and reinforced the themes of luxury and sex.[58] In a painting entitled *View in Pompeian Gardens*, slim cypress trees so characteristic of the Italian landscape frame a sculpture of Ariadne half reclining in a languid pose (Figure 74). Though the sculpture depicted in the painting looks very much like a sarcophagus—that is, a tomb, with statuary meant to depict grief and mourning—in Murray's it seems just another opportunity to display the female form and is a fine example of the way Erkins reinterpreted images from antiquity to suit the aims of his interior design.

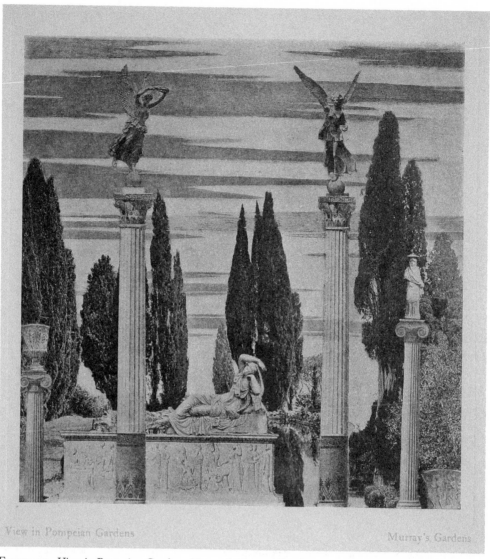

FIGURE 74. *View in Pompeian Gardens*, Murray's Roman Gardens, Manhattan, 1908.
Source: Public domain.

Another mural used an elaborate architectural setting—columns, a molding, a balustrade, all painted and not real—to create the illusion of looking out from a villa onto a scene of two nude women performing in a garden, similar to the villa landscapes so popular in Pompeian houses and villas on the Bay of Naples (Figure 75). One woman stands with her arms stretched upward, exposing her breasts and entire figure; a bracelet on her upper arm and shoes are her only ornaments. Next to her sits a flute girl, also nude or dressed in a sheer diaphanous garment, with dark hair cut in the angular style meant to identify her as Egyptian. Behind them, a third woman, modestly dressed, shakes a tambourine. The women are watched by two men, fully clothed and reclining on couches. These Roman men in the painting are like the diners in the restaurant; they gaze at the women, enjoying their

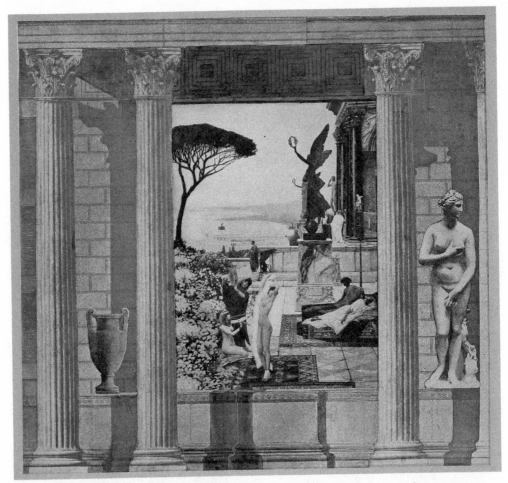

FIGURE 75. Unnamed wall painting, Murray's Roman Gardens, Manhattan, 1908.
Source: Public domain.

physical beauty without any shame or consequence. Classicism here serves another purpose, one it has supplied in art since the Renaissance: Antique settings or subject matter confer the distance of time and exotic foreignness and a sense of high-minded solemnity that makes it acceptable to look at naked bodies. Nudity in the parlor would be unthinkable, but if it is Diana caught bathing by Actaeon or Venus emerging in splendor from the sea foam, a viewer is allowed to see every curve and physical charm. Furthermore, this painting is modeled on a Gustav Klimt mural in the Burgtheater in Vienna, giving it an air of European sophistication.

The objectification of women continued in another painting, *Balcony and Bathing by Leighton*, which copied *The Bath of Psyche* (exhibited at the Royal Academy in London in 1890), by Frederic Leighton (Figure 76).[59] Again, the scene is framed with a foreground of painted columns and trompe-l'oeil architecture to give the illusion that the viewer is in an ornate Roman villa, looking out to a broad balcony or terrace backed by yet another, exterior set of colonnades and entablatures, beyond which the view opens out onto an an-

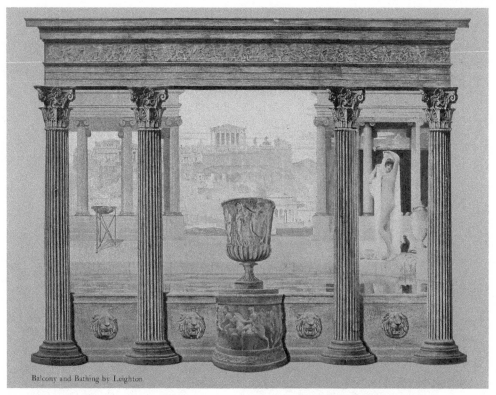

FIGURE 76. *Balcony and Bathing by Leighton*, Murray's Roman Gardens, Manhattan, 1908.
Source: Public domain.

cient Roman city. Out on the terrace in the foreground Psyche stands nude, raising her arms high in the act of slipping off her robes, beside a pool painted with reflective water. Her face is turned toward us but registers no surprise or recognition, as if she is unaware that anyone is watching her.

With most of the women in these wall paintings barely dressed or totally nude, the murals in Murray's present a particular vision of women.[60] They reflect the male atmosphere of the restaurant and the attitudes commonly held about the women—predominantly actresses, chorus girls, or mistresses—whom men would typically entertain in the lobster palaces. Chorus girls were deemed highly desirable female companions for an evening out on the town.[61] Actresses held a socially complex position at the start of the twentieth century—sometimes they were esteemed and celebrated for their beauty and talents, but other times they were looked down upon as morally loose and socially inferior.

Bevington's long celebratory brochure for Murray's presents a very different picture of women enjoying themselves at the lobster palace (Figure 77). In an illustration that depicts the main dining room, busy and glittering for an "afternoon Reception, after the theatre," the women are sumptuously attired in broad-brimmed hats, strands of pearls, and fashionable hairstyles—and covered neck to toe in modest gowns, rather than the racy dresses associated with showgirls. There is even a young girl in a child's frock, out with her family. In a scene intended to give "a faint conception of the life and brilliance that

FIGURE 77. Women and men dining at Murray's Roman Gardens, Manhattan, 1908.
Source: Public domain.

have done so much to make Murray's a favorite resort of the 'upper ten' in New York,"[62] Murray's is presented as the epitome of refinement and propriety, not as a setting for licentious male pleasure.

The main balcony had two murals, one of which was Roman in nature and the other Egyptian in inspiration. Like the Roman-themed murals, this Egyptian scene is framed with painted trompe-l'oeil architecture: Stout pillars hold a lintel decorated with winged solar discs, to give the impression that the viewer is at the threshold of a grand gateway that opens onto a vast approach to a temple. A fountain stands in the immediate foreground; far beyond looms a colossal statue of a pharaoh seated on a throne. Still further in the illusionary distance monumental colonnaded architecture recedes into an Egyptian landscape. Like so many of the other paintings in Murray's, it was not an original composition; this one was a copy of Karl Friedrich Schinkel's famous set for the final scene of Act II of

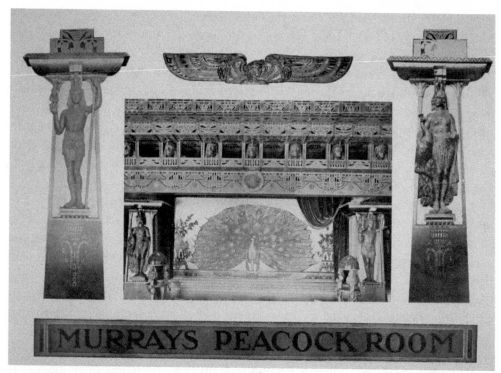

FIGURE 78. Peacock Room, Murray's Roman Gardens, Manhattan, 1908.
Source: Public domain.

the 1818 production of Mozart's *Magic Flute*, which depicted the Temple of the Sun with a statue of Osiris.[63] Schinkel was one of the most prominent nineteenth-century German architects and a major advocate of the adoption of classical architecture in Berlin. Thus, the set design for a famous European opera, as conceived by a top European neoclassical architect, was repurposed for the décor of a New York City lobster palace.

The Egyptian theme was continued, even more elaborately, in a room that not all diners would have had access to. Like many other lobster palaces, Murray's had private rooms where male customers could find space for their covert indiscretions. Murray's had twenty-four private dining rooms and bachelor apartments; the exact use and rental of these spaces are not detailed in Bevington or other sources, so they remain a mystery, but one can imagine a series of erotic male fantasies playing out. Perhaps the most ornate was the Peacock Room (Figure 78),[64] which was located off the main balcony. Named for the huge peacock with a fanned tail that adorned one of the walls, this banquet room made the main dining room look subdued. It shimmered with deep blues and iridescent colors, and the Egyptian fantasy was laid on without restraint. To add further sex appeal to the rooms, Bevington claimed that the "decorations in the apartment are suggestive of the period of Antony and Cleopatra, and are reproductions, with such changes as were necessary to confirm to the surroundings, of the works of famous artists."[65] The reference to Anthony and Cleopatra, the famed lovers of antiquity, no doubt underscored the overtones of luxury, sex, and pleasure. Cleopatra's Egypt, which had

been ruled by Greeks since Alexander the Great's conquest in 332 BCE, was also a hybrid, where the mixing of Greek and Egyptian traditions was evident in Ptolemaic art, architecture, and other aspects of life.

The rectangular room was decorated with a heavy cornice that appears, in surviving photographs, to have been supported by engaged columns and pilasters decorated with sculptures and statues. The four registers of the cornice are decorated with Egyptian motifs, including lotuses and other Nilotic vegetation and winged solar discs. In the main register, small niches held sculpted male pharaonic heads, wearing the royal *nemes* headcloth with the *uraeus* (snake), and veiled female heads, alternating almost like triglyphs and metopes in a Doric architrave.

The sculptures that decorate the walls and pilasters are highly sensuous; the men are muscular, the women voluptuous, and none of them are wearing much. *Castles in the Air* shows a muscular young Egyptian prince, clad in nothing but the royal headgear, leaning back on one strong arm, gazing dreamily at large bubbles floating into the sky, apparently from the pipe he holds in his languid left hand. Across the room, in *The Temple of Isis*, a nude female plays a lute while a naked child raises her hands to worship the rising sun. An Egyptian city sprawls below them, dotted with palms. Even more striking is a nude woman, perhaps an Egyptian queen, seated on an ornate throne (Figure 79). Again, nothing of her body is left to the imagination; the viewer can enjoy all of her physical charms.

Here again are the two pillars of Erkins's appropriation of antiquity in his lobster palace. His illusionistic style insists on authenticity: Part of its appeal is that it is meant to be a marker of sophistication and exclusivity. In 1908, any common New Yorker could claim to be living in the most dynamic capital of the new century, but only a person of wealth and discernment could spend the evening in ancient Pompeii or Alexandria. But more important than the supposed authenticity of Erkins's visual quotations from Rome or Egypt were the implications, the *feel*, imparted by the exotic ethos of the ancient world.

The rich decoration, heavy with painting, sculpture, and architectural ornament, contributed to an atmosphere of luxury but was more specifically calibrated to reinforce that Murray's Roman Gardens, like many other lobster palaces, was a masculine refuge, a male playground where women, whose social status and profession gave them much exposure but little power, could be consumed and discarded. It was in establishments such as Murray's that men entertained their mistresses while their wives were ensconced at home.[66] This aspect of Murray's—its aura of licentious decadence and forbidden pleasures—is where antiquity provided the designer, proprietor, and consumer with something that they could only get from a style that evoked these distant and storied historical periods. In Murray's Roman Gardens, New York's elite, especially men, could celebrate and enjoy aspects of life that they associated with the pleasures available to the Roman elite in their villas on the Bay of Naples or their elegant painted homes in Pompeii. At that particular moment in the history of the United States—and of New York, one of its richest cities—the wealth and luxury of the Roman Empire was seen in a positive light.[67] Once a byword for excess and immorality, it now represented possibility and permission.

But like the fast crowd that played hard in these rooms, it was not to last. Two floors of Murray's Roman Gardens were destroyed when the building was partially remodeled in

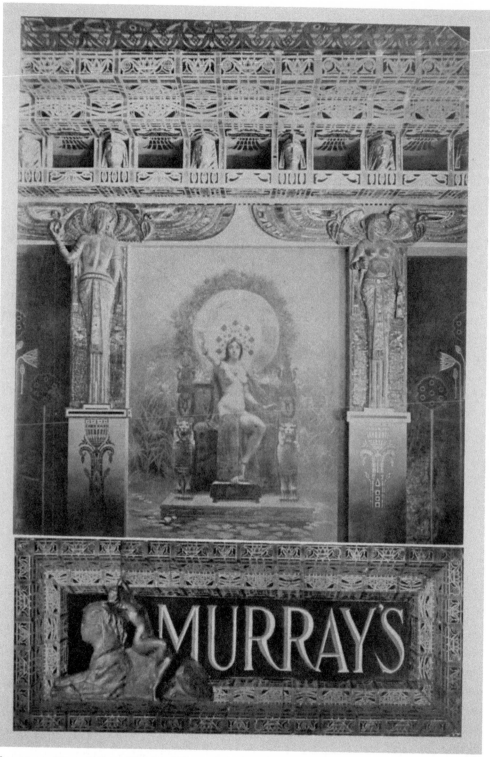

FIGURE 79. Peacock Room, Murray's Roman Gardens, Manhattan, 1908.
Source: Public domain.

the 1920s to become Hubert's Museum, which included a freak show, a penny arcade, and a world-famous flea circus and remained in operation until about 1965.[68] The top floor and the Garden Terrace survived somewhat intact until 1996, when the building was demolished to make way for the New York branch of Madame Tussaud's Wax Museum.[69] Fittingly, this Gilded Age fantasy of Roman and Egyptian antiquity was replaced by two museums where spectacle and artifice also reigned.

The Café de l'Opéra

Erkins let his fantasies—inspired by the grandeur and empire of antiquity—roam in another direction for the Café de l'Opéra, another lobster palace. Located in the old Rossmore Hotel, it stretched from Broadway to Seventh Avenue between Forty-First and Forty-Second Streets and was remodeled at the cost of somewhere between $1 million and $4 million in 1909.[70] Designed by the architect H. C. Pelton with Erkins as his design associate, the Café de l'Opéra embodied all of the extravagant decoration of the lobster palaces and their dubious taste. Despite the French name—the Café de l'Opéra was quickly rechristened Café de Paris—and a mostly French-inspired exterior (surprisingly punctuated with some Egyptian-style columns), the eight floors of over-the-top dining included a Japanese room, which the *New York Times* called the "Temple of Nikko." The most prominent, however, were the interiors of the main floor and staircase, which reinterpreted designs, art, and architecture from the ancient Near East. *Architects' and Builders' Magazine* described the interior in politely scathing terms:

> Lurid and gorgeous, overwhelmed with ornament, the Café de l'Opéra no doubt will appeal to many, and cause all to wonder at its lavish magnificence. The gloss of the gold, vivid color, variety of relief and applied ornament, shimmering lights and many mirrors which double and redouble the prospect and vastly increase the apparent size of the interiors are startling, astounding and of such influence as to overcome at once the more sober judgment of the critic and force an opinion rash and against the dictates of his reason.[71]

Pelton and Erkins certainly didn't allow their exuberance to be restrained by scrupulous adherence to one ancient model or even to one ancient civilization. The main dining room, with three stories of seating arranged around a lofty central court with a fountain located in one corner, was reportedly inspired by "Khorsbad or Perseopolis or an ancient Persian Tomb."[72] The fountain's central feature was a Mesopotamian step pyramid topped with an illuminated orb, tucked inside a pavilion supported by black marble columns and decorated with ancient "Assyrian" and Egyptian motifs (Figure 80). The pavilion was backed with mirrors, which had the effect of multiplying its size and its black columns, making it seem almost infinite.

Standing front and center outside the fountain's pavilion was the nude female figure of a priestess or "seeress." Again, the reviewer at *Architects' and Builders' Magazine* was tartly disapproving: "Her gilded nudities at the bath, a bewildering complexity purposeless except as gaudy ornament, is better passed with a hasty glance than observed with an analy-

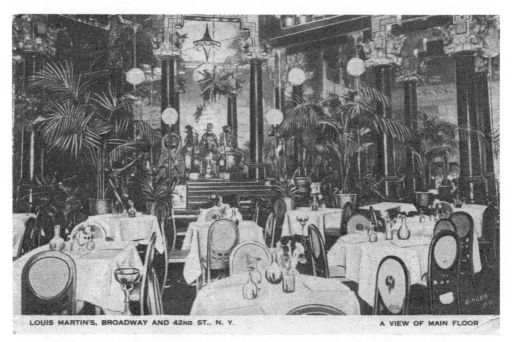

LOUIS MARTIN'S, BROADWAY AND 42ND ST., N. Y. A VIEW OF MAIN FLOOR

Figure 80. Main dining room, Café de l'Opéra (also known as Louis Martin's and Café de Paris), historic postcard, early twentieth century.
Source: Author's collection.

sis of its composition."[73] At least six nude women flanked the seeress in various revealing poses, allowing all aspects of their anatomy to be inspected. Two more female figures were posted atop the pavilion, holding strands of illuminated lights. All this female nudity might initially seem out of place, given that the restaurant required men and women to wear black tie and evening gowns—but as with Murray's Roman Gardens, it was very much in keeping with the spirit of the venue to offer female bodies for the diners to consume alongside their lobsters and champagne.

The walls were studded with projecting pavilions, which, like the fountain, were backed with mirrors to expand the sense of space in the room. Friezes with a rosette pattern purportedly derived "from Assyrian prototypes"; the balcony landing was decorated with painted lions, a motif central in the palaces of ancient Iraq and Iran from Babylonian and Assyrian times through the Achaemenid period.[74] Modern Persian rugs covered the floors. The author of the article in *Architects' and Builders' Magazine* doesn't seem to have been terribly familiar with the art of the Near East but gamely ventures that "the details [have] been more or less faithfully copied for the ornamentation of this home of frivolity."[75] The *New York Times* also seemed willing to accept that the fanciful décor reflected a degree of authenticity. Describing the monumental staircase, carpeted and flanked by pairs of gilded lions and colossal *lamassu*, that rose to the balconies and upper floors (Figure 81), the *New York Times* reported that "the great staircase, twenty-two feet wide . . . was modeled after the famous staircase in the Temple of Persepolis."[76]

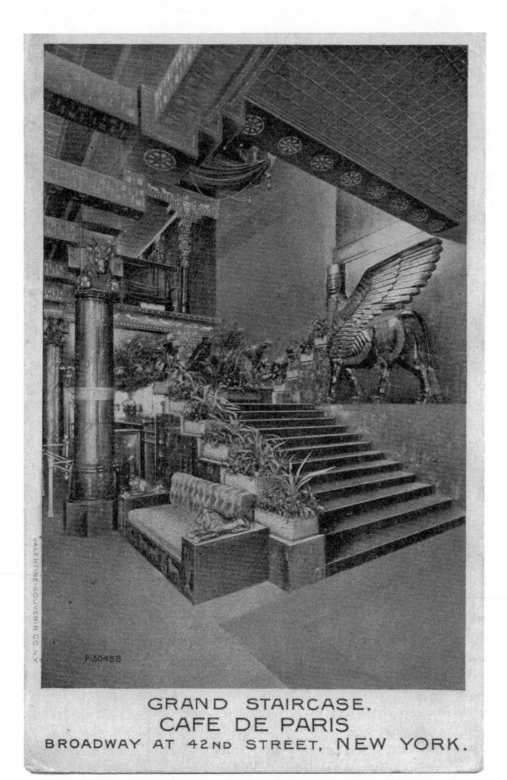

GRAND STAIRCASE.
CAFE DE PARIS
BROADWAY AT 42ND STREET, NEW YORK.

FIGURE 81. Staircase, Café de l'Opéra (also known as Louis Martin's and Café de Paris), historic postcard, early twentieth century.
Source: Author's collection.

But the modeling seems loose or conceptual at best, as the staircase lacks the reliefs and sculpture so conspicuous on the sides of the original. This is grandeur by association. Similarly, the *New York Times* remarked that the columns of the balconies were topped with capitals "of Assyrian and Babylonian design."[77] As so often, the contemporary newspaper got the ancient reference wrong. They are actually replicas of the bull capitals from the audience hall (*apadana*) of the palace of Darius I at Susa—Achaemenid Persian works of around 510 BCE, not Babylonian or Assyrian from earlier centuries.[78] Rather than delivering any accurate sense of a particular style or period of ancient Near Eastern architecture, the décor was meant to be evocative, a fantasy with no more rigor than we would expect in Las Vegas or Disneyland. It seems that "Babylonian" and "Assyrian" were vaguely accurate labels employed to add to the exoticism of the space.

Up on the third-floor balcony, diners could gaze down onto the main court (as they could in Murray's Roman Gardens)—but they might also find themselves suddenly centuries and thousands of miles away from the restaurant's Near Eastern theme. The major room on the third floor was a subtle, elegant, Japanese room, which critics considered "a pleasant and attractive interior" in contrast to the garish Persian-Assyrian décor downstairs.[79] The reviewer's approval of the Japanese room may reflect a shift in tastes, as some of the glitz of the Gilded Age lobster palaces gave way to something more refined and less excessive.

On that staircase from ancient Near Eastern pastiche to Japanese-style elegance, the customer of the Café de l'Opéra might feel himself momentarily dwarfed by a gigantic reproduction of *The Fall of Babylon* (1891), by the French painter Georges Rochegrosse, covering the lofty side wall. The well-known painting (which had won a medal of honor at the Paris Salon)[80] was in a sense a cautionary tale: Concubines languish within the walls of Babylon one hazy evening in 539 BCE, just as the massed armies of the Persian Empire are about to crowd through the city's undefended gates. The dramatic scene again provided plenty of sprawling naked women for the patrons' visual enjoyment, but it also alludes to the decline and fall that inevitably follows the luxurious zenith of any empire—perhaps a subtle reminder to guests in the lobster palace that the party could not continue forever.

"When the first astonishment of the Café de l'Opéra has passed, and one's eye travels over its architectural and decorative embellishments, the glamor passes, and its vagaries impress one more," warned the restaurant's reviewer in *Architects' and Builders' Magazine*.[81] And indeed, the gigantic establishment seems not to have captured the interest of its prospective patrons. Within four months of its grand opening in December 1909, the Café de l'Opéra had closed.[82] Just like Babylon, the Café de l'Opéra had fallen. Its speedy decline was attributed to the lack of a bar, the stringent dress code that insisted on "evening dress only," and the fact that many dishes arrived cold to the table after their long journey from the kitchen. Louis Martin, of the Café Martin, took over the restaurant and planned to remodel the kitchen while attempting to keep most of the décor the same.[83] The restaurant reopened and stayed in business until 1915, when it was demolished.

Conclusions

The interiors of Murray's Roman Gardens and Café de l'Opéra were designed to promise their patrons all the extravagant luxuries once enjoyed by the elites of the ancient world. Henry Erkins invoked the luxury of imperial Rome, the sensuality of Cleopatra's Egypt, and the exoticism of the ancient Near East to create immersive interiors to serve as the perfect stage for opulent meals. References, some freer than others, to the art and architecture of ancient Greece, Rome, and Egypt were blended to create such an environment in Murray's Roman Gardens, where the outdoor landscapes and gardens of the Roman villa and house were also brought indoors. The short-lived Café de l'Opéra, with its French-style street front opening into a gaudy riot of decorative allusions to ancient Persia, Babylon, and Assyria, was even more uninhibited in mixing its references to ancient civilizations. The idea of luxury and its various expensive indulgences were enjoying greater respectability and acceptance at this particular point in US history. It was the Gilded Age, and conspicuous consumption was lauded as the motivating incentive and well-deserved reward for entrepreneurial success. The United States was a fledgling world power with its own overseas empire, and the grandeur and luxury of the Roman Empire and the wealth that it symbolized were seen in a more positive light.[84] The playgrounds of ancient Rome and Pompeii were still at some level perceived as licentious and morally lax, but those associations held positive appeal to the men who created the popular lobster palaces of Midtown Manhattan. Antiquity provided a colorful, exotic model that legitimated these glitzy establishments, where the fast crowd could enjoy luxurious food and drink—and misbehave.

Roman, Greek, Egyptian, and Near Eastern forms were often mediated through European culture—through the artifacts known to architects and designers from the great museums of Rome, Berlin, Paris, and London; through examples of modern imitation and appropriation that had been tried first in those cities before they were attempted in New York and other American cities; and through art and literature such as Bulwer-Lytton's *Last Days of Pompeii*, Schinkel's famous set for Mozart's *Magic Flute*, or paintings by popular British and French painters. By combining recent works of art with ancient ones, Erkins created highly original interiors, succeeding at Murray's Roman Gardens while perhaps failing at the Café de l'Opéra. To our eyes, these lobster palaces seem garish and extreme, but they are also the progenitors of the fantasy settings that millions travel to see in Las Vegas: Caesar's Palace with its Forum Shops[85] and the Luxor Hotel with its pyramid and sphinx.

Different moments in ancient history evoked different images of luxury, opulence, and pleasure. If prosperous New Yorkers cared passionately about living at the right address with the right interiors, as discussed in the previous chapter, and dining in the right spots with the right people, then it should not be surprising that in death, being buried along with the right people was also a pressing social priority, one for which wealthy Gothamites overlooked no detail or expense.

SEVEN

To Be Buried Like a Pharaoh

Like the pharaohs of ancient Egypt and the emperors and freedmen of Rome, New Yorkers cared about where they spent eternity.[1] As the final residence for the deceased, a tomb provides an ultimate architectural moment for self-presentation.[2] Trimalchio, the outrageous nouveau riche freedman of Petronius's *Satyricon* whose description of his over-the-top tomb has delighted readers since the late first century CE, sums up the concerns of New Yorkers and ancient Romans well: "It is quite wrong for a man to decorate his house while he is alive, and not to trouble about the house where he must make a longer stay."[3]

The desire to be buried in a cemetery of high repute was as old as the United States, but burial in a grand mausoleum was uncommon in New York City before 1838. To understand the role that classical and Egyptian architecture played in the creation of some of New York's most striking tombs and memorials, this chapter briefly charts the development of Green-Wood and Woodlawn, New York City's most prominent rural cemeteries, and the role of ancient forms in funerary architecture from c. 1840 to 1930 (Figure 82). Because New York's cemeteries have enchanted countless scholars,[4] this chapter focuses on certain tombs where ancient Egyptian and classical forms were used in highly evocative ways that were often also deeply personal. The popularity and the longevity of these ancient architectural forms in Green-Wood and Woodlawn reflect the fact that such forms were flexible, culturally significant,[5] and, in this context, could convey the solemnity and finality of death.

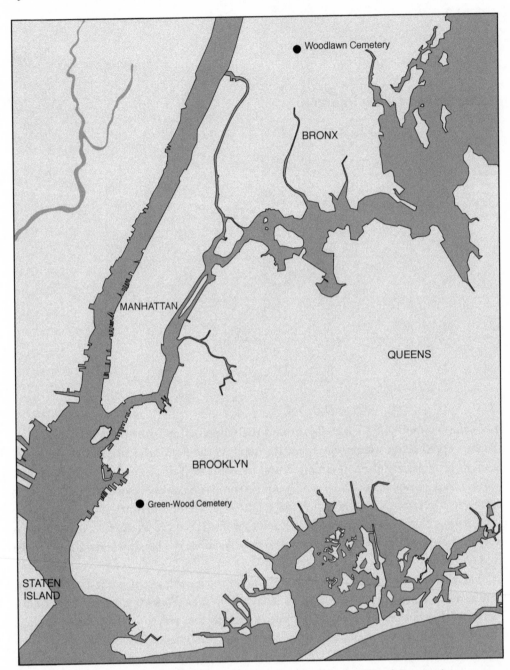

FIGURE 82. Map of New York City, indicating Woodlawn and Green-Wood Cemeteries.
Source: E. Macaulay-Lewis / A. Wilkins.

New York's Cemeteries before 1838

Alexander Hamilton's grave exemplifies the nature of burials and cemeteries in early nineteenth-century New York. After being killed by Vice President Aaron Burr in a duel, Hamilton was buried in the yard of Trinity Church in lower Manhattan. His grave is a pyramid, commonly mistaken for an obelisk,[6] resting on a base with four urns. It was

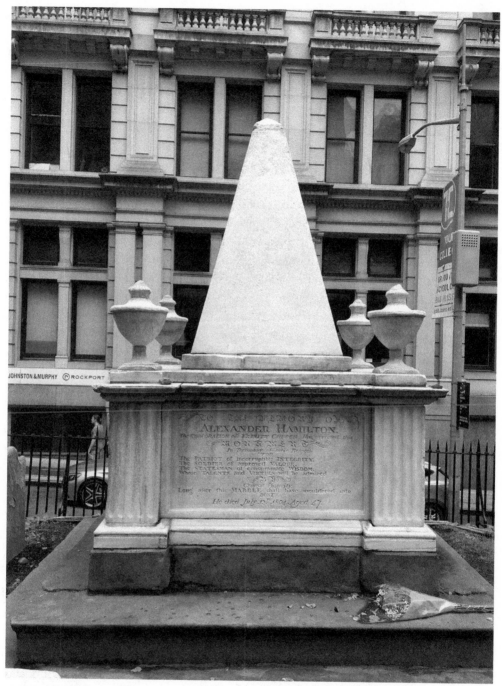

FIGURE 83. Alexander Hamilton's grave, Trinity Churchyard, Manhattan, 2018.
Source: Author.

erected in 1806, two years after his death (Figure 83).[7] The pyramid, clearly identifiable as such because of its squat proportions, is taller than the majority of headstones of other contemporary graves in the churchyard. It is made of extremely high-quality white marble.[8] The pyramid is flanked by classical-style urns, leading Alison M. Dalton to identify the monument "as one of the very earliest examples in the New York region of a large,

sepulchral monument in the Neoclassical style."[9] However, such a categorization ignores the Egyptian nature of the pyramid. This monument, like many others, embraced a Neo-Antique strategy that fused the classical, funeral urns with a pyramid, the most Egyptian of forms. This combination of Egyptian and classical drew upon contemporary European forms for funerary monuments,[10] giving the monument a cosmopolitan air.

The St. Andrew's Society, of which Hamilton was a member, also erected a small white obelisk[11] at the site of Burr and Hamilton's duel in Weehawken, New Jersey.[12] Tourists carted away bits of it as keepsakes of their own piece of history. In 1821, antidueling campaigners demolished it, and in 1894, a new memorial to Hamilton was constructed.[13] The decision to erect an obelisk and a pyramid to Hamilton reflects the commemorative power of ancient Egyptian forms. This tradition has its origins in the colonial period: An obelisk commemorating the British General James Wolfe, who died at the Battle of the Plains of Abraham in 1759, was located at the end of Monument Lane, now Fourteenth Street and Greenwich Avenue.[14] The Montgomery Monument in St. Paul's Chapel, on Broadway (discussed in the next chapter), the first memorial ever erected by the United States, also used classical and Egyptian elements to great effect.[15] The monuments erected to Hamilton, Wolfe, and Montgomery reflect the fact that ancient Egyptian art and architecture, popularized by publications starting in the mid–eighteenth century, were considered sublime and thus deeply evocative, as well as being funereal and commemorative.[16]

The location of Hamilton's pyramid within a church graveyard was typical. During the eighteenth and early nineteenth centuries, Americans were buried in churchyards or grounds immediately adjacent to a church, following a custom that had been established in medieval Europe. Members of affluent families might be buried in a church chapel, vault, or crypt. The close proximity of the deceased also served as a potent memento mori to the living.

The practicalities of urban life started to override spiritual considerations in early nineteenth-century New York City. By the 1830s, New York had been a major population center for two hundred years. The city's ten thousand annual interments meant the churchyards and vaults were simply filling up.[17] Burying bodies within the city was also problematic, as dead bodies contaminated water supplies and contributed to outbreaks of cholera and other waterborne diseases. By 1822, there were twenty-two burial areas south of City Hall in Manhattan, and many of these graveyards were poorly maintained and so furthered the risk of disease.[18] A law was passed in 1823 that outlawed all burials in graves or vaults south of Canal, Sullivan, and Grand Streets, to mitigate such risks.[19]

Someone had to figure out where to put all the bodies. Loath to miss an opportunity, New Yorkers created nonsectarian and then rural cemeteries. Nonsectarian cemeteries, which were not attached to a specific church, first appeared in the 1830s and were open to a broader cross-section of society. The most prominent of these were the New York Marble Cemetery (1830) and the New York City Marble Cemetery (1832), both located on Manhattan's Lower East Side, but both were too small to accommodate the ever-increasing numbers of the deceased.

Rural cemeteries located on the edges of a city were a practical and elegant solution to the problems of limited space in urban centers and the ever-present threat of disease. Con-

secrated in December 1804, the first large rural cemetery was Père Lachaise, east of Paris. Within two decades, its naturalistic landscape was filled with grand tombs and classical mausolea, interspersed with humbler monuments. The design of Père Lachaise was based in part on the picturesque landscapes filled with follies that framed the great houses of the English countryside so fashionable at this time,[20] and it soon became the model for European and American cemeteries.[21] By 1840, several important rural cemeteries were founded in the United States, including Mount Auburn, Cambridge (1832); Laurel Hill, Philadelphia (1836); and, importantly for New York City, Green-Wood, in Brooklyn (1838). Their landscape design was also influenced by the gardens of great English country houses,[22] and many of their sepulchral memorials took classical and Egyptian forms. The main entrance to Mount Auburn was an Egyptian-style gateway,[23] and a monumental sphinx was erected as a Civil War memorial there in 1872.[24]

At this time, the Elysian Fields, the physical location of the afterlife in the classical world, also emerged as a model for a landscaped or garden cemetery.[25] It was the paradisiacal landscape where the souls of the good and virtuous went after death in ancient Greece.[26] Thus, the underlying intellectual basis for these new cemeteries was also related to the reinterpretation and repurposing of a classical concept—a garden paradise. Attitudes toward death and the afterlife had also began to shift; resurrection and positive visions of heaven began to replace the damnation and eternal brimstone that had dominated the understanding of the afterlife in the eighteenth-century United States.[27]

Green-Wood and Woodlawn

In 1832, the Brooklynite Henry Pierrepont visited Mount Auburn and decided that Brooklyn should have a rural cemetery.[28] In 1838, Green-Wood Cemetery was incorporated; in 1850, the first 175 acres of land were purchased,[29] and the first interments were made.[30] Once on the edge of Brooklyn, it is now located between the neighborhoods of Sunset Park and Winsor Terrace. Adhering to the design principles typical of rural cemeteries,[31] D. B. Douglass, who had worked on the Croton Aqueduct, designed the original central-northwest part of the cemetery in a picturesque manner that emphasized the harmony of plots.

Green-Wood's start was inauspicious. In the first three years of its existence, there were only four hundred burials.[32] Convincing New Yorkers to bury their dead outside of Manhattan, far from their parishes, was difficult. However, a celebrity "endorsement"—the reburial of Governor DeWitt Clinton in 1844—brightened Green-Wood's prospects. Despite his illustrious political career, Clinton had died in Albany in 1828 in poor circumstances, and he was interred in a humble grave outside of Albany. The reinterment of Clinton transformed Green-Wood into Brooklyn and New York's most prestigious cemetery.

Because public green space was a precious commodity,[33] Green-Wood served as New York City's de facto public park until the founding of Central Park (in Manhattan) and Prospect Park (in Brooklyn). European tourists came to visit Green-Wood.[34] By the early

1860s, Green-Wood attracted a whopping 500,000 visitors a year, making it the United States' most popular tourist destination after Niagara Falls.[35] Despite its popularity, Green-Wood had serious drawbacks, given its geography. By the 1860s, passage to Green-Wood was becoming undignified.[36] One had to venture through the congested streets of lower Manhattan and board a ferry to Brooklyn. As a result, the respectable women of many of New York's elite families were unable to attend funerals.

On December 29, 1863, Reverend Absalom Peters, a Presbyterian minister, gathered a group of men, many of whom were connected to the New York and Harlem Railroad, in Morrisania, then a village in rural Westchester County, to discuss founding a cemetery along the line.[37] He needed investors to purchase land for the cemetery, and the New York and Harlem Railroad needed more passengers to increase profitability. These entrepreneurial businessmen agreed with Peters that establishing a rural cemetery accessible by train from New York City would be a successful economic venture for all, and thus Woodlawn Cemetery was born. From its inception, Woodlawn could be reached by horse carriage, railroad, and, later, by car and subway. The northward movement of residential developments and churches on the island of Manhattan ensured Woodlawn's success.[38]

In 1864, James Charles Sidney designed the cemetery as a rural, naturalist landscape. In April 1867, Robert Edward Kerr Whiting was hired as comptroller to run Woodlawn Cemetery. Whiting significantly changed the grid of funerary lots and fundamentally modified Woodlawn's landscape, basing it on the landscape lawn plan used in Spring Grove Cemetery, in Cincinnati, Ohio.[39] Like Green-Wood, Woodlawn offered a patron space and the opportunity to build a grand tomb to celebrate one's achievements and family. The rural cemetery was a place for aspiration and social posturing; regardless of class, background, and faith, anyone with sufficient funds could create his or her own final abode.[40] This also meant that even the simplest tomb or grave could be surrounded by more fashionable and affluent neighbors and natural beauty.[41] The new rural cemeteries also encouraged new modes of behavior—visiting and strolling—that augmented the tombs' visual impact on the viewer. Cemeteries were places of lived experience where tombs and landscapes also reaffirmed the social status of the deceased.

The success of the rural cemetery was also underscored by dramatic changes in commemorative art at this time. During the nineteenth century, radical social and political reform moved concurrently with the rise of the individual and of individuality in American society. Americans were also fascinated, or at least preoccupied, with death.[42] As a result, there was increased interest in the commemorative arts at all levels of society.[43] The expansion of the commemorative arts was also supported by the development of a middle class. The United States' established elites, nouveau riche, and bourgeoisie exploited material culture to express their status, achievements, and heritage.[44] Funerary memorials and mausolea began to replace the tombstones found in colonial- and early Republican-era cemeteries.[45] The advent of larger-scale commemorative architecture was also connected to several other nineteenth-century developments, including the growth and transformation of the quarry and monument industries.[46] The training of native-born and immigrant artists and sculptors also allowed for a wider scope of funerary and commemorative monuments. Furthermore, the American Civil War (1861–1865), the bloodiest con-

flict in US history, resulted in over 620,000 deaths.[47] The death of so many amplified the need for large family mausolea, where multiple generations or extended families could be interred.

Classical Temples to New York's Emperors and Gods

Of the mausolea that repurposed classical architecture, temple-style tombs were among the most widespread in the United States.[48] They are well suited to mausoleum architecture; the cella became an accessible chamber with crypts, vaults, and/or sarcophagi.[49] The popularity of these forms was partially due to ancient Greco-Roman temples' aesthetic form and functionality, as well as their grandeur.

Other contemporary commentators opposed classical and Egyptian tombs because they preferred the Gothic style;[50] still others worried about the pagan associations of Egyptian and Greco-Roman tombs.[51] Nehemiah Cleaveland, the principal of a girls' school in Brooklyn and Green-Wood's first chronicler, fiercely criticized the deployment of Egyptian and classical forms in America's rural cemeteries, especially at Green-Wood.[52] Yet temple tombs, such as the classical-style Miller tomb (1852), were attested as early as the 1840s and 1850s in Green-Wood. They became increasingly popular in the late nineteenth century with many of America's self-made millionaires.[53] As discussed in Chapters 2 and 3, the classical temple form was well established in New York's bank and financial architecture. The temple form emphasized how the entombed financiers and bankers amassed their vast fortunes. Classical mausolea were constructed in greater numbers at Green-Wood and then at Woodlawn. As industrialization progressed, Americans started to acquire unprecedented levels of wealth. This newfound affluence meant that successful men could afford to erect a monumental family tomb and that the selection of the design and style of the tomb often had a personal resonance that conveyed the individual and family's social status, wealth, and, sometimes, beliefs. These aesthetic concerns, as well as the cultural and social prestige and capital associated with ancient architecture, encouraged self-made men such as John Anderson, Jay Gould, and others to reinterpret the Greco-Roman temple in their mausolea.

A TEMPLE TO TOBACCO: THE MAUSOLEUM OF JOHN ANDERSON

The temple tomb of John C. Anderson exemplifies the appropriation of classical temple forms in a mausoleum at Green-Wood.[54] From a single cigar shop near City Hall on Broadway, John Anderson made a mint selling his Solace brand of tobacco (conveniently wrapped in tinfoil for freshness) and cigars,[55] before expanding his holdings into commerce and railroads.[56] Upon retiring as a millionaire, he owned two palatial mansions, including one on Fifth Avenue, and traveled to Europe.[57] He died in 1881, leaving a fortune of $5 to $10 million.[58]

Like many self-made men, he had well-developed philanthropic interests, including supporting science education[59] and the Union during the Civil War.[60] His commitment to

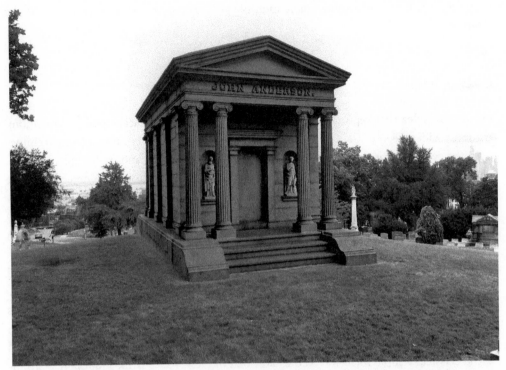

FIGURE 84. John Anderson's mausoleum, Green-Wood Cemetery, Brooklyn, 2018.
Source: Author.

democracy and to republicanism was further underscored by his financial support of Italy's unifier, Giuseppe Garibaldi.[61] Most nineteenth-century biographies skate over the taint upon his reputation: the brutal murder of Mary Rogers in 1842. Mary, a comely young woman employed at Anderson's Broadway shop, was meant to charm male customers into purchasing cigars and tobacco.[62] Although Anderson was arrested and questioned about her murder, he was released and not charged. Rumors swirled that he had been romantically involved with Mary before her murder and that after her death he believed that her ghost haunted him.[63] Such hearsay did not prevent him from erecting one of Green-Wood's finest classical mausolea, a monumental Greek Revival–style tomb (Figure 84).[64]

The mausoleum is an impressive hexastyle Ionic temple positioned on a podium on a hill. Pairs of Ionic columns frame the main entrance of the tomb, which has spectacular views of Manhattan and New York Harbor. Statues of two of the evangelists are set in niches and flank the entrance to the tomb.[65] The rear of the tomb has the same arrangement, although there is a blank wall in place of a door. Anderson's first and last names are inscribed along the frieze of the tomb's entablature on both the front and the rear. The lintel above the door includes the tomb's 1864 date of completion. The popular Greek Revival style, as previously discussed, embodied the idea that the United States was the political and intellectual successor of ancient Greece and a champion of its democratic ideals. For Anderson, a supporter of Garibaldi, this form may have had special resonance. While

the columns, pilasters, and architectural elements of the mausoleum belong to the Ionic order, the sculptures of the four evangelists, by the British sculptor John M. Moffitt, do not. Christian sculpture and classical architecture were complementary and together conveyed Anderson's religious and civic values respectively, as well as his financial success. The tomb was constructed in 1864, long before his death, which suggests that Anderson likely selected the tomb's design rather than leaving it solely to a designer or architect.

The tomb occupies a prime piece of real estate in the northeast section of Green-Wood, at the intersection of Highland and Battle Avenues. Anderson purchased and combined eighteen individual contiguous lots for $4,140 and stipulated that no one could build between the tomb and Highland Avenue.[66] From Highland Avenue, one has to climb up the hill, head bowed in respect, to reach Anderson's tomb via a stone staircase framed by two low pillars. Its high visibility in the landscape serves as a permanent reminder of John Anderson's rise from a humble tobacconist to millionaire.

THE GOULD MAUSOLEUM

At Woodlawn, similar patterns are also evident. The robber baron Jay Gould was interred in a temple-style mausoleum in Sections 60 and 73 of the Lakeview Plot, the cemetery's largest circular lot, almost an acre in size (Figure 85).[67] Gould spent a vast sum, between $130,000 and $150,000, on the plot and mausoleum.[68] David and Charles More described the tomb and its architectural sources. Reportedly, Gould wanted the tomb to be "built as strongly and massively as possible; that it should be simple in design" but not "ostentatiously large."[69] H. Q. French, a leading memorial specialist, designed the tomb in 1884, and the Smith Granite Company fabricated it.[70] Built of Westerly (Rhode Island) granite, the mausoleum is an Ionic, hexastyle, peripteral temple. Thirty Ionic columns support the plain entablature, undecorated pediments, and massive granite roof. The six columns on the south-facing side are arranged around a central, larger intercolumniation, where the tomb's entrance is located.

Several contemporary accounts misidentified the tomb's ancient inspiration. Henry Northrop erroneously identified the tomb's model as the Maison Carrée.[71] Northrop also reported that Mrs. Gould wanted the mausoleum to "be built somewhat after the style of the old Parthenon."[72] David and Charles More instead proposed that the tomb "more nearly resembles the temple of Theseus."[73] Presumably, they meant the Hephaisteion, in Athens, which was incorrectly known as the Theseion at this time. Although the hexastyle and peripteral Hephaisteion is a closer model, it is a Doric temple with much stouter proportions. However, it stands on a prominent hill overlooking the Agora, which may be the more relevant parallel for the mausoleum. While Northrop and the More brothers were misinformed about the mausoleum's inspiration, their accounts affirm that a classical temple was an appropriate model.

The mausoleum's front and rear porches are clearly modeled on the often reproduced east porch of the Erechtheion on the Athenian Acropolis.[74] The little details of the building also owe much to the Erechtheion. While the columns' shafts are unfluted, which is atypical for Greek temples, the capitals' volutes have the same carved folds as

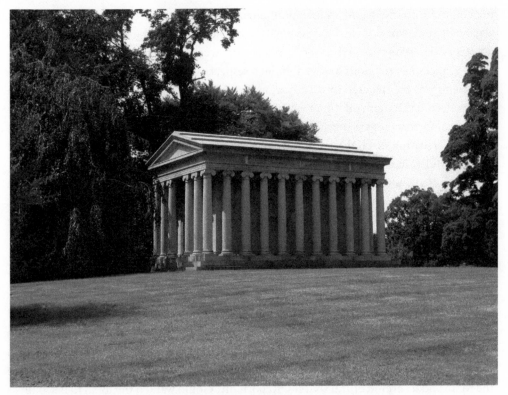

FIGURE 85. Jay Gould's mausoleum, Woodlawn Cemetery, the Bronx, 2016.
Source: Author.

the Erechtheion's capitals. Like the top of the Erechtheion's columns, those of Gould's tomb also have a band for decoration but remain undecorated, and its architrave is only decorated with three horizontal lines. Like the Erechtheion, the tomb's columns also have attic bases, and the mausoleum sits on a platform with three steps.

Eighteenth- and nineteenth-century reproductions of the Erechtheion restore a pediment, bordered with egg-and-dart motifs on the cornice; however, the pediment is empty.[75] The frieze, pediments, and cornice of Gould's tomb are also entirely undecorated. This lack of pediment decoration, which is fairly standard in earlier nineteenth-century American interpretations of Greco-Roman temples, seems here to be an aesthetic choice.[76] The decision not to include pedimental sculpture may have lessened the pagan associations of the models and meant that the viewer focused on the tomb's architecture. Furthermore, the relatively small scale of a tomb like this and its pediment is such that it cannot accommodate large sculpture. If the pediments were decorated in temple tombs at Woodlawn, they often featured Christian iconography such as crosses. The tomb's bronze doors and interiors incorporate motifs from other periods, including an interlaced design of vines and cherubs and, on the bronze double doors, two dragons' heads.[77] A stained-glass window of a choir of thirteen robed angels is located on the tomb's north (rear) side. Two tiers of five *loculi* line each side of the interior.[78] Christian symbols are included in the tomb, reinforcing that classicism and Christianity were not incompatible.

The naturalistic landscaping of Gould's tomb focuses on several large trees, including a massive weeping beech that now obscures the tomb's entrance.[79] The tomb is situated on a grassy knoll on the cemetery's highest point.[80] Its view "stretch[es] away amid the hills of Westchester,"[81] ensuring that Gould remained highly visible in the landscape.

Other grandees erected temple tombs at Woodlawn. Collis Huntington, who established the Central Pacific Railroad and who, at one point, was America's largest landowner, is buried in a temple tomb. Senator William A. Clark of Montana, who made his fortune through mines, banks, smelting, railroads, timberlands, and cattle ranching, erected a temple-style tomb with partially fluted Ionic columns and pilasters,[82] a pediment with a cross, and a bronze door decorated with a woman in mourning. John W. Sterling, a corporate attorney who represented Jay Gould, James Fisk, and Standard Oil, is interred in a small Doric temple.[83] Francis Garvan, who was instrumental in the founding of the American chemical industry, found eternal rest in a classical tomb that was probably modeled on the Temple of Portunus in Rome.[84]

Obelisks, Pyramids, Temples, and a Barque Kiosk

New Yorkers also looked to ancient Egypt for their tombs' architectural inspiration. Obelisks, already a preeminent form in the repertoire of American commemorative architecture, continued to serve as prominent grave markers. The popularity of the obelisk as a commemorative monument was confirmed when Robert Mills's design of an obelisk was selected in 1845 for the Washington Monument in Washington, DC.[85] At Green-Wood, an obelisk commemorated the death of 287 people who died in the Brooklyn Theatre Fire disaster on December 5, 1876.[86] Egyptian architecture's association with death and funeral traditions meant it remained a popular form for mausolea, grave markers, and commemorative architecture.[87] In the late nineteenth century, affluent Americans started to travel to Egypt to visit ancient sites and reap the health benefits of Egypt's dry climate. The popularity of obelisks and Egyptianizing architecture received yet another boost when the obelisk known as Cleopatra's Needle was erected in Central Park in 1881.[88] The deployment of Egyptian motifs and elements in mausolea at Green-Wood follows the same patterns of use as in classicizing tombs: Some are highly accurate, clearly replicating an ancient building, whereas others use a range of Egyptian elements to create original, innovative monuments. The Egyptian-style mausolea of John Taylor Johnston (post-1843),[89] W. B. Crosby (1846), John Taylor (1847), and Peter Schermerhorn (1847) attest to the early presence of such tombs.

PYRAMIDS IN BROOKLYN

Nestled in the hills of Green-Wood, pyramid mausolea were erected to Henry Bergh, the founder of the American Society for the Prevention of Cruelty to Animals, and the Van Ness-Parsons family (1931).[90] Henry Bergh died during the Great Blizzard of 1888, and his sons, Henry and Edwin, arranged his burial, purchasing a 384-square-foot lot on

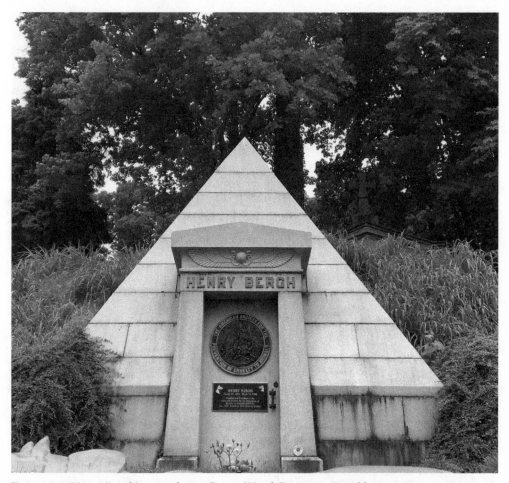

FIGURE 86. Henry Bergh's mausoleum, Green-Wood Cemetery, Brooklyn, 2018.
Source: Author.

April 7, 1888, for $1,000. Although Bergh did not erect his tomb during his lifetime, he had a genuine interest in ancient Egypt. His honeymoon in 1847–1850 included a visit to Egypt. His travel journals expressed his amazement at seeing the pyramids, in which he had been interested since his childhood.[91] His sketches of pyramids are in the ASPCA archive.[92] ASPCA documents were included in the time capsule that was placed in the cornerstone of the platform for Cleopatra's Needle, suggesting that he had a genuine interest in ancient Egypt.[93]

The pyramid form was also adapted to serve as a tomb (Figure 86). The entrance is composed of a triangular pediment with an entablature with the deceased's name and the Egyptian winged solar disc and *uraei*. By the time of the New Kingdom, the solar disc was a symbol of protection found on temple ceilings as well as above pylons and other ceremonial portals.[94] On the door, a bronze plaque, recently restored, includes the logo of the ASPCA, a reminder of Bergh's achievements during his life.

The most idiosyncratic tomb in Green-Wood is arguably the Van Ness-Parsons mausoleum, a free-standing pyramid (Figure 87). Located at the intersection of Battle and Bay

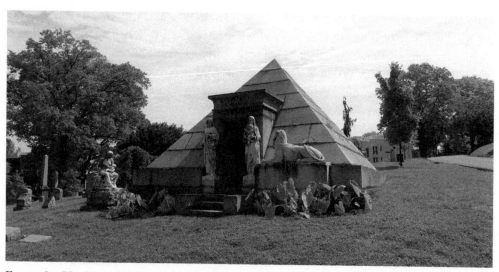

FIGURE 87. Van Ness-Parsons mausoleum, Green-Wood Cemetery, Brooklyn, 2019.
Source: Author.

View Avenues, it is composed of four lots, which Mrs. Alice Van Ness Parsons purchased on August 4, 1899.[95] The design and sculptural program reflect the beliefs of her husband, Albert Ross Parsons. A talented musician, Parsons served as the head of the piano department of the Metropolitan Conservatory of Music, as the president of the Music Teachers' National Association and the American College of Musicians of the State of New York,[96] and as an organist at the Holy Trinity and Fifth Avenue Presbyterian Churches. When he was not conducting or teaching, he turned his attention to Egyptology. An amateur Egyptologist and enthusiast, Parsons wrote a sweeping treatise, *The New Light from the Great Pyramid* (1893), which combined astrology, astronomy, Christianity, history, and metaphysics. In the first chapter, Parsons argued that the Great Pyramid of Giza was "an altar signifying death by fire" and bore "witness to the 'Fall of Lucifer.'"[97] His claims, based on confused and inaccurate etymological arguments, do not withstand the scrutiny of basic archaeological and philological methods; however, Parsons's writings, like his mausoleum, reflect his belief that Egypt and Christianity were intertwined.

The Van Ness-Parsons mausoleum has a prominent entrance with the family name inscribed in the entablature and a cornice with a winged solar disc with *uraei*. The heavy bronze door is decorated with the crucifixion and, below it, a zodiac. Four marble sculptures accompany the pyramid. A statue of Jesus with a lamb on his left arm and a staff (which has broken off) in his right hand stands to the left of the entrance, along with a statue of the Virgin Mary with the baby Jesus. To Mary's right is a female sphinx. To the left of the pyramid is a statue of Moses, held by his mother, who is identifiable by her Egyptian-style clothing and headdress. Moses, who led the Jews out of Egypt, is an obvious link between ancient Egypt and Christianity. Likewise, the story of the Flight into Egypt (Matt. 2:13–23), when an angel told Joseph to bring Mary and Jesus into Egypt, to prevent King Herod from killing Jesus, also forges a link between Egypt and Christianity.

The statue of Moses has the inscription "IN LOVING MEMORY OF OUR HER-BERT," which may allude to the death of one of Alice and Albert Parsons's three sons. While the combination of Christian sculpture, a sphinx, and a pyramid might seem odd, if not contradictory, such a combination—typical of many Neo-Antique buildings—clearly embodied Parsons's beliefs. While pyramids never achieved the same widespread adoption as other Egyptian monuments, like obelisks, they can be found in a surprising number of cemeteries in the United States, including the Evergreen Cemetery, Washington; the Metairie Cemetery, New Orleans; the Homewood and Allegheny Cemeteries, Pittsburgh; the Cedar Hill Cemetery, Hartford; the Woodside Cemetery, Toledo; and others.[98]

WOODLAWN ON THE NILE: JULES BACHE'S KIOSK MAUSOLEUM

Egyptian architecture features prominently at Woodlawn. Upon his death on March 24, 1944, Jules S. Bache, a wealthy financier, was entombed in a grand mausoleum, modeled on the so-called Kiosk of Trajan at Philae, on a circular plot in Whitewood (section 133). Davis, McGrath, and Kiessling—not John Russell Pope—designed the building in 1916,[99] and Farrington, Gould, and Hoagland built it in Barre granite.[100] While there is no publicly accessible collection of his papers[101] to aid us in determining why he selected the Kiosk of Trajan as a model for his tomb (Figure 88), Jules Bache visited Egypt in 1909 and collected Egyptian antiquities.[102] A close analysis of the mausoleum, a comparison of its forms with those of the original monument, and a detailed study of its original landscape design suggest that Bache was a knowledgeable and engaged patron.

The island of Philae, nearly five miles south of Aswan, housed a temple to the goddess Isis, who was widely worshiped until the advent of Christianity.[103] Kiosks were traditionally barque stations, the processional resting location for a god's barque, or boat, in ancient Egypt.[104] In this case, it was the station for Isis and the gods of Philae.[105] The so-called Kiosk of Trajan (c. 50×65.6 feet, 52 feet high) was erected during either the Ptolemaic or the Roman era.[106] Under Trajan, the interior decoration was completed, but the exterior screen walls and at least one of its capitals were unfinished.[107]

American and European tourists considered Philae to be the most romantic Ptolemaic site in Egypt.[108] The 1892 edition of *Baedeker's Egypt* and the 1897 *Cook's Tourists' Handbook for Egypt, the Nile and the Desert* recommended a visit to Philae for its beauty and singled out the Kiosk as an outstanding piece of architecture.[109] It was also widely reproduced in photography (Figure 89). Because it was a well-known building, an informed traveler would recognize it regardless of context. The architecture of the Bache Mausoleum, which replicated the kiosk accurately on a reduced scale with minor adaptations, demonstrated that Bache was an involved, well-traveled, educated, and sophisticated patron.

Like the Egyptian original, Bache's tomb's exterior is composed of fourteen columns with screen walls that support an architrave. As on the original kiosk, the capitals differ and follow the same alternating pattern. Placed in the center of columns, where the barque would have rested, is instead the tomb. The broken lintel of the original kiosk is replaced with a complete lintel with two registers. "BACHE" is inscribed on the lower register. Above this, in each register of the architrave, is a winged solar disc, echoing the double

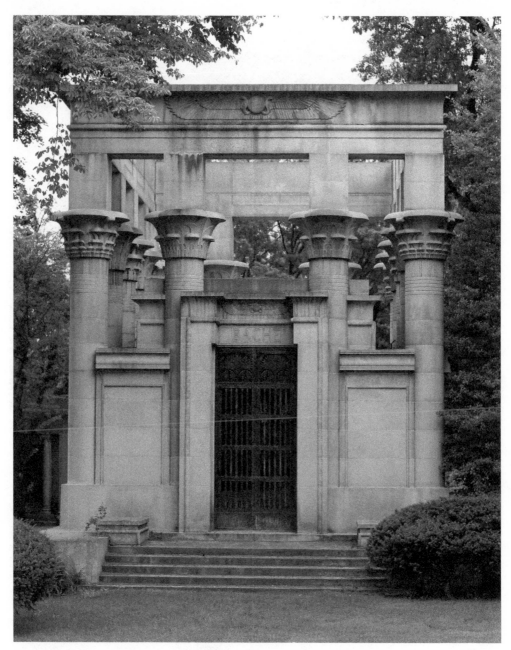

FIGURE 88. Jules S. Bache's mausoleum, Woodlawn Cemetery, the Bronx, 2016.
Source: Author.

solar disc of the original monument. A semicircular small pilaster stripe of bundled rods frames the doorway on each side. These are not found on the original; however, these pilasters reuse the motif found between the two solar discs on the architrave of the ancient kiosk. The tomb is accessed through double-leaf bronze entrance doors decorated with stylized lotus leaves.[110] The detailed use of Egyptian motifs continues on the interior.[111]

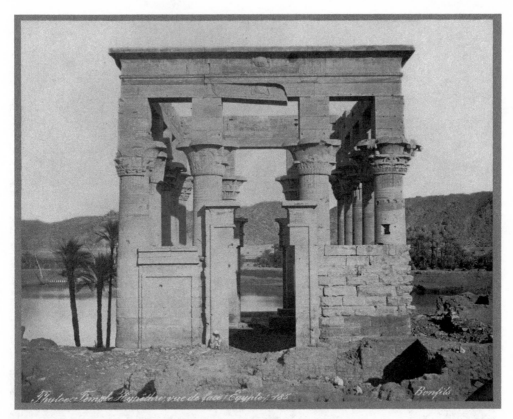

FIGURE 89. The so-called Kiosk of Trajan at Philae, Egypt, 1867–1899.
Source: The Library of Congress.

Writing about the tomb and its landscape for the widely circulated *Park and Cemetery Landscape Gardening Journal* in 1921, Ernest Stevens Leland, a prominent landscape architect, observed that "as an archetype for a mausoleum, this beautiful Egyptian structure was at once picturesque and not without appropriate significance."[112] The sophisticated reinterpretation of Egyptian architecture was matched in the tomb's landscape architecture. Charles Wellford Leavitt designed this landscape in 1918. Because Egyptian plants would not take well to the Bronx's environment,[113] Leavitt created an Egyptianizing landscape by using indigenous substitutes for red soil, pampas, and cactus.[114] Instead of grass, Leavitt used a coating of red shale (some four inches deep), which Leavitt's assistants found in Leslie Run, Pennsylvania.[115] The original blueprints for the tomb and plot show four platforms for sphinxes (two on each side) framing the approach to the tomb,[116] which would have evoked the sphinx-lined avenues of famous Egyptian temples. There is no trace of these platforms or the sphinxes (nor are they visible in early publications about the tomb and its landscape), suggesting that they were never erected. Leland praised Leavitt for not creating a "theatrical representation of some Egyptian setting"[117] but for skillfully using "what materials Nature gave him here in this country and through art, and art alone, succeeded in recalling the atmosphere of the Nile without in the least resorting to imitation."[118]

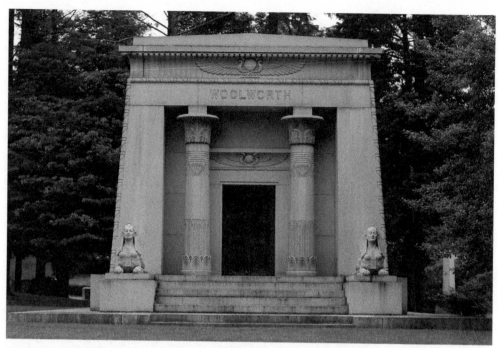

FIGURE 90. F. W. Woolworth's mausoleum, Woodlawn Cemetery, the Bronx, 2016.
Source: Author.

The thoughtful combination of architecture and landscape meant that Bache's tomb was like a small piece of Egypt, thoughtfully and tastefully transposed to New York City.

Other Egyptianizing tombs at Woodlawn include that of the five-and-dime pharaoh F. W. Woolworth.[119] Woolworth, who died on April 8, 1919, was entombed in his mausoleum in the Pine Plot (Sections 123, 135), which faces Woodlawn's Central Avenue (Figure 90). This Egyptianizing tomb is closely modeled on the Temple of Dendur,[120] which appears in Denon's *Voyage* and was the inspiration for other buildings, such as the Freemasons' Hall, in Boston, Lincolnshire, in the United Kingdom (1860–1863). It was also photographed extensively in the late nineteenth century, so images of the temple were circulating widely. The column shafts of Woolworth's tomb are decorated with Egyptian motifs, which also echo the hieroglyphs on the columns of the Temple of Dendur (Figure 91). The composite capitals are decorated with papyrus reeds;[121] they do not derive from the Temple of Dendur but more likely from the court in front of the Temple of Hathor, on Philae. The columns are a pastiche of Egyptian elements. The use of motifs from the Temple of Dendur continues throughout the tomb: The lintel over the entrance and the mausoleum's entablature are both decorated with a winged solar disc and two asps. Above the entrance is a bundle of reeds; this motif also edges the mausoleum's sides. "WOOLWORTH" is inscribed on the lower register of the entablature, directly over the entrance. The tomb has a cavetto cornice decorated with vertical leaves, and its façade is slanted at an angle of 70 degrees.[122] Two female sphinxes resting on plinths flank the tomb's entrance.[123]

FIGURE 91. Temple of Dendur, Egypt. The right screen wall was not visible in historical photo-
graphs, 1860–1900.
Source: The Library of Congress.

Woolworth's tomb became a trendsetting monument. Richard Kyle Fox, the editor of
the tabloid *National Police Gazette*, modeled his tomb, complete with two male sphinxes,
in Woodlawn on Woolworth's mausoleum.[124] The steel magnate Emil Winter had an iden-
tical copy of the tomb built for himself in Allegheny Cemetery, Pittsburgh. Winter and
Fox's decision to replicate Woolworth's tomb demonstrates that the style was prestigious
and that other self-made men looked at the tombs of their peers for inspiration and
emulation.

Conclusions

At Green-Wood, Woodlawn, and other rural cemeteries in the United States,[125] patrons
and architects reinterpreted antiquity's diverse architectural traditions to construct tombs
with potent cultural resonances in their own era. Ancient forms satisfied the patron's and
the architect's aesthetic concerns: These buildings were monumental, impressive, and
highly original for their innovative combination of diverse motifs and architecture. Clas-
sical or Egyptian forms could also address the social and cultural concerns of the patron:

A monumental mausoleum that utilized the architectural styles of previous eras was a visible symbol of social standing, elite belonging, erudition, and personal beliefs. A classical temple could embody the ideals of democracy and the financial success of a newly minted millionaire, as in the case of John Anderson, while a pyramid with classical sculpture could capture the interest in Egyptology and Christianity that Albert Parsons had. While the level of engagement in the commission of mausolea also varied from patron to patron, the highly accurate details and Egyptian-inspired landscape of some tombs, like Bache's, suggest that Bache, who had traveled to Egypt, had a direct hand in designing his tomb. Neo-Antique tombs—be they temples or pyramids—also fulfilled the practical considerations required of a tomb: One can bury an extended family in a grand building that will endure for generations.

The use of classical and Egyptian forms in funerary architecture also signaled that the deceased was a member of a cultured, educated class; the tomb was the final act of these new tycoons' process of legitimacy. Although Anderson made his money in tobacco, Gould in stocks and railways, Bache in finance, and Woolworth in five-and-dime shops, the ancient architecture of their tombs identified them all as members of America's economic elite and possessors of elite culture, even if their wealth was new. Because the United States had no landed aristocracy, these men could not join the ranks of the dukes, earls, and lords of old Europe to legitimate their wealth; however, these men were *the* Titans, Olympians, and pharaohs of America and, as such, warranted burials as grand as those of the heroes, gods, and kings of antiquity.

Heroic New Yorkers

Monuments enable families, cities, and nations to commemorate important—and some-times traumatic—events that are vital to their communal experience. The attacks of Sep-tember 11, 2001, for example, are seared into New Yorkers' collective consciousness. The 9/11 Memorial is composed of two waterfalls and reflecting pools imbedded within the footprints of the original Twin Towers. The names of those who perished are inscribed in bronze. The memorial is set into a grove of trees. The museum, which charts the tragic events of 9/11, concludes with a quotation from Virgil's *Aeneid* (9.447), "NO DAY SHALL ERASE YOU FROM THE MEMORY OF TIME." While some scholars have challenged the appropriateness of this verse, the classical quotation's power, as Matthew McGowan has argued, "lies beyond the claim of an individual people or contemporary religion."[1]

The 9/11 memorial and museum are the most recent entries in New York's long tradi-tion of memorials that appropriate Latin and classical art and architecture to bring dig-nity and gravitas to a monument. The tradition originated with the Montgomery Memorial, the United States' first-ever memorial.[2] Although intended for Philadelphia's Independence Hall, it ended up at the Georgian-style St. Paul's, at 209 Broadway, in 1787. The memo-rial honored General Richard Montgomery, who died at the Battle of Quebec on Decem-ber 31, 1775. The battle was the first American offensive of the war and resulted in a major defeat. Montgomery's untimely death transformed him into a much-needed martyr whose death Congress used to galvanize support for the Revolution.[3]

There were no prominent American sculptors at this time, so naturally Congress looked to Europe. France, a key American ally, supplied funds, military support, and expertise.

Benjamin Franklin commissioned Jean-Jacques Caffieri, Louis XVI's royal sculptor, to design the memorial. Pierre L'Enfant, the designer of Washington, DC, installed the monument according to Caffieri's detailed instructions, which were sent from Paris.[4]

The monument, originally a cenotaph,[5] was composed of a marble column topped by a funerary urn, composed of Italian red-and-brown-spotted marble,[6] set against a dark-blue and black marble pyramid (Figure 92).[7] The monument rested on a blue-gray Turkish marble slab supported by two modillions, under which a white inscribed slab of marble detailed the monument's purpose. The original polychrome elements of the monument made it all the more visible to the passersby on Broadway. The club of Hercules rested against the column and was inscribed with the Latin phrase LIBERTAS RESTITUTA (Liberty restored). A version of the phrase "Libertas P[populi] R[omani] Restituta" is used on the coinage of Galba and Vitellius, who were both briefly emperors in 69 CE after Nero's suicide.[8] This coin in turn drew on the coinage of Brutus (minted after the assassination of Julius Caesar), which features the word *Libertas* and the *pileus*, the cap of liberty worn by slaves at their time of manumission.[9] L'Enfant solved the problem of how to the hide the unseemly back of the monument within the chapel, as it dominated the east window of St. Paul's, by creating an elaborate, symbolic wooden sculpture.[10]

For the United States' first public monument, Latin was selected because of its enduring permanence as much as for its engagement with the classical past.[11] LIBERTAS RESTITUTA, with its obvious English cognates, meant that the monument was legible to one and all, regardless of one's knowledge of Latin. The club of Hercules also symbolized the smashing of English tyranny and France's support for the United States. The palm proclaimed victory, and a cypress branch, a broken yoke of tyranny, and other ancient Roman symbols of liberty, including the helmet of a fallen soldier and the *pileus*, were also included.[12] While there were no major tombs or chapels in New York at this time, the combination of an urn and column for a funerary monument was a common eighteenth-century British funerary motif;[13] one need only think of Westminster Abbey.[14] Thus, the visual language of antiquity, again refracted through European models, was used to honor one of the first martyrs to the American cause.

After the Civil War there was a veritable explosion of monuments to commemorate the loss of life and to construct competing historical narratives about the war.[15] Furthermore, as the United States' centennial approached, Americans wanted to celebrate the founding of their nation, and such celebrations often involved the unveiling of monuments. The result was one of the richest periods (c. 1880–1920) for the erection of public memorials and sculpture in the United States' history. This chapter examines how the arches erected to George Washington and to Brooklyn's Civil War veterans appropriated the architecture of Rome's triumphal arches to commemorate the achievements of the United States' first president and the average Civil War soldier, respectively. The chapter then examines the column erected by Italian Americans to Columbus, as a part of New York City's celebration of the quadricentenary of Columbus's voyage to North America in 1892, and the neighboring *Maine* Monument. It concludes by briefly discussing the temporary arches erected in New York at the start of the twentieth century and the shift away from classical forms at that time.

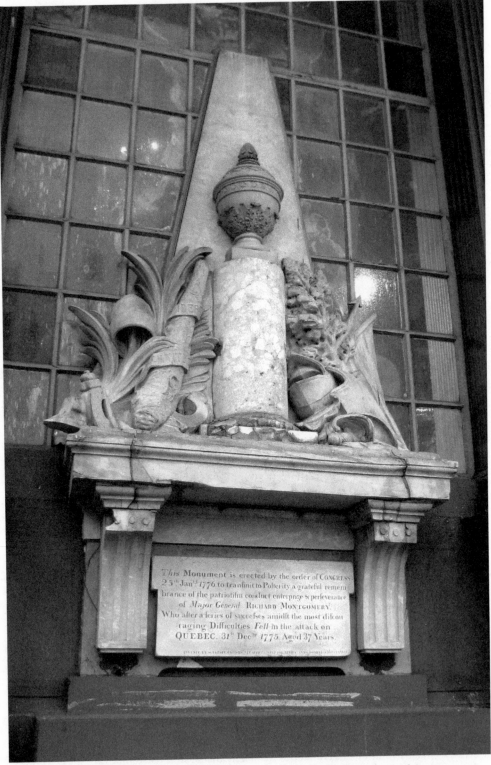

The text visible on the monument reads:

This Monument is erected by the order of CONGRESS
25ᵗʰ Janʸ 1776 to tranſmit to Poſterity a grateful remem-
brance of the patriotiſm conduct enterprize & perſeverance
of *Major General* RICHARD MONTGOMERY.
Who after a ſeries of ſucceſſes amidſt the most diſcou
-raging Difficulties *Fell* in the attack on
QUEBEC. 31ˢᵗ Decᵣ 1775 Aged 37 Years.

FIGURE 92. Montgomery Memorial by J. J. Caffieri, 1777, St. Paul's Chapel, Manhattan, 2009.
Source: W. Gobetz (CC BY-NC-ND 2.0)

Monumental arches were one of the most powerful and prolific forms of memorials from antiquity. Arches, first erected in Rome in 198 BCE, became perhaps the most widespread monumental and commemorative type of architecture in the Roman world.[16] Arches were discursive monuments whose form, sculpture, and inscriptions presented a highly constructed view of an individual or people's achievements or agenda.[17] Rome was home to the most famous examples, including the Arch of Titus and the Arch of Constantine. As early as late antiquity, the arch was already being reinterpreted. After a relative dip in popularity during the medieval period, the arch resumed its position as a key rhetorical monument. Temporary arches were staged for the coronations of James I and Charles II of England and put up to welcome foreign royal brides to London.[18] During the eighteenth and nineteenth centuries, arches were erected in London, Berlin, and Paris to celebrate military victories.[19] Thus, the arch's ancient and European associations made it appealing to Americans seeking an architectural language to honor their own heroes and veterans.

Arches to Washington

The year 1889 saw nationwide celebrations of the centennial of George Washington's inauguration as president. William Rhinelander Stewart, a well-known attorney and a principal in the Rhinelander Real Estate Company, organized the celebrations for New York City. Stewart started fundraising in March 1889 for the erection of a triumphal arch to be placed on Fifth Avenue between Washington Square Park and Clinton Place (Eighth Street).[20] He enlisted Stanford White, who agreed to provide plans and supervise the arch's construction free of charge.[21] Time and cost were of the essence, so White built a temporary arch made of staff, a wood framework covered with a thick icing of molded white plaster over straw. Such arches were visually potent and had been used to celebrate Lafayette's visit, earlier in the century, giving arches additional prestige.[22] Two other temporary arches stood on Wall Street and at Twenty-Sixth Street and Broadway.[23]

White conceived of the temporary arch as a "grand triumphal arch" (Figure 93).[24] While modeled on Roman forms such as the Arch of Titus (Figure 94), the arch also incorporated details from colonial and early republican architecture as well as from nearby Greek Revival buildings.[25] The garlands and laurel wreaths that adorned the arch trumpeted Washington's military and political achievements. Colorful bunting, flags, and white streamers embellished the arch. Stuffed American eagles perched on the keystones, and a ten-foot-tall statue of George Washington crowned the arch. On Tuesday, April 30, 1889, a military parade progressed from Fifty-Seventh Street and passed under the fifty-foot arch into Washington Square.[26]

The public and media delighted in the arch—no doubt in part thanks to White's ingenious idea to illuminate the arch at night with small hanging electric white lights. After the celebrations ended, the elements quickly caused the plaster and wood frame to rot. Shameless but historically minded New Yorkers also broke off parts of the arch as mementos. Despite the temporary arch's ignoble end, its success resulted in the decision to make the arch permanent. Stewart was to raise the money,[27] and White agreed to design

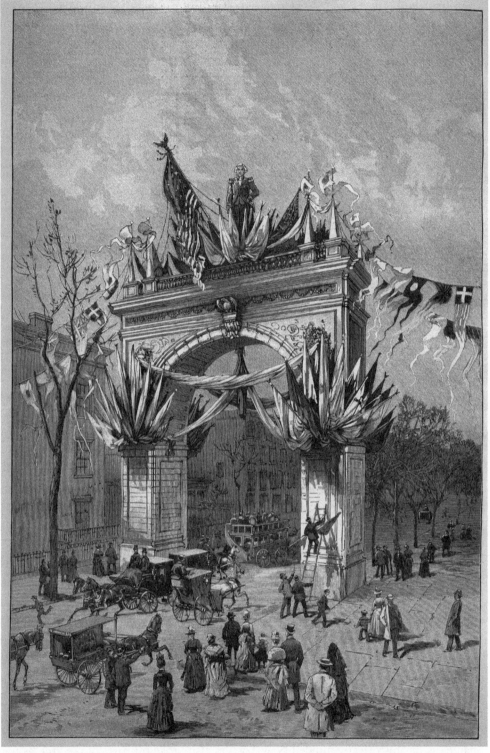

FIGURE 93. Temporary arch to Washington, just north of Washington Square Park, Manhattan, c. 1889.

Source: Author's collection.

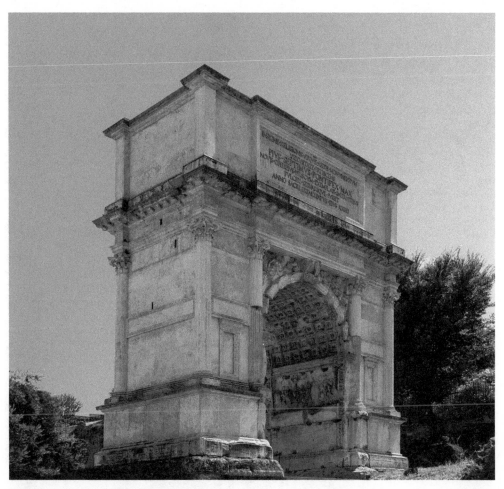

FIGURE 94. Arch of Titus, Rome, 2013.
Source: Jebulon (CC0).

it for free. The arch's original footprint was deemed disruptive to pedestrians, so the permanent arch would be placed at the intersection of Fifth Avenue and Washington Square Park, serving as a monumental entrance to the park.

From the outset, White conceived of the permanent arch as "Roman."[28] Classical designs ensured, in White's words, that the arch will "stand for all time and to outlast any local or passing fashions."[29] White's arch would be larger than its classical predecessors, "lighter" in terms of sculptural decoration, have a prominent frieze, and exclude the classical orders on the pillars.[30] White believed, in typical American fashion, that he was improving the ancient form.

In 1890, construction on the arch started. The cost of the arch had already ballooned to $150,000, which Stewart had raised by June 1892, just after the arch's completion on April 5, 1892 (Figures 95–96).[31] The dedication of the arch (77 × 62 feet) on May 4, 1895, was composed of a parade down Fifth Avenue to the arch, accompanied by a ceremony and speeches.[32] Such parades inevitably recalled ancient Rome's triumphal processions, in

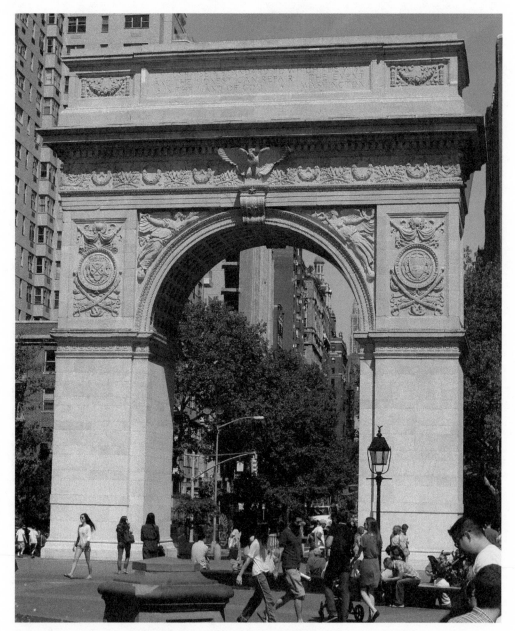

FIGURE 95. South façade, Washington Square Arch, Manhattan, 2015.
Source: Author.

which generals and later emperors victoriously marched with their troops, booty, and captives through Rome.[33] The arch's position also monumentalized the parade route, just as triumphal arches had in antiquity.

The arch's inscriptions and sculptures drew heavily upon the language of classical architecture, but in a distinctive American dialect. The American eagle with wings spread crowns the archivolt. In the frieze, stars, set in triumphal wreaths, alternate with crossed and bound laurel branches that frame a repeated W, for "Washington," with an acanthus

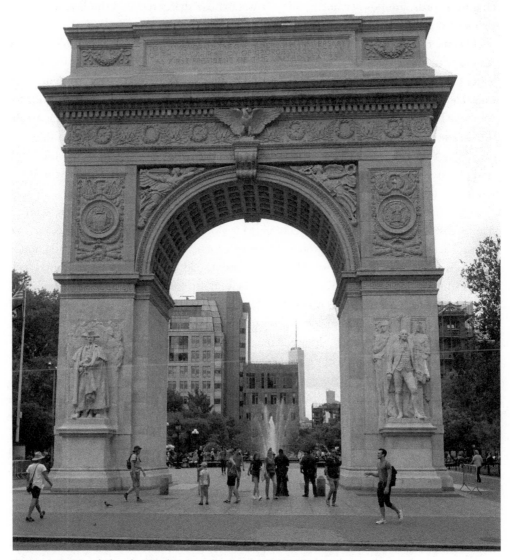

FIGURE 96. North façade, Washington Square Arch, Manhattan, 2019.
Source: Author.

spiral at each end of the frieze (which continues around the monument). The arch's south side has a prominent English inscription in its attic, which quotes from Washington's speech at the Constitutional Convention, March 25, 1787.[34] In panels that frame the inscription in the attic, fruited garlands are suspended between incense burners (also adapted from Roman arch reliefs). In the arch's spandrels, victories, taken directly from Roman arches, are modified so they twist outward; the left Victory blows a trumpet, while the right Victory waves a triumphal wreath and shoulders what appears to be a trident. Standing on their little globes, the victories claim to be bringing new freedom to the world via

a nation governed by its people. The seal of New York City appears on the southwest pillar and the arms of New York State on the southeast pillar.[35] The decorative elements, including swords, gunpowder horns, and arrows (whose shafts recalled the Roman fasces) that surround the seals, are militaristic.

The inscription on the architrave of the arch's north side proclaims the arch's purpose of commemorating the centenary of Washington's inauguration and notes that it had been "ERECTED BY THE PEOPLE OF THE CITY OF NEW YORK." This dedicatory line echoes "SPQR," which appeared on countless Roman monuments. SPQR stands for "Senatus Populusque Romanus," which means "Roman Senate and People" and was an abbreviation for the government of republican (and later imperial) Rome. By echoing this line, New York City was likened to ancient Rome. On the northeast pillar is Washington's coat of arms with his Latin motto; on the northwest pillar appears the Great Seal of the United States. Spears, swords, flags, and wreaths frame the seals.

White had intended a quadriga and a court of honor for this arch, but they were omitted due to cost.[36] At White's behest, Frederick MacMonnies also prepared sketches for two high-relief sculptures of Washington for the north piers,[37] but necessary funds could not be raised. In a 1912 letter to McKim, Mead & White, David H. Knott, a neighborhood resident, expressed his desire to raise money for the sculptures.[38] By 1913, the funds had been secured. At this stage, McKim, Mead & White now considered MacMonnies's sculptures unsuitable and withdrew the proposed commission from the outraged sculptor.[39] Instead, desiring "much more classic" sculpture,[40] the committee hired Hermon MacNeil and Alexander Stirling Calder to create the sculptures of Washington for the two north-facing piers.

Sculpted by MacNeil in 1916, *Washington at War* stands on the northeast pillar. He is flanked by personifications of Fame (on the left) and Valor (on the right) (Figure 97).[41] Fame carries a palm branch and a trumpet, which symbolize peace and fame, respectively.[42] Valor wears a helmet, bears a sword in his left hand, and holds an oak branch. Fame and Valor allude to Washington's military achievements, which resulted in the founding of the United States. On the northwest pillar of the arch, *Washington at Peace*, sculpted by Calder, was completed in 1918.[43] Here, Wisdom (on the right) and Justice (on the left) flank him. Wisdom has the attributes of Athena, specifically a helmet, aegis (or cloak), and scroll. Justice holds the sword and scales of justice.[44] The inclusion of Justice underscores Washington's important role in shaping the Constitution, the basis of the American legal system. Behind Washington's head, a Latin inscription carved on the pages of an open book reads "EXITUS ACTA PROBAT," or "The end justifies the means," Washington's motto.

By 1918, a classical education focused on Latin and Greek was the purview of New York's well-to-do. While the use of Latin might have reinforced the timeless nature of the arch, it also meant that parts of the monument were legible to a select few, typically those elite members of society who had enjoyed the privilege of a classical education. That said, the rest of the arch's highly recognizable sculptures of George Washington—dressed in a general's uniform and in a civilian's clothes—and the English quotations from Washington make the arch's messages intelligible to all. For immigrants newly arrived in New York, the arch's inscriptions and sculptural program served as a concise visual introduction to the first president of the United States and the nation's early history.

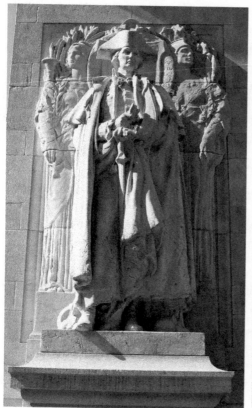 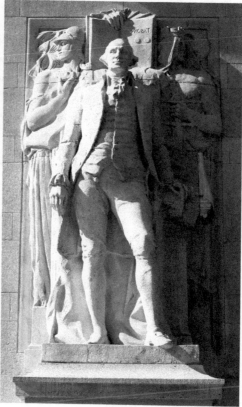

FIGURE 97. *Washington at War* (left) and *Washington at Peace* (right), north façade, Washington Square Arch, Manhattan, 2015.
Source: Author.

It is ironic that an arch, the monument most closely associated with Roman emperors, was selected to commemorate Washington, a man who refused to be an autocrat and very famously turned down the permanent office offered to him. Its suitability may be because the arch had been used in Europe to commemorate soldiers, as at the Arc de Triomphe in Paris, or to celebrate General Wellington's victories over Napoleon. Despite its imperial echoes, the arch was a respectable way to celebrate war, peace, and great men in Europe.[45] Other states would use a Roman arch to honor Washington soon after; the National Memorial Arch (completed in 1917) commemorates Washington and the Continental Army's arrival into Valley Forge, Pennsylvania. Like the Washington Square Arch, this arch was explicitly modeled on the Arch of Titus.[46]

The Soldiers' and Sailors' Memorial Arch, Grand Army Plaza

In the 1880s, the city of Brooklyn planned to erect a permanent monument to commemorate its Civil War veterans and to present a specific, Northern vision and memory of the Civil War.[47] Because many veterans were starting to pass away, monuments to citizen-soldiers

began proliferating across nearly every city, town, and village in the North and the South.[48] Many of these statues, erected between 1880 and 1920 to both Union and Confederate soldiers, have caused controversies in the twenty-first century. The debates over whether monuments to Confederate soldiers are inherently racist or celebrate the lost-cause rhetoric of the South demonstrate that these monuments are far from being forgotten relics of American history.

In the late 1880s, the Brooklyn Common Council planned to build a ninety-foot shaft or column with allegorical statues in honor of the city's Civil War veterans.[49] Mayor Alfred C. Chapin vetoed the choice, explaining:

> [The] design, if not commonplace, certainly does not depart strikingly from the conventional. . . . Equally meritorious, if not equally elaborate, designs may be found in Greenwood [*sic*]. Its tone is essentially funereal. It does not recall to the mind the patriotic pride, the consciousness of sufficient strength which animated and sustained the Nation in that supreme hour.[50]

In the summer of 1888, a design competition was held, this time for a "memorial arch of granite" to be erected at Prospect Park's north entrance.[51] Only the triumphal and heroic overtones of an arch could honor the service and sacrifice of Brooklyn's veterans. John H. Duncan's design of an arch was selected from thirty-nine entries.[52] Built between 1889 and 1892, the arch and its sculpture cost $250,000, which was raised by a tax levy and bond issues.[53] The high degree of involvement by civic officials in the design competition and the use of public funding for the arch reflect the desire of Brooklyn's leading men to sanction the memorial and to curate the city's collective memory of the Civil War.

Along with Duncan, who also designed Grant's Tomb, Stanford White oversaw the arch's construction, perhaps because of his successful erection of the temporary Washington Square Arch and his concurrent work on the permanent Washington Square Arch. While Kahn gives much of the design credit to Duncan,[54] the McKim, Mead, & White archives at the New-York Historical Society demonstrate that White actively modified its design (adding an extensive sculptural program and a quadriga) and planned the arch's surrounding plaza. White, therefore, should be accorded much of the credit for the arch's final appearance. In 1894, White commissioned Frederick MacMonnies to execute the major sculptural groups. The monument's discursive message was conveyed through the arch's form, the iconography of its sculpture and bas-reliefs, and its placement in the cityscape (Figure 98).

In an 1896 letter to White, MacMonnies, who had lived in Paris for over thirty years and trained with French sculptors, explicitly identified the arch as "an Arch of Triumph,"[55] like the Arch of Titus. The arch, its sculptural groups, and their position owe a great deal to two French neoclassical precedents, the Arc du Carrousel and Arc de Triomphe (Figures 99–100). The use of sculptural groups on pedestals of the piers, as well as the use of a low attic story with alternating pilasters and roundels, is a clear borrowing from the Arc de Triomphe.[56] The large sculptural group atop the Arc du Carrousel inspired the quadriga.[57]

The echoing of the sculptural groups and their placement on the Arc de Triomphe was significant. The Arc de Triomphe celebrated and commemorated the soldiers who had

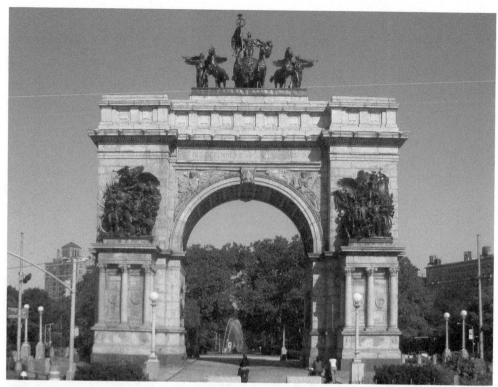

FIGURE 98. South façade, Soldiers' and Sailors' Memorial Arch, Brooklyn, 2016.
Source: Author.

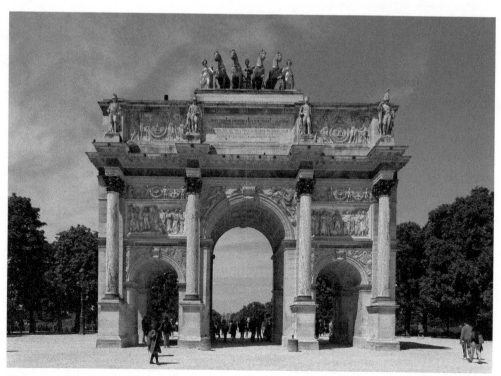

FIGURE 99. The Arc du Carrousel, Paris, 2011.
Source: Thesupermat (CC BY-SA 3.0).

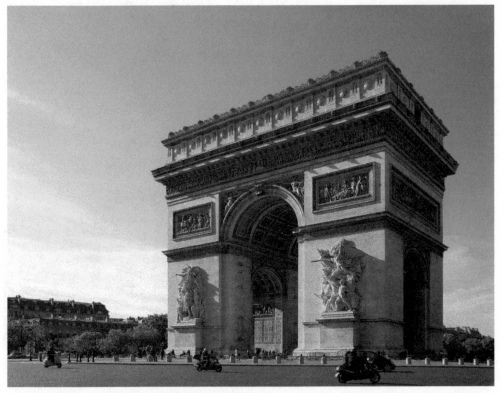

FIGURE 100. The Arc de Triomphe, Paris, 2010.
Source: Jiuguang Wang (CC BY-SA 2.0).

fought and died in the French Revolution and the Napoleonic Wars. By alluding to this arch and its sculptural program, MacMonnies drew a parallel between the American Civil War and the French Revolution. The French had overthrown their king to achieve a republic and equality for its people, and, during the Civil War, the Union had been saved and slavery abolished, thereby creating equality for all Americans. Of course, while neither nation achieved all of their ideals and aims in the aftermath of these formative conflicts, both France and the United States had taken significant steps toward equality in terms of class and race, respectively. Thus, these achievements could be memorialized in the same way—with a Roman-inspired arch.

Stanford White reduced the arch's height from one hundred to eighty feet. Small Civil War statues, intended for display under the arch, were replaced by two bronze bas-reliefs. The depth of the projecting piers was also reduced, so that the sculptural groups could be better integrated into the monument.[58] Despite the cost, a quadriga, which White had originally intended for the Washington Arch,[59] was included. In 1894, four monumental, fifty-foot-high Doric columns, also planned for the Washington Arch, were added to the plaza. Two columns flanked the arch on each side, forming a large arc at the south end of Grand Army Plaza. Two twelve-sided gazebos, each reminiscent of a tholos, an ancient circular building, accompanied these columns. Each has Tuscan columns, Guastavino tiled ceilings, and bronze finials.

The arch's cornerstone was laid on October 30, 1889, at a ceremony where General William Tecumseh Sherman spoke.[60] Generals Slocum and Howard also attended the event, and together they inspected the troops and watched ten thousand veterans parade through the streets of Brooklyn, whose buildings were adorned with patriotic red, white, and blue buntings and American flags. The completed monument was dedicated on October 21, 1892,[61] in time to coincide with the four hundredth anniversary of Columbus's discovery of America. A parade of police, veterans, members of the Board of Aldermen (Brooklyn's governing council), schoolboys, and others passed under the arch.[62] Brooklyn's mayor, David A. Boody, spoke, and Rev. Dr. T. DeWitt Talmage gave the day's principal oration, stating:

> The curve, copied by Trajan's arch at Beneventum and Titus' arch [sic] at Rome and the Arch de E'toile [sic] at the Champs Elysees,[63] and gradually coming to American adoption, but with an important change[,] for . . . in America we lift the arch, as here you have lifted it to commemorate the men who fought the battles and the women who scraped the lint during these four awful years, when the best government of all the earth was ransomed and re-established.[64]

To Talmage, the Soldiers' and Sailors' Memorial Arch surpassed its Roman and European predecessors because it celebrated those who fought to save the Union, a just and noble cause. Talmage also Christianized the pagan arch, which "borrowed from God's architecture of the sky" and thereby reconciled classical forms with Christianity.[65]

The arch's south façade, facing Prospect Park, has a rich sculptural program. MacMonnies designed the arch's south-facing quadriga (installed in 1898) and two compositions for the arch's south piers (installed in 1901). The arch's north façade is unadorned except for the medallions of the different army corps and the seals of New York State and the city of Brooklyn. MacMonnies's large sculptural groups on the west and east pillars are highly evocative installations. These sculptural groups' positions on projecting plinths and their composition with a central female figure are clearly modeled on the sculptural groups set on the four pillars of the Arc de Triomphe[66] and, in particular, on *The Departure of the Volunteers of 1792*, also known as La Marseillaise (see Figure 100).

On both piers, the *Genius of Patriotism* readies her troops for battle. Here, MacMonnies fused the iconographic attributes of Minerva or Athena, Victory (wings and all), and of Rude's France/Liberty to create a uniquely American personification. The west group, entitled *The Army: The Genius of Patriotism Urging American Soldiers on to Victory*, depicts the Union Army in the chaos of battle (Figure 101). From atop her galloping steed, she dons scaled armor, a helmet, and an aegis and sounds a trumpet, compelling the men onward. In a complementary position on the east pier is a sculptural composition of the sailors of the Union's navy, entitled *The Navy: American Sailors Boarding a Vessel at Sea, Urged On by the Genius of Patriotism* (Figure 102). Flanked by an eagle, she wears only a helmet and holds a trident. In both compositions, the presence of youths and battle-weary men signifies the totality of the men involved in the Civil War. The head of a deceased sailor hangs limply at the rear left of the east composition, and a wounded drummer appears on the west pier, emphasizing the nobility of death for one's country.

FIGURE 101. *The Army: The Genius of Patriotism Urging American Soldiers on to Victory*, Soldiers' and Sailors' Memorial Arch, Brooklyn, 2016.
Source: Author.

In the center of the east pier, a kneeling, armed African American sailor stares straight out, defiantly. Dressed like the Caucasian sailor to his right, he wears only a sailor's baggy trousers, marking him as an equal to his white peers, who were also enlisted men. His central position in the group seems to underscore the invaluable contribution that free-born African Americans from Brooklyn made to the Union's defense and the North's victory. Yet he is the only kneeling figure. Freed slaves were typically depicted in a kneeling, subservient position, as in the Freedman's Memorial to Abraham Lincoln in Washington, DC.[67] Therefore, his kneeling stance identifies him as inferior to the white soldiers around

FIGURE 102. *The Navy: American Sailors Boarding a Vessel at Sea, Urged On by the Genius of Patriotism*, Soldiers' and Sailors' Memorial Arch, Brooklyn, 2016.
Source: Author.

him, reflecting the ambiguous position of African Americans and the commemoration of their contribution to the Civil War efforts as well as their position in the postwar society.

The inscriptions and sculpture in the spandrels of the arch's south façade also honored the veterans (Figure 103). The central inscription, which reads "TO THE DEFENDERS OF THE UNION 1861–1865," presents the Northern view of the Civil War. The North was forced into a necessary and just war to save the Union. The inscription's specific reference to the "defenders" demonstrates that the monument was focused primarily on the collective efforts and contributions of ordinary soldiers and sailors. In the

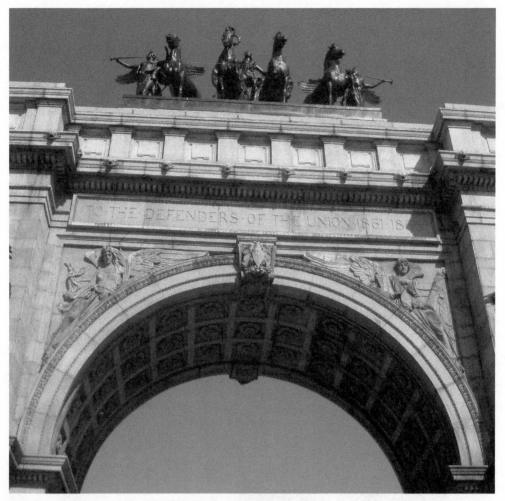

FIGURE 103. Detail, south façade, Soldiers' and Sailors' Memorial Arch, Brooklyn, 2016.
Source: Author.

spandrels, the two victories, carved by Philip Martiny, further articulate these themes. The eastern Victory holds a carved slab with the phrase "CON—STI—TV—ION" in her right arm, while her left arm supports the fasces, a bundle of sticks, the symbol of political power in the Roman Republic. The meaning is explicit: The Constitution is the legitimate source of power in the United States, just as the fasces symbolized political authority in Rome. These elements reaffirm the right to defend the Union and justify the Northern states' position in the war.[68]

Sixteen roundels adorn each of the arch's piers. Reminiscent of the *tondi* on the Arch of Constantine, the medallions represent the different Union Army corps in which Brooklynites served.[69] These badges, worn by veterans, demonstrated one's service publicly and would have been deeply meaningful to veterans and their families. The iconography of certain badges is particularly evocative, including the *pileus*, a symbol of the abolition of slavery, for which the North had fought. These roundels were set between elaborate com-

posite columns, whose volutes are composed of scaly tentacles and frame either an eagle with outstretched wings, an enduring symbol of the United States, or a *rostrum*, a ram of a Roman ship's bow. The *rostrum* was an ancient symbol of naval victories, and *rostra* were displayed as victory monuments in the Roman Forum as early as 338 BCE.[70]

The Triumphal Progress of Columbia, a monumental quadriga, crowns the arch (see Figures 98 and 103). The quadriga's composition and placement evoked that of the Arc du Carrousel.[71] The arch to Columbus that was erected in the Court of Honor in the 1893 Columbian Exposition also probably influenced the quadriga (see Figure 24).[72] MacMonnies created the monumental fountain of a triumphal barge carrying a victorious Columbia with Fame; this stood opposite the arch to Columbus. Two trumpeting victories flank the quadriga, which bears a draped, winged figure of Columbia.[73] An allegorical female figure, Columbia came to represent America in nineteenth- and early twentieth-century art[74] and featured prominently as a symbol of America at the Columbian Exposition of 1893 and in related celebrations.[75]

The presence of a triumphant Columbia presents an image of the reunified United States progressing forward after the Civil War. Columbia embodies the reconciliationist view that came to dominate and overwhelm all of the other memories and visions of the Civil War.[76] Likewise, the inclusion of the Latin motto on the seal of the United States of America, *E Pluribus Unum* ("out of many, one"), underscores this view. The unresolved issues left over from the Civil War, such the integration of ex-slaves in society and the failures of Reconstruction, are purposefully forgotten here in place of unity.[77]

In 1895, the bas-reliefs of Abraham Lincoln and Ulysses S. Grant, by Thomas Eakins and by William O'Donovan, respectively, were added on the interiors of the arch's bay. The position of these reliefs recalls the relief panels on the Arch of Titus[78] and the Arc de Triomphe. The arch also has an interior room, which is open to the public on special occasions, where banners and other unspecified "relics" from the war could be displayed.[79] The arch became a locus of memory where veterans and other Brooklynites could visit these relics, a physical reminder of the sacrifice of so many.

While a few erudite, classically educated viewers could identify the arch's classical references—the *rostra* and *pileus*—the Soldiers' and Sailors' Memorial Arch's array of sculptural details rendered it legible to any viewer. The Civil War veteran could identify his unit's badge or relive his experience of the war through the sculptural battle compositions. Furthermore, such monuments were concerned, as David Blight noted, with educating subsequent generations about a "soldier's virtues—honor, devotion, sacrifice, love of country."[80] The arch educated new immigrants about the Civil War, a defining event in American history. The prominence of the sculptural groups also emphasizes that this was a monument dedicated to rank-and-file soldiers—not a general or president.[81] Like their soldiers, Grant and Lincoln were also memorialized with Neo-Antique monuments. Completed in 1897, Grant's Tomb, located at 125th Street and Riverside Drive, is a mélange of ancient forms, while the Lincoln Memorial (1922), in Washington, DC, is a grand Doric temple where a statue of Lincoln by Daniel Chester French sits enthroned.

The Soldiers' and Sailors' Memorial Arch became a magnet for Brooklyn's collective remembrance of the Civil War. Concentrating commemoration around the arch and

the north entrance to Prospect Park, sculptures honoring other major figures in the Civil War, such as General Slocum, proliferated in the park. A monument dedicated to the Maryland Four Hundred, the soldiers who died in the Battle of Long Island, an important Revolutionary War battle, was erected,[82] as were statues to major literary and artistic figures.

The complex and diverse messages conveyed by the arch's iconography and form were magnified by its position within the plaza, which came to be known as Grand Army Plaza, which Frederick Law Olmsted and Calvert Vaux, the landscape architects of Central Park and Prospect Park, designed. The plaza became the park's de facto monumental entrance, and as one walks north toward the arch, the columns frame the way, making it one of Brooklyn's greatest monuments. The overall design of the arch, plaza, and entrance to Prospect Park evokes the relationship between the Arc de Triomphe and the Champs-Élysées in Paris.[83] Again, Americans interpreted Roman monuments through the lens of European architecture.

The Column to Columbus

Another opportunity to show off the unity of the United States and its emergence as a cultural and economic powerhouse presented itself in the quadricentennial celebrations for Columbus' discovery of America. While the Columbian Exposition of 1893 in Chicago was the center of America's celebrations, New York held its own festivities on October 10–13, 1892. These elaborate celebrations included three days of parades and fireworks and the unveiling of the Column to Columbus, which stands at the center of Columbus Circle today.

Christopher Columbus is now a contested historical figure.[84] His "discovery" of the New World has been recast through the earlier voyages of the Vikings and their settlement at Vinland in modern-day Canada c. 1000 CE and through the narratives and experiences of the indigenous populations that had long inhabited North America. In light of such revisions to our historical understanding of Columbus, some have called for the removal of his statue and the renaming of Columbus Day as Indigenous Peoples' Day.[85] However, in 1892, Columbus held a hallowed position in American history, as the man whose journey set in motion the events that would result in the founding of the United States. Columbus was seen as a hero, and as one who could be reenvisaged to suit the ever-changing needs of Americans, including new Americans who were neither Protestant nor English speaking, as they articulated their identity as Americans.[86]

Once Chicago was selected to host the World's Fair, the movement to hold quadricentennial celebrations in New York City was initially spearheaded by the Italian Club of New York City, then by Spanish and German organizations.[87] While New Yorkers were initially lukewarm about the festivities, they came to see Columbus as a symbol of progress and unity and as a testament of Manifest Destiny and the inevitability of American great-

ness.[88] On April 2, 1892, New York State passed a law directing Mayor Grant to appoint a committee, including John D. Rockefeller and the former US secretary of the Navy William Whitney, to oversee fundraising and organizing the celebrations.[89] Contributions poured in from the likes of J. P. Morgan, Samuel D. Babcock, Cornelius Vanderbilt, John H. Strain, and the labor leader Samuel Gompers.[90] The crème de la crème of New York society had taken over organizing the official ceremonies.[91]

Despite this, New York City's diverse ethnic communities and religious groups, including Catholics and Jews, continued to view Columbus as a vessel for their ambitions and saw his success as a means of their legitimatization.[92] The pope asserted that Columbus had been inspired by his faith, while New York's chief rabbi claimed that two Jews had sailed with Columbus.[93] Both St. Patrick's Cathedral and Temple Emanu-El held celebrations connected to the event. The involvement of Catholics and Jews in the celebration of Columbus allowed these two groups, which were both often marginalized in New York City, to assert and affirm their American identity.[94]

ITALIAN AMERICANS AND THE COLUMN TO COLUMBUS

The two statues erected in Central Park to Columbus were impressive but small-scale works of art.[95] Carlo Barsotti, the editor and proprietor of *Il Progresso Italo-Americano*, the most widely circulated Italian-language newspaper, had far grander ambitions: to memorialize Columbus by erecting a column at Eighth Avenue and Fifty-Ninth Street to honor the great man. In 1893, Nestor Ponce de León declared the column to be "the finest memorial of Columbus, in this country" (Figure 104).[96] Plans for this monument had been in the works as early as January 1889, when the designs for the column were sent to the Italian minister of public instruction by Barsotti on behalf of New York's Italian residents.[97] The funds for the monument were raised through subscriptions, advertised in *Il Progresso Italo-Americano*, from New York's Italian American population. A gift of New York City's Italian population, it was dedicated on October 12, 1892, during the city's Columbus celebrations.

The monument is seventy-six feet tall.[98] From the top of the column, a thirteen-foot statue of Columbus stands gazing out intently, his right hand grasping a ship's rudder, seemingly assured of his future discovery.[99] The column is decorated with anchors and the prows of six ships, which look like ancient triremes and allude to his ships, the *Niña*, the *Pinta*, and the *Santa Maria*. The column rests on a pedestal on an octagonal base. The pedestal is flanked by a winged youth, who peers over a globe, and a fierce eagle. The winged youth, a personification called the *Noble Figure of Genius*, seems to bless the journey, while the eagle is both a symbol of victory and of the United States.[100] On the base are two bronze bas-reliefs that depict two historic scenes from Columbus's journey; the south face shows Columbus's discovery of land, and on the north face, Columbus and his joyful crew give thanks to God for his success, and they are observed by indigenous people, set amid tropical plants, who gaze in wonder—and perhaps fear—at the new arrivals.

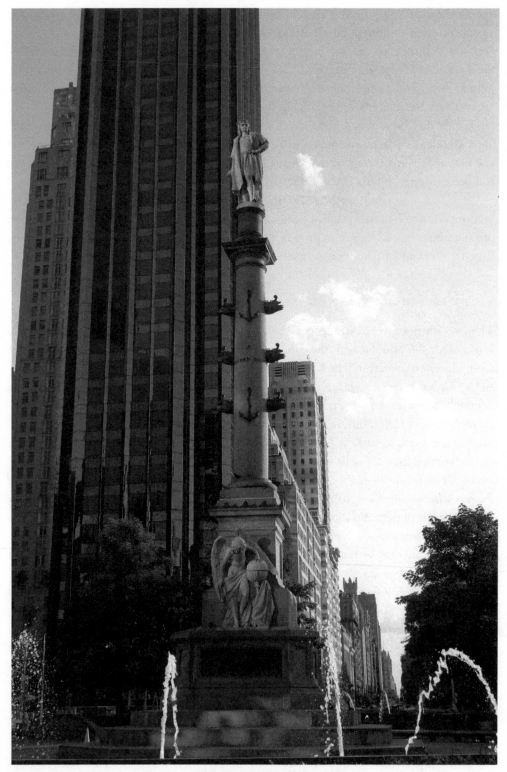

Figure 104. Column to Columbus, Columbus Circle, Manhattan, 2018.
Source: Author.

The dual-language English and Italian dedicatory inscription celebrates Columbus with pride:

TO CHRISTOPHER COLUMBUS / THE ITALIANS RESIDENT IN AMERICA, / SCOFFED AT BEFORE, / DURING THE VOYAGE, MENACED, / AFTER IT, CHAINED, / AS GENEROUS AS OPPRESSED, / TO THE WORLD HE GAVE A WORLD. /

JOY AND GLORY / NEVER UTTERED A MORE THRILLING CALL / THAN THAT WHICH RESOUNDED / FROM THE CONQUERED OCEAN / IN SIGHT OF THE FIRST AMERICAN ISLAND / LAND! LAND! /

ON THE XII OF OCTOBER MDCCCXCII / THE FOURTH CENTENARY / OF THE DISCOVERY OF AMERICA / IN IMPERISHABLE REMEMBRANCE.

The monument unequivocally celebrated Columbus' Italian heritage and bound the Italian Americans to Columbus's success. The artists involved, as well as the materials and the form of the column, proclaimed the monument's Italian nature. The capital of the column was composed of Carrara marble, while the red granite of Ravenna was imported for the pedestal. Columbus is hewn out of gray Italian granite. Only Italian-born sculptors were eligible to compete to design the monument.[101] Gaetano Russo, who was born in Messina, was selected to design the sculpture, and the Sicilian poet Ugo Fleres composed the inscription. Barsotti was a Tuscan émigré, and, of course, Italian Americans had paid for the column. Thus, the monument also celebrates the idea of being "Italian" and "Italian American." The modern nation of Italy had been forged within living memory, so many Italians thought of themselves not as Italian but as Florentine, Milanese, or Sicilian. Thus the use of materials from central and northeast Italy along with the employment of a southern Italian artist and a Sicilian poet reflect the new Italian nation and a new Italian American identity. The idea of an "Italian" identity was very important to the leaders of the Italian American community and to the formation of an Italian American identity. Italians were often looked down upon in the United States because of their Catholicism, and so internal divisions were not helpful in advancing the interests and standing of the community. This column clearly recalled the *columna rostrata*, or the rostral column. Gaius Duilius erected the first rostral column, which was decorated with the *rostra*, or bronze ship beaks, in the Roman Forum to celebrate his naval victory over the Carthaginians in 260 BCE, Rome's first naval victory.[102] This column would set the stage for the erection of rostral columns in the Roman Forum and on the Capitoline Hill during the Republic and Empire.[103] The meaning of the *rostra* was clear. While Columbus had not defeated anyone in battle, his crossing of the Atlantic with his small fleet was a victory over the ocean. Likewise, the Italian immigrants had undertaken a similar journey—filled with unknowns—in search of a better life by boarding a ship to come to the United States. In a sense, the anchors were also memories of their own crossing. Thus, the selected form had a particular Italian—and an ancient Roman—resonance.

By this time, the column was a well-established American monument. It had been used in Civil War memorials, including the column erected in Green-Wood Cemetery in 1869 to commemorate Civil War veterans. As early as 1829, a column, designed by Robert Mills, was erected to honor George Washington in Baltimore.[104] The popularity of the column

as a memorial in New York City persisted well into the twentieth century, with the erection of the Stanford White–designed Prison Ship Martyrs Monument in Fort Greene, Brooklyn, in 1908.[105] A memorial column to Henry Hudson was completed in 1938 after years of delay in the Bronx.[106] Bronx Victory Memorial, New York's last memorial column, was also erected through public subscription and dedicated on September 24, 1933, to the men of Bronx County who perished in World War I.[107] Columns were also important elements of the contemporary European monumental tradition. The exchange of St. Petersburg, Russia, also had a rostral column (1811). In England, a column (1843) to commemorate Admiral Horatio Nelson was erected in Trafalgar Square, while Colonne de Juillet (the July Column, 1835–1840) was erected in Paris to commemorate the Revolution of 1830. Berlin had the Siegessäule (the Victory Column, 1873), which celebrated Prussia's victory in the Franco-German War.

The column occupied a prominent position in New York City's landscape at the southwest corner of Central Park. Its potential as a potent commemorative anchor was acknowledged within twenty years: The USS *Maine* National Monument was erected at the corner of Fifty-Ninth Street and Central Park West and dedicated on May 30, 1913 (Figure 105).[108] The monument honored the 258 sailors who had died when the *Maine* exploded for unknown reasons on February 15, 1898, in Spanish-held Havana's harbor, starting the Spanish-American War and heralding the start of the United States' empire, as the United States would take temporary control of Cuba and ownership of the Philippines, Guam, and Puerto Rico as a result. The memorial is the physical embodiment of the rallying call "Remember the *Maine*!" Its allegorical classical sculpture and fountain with dolphins and a *rostrum* of an ancient ship underscored that classical forms were suitable for such memorials. This corner of New York City, centered on a column, became an urban hub that celebrated the United States' founding, its implicitly colonialist nature, and its transformation into an empire.

The *Maine* Monument was erected through the efforts of the newspaper mogul William Randolph Hearst. Scholars have long debated Hearst's involvement in starting the Spanish-American War; his actions have been likened to creating what we would recognize today as a "media event."[109] His newspaper undoubtedly benefited from the coverage of the *Maine*'s destruction. Within days of the explosion, he had also offered to contribute funds to a monument commemorating the fallen men. He established the *Maine* Monument Committee, and the monument was partially funded by public subscription, like the Column to Columbus, and its design was selected through an open competition, with unknown artists receiving the commission.[110] So, like the Column to Columbus, and unlike many of the other monuments erected in New York City, the *Maine* Monument was truly a "*popular*" memorial.[111]

Monuments in Early Twentieth-Century New York

While columns remained popular during the first four decades of the twentieth century in New York City, the appeal of arches started to wane. A temporary arch was erected to honor the victories of Admiral Dewey in the Spanish-American War. The proposed per-

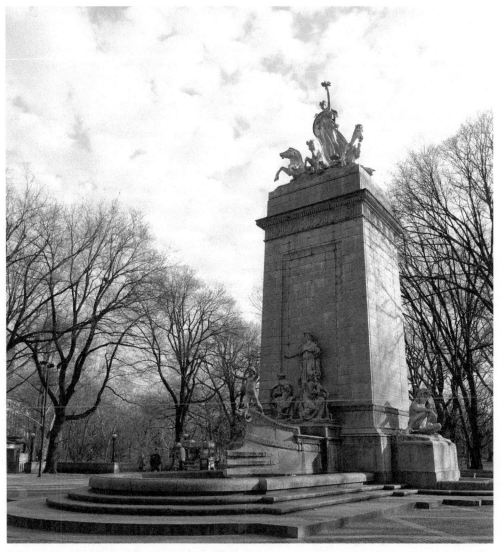

Figure 105. The *Maine* Monument, Manhattan, 2020.
Source: Author.

manent arch to Dewey became untenable in 1900 when the admiral declared himself as a possible presidential candidate, making such a memorial too politically partisan.[112] In 1919, a temporary Memorial Arch, also called the World War I Arch, honored the veterans of the war. While there were calls to make this arch permanent, it failed due to conflicting views over the appropriateness of the arch as a commemorative form.[113] Alexander Stirling Calder's scathing critique of the proposed arch in a letter to the editor of the *New York Times* in 1919 signals an important shift in the attitude toward the use of ancient forms in American architecture:

> There are the creators and the plagiarists. . . . They proceed upon a theory that everything worth while has already been done, that nothing remains for us but to copy, to

adapt the superficial aspects of works of approved age, leaving their spiritual significance either quite out of consideration or violating it by the adaptation. It is the practice of this theory that has studded our cities with Greek and Roman temples, Italian and French palaces. . . . And now we have a mutilated Roman arch of imperial triumph doing duty as our monument celebrating the victory of a free democracy over an imperial power.[114]

The imperial associations of the arch, once so celebrated by America's artists and architects, were now no longer in keeping with American democratic values. Considering that the United States had helped France and the United Kingdom (with its constitutional monarchy and parliamentary system) defeat the Austro-Hungarian Empire and imperial Germany in World War I, the arch, so closely associated with the Roman Empire, was not an appropriate commemorative form for the democratic United States. Calder's comments also highlight that Roman forms often sat on tensions, whether the extravagance of the lobster palaces and mansions of the Gilded Age or, in this case, the problematic nature of empire for Americans.

Calder's objections to the arch form were not only political but also artistic. Calder argued that "too often the husks of archaeology are preferred to the kernel of living thought" for memorials. Ironically, Calder, who had only a year earlier completed the classical *Washington at Peace* sculpture for the Washington Square Arch, voiced a sentiment that was becoming more prevalent: Classical and historical European forms with imperial overtones were not where American architects should seek inspiration.

Conclusions

Monuments, like the arches to George Washington and Brooklyn's Civil War veterans, were connected to the City Beautiful movement and the ideals of the Progressive Era. They embodied the belief that these memorials could shape and educate America's population, transforming the working poor and immigrants into upright, moral American citizens.[115] The Washington Square Arch aimed to educate Americans about the first president of the United States and early American history, while the Soldiers' and Sailors' Memorial Arch in Brooklyn conveyed the North's view of the war and celebrated the average soldier, whose sacrifice had ensured that the North would be victorious and the Union would survive. The arch, with its inscriptions and sculpture, was, as it had been in antiquity, a potent form for expressing American political narratives, ideas, and values.

The power to erect public monuments was not limited to one sector of society. New York City's grandees were involved in commissioning and executing the Washington Arch, the city of Brooklyn used a bond to pay for its arch, and the column to Columbus was erected through a subscription by everyday Italian Americans. But the fact that Italian Americans could raise the funds to erect the column in a prominent location in Manhattan signaled that all New Yorkers could participate in honoring important historical figures.

The failure to erect a permanent arch to honor World War I veterans in Manhattan reflects a marked shift over the course of the early decades of the twentieth century in the attitude to the purpose, meaning, and implications of classical architecture and its role in

American architecture. Classical forms were now contested: They were no longer seen an exemplary models but instead as derivative and unoriginal. The column and arches are not, however, relics of a bygone era but dynamic elements of twenty-first-century New York's cityscape. In the fall of 2012, with the support of the Public Art Fund, the Japanese-born artist Tatzu Nishi created an art installation, called *Discovering Columbus*, at the top of the column, around the statue. Nishi created a furnished living room where visitors could sit, while looking down Broadway, gazing up at Columbus, or watching TV. Nishi stated that he was interpreting the column in a "contemporary New York style"[116] to create a unique, surreal opportunity to experience a historical monument.[117] In 2018, the Chinese artist Ai Weiwei created a series of installations for the Public Art Fund called *Good Fences Make Good Neighbors*, which included a thirty-seven-foot-tall steel cage with two united figures within it, set below the Washington Square Arch. The work alludes to Marcel Duchamp's *Door for Gradiva* (1937), which framed the entrance to Andre Breton's Paris art gallery.[118] Ai Weiwei selected Washington Square because he had lived nearby in the 1980s and because Duchamp also had lived locally and spent many hours in the park.[119] The artistic spark that these monuments provided later artists is a testament to the enduring legacy of classical antiquity and its architecture.

Eclectic Antiquity

In New York City, ancient architecture was reborn as busy stock exchanges, virtuous court-houses, imposing train stations, and elegant mausolea. This chapter explores how, from the 1830s until the 1930s, the architecture of antiquity was appropriated for a wide range of other types of buildings, including retirement communities, churches, Masonic lodges, and theaters. Ancient architecture's widespread appearance in New York reflects how deeply antiquity had pervaded American architecture and consciousness.

Snug Harbor and Grecian Temple Churches

During the height of the Greek Revival in the 1830s and 1840s, Greek temple architecture was appropriated for the design of Snug Harbor on Staten Island and for churches in Manhattan and Brooklyn. The architects and patrons of these buildings used Greek architecture to signal that they were fashionable democrats committed to the ideals of the new nation. Snug Harbor, today a cultural center, is one of the best groups of Greek Revival buildings in the United States; its architectural significance is rivaled only by the buildings of Girard College (1833–1847), in Philadelphia. Robert Richard Randall, an affluent shipping merchant, made a provision in his will that his Manhattan farm, which bordered today's Washington Square, should be used to establish a marine hospital for "aged, decrepit, and worn-out sailors." After lawsuits over the will had been settled, the trustees kept the Manhattan farm to produce income to support Snug Harbor, located on

FIGURE 106. Snug Harbor, Staten Island, 1930–1940.
Source: The Library of Congress.

130 acres on the north shore of Staten Island. During the nineteenth century, between four hundred and eight hundred retired sailors lived here, as well as administrators and staff members.[1]

The main building (C) was completed in August 1833, and two flanking buildings (Buildings B and D) were subsequently built, housing thirty-seven retired sailors (Figure 106).[2] Building C had an elegant octastyle Ionic portico. Buildings B and D each only have a small portico over the entrance with triangular pediments, and their windows have individual pediments. A gallery at the rear links the buildings. Buildings A (1879) and E (1880),[3] which flank the three older buildings, were erected as part of a major expansion of the complex under the author Herman Melville's brother Thomas Melville, who managed Snug Harbor from 1867 to 1884.[4] Buildings A and E were both dormitory buildings with hexastyle Ionic porticoes that echo that of Building C.

Snug Harbor's records demonstrate that Minard Lafever won the 1831 competition to design the complex and was paid for drawings related to the portico, stonework, and columns.[5] The Ionic order in the porticos of Snug Harbor's Buildings B, C, and D was based on the restored drawings of the Temple on the Ilissus at Athens, published in Stuart and Revett.[6] The eight Ionic capitals used on Building C follow a design in Lafever's *The Modern Builder's Guide*, although these were added later.[7] The complex may also have drawn inspiration from the London Orphan Asylum, which was depicted in James Elmes's 1827 book *Metropolitan Improvements*, which Lafever knew.[8] In place of a classical temple's cella, Lafever gave Building C an effective, functional two-story interior with individual rooms for the retirees. Windows and a dome provided light. Lafever's use of ancient and contemporary sources suggests that he was thinking creatively, not just copying Greek or English forms blindly or aiming for archaeological accuracy.[9]

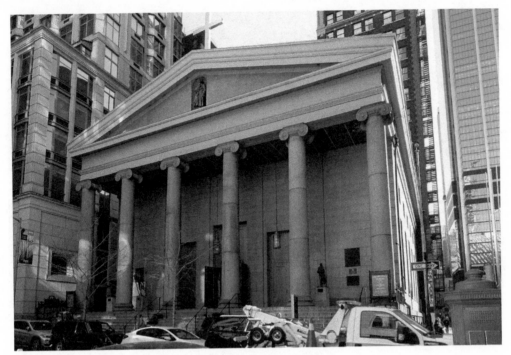

FIGURE 107. St. Peter's Church, Manhattan, 2020.
Source: Author.

Lafever's involvement ended around 1833, for unclear reasons. Samuel Thomson and his son, William, assumed the role of building superintendents and architects until 1840.[10] The creation of the Buildings A and E around 1880 in the same style and the renovation of the interior of Building C in a classical style in 1884 demonstrated that classical architecture had lasting significance in the United States.

In the 1830s, if one strolled the streets of Manhattan and Brooklyn, one would rightfully be mistaken for thinking that New York was a city of pagans—not Christians—because so many prominent churches of different dominations were built with Ionic and Doric porticos surmounted by pediments. St. Peter's (1836–1840), located at 22 Barclay Street, was a grand granite building with an Ionic hexastyle portico and pediment (Figure 107).[11] It replaced New York's first Roman Catholic church, which had been built in 1786. Although St. Peter's was clearly built using Greek forms, classical architecture could also be connected to the tradition of monumental buildings in Rome,[12] the seat of the papacy. The cross that stands at the apex of the pediment and the statue of St. Peter in the pediment transformed the building from pagan temple to church. The church's close proximity to the Twin Towers meant that it had a special role on 9/11. Although the church was damaged in the attacks, it was transformed into a round-the-clock supply station hosting first responders, rescue workers, and volunteers who came to help on that Tuesday morning and in the aftermath of the attacks.[13]

Brooklyn was home to an equally stunning array of Grecian churches. The First Reformed Dutch Church (1834–1835), built by Minard Lafever and James Gallier, stood on

Joralemon and Court Streets, where the Brooklyn Municipal Building now stands. The church, organized in 1654, was Brooklyn's oldest. Because it needed more space, this, the church's fourth building, was constructed.[14] The large church (111 × 60 feet) had an Ionic octastyle portico on both ends. The apex of the pediment reached forty-eight feet high. It cost $26,000, a prodigious sum at the time.[15] Stuccoed to look like white marble, the church must have gleamed brightly, like a holy beacon, standing in sharp contrast to the surrounding muddy streets.

Lafever did not identify his inspiration for this building, but the most likely source for the pediment is the Temple of Dionysus at Teos, and the Ionic order of the columns may relate to the amphiprostyle Temple on the Ilissus, which only survives in drawings.[16] The capitals were decorated with egg-and-dart motifs. The vestibule of the doorway looked like a scaled-back version of the doorway of the Erechtheion's north porch.[17] Lafever's own drawings and pattern books present possible models, as a similar portico appears in a country residence in *The Modern Builder's Guide*.[18] Contemporary sources considered the church to be an outstanding example of Grecian architecture, but they also confused its architectural order. Some identified it as Corinthian, while others mistakenly saw it as replicating the Parthenon.[19] Such responses were common[20] and underscore that for many Americans having a building that evoked the classical past was more important than archaeological accuracy or a specific architectural reference.

The First Congregational Church in Brooklyn, now the Wunsch Student Center of the Polytechnic Institute of New York University, was an elegant, understated brick church built with a Doric portico with two columns in antis. The façade also had windows framed by pilasters and pediments (Figure 108). Its builder probably used Lafever's pattern books.[21] Built for New England Congregationalists in the first half of the nineteenth century, the church became home to the African Wesleyan Methodist Episcopal Church (founded in 1818), the oldest African American congregation in Brooklyn, in 1854.[22] This unpretentious church served as a stop on the Underground Railroad and in 1863 a sanctuary for African Americans who were fleeing mob violence in the wake of the Draft Riots. It was a church until 1938; in the 1960s NYU purchased it and completed renovations to it in 1996.[23] Again Brooklyn and New York City were not outliers in this adaptation of Greek forms for churches, as good examples of such church architecture can be found in many other cities as well, including Baltimore, Richmond, and St. Louis.[24]

By the end of the 1840s, Gothic vaults and spires started to replace the Grecian porticos and pediments of New York's churches. Such forms were undoubtedly more appropriate to the Christian faith. One late exception to this trend was the Madison Square Presbyterian Church (1906). Located on the northeast corner of Madison Avenue and Twenty-Fourth Street, it was designed by Stanford White (Figure 109). It seems to embody White's abiding desire to erect Pantheon-like buildings, referencing Palladio's work and Jefferson's Rotunda at the University of Virginia, which White had controversially restored.[25] It had a pronounced hexastyle Corinthian portico with pale green granite columns, a glorious dome of green and white tiles, yellow Roman bricks in two tones, terra cotta moldings in ochre, blue-gray, and green, as well as a lantern, all of which are similar to White's Gould Memorial Library.[26] The pediment was decorated with terra cotta angels in blue and

FIGURE 108. First Congregational Church, now the Wunsch Student Center of Polytechnic
Institute of New York University, Brooklyn, 2009.
Source: Jim Henderson, public domain.

white, in the mode of the Italian Renaissance sculptor Luca della Robbia, designed by
Adolph Weinman.[27] While the exterior was a Roman tour de force, the interior was in-
spired by Hagia Sophia, the most famous Byzantine church in the world.[28] Here mosaics
and Tiffany glass created a glorious monument to God. This building, one of White's
favorites, embodies the Neo-Antique; it draws upon ancient sources but melds them
with Italian and Byzantine models to create something truly original. The polychrome
exterior and interior helped distinguish this petite, elegant building. Yet it was demolished
only thirteen years later when the Metropolitan Life Insurance Company purchased the
land and built a forty-eight-story tower, the tallest building in the world when it was com-
pleted in 1909. The building's fragments are now scattered across churches, museums,
newspaper buildings, and universities in New York, Connecticut, Ohio, and California.[29]

Bathing Culture in New York City

Roman bathing buildings, or *thermae*, were far more than just an architectural shell that
could be adapted to the needs of New York's train stations and museums. Ancient *thermae*

McKim, Mead & White, Architects. Color drawing by Jules Crow

THE NEW MADISON SQUARE PRESBYTERIAN CHURCH

Madison Avenue and Twenty-fourth Street, New York City; the Rev. Dr. Charles H. Parkhurst, Pastor

FIGURE 109. Madison Square Presbyterian Church, Manhattan, *Century Magazine*, September 1905.

Source: Author's collection.

also, fittingly, served as models for public bathing in the city.[30] Bathing was a fundamental social institution in ancient Rome, in which everyone, from the emperor to a freedman, participated.[31] Bathing was accessible and affordable, and bath complexes were some of a Roman city's greatest amenities, providing baths as well as spaces for exercise, strolling, eating, and philosophical debate. They were lavishly decorated with sculpture and marble from across the empire.

In the early twentieth century, New Yorkers engaged in two different, but related, dialogues with ancient Roman bathing and bath architecture. First, certain establishments, such as the Fleischman Baths, created a luxurious bathing experience for the well-to-do. Second, in accordance with the values of the Progressive Era, there was an emphasis on creating public bathing facilities in New York, to cultivate good hygienic practices and instill civic virtues in New York's urban poor and newly arrived immigrants. This resulted in the creation of affordable public bath buildings in New York City, which often used the architectural language of Roman baths.[32]

THE FLEISCHMAN BATHS

The Fleischman Baths offered affluent New Yorkers an opportunity to bathe like a Roman emperor. Located at Forty-Second Street and Sixth Avenue, on the upper three stories of the Bryant Park Building and covering a massive 54,000 square feet, the Fleischman Baths opened with much fanfare in 1908.[33] The publicity materials and the press compared them to the Baths of Agrippa, Titus, Caracalla, and Diocletian.[34] Illustrated advertisements promoted the baths as having "balneal accuracy . . . combined with all modern sanitary appliances—but are also to be fitted out with the luxurious addenda" (Figure 110).[35]

The facilities in the Fleischman Baths appropriated the spaces and language of the imperial Roman baths and included a *tepidarium*, *caldarium*, and *natatorium*. One entered the baths via an entrance, called an *antelarium*.[36] *Antelarium* is not an actual Latin word, but its use attempted to give the baths' increased cultural standing. It also suggests that some of Fleischman's moneyed clientele might not have had (enough of) a classical education to know the difference. The words of the Italian Renaissance poet Dante were also used and conflated with ancient Rome: "Abandon care all ye who enter here and do as the Romans did."[37] This type of comingling classical and Renaissance forms and the use of faux-Latin is typical of many appropriations of such forms and of the Neo-Antique, as it provided freedom and flexibility for those designing these buildings and underscores that sometimes the idea of antiquity was more important than any accurate reference.

The patrons of the Fleischman Baths could enjoy countless creature comforts, including massages with oils and perfumes, pedicures, and manicures, or they could visit a barber or hairdressing salon. Sleeping and resting rooms were also available. The glorious *solarium*, over 20,000 square feet, on the top floor featured a restaurant and grill set within a tropical garden filled with rare trees, plants, and birds, as well as marble fountains and monumental columns.[38] Guests could also play pool and billiards, go bowling, or box in the gymnasium.[39]

The admission price of one dollar was steep.[40] In 1920, the average cost of a pound of butter was thirty-six cents, and the average annual salary for an industry worker was $564,

THE SOLARIUM

FIGURE 110. Fleischman Baths, Bryant Park Building, Manhattan, *The Theatre Magazine Advertiser*, 1910.
Source: Author's collection.

making admission out of the reach of most New Yorkers.[41] One could even join the more exclusive Diocletian Club, which evoked the baths of the Emperor Diocletian in Rome.[42] The annual dues of $100 bought one access to a private entrance, clubrooms, unrestricted use of the baths, and a valet service that provided bath linens and a private wardrobe, so a gentleman could dress for dinner without having to trudge home to Harlem, Brooklyn, or the suburbs.[43] The Fleischman Baths was theoretically accessible to all, but, in reality, it provided a luxury service to the newly affluent upper-middle and upper classes. Like the lobster palaces, it was not to last. In the fall of 1908, Joseph Fleischman declared bankruptcy, and his creditors began actively seeking his assets, including the missing accounts from the baths.[44] The Fleischman Baths was not unique but belonged to a small handful of establishments, like Everard's Turkish, Roman, and Electric Baths, that used the language of Roman bathing and architecture in part to create a unique bathing experience available to those who could afford it.[45]

THE ASSER LEVY BATHS AND OTHER PUBLIC BATHS

By the late nineteenth century, bathing establishments that catered to the urban poor were well established in New York City.[46] Bathing was viewed as a hygienic necessity but also with suspicion by New York's Protestant elite, who saw the baths as ripe for sin and moral

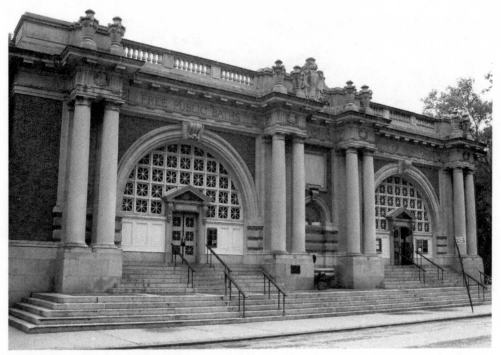

FIGURE III. Asser Levy Baths, Manhattan, 2010.
Source: Beyond My Ken (CC BY-SA 4.0).

depravity. Bathing was supposed to be about cleanliness—not recreation. However, by the start of the twentieth century, baths increasingly came to be viewed, in the words of Allyson McDavid, "as both hygienic *and* recreational."[47] This is evident at the Public Baths at Asser Levy Place and East Twenty-Third Street, which opened in 1908. Designed by Arnold W. Brunner and William Martin Aiken, it is a splendid example of a bath complex that used Roman bath architecture (Figure 111).[48] The limestone columns evoke the white marble that decorated the imperial baths, as did the large arched windows.[49] They aggrandize the building's undistinguished red brick walls. "FREE PUBLIC BATHS" and "NEW YORK CITY" were carved on the building's entablature, just as imperial monuments were inscribed.[50] Together, the architectural form, limestone embellishments, and inscriptions proclaim that this affordable bath was every bit as grand as New York's civil and public monuments.

The bathing and leisure activities of the baths, renamed for Asser Levy, an early Jewish settler in New Amsterdam, drew up to 18,000 daily visitors.[51] Its popular swimming pool demonstrated that recreation was starting to overtake hygiene as the key aspect of public baths.[52] It was expanded in the 1930s to include outdoor facilities, a diving pool, and a new playground, and it is still in use today. Roman bathing and bath architecture provided reference points and models for luxurious and recreational bathing, which both the affluent and poor could enjoy, highlighting the fluidity, flexibility, and potency of ancient architecture.

Fraternal Organizations: The Grand Masonic Lodge and the Pythian Temple

Fraternal organizations and Masonic lodges were a large part of New York City's social fabric, especially in the late nineteenth and first half of the twentieth centuries. The Freemasons had long viewed elements of the Bible and the mystery cults of ancient Egypt and the classical world as central to their creed.[53] Thus, a way to connect to this long history was through the creation of period or thematic rooms that evoked ancient Greece, Rome, and Egypt in many Masonic lodges across the United States, including John Russell Pope's House of the Temple, the Masonic Lodge for the Scottish Rite of Freemasonry in Washington, DC. This award-winning commission (dedicated in 1915) reinterpreted the Mausoleum of Halicarnassus and helped establish Pope, who later designed the New York State Memorial to Theodore Roosevelt[54] and the Leeds Tomb in Woodlawn Cemetery.[55]

In New York City, Harry P. Knowles designed the Masonic Hall (1912), on Twenty-Third Street. The lodge's different rooms include Egyptian and classical interiors, called the Doric, Corinthian, and Ionic Rooms, as well as the French Doric and Ionic Rooms, both of which have French-style paintings and columns intended to evoke the Temple of Solomon. The reason behind the selection of these styles is obscure, as archival documentation does not survive. However, Joseph Patzner, the librarian at the Chancellor Joseph R. Livingston Masonic Library, notes that the Freemasons, who focus on personal betterment, drew upon a large range of symbols and practices from other cultures, with a particular emphasis on antiquity.[56] Therefore, these Neo-Antique rooms probably embody the order's ties to the distant past.

The Masonic Lodge was not the only fraternal organization to appropriate ancient art and architecture in New York. Designed by the theater architect Thomas W. Lamb, the Pythian Temple (at 135 West Seventieth Street between Amsterdam and Columbus Avenues) is one of the city's most daring buildings and combined the artistic and architectural traditions of ancient Assyria, Babylon, and Egypt (Figure 112). The Pythian Temple was completed in 1927 as a meeting lodge for the Knights of Pythias. Justus H. Rathbone established the Order of the Knights of Pythias as a nonsectarian fraternal order in Washington, DC, in 1864.[57] Core to the beliefs of the Pythian Knights are the ancient, democratic ideals of fraternity and friendship. The use of ancient architectural forms in New York's Pythian Temple were thus entirely appropriate.

The main entrance is decorated with a golden inscription with Rathbone's words, "IF FRATERNAL LOVE HELD ALL MEN BOUND HOW BEAUTIFUL THIS WORLD WOULD BE," against a black tile background and framed by two crowned asps, each with an ankh (the ancient Egyptian symbol of life) and two Egyptian-style vultures (Figure 113). Above the inscription were polychrome terra cotta, evocative of Babylonian brickwork, and Egyptianizing plant motifs, with open and closed lotus leaves alternating. At the top, there was the inverted triangular, multicolor symbol of the Pythian Knights, flanked by two muscular griffins. The double-height lobby was also once decorated in polished black marble with Egyptian decor.[58]

Four massive columns flank the main entrance on each side. The capitals are composed of two bearded, male heads with headdresses that derive from male figures in ancient

FIGURE 112. Pythian Temple, Manhattan, 1928.
Source: Irving Underhill. Museum of the City of New York.
X2010.28.381.

FIGURE 113. Main entrance, Pythian Temple, Manhattan, 2016.
Source: Author.

Assyrian sculptural reliefs. At the west and east ends of the building are pairs of *lamassu*. While the *lamassu* in the Metropolitan Museum of Art's collection would not arrive until 1932 (as a part of a major bequest by John D. Rockefeller Jr.), earlier there were many antiquities, including cylinder seals and cuneiform tablets, from the ancient Near East on display in New York.[59]

The middle section of the building was completely remodeled when it was converted into condominium apartments in 1982, and the polychrome lions that project like gargoyles or

simas are one of the few surviving details. Originally, the middle section of the building (and much of the upper setbacks) was composed of austere patterned brick with architectural details and crenellations. The upper third is divided into three levels with setbacks. The upper part of the Pythian Temple draws heavily on Egyptian architectural and sculptural traditions. On the lowest of these levels, four seated, polychrome statues of pharaohs are based on the statues from the famous site of Abu Simbel, which Ramesses II erected in the mid–thirteenth century BCE. Abu Simbel was well known through photography and travel accounts. The Met's Egyptian department, founded in 1906, already had a premier collection of antiquities on display, and during the first four decades of the twentieth century, the museum was sponsoring excavations in Egypt.[60] Directly above the statues at the east and west ends of the building is a small kiosk with Doric columns with polychrome Egyptianizing motifs in antis and a step pyramid roof. On top of each step pyramid there were three yellow bulls with a ruddy red yoke and a green tuft of hair (which are virtually impossible to make out from the street without binoculars). They stood in front of a tholos-like pavilion.

The building cost $2 million, a huge sum in the 1920s. One hundred twenty lodges in New York City used the building for meetings and recreational pursuits.[61] By the mid–twentieth century, fraternal orders were declining in popularity. In the 1950s, the Pythians rented out space to Decca Records, which used it as a studio. Buddy Holly, Sammy Davis Jr., Billie Holiday, and others recorded there.[62] In 1959, they sold the building to the New York Institute of Technology. No archival materials about the Knights of Pythias or Lamb's inspiration for the building survive.[63] However, Lamb did know of elaborate Babylon-inspired film sets, like those from D. W. Griffith's film *Intolerance*, and so film sets may have influenced Lamb's choice of Egyptian and Assyrian motifs.[64]

Theaters

One of the earliest theaters in New York City was the New York Theater (1826), later renamed the Bowery Theater, on Elizabeth Street. Designed by Ithiel Town, it was a diastyle Doric temple with an unadorned pediment.[65] It was considered by contemporaries to be "the boldest execution of the doric order in the United States, and is also a more exactly [*sic*] according to the true spirit and style of the best Grecian examples in the detail, than any other specimen yet executed."[66] The façades of many theaters on Broadway included columns and classical motifs. The forms of the Greco-Roman theater with its seating area and, in the case of Roman theaters, the *scaenae frons*, were inherent in these buildings, but there does not seem to have been an active, conscious adaptation of classical architecture in most of Broadway's theaters. Some theaters had ancient names, like the Lyceum (opened in 1903) at 149–57 West Forty-Fifth Street[67] and the Hippodrome (opened in 1905) at 456–70 Sixth Avenue (and 51–79 West Forty-Third Street).[68] Neither theater's architecture purposefully alluded to or drew upon the traditions of the classical world; rather the names alone alluded to antiquity. In the 1870s, P. T. Barnum called his open-air theatrical staging ground the Hippodrome, suggesting the spectacle-like quality of antiquity's hippodromes and amphitheaters.[69] The only theater that evoked antiquity was the Rivoli Movie Theater (1917–1987), located at Forty-Ninth Street and Broadway. Designed by Thomas Lamb for

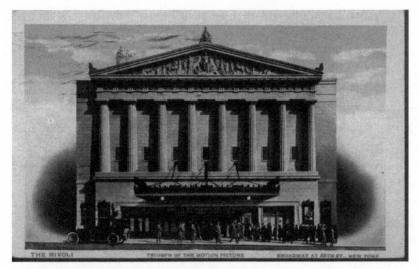

FIGURE 114. Rivoli Theater, historic postcard, 1920.
Source: Courtesy of the Avery Classics Collection, Seymour B. Durst Old York Library
Collection, Columbia University.

the show-business magnate Samuel L. Rothafel, its façade was composed of a grand, octa-style Doric temple, with a pediment and sculptural program composed of white glazed terra cotta tile, clearly evoking the Parthenon (Figure 114).[70] This classical garnish signaled that movie theaters were the cultural equal of live performance theaters.

Conclusions

Antiquity was an architectural and artistic repository—of sculptural ideals, architectural forms, and design motifs—that New York architects could adapt in original and innovative ways that do not fit neatly into the traditional scholarly narrative about the appropriation of ancient architecture. These engagements follow the same chronological pattern as other building types. In the 1830s and 1840s, the Grecian temple, which embodied the ideals of the young nation, was considered appropriate for nearly any type of building—from a church to a retirement community. The next peak of the adaptation of ancient forms was at the end of the nineteenth century, and can be seen in use of ancient—classical, Egyptian, and Near Eastern—architectural and sculptural motifs in public baths, lodges of fraternal organizations, and theaters. By the early twentieth century, some of these engagements were more superficial forms of architectural garnish. Although the Parthenon-like portico and pediment on the Rivoli Theater were designed to attract attention, they also elevated the lowly movie theater to the equal of a Broadway theater. While these forms were decorative, they underscore that ancient forms continued to be viewed as meaningful and valuable sources for architecture, motifs, and decorative elements that brought prestige and visual prominence to buildings throughout New York City's history.

Reflections: Useable Pasts and Neo-Antique Futures

> Of all the figurative definitions given of architecture, none is more apt for
> expressing the general effect of a noble work than this: poetry in stone. . . . As an
> illustration of a thought, then, as a symbol of an idea, as an exposition of the
> characteristics of an age and people, architecture enters a province above and
> beyond that which merely concerns the values of things utilitarian.
>
> —PERCY STUART

For much of New York's history, Stuart's observation—here given on the architecture of
the New York Stock Exchange in 1901—rang true.[1] Architecture was something more than
the merely functional—it was symbolic of a people, a company, and an era. From the end
of the eighteenth century until the 1930s, the architecture and art of Egypt, Greece, Rome,
and the ancient Near East held a steady grip on New York's architects, patrons, designers,
builders, and planners. Antiquity was fluid, flexible, and timeless. To architects and pa-
trons, it offered each individual an array of usable pasts and architectural forms that could
be co-opted and liberally reinterpreted. Ancient architecture had already been appropri-
ated by European empires, monarchs, aristocrats, and companies, and so in America's quest
for historical legitimacy, these ancient forms, which were often mediated through Euro-
pean interpretations, were even more appealing. They had a symbolic and functional
weight.

Early archaeological publications such as *The Antiquities of Athens* and the *Description of
Egypt* and practical building manuals taught antiquity to American architects, artists, and
patrons. By the mid–nineteenth century, photography (often published in magazines)
brought ancient Greece, Rome, Egypt, and the Near East to the United States. Interna-
tional travel became more affordable, and Americans embarked on their own Grand Tours
and began to see major cities and archaeological sites in Europe, the Middle East, and
Egypt at first hand.

Classical architecture, especially the Greek temple, became synonymous with early
American and New York architecture, especially from 1820 to 1850. It embodied the

ideals of the new nation and its democracy. The Greek Revival could almost be defined as an Athenian Revival; the overwhelming majority of the Greek architecture repurposed in New York was Athenian—the Parthenon, Erechtheion, and Choragic Monument of Lysicrates. Yet these buildings were not copies; rather, they were Grecian, inspired by ancient Greek forms. As is evident at the US Custom House and the second Merchants' Exchange, these buildings often incorporated Roman domes, inspired by the Pantheon, which provided much-needed light. They were original Neo-Antique syntheses of ancient architecture.

These early Neo-Antique buildings also brought beauty and elegance to a city defined by dirt, disease, and, until 1842, a lack of clean water. Buildings like the US Custom House articulated New York City's position as America's commercial center and proclaimed its ascendancy. Likewise, just as the public sphere might be dominated by temples and rotundas, meanders, the egg-and-dart, and acanthus weaseled their way into the homes of well-heeled New Yorkers in the 1820s and 1830s, while smart, gleaming white columns and pediments marked out their owner's homes as fashionable. New York now had the architectural chops to prove it was the equal of its European predecessors and superior to its American rivals like Philadelphia, Boston, and Washington, DC.

The monumentality of Egypt offered a symbolic language of strength, permanence, and technological progress that appealed to the engineers constructing the Murray Hill Reservoir and to John Haviland, who was designing the Tombs. At the same time, ancient Egypt's obsession with the afterlife meant that Egyptian architecture pervaded the world of New York's dead for most of the city's history. Obelisks, erected in New York City as early as the 1760s, established the suitability of Egyptian architecture for funerary monuments. From the 1840s onward, Egyptian temples, pyramids, and obelisks populated the landscapes of Green-Wood Cemetery and then Woodlawn Cemetery alongside classical temples well into the twentieth century. Yet Egyptian forms never found the same wide appeal as Greco-Roman forms; they may have been too hard to adapt and, possibly, too non-Western.[2] The demolition of the Murray Hill Reservoir and the Tombs around 1900 reflects the decline of Egyptian architecture outside the funerary realm.

While the middle part of the nineteenth century saw an embrace of contemporary European and medieval European architectural forms by many architects and artists in New York and other American cities, echoing the trends in European art and architecture, antiquity never went away. In the second half of the nineteenth century, especially after the Civil War, classical, especially Roman, forms emerged as one of the major, if not the preferred, forms of architecture for almost any type of building in New York City—from a stock exchange to the interior of a Fifth Avenue mansion. At this time, the United States industrialized, and its booming international trade gave the United States an economy to rival most European powers. By the end of the nineteenth century, the United States would also have its first empire.

To match the new status of the United States as an empire, a new architecture was needed, and imperial Rome obliged. The Roman baths provided functional and symbolic architecture for Pennsylvania Station and Grand Central Terminal, New York City's de

facto entrances, as well as for the approach to the Manhattan Bridge. These buildings married utility and beauty, making them truly exceptional edifices. These forms were popularized at the Columbian Exposition of 1893, which millions of Americans visited, and those who did not visit experienced the fair through photographs and postcards. The City Beautiful movement also gave classical forms another boost across the United States; the libraries and museums erected in countless American cities during the first three decades of the twentieth century reflect this trend. Archaeological discoveries would also spark an increased interest in ancient art and architecture.

Pompeii's painted, polychrome interiors provided new millionaires with sumptuous rooms and morally dubious lobster palaces with artistically sanctioned luxury, gluttony, and sex. The designers of the Pompeian rooms and the lobster palaces did not just merely copy antiquity's interiors; rather, they adapted and incorporated different architectural and artistic elements from imperial Rome, Pompeii, Greece, and Egypt to create opulent, Neo-Antique fantasies like Marquand's Greco-Pompeian music room and Murray's Roman Gardens. The tensions around such buildings persisted, and the decadence and destruction of Pompeii remained in part a cautionary tale. The contents of Marquand's music room and his prohibitively expensive piano were auctioned off at a steep discount after his death, and the Café de l'Opéra, the Neo-Assyrian/Babylonian–inspired lobster palace, was a financial disaster.

The arches and columns of imperial Rome also provided suitable models for many of the major monuments erected in New York City. These monuments were not just erected by New York City's patrician elite but also by those outside the normal corridors and stations of power. Italian Americans erected a column to Columbus, a man whom they and other Americans venerated as a hero in a prominent Manhattan location. Likewise, the Civil War veterans of Brooklyn, even the African American veterans, were honored with an arch that celebrated their contributions to the Civil War.

Given shifts in the American educational system, which favored a move toward more practical, vocational training in the second half of the nineteenth century, a classical education became the purview of the elite. Therefore, it is unsurprising that this shift was matched by an embrace of Roman architecture for elite cultural institutions, like the Metropolitan Museum of Art and the Brooklyn Museum. Two of New York's leading universities—New York University and Columbia—both adapted the Pantheon for their libraries, and their campuses were littered with classicizing buildings. Likewise, City College's erection of the classical-style Lewisohn Stadium stated that it was a peer of these august institutions.

While the chronological sweep and the trends I have outlined in this book broadly hold true, there were, of course, exceptions. The art and architecture of the ancient Near East was never adapted as widely as the architecture of ancient Egypt, Greece, or Rome. It was only used in exceptional cases, where the exoticism of the designs, as at 130 West Thirtieth Street or the Fred French Building, would help attract tenants, or at the Pythian Temple, where the Egyptian and ancient Near Eastern elements distinguished the building. The Pythian Temple also highlights the Neo-Antique strategy of visually stacking different cultures and forms together: here, the Egyptian and Assyrian. There was no proscriptive

process for engaging with ancient architecture; artists, architects, and patrons could pick and choose as they saw fit.

At the start of the twentieth century, the architectural, artistic, and commemorative landscape started to shift. While the first two decades of the twentieth century saw the erection of many of New York's greatest Neo-Antique buildings—like the New York Stock Exchange, the Bankers Trust Building, and Grand Central Terminal—modernism was dawning. As early as the 1880s there were already rumblings against classical and historical forms, and by the 1930s it had reached a fever pitch. Critics, for example Lewis Mumford, urged the rejection of classical forms in favor of new modern lines. While many modern buildings rejected antiquity's allegorical sculpture and architecture, the fundamental principles of classical design, which emphasized ratios, proportions, and mathematics, found clear expression in important mid-twentieth-century buildings, like the Seagram Building and Lincoln Center. Just because a building does not look classical does not mean it is not indebted to classical architecture.

While architects and patrons shifted away from ancient architecture, antiquity still held sway in other artistic media in the twentieth century. Classical myth remained a font to which artists, choreographers, and others returned repeatedly.[3] The innovative choreography and sets of Serge Diaghilev's *Ballets Russes* drew inspiration from antiquity.[4] The *Ballets Russes*, performed between 1909 and 1929, were, in the words of the curator Rachel Herschman,

> inspired by the ideals of ancient dance culture—by its ability to represent truths about the human condition. The values of antiquity represented a way to free body and spirit from repressive cultural forces by returning to a more cohesive, natural state while at the same time offering an alternative to the conventions of traditional ballet.[5]

Leon Bakst, a long-time associate of Diaghilev, designed sets that drew upon ancient Greece and Egypt.[6] Isadora Duncan also looked to newly discovered ancient artifacts for artistic inspiration.[7] Edward Steichen famously photographed her among the ruins of the Parthenon, a place of inspiration for her.[8] The reception of antiquity in the dramatic arts continues in New York to this day; the winner of the 2019 Tony for best musical was *Hadestown*, in which Hermes retold the entangled tales of Orpheus, Eurydice, Hades, and Persephone set against the background of a rough company town.

Artists working in the Art Nouveau style divested their art of classical forms, but they still looked to the myths and heroes of antiquity for their inspiration.[9] The engagements with ancient art continued through the twentieth century, and the early twenty-first century has seen a flourishing of artistic dialogues with antiquity. The exhibition *Liquid Antiquity* and its associated 2017 catalogue explored the multifaceted intersections between contemporary artists and classical culture.[10] The 2018 *Classical Now* exhibition at King's College, London, featured contemporary works of art that engaged with classical antiquity.[11] In 2020, Rayyane Tabet's *Alien Property* was staged in the galleries of the ancient Near East at the Metropolitan Museum of Art. Tabet's contemporary art installation focused on the reliefs from Tell Halaf, a famous Neo-Hittite site in modern-day Syria, and examined the intersections of imperialism, colonialism, archaeology, and cultural heritage

through a series of contemporary rubbings that were displayed alongside an ancient Neo-Hittite seated statue and reliefs.[12] Likewise, the Boston Museum of Fine Art's *Cy Twombly: Making Past Present* (2020) aimed to explore the intersections among ancient culture, art, and the painter's work. In New York, contemporary artists have also reinterpreted or engaged with the classical monuments of the city: Ai Weiwei brought New Yorkers back under the Washington Square Arch, and Tatzu Nishi created a living room around the Column of Columbus, where in the fall of 2012 you could surreally watch TV while on a couch next to Columbus. These monuments are not static relics of a bygone era but dynamic memorials that artists continue to reinterpret.

Neo-Antique buildings in New York have also had a rich afterlife. The Farley Post Office may be the best example; Governor Cuomo and others recognized what their predecessors had a hundred years ago—that a merely functional building does not make a great train station or bridge. Pennsylvania Station is miserable partially because it is simply utilitarian. Thus, the desire to turn part of the Farley Post Office into a new Amtrak/Long Island Railroad station reflects the idea that architecture should be functional, gracious, glorious, and, as Stuart would have said, symbolic. Thus, the criticism that historical buildings were too symbolic and not modern enough, which architectural critics like Lewis Mumford and others lay at the feet of Neo-Antique and other historical buildings, has fallen flat in the long run. New Yorkers want to have functional *and* beautiful train stations and buildings. Grand Central Terminal encapsulates this dynamic combination. Furthermore, many of these buildings—like the second Merchants' Exchange, now Cipriani Wall Street; or 130 West Thirtieth Street, now luxury condominiums—are desirable because they are beautiful, have a history, and have interiors adaptable to the changing demands of hotels, restaurants, homeowners, or businesses today. Beauty is not, however, singular in its definition; it is not simply a columnar ideal. There is beauty in the Seagram Building as much as in the Gould Memorial Library. Through contemporary artists' engagement with New York City's monuments, the staging of contemporary art exhibitions that dialogue with antiquity and archaeology, and the repurposing of older Neo-Antique buildings, ancient architecture remains a vibrant part of New York City's current architectural and artistic scene—not just a historical note from its past.

Neo-Antique architecture has played a major part in New York City's architectural history, but this is only one story about the influence of antiquity on New York City's art, architecture, urbanism, and cultural life. There are other stories that should be told. The role that interior designers played in bringing classical art and architecture to the elites of the Gilded Age is ripe for study. Likewise, the careers of artisans like Henry Erkins, who designed mass-produced replicas of ancient art and ancient-inspired furniture, as well as deeper looks into the design magazines that middle-class women consumed should prove fertile sites for research. The bulk of this book focuses on Manhattan and Brooklyn, so specific studies on the ancient architecture in these boroughs, as well as the Bronx, Staten Island, and Queens, would provide new insights into the scope of ancient architecture in the city. Likewise, more detailed studies on specific types of buildings, such as tombs, should also yield new insights and understandings into New Yorkers' engagements with antiquity. Popular entertainments staged by Barnum (at his Hippodrome) and others would

be another way to examine how New York's working-class population engaged with antiquity. The significance of Latin and Greek inscriptions in New York would be another obvious place to look for dialogues with antiquity in the city.

New York is a city of perpetual evolution. If one thing is constant about New York it is that change is inevitable. Antiquity—especially ancient architecture—has given New York's architects, patrons, bureaucrats, and citizens the freedom and creativity to erect exceptional buildings throughout its history and to this very day. From Staten Island's Snug Harbor to Lincoln Center, these Neo-Antique buildings, constructed through multifaceted and complex dialogues with ancient architecture, have indeed made New York one of the world's greatest metropolises and will continue to influence and shape the city's art, architecture, and cultural pursuits in the twenty-first century.

Note: These terms are defined with respect to their use in classical architecture and in the architecture of New York City. If a term is defined in the text, it has been omitted. This glossary is based on that in Macaulay-Lewis and McGowan (2018a).

acanthus: a type of herbaceous plant used extensively in classical decoration and in Corinthian and Composite capitals.

acroterion (-a pl.): an ornament or figure at the apex or lower angles of a pediment, often on a plinth.

agora: a public space in an ancient Greek city used for public assemblies and as a marketplace.

amphitheater: an oval-shaped arena where gladiatorial combat took place. An original type of Roman architecture.

anthemion: a floral design typically composed of a palmette or radiating petals. Used in decoration in classical architecture.

arcade: a row of arches supporting a wall; also, a covered, vaulted passageway.

arch: a curved structure over an opening that supports a wall, roof, bridge, or another opening above it. Also erected as a standalone honorific or commemorative monument.

architectural order: in classical architecture, a vertical assembly of a column, sometimes a base, and an entablature.

architrave: the lowest part or beam of an entablature, which rests on top of columns.

balustrade: a railing supported by balusters (small pillars or columns), often part of an ornamental parapet (the protective wall of a roof or balcony).

bas-relief: a sculptural relief where the carvings are slightly raised from the surface.

belt course: a continuous, horizontal row of stones or bricks; also known as a string course.

capital: the head of a column, pillar, or pilaster.

cavetto cornice: a concave molding at the top of a building with the profile of the quadrant of a circle. Characteristic of most Egyptian buildings, especially above temple doors.

clerestory: a window or series of windows located in the upper part of building.

coffering: a series of recessed panels, typically in the shape of a square, rectangle, or octagon, in a ceiling, soffit, or vault.

colonnade: a row of columns supporting a wall; also, a covered passageway.

column: an upright pillar, generally cylindrical, made of stone, brick, or concrete that supports an arch, entablature, or another structure. Also erected as a stand-alone honorific or commemorative monument, often surmounted by a statue.

Composite order: a classical order that has a base, a column, and a capital that combines the volutes of the Ionic order with the acanthus of the Corinthian order.

Corinthian order: a classical order that has a base, a column, and a capital where acanthus leaves are the primary decorative element.

cornice: the topmost element of the entablature, often decorative, in the classical orders; also, a horizontal decorative molding that tops a building or part of a building.

decastyle: a building with ten columns at one or both ends.

dentils: rows of small, tooth-like blocks, usually located on the underside of a cornice.

distyle: a building with two columns at one or both ends.

Doric order: a classical order with a column that normally has no base and a simple capital. Its frieze is composed of alternating triglyphs and metopes.

egg-and-dart: a decorative device where egg- and dart-shaped motifs alternate.

engaged columns: columns partially built into a wall and not freestanding.

entablature: a horizontal, continuous lintel that is supported by columns; it is composed of an architrave, frieze, and cornice.

frieze: the part of an entablature between the architrave and the cornice.

forum (-a pl.): a public space in ancient Roman cities used for public assemblies and as a marketplace.

garland: a decorative cord of leaves, fruits, and/or flowers.

Greek-cross plan: a plan with a square central mass and four arms of equal length.

hexastyle: a building with six columns at one or both ends.

hippodrome: a Greek arena with curved ends, used for chariot races; the Roman equivalent is a *circus*.

intercolumniation: the space between two columns.

Ionic order: a classical order composed of a base, a column, and a capital with volutes and carved moldings and a continuous frieze.

lintel: a horizontal structural beam or member that spans an opening (a door or window) and carries the weight of the wall above it.

lunette window: a semicircular arched opening or window in a wall or vaulted ceiling.

metope: a square space that alternates with a triglyph in a Doric frieze. Often decorated with sculpture.

octastyle: a building with eight columns at one or both ends.

oculus: a circular window in a façade or in the crown of a dome.

oecus: Latin for a room in a Roman house.

opus sectile: a floor- or wall-decoration technique using large, cut pieces of colored stone (typically marble) to make geometric or decorative patterns.

palmette: a stylized plant motif in which palm leaves are fanned out; used as ornamental decoration.

pediment: the triangular gable at the end of a classical building, often filled with sculpture in classical architecture. It can also surmount a portico or opening.

peripteral: a building with continuous row of columns around it.

pilaster: a shallow pier or column that projects only slightly from a wall, often similar to a column in one of the Classical orders with an entablature and sometimes with a capital.

pillar: a tall vertical structure of stone, wood, metal, or another material, used as a support for some type of a building, monument, ornament, or structure.

polis: ancient Greek for a city-state. The major political unit of ancient Greece.

portico: a structure with a roof supported by columns. It often serves as a porch and monumental entrance for a building.

roundel: a circle used to enclose decoration.

rosettes: a decorative motif in the form of a stylized rose, often with petals opening outward from the center.

rotunda: a large round room, often with a dome.

rostrum **(-*a* pl.):** the prow of an ancient ship. Often erected as symbol of naval victories.

spandrel: the triangular area between an arched opening and the wall or ceiling above it.

stadium: a Roman arena for athletics.

staff: a wood framework covered with a thick icing of molded white plaster over straw, used to create temporary architecture.

strigil: an instrument with a curved blade used by ancient Greeks and Romans to scrape sweat and dirt from one's skin after exercise or a bath; a common decorative motif on Roman sarcophagi.

tabula ansata: Latin for a table with handles, often depicted in architectural reliefs.

temenos: the inaugurated, bounded sacred space of a classical temple.

tetrastyle: a building with four columns at one or both ends.

thermae: the large public bath complexes erected in the Roman Empire.

tholos: an ancient circular building.

tondo **(-*i* pl.):** decorative roundel containing a painting or sculpture.

travertine: a type of white or light-colored limestone used extensively in ancient Roman architecture.

trireme: an ancient Greek or Roman warship with three banks of oars.

triglyph: part of a Doric frieze with three vertical grooves; it alternates with a metope.

uraeus **(- *i* pl.):** Latin for snake.

vault: an arched form that serves as a roof for an interior surface.

vestibule: an entrance hall.

ACKNOWLEDGMENTS

I could not have completed this manuscript without the help of many people. I am very grateful to John Ritter, Jared Simard, and Jennifer Udell, whose insightful comments on drafts of this manuscript and on particular chapters materially improved this book. Over the last few years, my discussions with Matt McGowan, Katharine von Stackelberg, and Jared Simard about reception studies have proved invaluable.

At CUNY, I am so grateful to my generous colleagues and students. My research assistants Vivian Chen and Katie Shapiro provided much needed help. My liberal studies students responded to readings in my various courses on New York City and offered new and different perspectives on these buildings and on New York's history that helped shape my thinking. The opportunity to present an early version of the funerary chapter at the Rewald Seminar was very helpful. At City College, Sydney Van Nort and Dalton Whiteside's assistance in the archives about Lewisohn Stadium and the "Marathon Stone" was gratefully appreciated, as was working with my colleague Matthew Reilly. Jeff Burden and Jason Montgomery of the Building History Project kindly drafted plans for this project. Carrie Hintz's guidance about the cost of eighteenth-century books was incredibly helpful. David Humphries provided reading suggestions about democracy and America's mercantile spirit. The librarians and staff of the Mina Rees Library at the Graduate Center also found countless articles and books for this project. At Bronx Community College, Cynthia Tobar, Remo Constantino, and Wendall Jenner were incredibly helpful when I was working on the Gould Memorial Library.

In my research on the Croton Aqueduct and Murray Hill Distributing Reservoir, I owe thanks to Thomas Lannon and the staff of the Brooke Russell Astor Reading Room for Rare Books & Manuscripts at New York Public Library. Thank you also to Lori Chein, of the Jervis Library, in Rome, New York, for her exhaustive help in trying to track down any and all primary documents about the Croton Reservoir and John Jervis. For my research on the New York State Memorial to Theodore Roosevelt at the American Museum of Natural History, Mai Reitmeyer's assistance was invaluable. Thanks are also due to the librarians and archivists at the Avery Library at Columbia University, the New-York Historical Society, the Amon Carter Museum of American Art, the Library of Congress, and the Frederick Law Olmsted National Historic Site. The archivists at the New York University Archives provided essential assistance when I was researching the Gould Memorial Library. Whitney Flynn at the Trinity Church archives and Jeff

Richmond and the volunteers in the archives at Green-Wood Cemetery were incredibly helpful.

The comments of the audiences at the various AIA/SCS Annual Meetings, the 2015 New York Classical Club conference, and the American Classical League Affiliated Panel at the 2018 annual meeting of the Society for Classical Studies (with special thanks to Ronnie Ancona, Jared Simard, and Kathleen Durkin, who organized the panel) were inspiring and helpful. The comments of the receptive audiences at the Open University, the University of Massachusetts at Amherst, the New York Public Library, and the Skyscraper Museum also informed this study.

Others provided constructive feedback or served as a sounding board for my ideas, including Harper Montgomery, Kim Benzel, Yelena Rakic, Sarah Graff, Charles Warren, and Anastasia Bakogianni. Subutay Musluoglu's tour of Grand Central was invaluable for gaining new insights into the terminal. Joe Greene kindly supplied information about Neo-Assyrian casts. Gilles Bransbourg kindly helped me track down a rare coin of Galba, which did not manage to appear due to COVID-19. Carol Willis's and Charles Warren's ideas about skyscrapers and more modern buildings were very helpful. Dragana Mladenović kindly photographed the Pantheon for me and read versions of several chapters. David Sider was my original partner in exploring the city, and his candor and insights were particularly helpful. David Gorgi's magical editing skills helped me become a better writer and reminded me not to exhaust the reader with every bit of detail. Susanna Throop's sensible advice and proofing of book proposals was also essential.

Funding for various aspects of this project came from the Graduate Center Provost's Research fund, the PSC-CUNY (which also has supported the City Seminar in Reception, which has been so generative for my work on reception studies), and the Classical Association of the Atlantic States, which funded my work on creating podcasts associated with the project.

At Fordham University Press, I am indebted to Fred Nachbaur, who has supported this project from its inception and seen it through all stages of development. I am also grateful to Eric Newman, Will Cerbone, and the staff of the Press for their support of this book and of *Classical New York*. Rob Fellman's attention to detail and editing skills also improved this manuscript. The comments of the anonymous readers were invaluable. All errors remain my own.

I owe thanks to my sister, Anne, for her support throughout this project. Ellie and Arthur helped scan images and cropped photographs for the book—all while tolerating their mother writing yet another book. Linda, my mother, helped by entertaining her grandkids so I could work, and she was always up for a tour. Carrots the bunny provided much need stress breaks and nibbled on more than one draft. The Onteora Library was once again an excellent place to write and edit.

This book is dedicated to the memory of two people: Judith S. McKenzie (1957–2019), a dear teacher, mentor, and friend, from whom I learned so much about the study of architecture and archaeology; and William E. Macaulay (1945–2019), my wonderful father,

who loved travel, history, and his hometown, New York City. He always thought a visit to a museum or cemetery with his daughter was a perfect way to celebrate his birthday—who wouldn't agree? You are with me always.

EML
New York City
March 2020

INTRODUCTION. FROM THE APPIAN WAY TO BROADWAY

1. For a discussion of these figures, see Chapter 4; also see Coleman (2019) and Pogrebin (2020). As of June 21, 2020, the American Museum of Natural History decided to remove the statue, because it had become a symbol of "systemic racism," according to museum president Ellen V. Futter (Pogrebin 2020).

2. Butler (2016, 1–20); Holmes (2016, 269–90).

3. Holmes (2018, 141).

4. Postclassicisms Collective (2019, 161–81).

5. Richard (1994).

6. Rosenthall (2016, 571–98).

7. McGowan (2018, 211–14, 229–30).

8. Carrott (1978); Giguere (2014).

9. von Stackelberg and Macaulay-Lewis (2017, 1–18).

10. Major works on classical reception studies include Martindale (1993), Martindale and Thomas (2006), Hardwick (2003), and Hardwick and Stray (2011). On the classical tradition, which also examines with the afterlife of the classical world, see Kallendorf (2007); Grafton, Most, and Settis (2010); Landfester (2006–2011); and Silk, Gildenhard, and Barrow (2014).

11. It builds on my earlier work (Macaulay-Lewis 2015, 2016, 2017, 2018a, 2018b) and Macaulay-Lewis and McGowan (2018a), which has essays on specific buildings, museum collections, art, and inscriptions.

12. Victoria and Albert Museum (2012).

13. On the reception of Egyptian art, architecture, and culture, see Carrott (1978), Brier (1992), Jeffreys (2003), Humbert and Price (2003), Ucko and Champion (2003), Moser (2012, 2015, 2020), Colla (2007), Rice and MacDonald (2009), and Giguere (2014).

14. von Stackelberg and Macaulay-Lewis (2017, 9).

15. Pedde (2001, 2012, 2013) is a notable exception.

16. von Stackelberg and Macaulay-Lewis (2017, 7).

17. Brinkmann and Wünsche (2007); Østergaard and Nielsen (2014); Panzanelli, Schmidt, and Lapatin (2008).

18. Robinson (1926, 4).

19. On polychromy in Near Eastern and Egyptian art, see Nagel (2014, 130–45; 2019, 45–58).

20. On Washington, DC, and Philadelphia, see Hamlin (1944, 22–89).

21. In general, see Hamlin (1944). On California, see Holliday (2016); on Chicago, see "Classicizing Chicago," https://classicizingchicago.northwestern.edu/; on San Francisco, New York, and Cleveland, see Ritter (2007; 2018, 114–39).

22. Dolkart (1982, 3).

23. Arrowsmith (1800, 112).

24. Bohn (1843, 682). Bohn was also selling a new edition of Stuart and Revett, which was compressed into two volumes, for fourteen pounds, fourteen shillings.

25. The 2019 prices are calculated using the Bank of England's inflation calculator: https://www.bankofengland.co.uk/monetary-policy/inflation/inflation-calculator.

26. Sowerby (1952–1959, 4:358–84).

27. Nichols (2003).

28. Sowerby (1952–1959, 1:vii).

29. Morrone (2018, 23n31).

30. Wallach (1998, 38–56); Born (2002). On casts from the ancient Near East in the Harvard Museum of the Ancient Near East, see Lyon (1903, 7) and Greene (2017, 57–69).

31. Ward, Marien, and Ward (2003).

32. See Macaulay-Lewis (2018c), my website that maps these sites: https://ancientarchny.commons.gc.cuny.edu/.

1. HERCULEAN EFFORTS: NEW YORK CITY'S INFRASTRUCTURE

1. Fitzsimmons et al. (2017).

2. Hu (2018).

3. On the grid, see Ballon (2012) and Koeppel (2015).

4. Ballon (2012, 27).

5. Addiss (2019).

6. Ballon (2012, 27).

7. Hoepfner (2003); Koeppel (2015, 2). On the grid in classical cities, see Ward-Perkins (1991).

8. Koeppel (2015, 3).

9. Koeppel (2015, 4).

10. Tower (1843, 57–59, 63).

11. Jervis (1842, 28).

12. Gray (2011).

13. Throughout this book, "America" and "American" refer to the United States of America and its inhabitants.

14. Jervis (1842, 1971); King (1843); Tower (1843).

15. Tower (1843, 122). $5.4 million was the original estimated cost (Tower 1843, 67).

16. Tower (1843, 10–11).

17. *New World* (1842, 32).

18. Fiske (1898, 32); Carrott (1978, 107).

19. Bill (1843) rendered for the City of New York for the erection of the Croton Aqueduct, signed by the contractor Thomas Price, New York City miscellaneous collection, New York Public Library, box 15, folder 26.

20. King (1843, 213).

21. Jervis (1842, 27).

22. Wilton-Ely (2003). The renewed European interest in ancient Egypt started in the mid–seventeenth century.

23. Dominique-Vivant Denon's *Voyage dans le Basse et Haute Égypte* (1802) also recounted part of this campaign.

24. Carrott (1978, 103).

25. "The Croton Aqueduct: Croton Aqueduct Distributing Reservoir" (1842, 2).

26. Carrott (1978, 106).

27. "Against the Beer Garden" (1891); "The Library Site Again" (1895); "The Old Reservoir" (1896); Gray (2011); Macaulay-Lewis and McGowan (2018b, 1–3).

28. *The Arch and Colonnade of the Manhattan Bridge Approach* (1975, 2).

29. *The Arch and Colonnade of the Manhattan Bridge Approach* (1975, 2).

30. Rowell (2012, 102n61); Sanger and Warmoes (2003, 58, fig. 5). François Blondel, the arch's architect, included a drawing of the Arch of Titus in his *Cours d'architecture enseigné dans l'Académie royale d'architecture* (Book 11, Chap. 4, 581).

31. Macaulay-Lewis (2016, 450–53, 472); Nichols (2017, 128–30).

32. *The Arch and Colonnade of the Manhattan Bridge Approach* (1975, 2).

33. Rumsey (1917, 311); Evren (1983).

34. On public sculpture of this era, see Bogart (1997) and Savage (1997).

35. See the discussion of sculpture on the New York Stock Exchange's façade in Chapter 3.

36. "To Beautify Manhattan Bridge" (1912, 12). The author also suggests that the Arc de Triomphe was a model.

37. "Manhattan Bridge Portal, New York" (1918, 32).

38. "Artistic Design for Manhattan End of New Bridge" (1912, 36).

39. Reier (2000, 29).

40. "Fine Approaches" (1913). He does not cite specific examples.

41. "To Beautify Manhattan Bridge" (1912, 12).

42. Hewitt et al. (2006, 217).

43. For more information and an extensive bibliography, see Fenske (2003).

44. I refer to Pennsylvania Station and Grand Central Terminal as stations, although Grand Central Terminal is technically a terminal (or terminus), where trains terminate.

45. On Penn Station's design and construction, see Ballon and McGrath (2002) and Jonnes (2007). On the connection to Roman baths, see DeLaine (1999a) and Gensheimer (2018, 161–81).

46. Gensheimer (2018, 161).

47. Gensheimer (2018, 161–62).

48. Pennsylvania Railroad Company (1910, 6).

49. Broderick (2010).

50. Fagan (1999); DeLaine (1999b); Yegül (1995); Hrychuk Kontokosta (2019, 45–77).

51. Gensheimer (2018, 164).

52. Broderick (2010, 13–22).

53. DeLaine (1999a, 153).

54. Gensheimer (2018, 170).

55. Moore (1929, 275). See also Ballon and McGrath (2002, 65n59).

56. DeLaine (1999a).

57. On Euston, see Pevsner (1997, 225–27, fig. 14.1) and DeLaine (1999a, 147–48). On the other stations, see Pevsner (1997, 226–27, figs. 14.3, 14.5).

58. Lombardi, Corazza, and Coarelli (1995, 58).

59. Gensheimer (2018, 172).

60. Gensheimer (2018, 164).

61. Huxtable (1963).

62. McGeehan (2017).

63. McGeehan (2017).

64. For a detailed discussion of the terminal's history, see Condit (1980), Powell (1996), Belle and Leighton (2000), and Schlichting (2001).

65. Schlichting (2001, 31).

66. Schlichting (2001, 31–32).

67. Schlichting (2001, 38).

68. "Topic of the Times" (1899, 6, col. 5).

69. For a detailed discussion, see Schlichting (2001, 55–114).

70. The building, now known as the Helmsley Building, had a Corinthian colonnade surmounted by a clock and two reclining figures of Mercury and Ceres.

71. Schlichting (2001, 57–60).

72. Schlichting (2001, 117–19).

73. Stem and Reed were illegally pushed out of the contract in 1911. Schlichting (2001, 122–23) and Belle and Leighton (2000, 55–56) give slightly different accounts of these events.

74. Warren (1913, sec. 9, p. 2, col. 3).

75. Warren (1913, sec. 9, p. 2, col. 3).

76. The constellations are inverted. Rather than seeing them as one would when looking up from earth, they appear as if one is viewing them from outer space.

77. Belle and Leighton (2000, 57).

78. Belle and Leighton (2000, 57).

79. Schlichting (2001, 130–54).

80. Adams (1987, 5).

81. "About Grand Central Terminal" (n.d.).

82. Belle and Leighton (2000, 3).

2. THE GENIUS OF ARCHITECTURE: ANCIENT MUSES AND MODERN FORMS

1. The epigraph to this chapter is from Verplanck (1824, 8–9). While "genius" in Latin is masculine, Anglophone personifications tend to be feminine. For example, Patriotism is female; see Chapter 8.

2. Verplanck (1824, 12).

3. Verplanck (1824, 9–10).

4. Verplanck (1824, 13).

5. Verplanck (1824, 10).

6. Verplanck (1824, 14).

7. Verplanck (1824, 15). Gothic was also permissible, if done correctly.

8. Verplanck (1824, 11).

9. Verplanck (1824, 14).

10. Also see the Introduction.

11. For a discussion of other building manuals, see Chapter 5.

12. Morrone (2018, 15).

13. Morrone (2018, 17).

14. See Chapter 3.

15. Hamlin (1944, 24–28, plates V–VIII, fig. 3). Charles Bullfinch oversaw the reconstruction of the building in a classical style; see "History of the U.S. Capitol Building—Architecture."

16. See the Introduction.

17. Sowerby (1952–1959, 1:vii).

18. Morrone (2018, 23–24).

19. Richard (1994, 12–38).

20. Winterer (2002, 1, 5, 15).

21. Winterer (2002, 15).

22. Winterer (2002, 25); Webster (2015, 33).

23. Turner (2002, 198).

24. Dyson (2001, 60).

25. Ross (1835, 492).

26. Morrone (2018, 20).

27. Pierson (1970, 417).

28. Morrone (2018, 21).

29. Homberger (2002, 50).

30. Peck (1992) contains extensive illustrations of his work.

31. Morrone (2018, 23–24).

32. Isaiah Rogers oversaw the building's completion in 1858.

33. Boston's Greek Revival Custom House (1849), on India Street, designed by Ammi Young (1798–1874), also combined a Doric portico and Pantheon-like dome. For a detailed discussion of the Pantheon, see Chapter 4.

34. Morrone (2018, 25). On Snug Harbor, see Chapter 9.

35. Morrone (2018, 26).

36. Torres (1964, 146); Morrone (2018, 26). The second floor and basement also contained offices.

37. Morrone (2018, 30).

38. Morrone (2018, 30).

39. Morrone (2018, 31).

40. Morrone (2018, 32–33, fig. 1.9).

41. Morrone (2018, 34).

42. *Brooklyn Borough Hall* (1966); Dolkart (2010, 174).

43. Morrone (2001, 39–40).

44. Gray (1987).

45. Cassas (1800, vol. 2, plates 54, 56, 57); Gordon (2013).

46. On the process of triangulation, see Macaulay-Lewis (2016, 472).

47. Ritter (2007; 2018, 114–39).

48. *Municipal Building* (1966).

49. Nash (2010, 21).

50. "The David N. Dinkins Manhattan Municipal Building."

51. For example, see the Tennessee State Capitol (1845) and the Soldiers' and Sailors' Monument in Manhattan (1920).

52. Ritter (2007, 210–64; 2018, 125–35).

53. Ritter (2018, 126–27, figs. 5.7–8).

54. Gilbert had already designed the similar Union Central Life Insurance Co. Building (1911–1913) in Cincinnati.

55. The Mausoleum of Halicarnassus is discussed in the next chapter in reference to the Bankers Trust Building. See Pliny the Elder, *HN* 36.30–31; and Vitruvius, *De arch.* 2.8.10–15.

56. Mumford (1955, 57–59).

57. Ritter (2007; 2018, 114–39). Not all of these buildings were completed.

58. Baigell (1965, 270).

59. This system, also called the separate system, advocated for solitary confinement to prevent moral corruption from transferring from a guilty inmate to another. The single cells were also intended to enable inmates to reflect on their ill deeds, repent, and reform (Trafton 2004, 152–53). American prison architecture reflected different views on the punishment and reformation of incarcerated (Johnston 2006).

60. Baigell (1965, 270–71).

61. Baigell (1965, 271).

62. Baigell (1965, 271).

63. Carrott (1978, plates 107, 110).

64. Carrott (1978, 120).

65. Carrott (1978, 120).

66. Baigell (1965, 241n53, 273).

67. Carrott (1978, 81).

68. Carrott (1978, 165).

69. Carrott (1978, 120).

70. Baigell (1965, 274).
71. Baigell (1965, 274–75).
72. As quoted in Carrott (1978, 164).
73. As quoted in Baigell (1965, 275).
74. Peck (1992, 46, fig. 2.11; color plate 27).
75. Baigell (1965, 177–78).
76. Gilfoyle (2003, 526).
77. Baigell (1965, 178).
78. Disturnell (1837, 25).
79. Disturnell (1837, 25).
80. Disturnell (1837, 25).
81. Trafton (2004, 151) and Carrott (1978, 165) note other problems with this theory. Charles Sutton, the former warden of the prison, repeated this story in his memoir (1973, 48).
82. "New House of Detention" (1837).
83. "Death of an Eminent Artist" (1852).
84. Gilfoyle (2003, 528).
85. "The Tombs, New York's Historic Prison, Now Being Torn Down" (1897).
86. "Pictures of Life in New York: John Henry Visits the Tombs" (1875).
87. "How About the Tombs Facade?" (1897, 8).
88. "The Tombs Prison Last Days of the Famous New York Building" (1897).
89. Ryan (2000, 1152–53).
90. For a detailed study of the building, see Architectural League of New York, and Association of the Bar of the City of New York (1977).
91. Dolkart (1982, 2).
92. Dolkart (1982, 1).
93. Baigell (1965, 176); Trafton (2004, 148).
94. Richard (1994); Winterer (2002).
95. Dolkart (1982, 3).

3. TREASURIES OF OLD AND TREASURIES OF NEW

1. Pevsner (1997, 200–1, fig. 12.15).
2. Fletcher (1987, 1058); Pevsner (1997, 201–2, figs. 12.16–19, 12.21).
3. Pevsner (1997, 204–5, figs. 12.33–34).
4. Pevsner (1997, 203–6, figs. 12.20–37).
5. The façade has been in the American Wing of the Metropolitan Museum of Art since 1924.
6. Heckscher (2000, 170).
7. Cooper (1993).
8. Landau and Condit (1996, 6–7).
9. Landau and Condit (1996, 6–7), Heckscher (2000, 171), and the lithograph in the Metropolitan Museum of Art date the bank to between 1824 and 1829.
10. It was under construction by May 1835 (O'Gorman 2015, 67).
11. O'Gorman (2015, 67).
12. O'Gorman (2015, 67).
13. O'Gorman (2015, 67).
14. Stuart and Revett (1762, vol. 1, chap. 3, 13–25, plates 3–4).
15. Morrone (2018, 30).
16. They also designed the expansion of Bank of Montreal (1903–1905) in Canada and the Girard Trust Company in Philadelphia (1904–1908).

17. Gordon's (1998, 219–22) comprehensive catalogue of MacMonnies work does not identify them.

18. Capitale, "Architecture." In 2020, the building was again up for sale.

19. Roth (1983, 302).

20. Schuyler (1904, 444).

21. On the Maison Carrée, see Gros (1996, 155–59, figs. 179–81) and Wilson Jones (2000, 66–69, figs. 3.28–31). Roth (1983, 302) also notes other Roman comparanda.

22. Schuyler (1904, 437).

23. Gray (2009a).

24. Schuyler (1904, 444).

25. Schuyler (1904, 436).

26. Schuyler (1904, 436).

27. As quoted in Gray (2009a).

28. Landau and Condit (1996, 7) give the date of 1826; Hamlin (1944, 149) gives the date of 1831; Heckscher (2000, 183, fig. 144). Hamlin incorrectly locates the store on Wall Street (contra Tappan 1870, 273). It was rebuilt after the fire of 1835.

29. Landau and Condit (1996, 7).

30. Wilson Jones et al. (2003).

31. Postal (2005, 3).

32. McEntee (1921, 20).

33. Postal (2005, 5).

34. Postal (2005, 2).

35. Kurshan (2001, 2).

36. Kurshan (2001, 3).

37. Kurshan (2001, 5).

38. Ferriss (1929, 98).

39. Graff (2014, 266–67).

40. Graff (2014, 266–67).

41. Graff (2014, 269, see no. 140).

42. Kurshan (2001, 4) identifies these as antelope.

43. Kurshan (2001, 4).

44. Louvre no. AM 255. A similar chariot relief from Tell Halaf (no. 43.135.2) is now in the Metropolitan Museum of Art. Sarah Graff and Yelena Rakic kindly brought these references to my attention.

45. Kurshan (2001, 4); also see Department of Ancient Near Eastern Art, "Animals in Ancient Near Eastern Art."

46. Betts (2001, 73).

47. Layard (1849, 1854, 1849–1853, 1852, 1853).

48. Collon et al. (2003). Susa had the famous bull capitals. Babylon was excavated by the Germans, and their most spectacular finds come from the start of the twentieth century, including the polychrome Ishtar Gate.

49. Seymour (2015, 18–34).

50. The Produce Exchange, built in 1881 of red brick and terra cotta at Bowling Green, had a façade with a portico with what was described as "Roman Doric Columns" (Sturgis 1898, 29–30).

51. Fletcher (1987, 1062B); Morrone (2018, 19); Heckscher (2000, 171).

52. Morrone (2018, 19).

53. Heckscher (2000, 171, fig. 130).

54. Kurshan (1999, 2); O'Gorman (2015, 58–63, figs. 18–20). Rogers would also design Boston's Merchant's Exchange (1842–1890), which had a classical temple façade (O'Gorman 2015, 88–100, fig. 30).

55. Kurshan (1999, 3).
56. Pollitt (1986, 2–3); Matheson and Pollitt (1994).
57. Pevsner (1997, 203–5, figs. 12.33–34).
58. Roth (1983, 304).
59. Kurshan (1999, 2).
60. As quoted in Kurshan (1999, 2).
61. As quoted in Kurshan (1999, 4n19).
62. Kurshan (1999, 3).
63. Holusha (1998).
64. Stargard and Pearson (1985, 1, 3–4).
65. Stargard and Pearson (1985, 3).
66. Malamud (2009, 150–65).
67. Stuart (1901, 537).
68. For a discussion of the figures and detailed photographs, see Sturgis (1904, 476–81).
69. Sturgis (1904, 481); Stargard and Pearson (1985, 5) identified these figures as a mechanic and his helper and thus as Motive Power.
70. Stargard and Pearson (1985, 5).
71. Sturgis (1904, 481) does not identify them.
72. Sturgis (1904, 481); Stargard and Pearson (1985, 5).
73. Stuart (1901, 526–27).
74. Sturgis (1904, 467). Also see Sturgis (1898, 4–5).
75. Sullivan (1896, 406).
76. Sullivan (1896, 407).
77. The building was among the first to use a cofferdam foundation system in New York (Harris 1997, 1). It was steel-framed construction with granite.
78. Harris (1997, 1).
79. Later modified and went to five stories (Harris 1997, 6).
80. Nash (2010, 15).
81. The building is either twenty-one stories (Harris 1997, 6) or twenty stories (Nash 2010, 15).
82. Nash (2010, 15).
83. Harris (1997, 1, 3).
84. "The Bankers Trust Company Building" (1912, 245).
85. Pliny the Elder, *HN* 36.30–31. Vitruvius's description of Halicarnassus (*De arch.* 2.8.13) only mentions the Mausoleum briefly.
86. Waywell (2003).
87. Vitruvius calls Pythias Pytheos and identifies him as one of the Mausoleum's two architects (*De arch.* 7.Pref.12–13). Also see Waywell (2003).
88. Pliny and Vitruvius differ over the sculptors; for a summary, see Waywell (2003).
89. Newton excavated in 1856–1858 and published his accounts (1862–1863). Kristian Jeppesen led important excavations in 1966–1976 (Jeppesen and Zahle 1975; Jeppesen 1976, 1977–1978). On the sculpture, see Smith (1900, 65–135) and Waywell (1978).
90. Newton (1862–1863, 157–58).
91. "A Notable Skyscraper" (1912, 66); "The Bankers Trust Company Building" (1912, 245).
92. "A Notable Skyscraper" (1912, 63).
93. "A Notable Skyscraper" (1912, 62).
94. On the misidentifications for the sources of Jay Gould's tomb, see Chapter 7.
95. Harris (2006, 5). The rest of the AT&T building also drew on classical forms, and the upper-story columns derived from the Temple of Artemis at Sardis (Harris 2006, 5).
96. Christen (2009, 68); Irish (1999, 136).

97. Christen (2009, 54); Irish (1999, 136).

98. Nash (2010, 15).

99. "The Bankers Trust Company Building" (1912, 246).

100. Landau and Condit (1996, 379).

101. Nash (2010, 15).

102. Harris (1997, 4).

103. Breiner (1988).

104. Galanos and Adams (1986, 6).

105. Nash (2010, 39) sites only Babylon as the inspiration.

106. Galanos and Adams (1986, 8).

107. Although Sloan & Robertson were probably responsible for the design (Galanos and Adams 1986, 7), Ives was the driver behind the ancient Near Eastern motifs (Krinsky 1982, 287).

108. As quoted in Kurshan (2001, 4).

109. On the Tower of Babel, see Genesis 11:3–4. On the association of the Tower of the Seven Planets with the Tower of Babel, see Furnival (1904, 27–28). No ancient evidence confirms whether the Tower of Babel was polychrome.

110. Krinsky (1982, 287). The idea of Hanging Gardens was also at play at Rockefeller Center, as the setbacks were to be planted, but they never were (Simard 2016, 150).

111. As quoted in Krinsky (1982, 287).

112. Galanos and Adams (1986, 10).

113. Krinsky (1982, 287–88). The Neo-Babylonian glazed bricks that lined the processional way to the Ishtar Gate at Babylon are a good example of this tradition.

114. Layard (1849, 1849–1853).

115. Krinsky (1982, 287–88); Tunick (1997, 79–80, figs. 89–90). Also see Gray (1992).

116. Tunick (1997, 72, fig. 82).

117. Galanos and Adams (1986, 5).

118. Galanos and Adams (1986, 11).

119. Nash (2010, 39) observed that the lobby motifs were modeled after the Ishtar Gate.

120. See Roaf (2003, 207). Persepolis, while known since the early seventeenth century, was not subject to systematic excavations until the 1930s by the Oriental Institute of the University of Chicago (Root 2003).

121. Galanos and Adams (1986, 1).

122. Galanos and Adams (1986, 1).

123. Thank you to Jon Ritter for his insightful suggestions about modernism's relationship to classical architecture.

124. Roth and Clark (2014, 578).

125. Roth and Clark (2014, 578–79, fig. 19.22).

126. On the building's design and construction, see Lambert (2013).

127. Mumford (1959, 19–20).

128. Anderson (1991, 79–82); Vidler (2019).

129. As quoted in Stern, Mellins, and Fishman (1995, 344).

130. On the mathematical principles of Roman architecture and their role in design, see Wilson Jones (2000, 49–132).

131. Schulze (1985, 275).

132. Breiner (1989, 5).

133. Schulze (1985, 277–78).

134. Simard (2016; 2018, 140–60).

135. Prettejohn (2012).

136. Silver (2010). On the artistic movements in Europe after World War I, see Green and Daehner (2011).

4. MODERN *MUSEIONS*

1. Burrows and Wallace (1998, 467).

2. Burrows and Wallace (1998, 468).

3. Hagaman (1910, 397–98); Burrows and Wallace (1998, 468); Heckscher (2000, 170, 424, cat. 70).

4. Hagaman (1910, 397). The dome was between 54 and 56 feet in diameter. Three surviving engravings of the Rotunda have different depictions of the sculptural detailing over the arch and the inscription over the door (Alexander Jackson Davis Collection, New-York Historical Society, nos. 22, 23, 24).

5. Hagaman (1910, 397–98).

6. Winterer (2002, 15, 110).

7. Heckscher (1995, 5).

8. Heckscher (1995, 18).

9. As quoted in Heckscher (1995, 18).

10. Heckscher (1995, 23, fig. 28).

11. As quoted in Heckscher (1995, 24–25).

12. Created by Rafael Guastavino, his patented title arch system was used extensively in late nineteenth- and early twentieth-century New York.

13. Heckscher (1995, 38). Saint-Gaudens did not actually like the effect.

14. Heckscher (1995, 36–37). Karl Bitter (1867–1915), the Austrian American sculptor, carved the sculptures.

15. Robinson (1926, 3–4).

16. On the collection's formation, see Bartman (2018, 63–84).

17. Letter from Edward Robison to McKim, Mead & White. McKim, Mead & White Archive, 42, box 262, The New-York Historical Society (hereafter, Archive-NYHS). Robinson discussed the court with Mr. Stevens, presumably Gorham Philip Stevens, the director of the American Academy in Rome from 1917 to 1936.

18. Robinson (1926, 4).

19. Robinson (1926, 4).

20. Robinson (1926, 4).

21. See von Stackelberg (2017, 232–68) on the Getty Villa, the Pompeia (in Saratoga Springs, New York), and the Crowninshield garden (Delaware), which she sees as spaces that used a strategy of immersive hyperreality.

22. Picon et al. (2007, 15–16, fig. 19).

23. Roth (1988, 29).

24. This building was demolished during the construction of the approaches to the Brooklyn bridge (Roth 1988, 33–34, fig. 1.6).

25. Roth (1988, 32).

26. Roth (1988, 32).

27. Roth (1988, 32).

28. "Plan No. 6 The Winner" (1893).

29. Roth (1988, 37n37).

30. McKim, Mead & White Archive, box 182, Archive-NYHS.

31. "Brooklyn Institute: The Plans for Its New Building and How They Were Selected" (1894).

32. "Pediment for the Brooklyn Museum."

33. "Pediment for the Brooklyn Museum."

34. Wallach (1998, 38–56). The Boston Athenaeum acquired its first casts in 1822 and had a major exhibition that included casts in 1827 (Born 2002, 8).

35. Roth (1988, 39).

36. *New-York Historical Society* (1966).

37. *Audubon Terrace Historic District* (1979).

38. Pevsner (1997, 111–38).

39. Today it is known as the Wildlife Conservation Society.

40. For a history of zoos in the United States, see Hyson (1999).

41. Gerety (2010, 225).

42. Bridges (1974).

43. Scott (1981, 54).

44. Postal and Brooks (2000, 3).

45. First Annual Report (March 15, 1897), as quoted in Postal and Brooks (2000, 3).

46. As quoted in Scott (1981, 56).

47. Postal and Brooks (2000, 3).

48. Postal and Brooks (2000, 2).

49. Postal and Brooks (2000, 5).

50. Scott (1981, 58); Postal and Brooks (2000, 5).

51. *The American Museum of Natural History* (1967, 1).

52. Pindar (1930, 285).

53. Osborn (1922, 19–20).

54. "Great Roosevelt Memorial" (1922, 93).

55. Letter from Trowbridge & Livingston to Henry Fairfield Osborn, January 10, 1925, Central Archive, 1178.3, AMNH. Their designs were published in "Great Roosevelt Memorial" (1922, 93) and are held in the AMNH archives.

56. Osborn (1928, 13).

57. Osborn (1928, 13).

58. Coleman (2019).

59. Pogrebin (2020).

60. Pindar (1931, 15).

61. Mackay and Canfield (1944, 2).

62. New York State Roosevelt Memorial, notes on Joint Conference, April 4, 1929, Central Archive, 1178.3, AMNH, 4.

63. Mumford (1998, 69).

64. Turner (1995).

65. This discussion builds on Macaulay-Lewis (2018a, 85–113).

66. Kostof (1995, 217); Thomas (1997, 163); Claridge (2010, 226–34).

67. Hetland (2007, 95–112).

68. Thomas (1997, 171–74).

69. Davies (1987, 133–53); Wilson Jones (2000, 177–213).

70. Beyer (2003); Macaulay-Lewis (2018a, 89–90).

71. Macaulay-Lewis (2018a, 98–101, fig. 4.8).

72. Broderick (2010, 394–99).

73. McKim had an active role in the design of the new campus; for more information, see Bergdoll, Haswell, and Parks (1997).

74. Broderick (2010, 395).

75. Mumford (1955, 64).

76. Pearson (1997, 5).

77. Rudy (1949, 327).

78. City College Stadium dedication pamphlet, Lewisohn Archive, box 1, City College.

79. City College Stadium dedication pamphlet, Lewisohn Archive, box 1, City College.

80. Rudy (1949, 330); "Stadium for the Whole City; The Donor, Adolph Lewisohn, Tells of Program for 1916" (1915).

81. "Lewisohn Stadium, Center for Culture, to Be Razed" (1973).
82. Camp (1996, 10).
83. Lord (2009).
84. The Lenox Library was built by Richard Morris Hunt in the French "Neo-Grec" style, another classicizing style (Lord 2009, 4–5, 17, 105–44).
85. He also gifted his library.
86. "The Piccirilli Brothers."
87. *The Yorkville Branch of the New York Public Library* (1967).
88. The Morgan Library has classicizing Renaissance architecture.
89. Bobinski (1969).
90. Winterer (2002).
91. Winterer (2002, 142).
92. Broderick (2010, 395).

5. TOGAS AT HOME

1. Bushman (1992, 239).
2. Bushman (1992, 412–13).
3. Bushman (1992, 264–65, 304).
4. Bushman (1992, 264).
5. Hamlin (1944, 92).
6. Cooper (1993, 15).
7. Hamlin (1944, 194–210, plates XLIX–LVI, 238–48, plates LXIX–LXXI). On the Greek Revival in the United States, see Kennedy (2010).
8. Heckscher (2000, 179, 431, cat. 86).
9. "La Grange Terrace" (1836, 5).
10. Price (1911, 245).
11. Diamonstein-Spielvogel (2016, 135).
12. Price (1911, 246).
13. Stuart and Revett (1762, vol. 1, chap. 4, 27–36, plates 1–26); Price (1911, 247).
14. Price (1911, 247).
15. "La Grange Terrace" (1836, 5).
16. Knapp (2012, 29, fig. 25).
17. Knapp (2012, 36–37, fig. 29).
18. Hamlin (1944, 340–55).
19. Hamlin (1944, 142).
20. Knapp (2012, 31).
21. Cooper (1993, 45).
22. Knapp (2012, 37–38).
23. Bushman (1992, 419).
24. Hoganson (2002, 57; 2007, 14–15).
25. Nichols (2017, 131); Taube (2015).
26. Hoganson (2007, 15–20); Taube (2015).
27. Winterer (2002, 110, 142–51).
28. Nichols (2017, 126–52).
29. Nichols (2017, 129, fig. 4.1).
30. Kuttner (2017, 24–53, also see her extensive bibliography, 281–83).
31. Kuttner (2017, 46).
32. Kuttner (2017, 24–53).
33. Bulwer-Lytton (1946, 14–29) references the "House of the Dramatic Poet" as the model.

34. On the Pompeian court at the Crystal Palace, see Hales (2006, 99–134), Nichols (2015), and Hales and Earle (2017, 179–208).

35. Nichols (2017, 151).

36. Nichols (2017, 146, fig. 4.9).

37. Late nineteenth-century scholars gave this name to the domestic remains to the southwest of the Domus Tiberiana on the Palatine Hill. See Lanciani (1894, 109, 119; on unlabeled map, no. 34).

38. Sheldon (1883, 76).

39. "The Morgan House."

40. Sheldon (1883, 76).

41. Nichols (2017, 144). The mansion's location is not noted in "Two Highly Interesting Rooms" (1903, 4).

42. Nichols (2017, 144–45).

43. "Two Highly Interesting Rooms" (1903, 4).

44. See Nichols (2017, 135–46) on the designers of such interiors and the literature on American interior design.

45. "Vanity Fair—Fads, Foibles, and Fashions" (1889, 118).

46. Nichols (2017, 138).

47. Nichols (2017, 135).

48. Nichols (2017, 135–38).

49. Nichols (2017, 131).

50. Constantino Burmidi's Pompeian mural of the Naval Affairs Committee Room (now the Senate Appropriations Committee Room) in Washington, DC, was considered to be too opulent, foreign, and effeminate by some (Nichols 2017, 133–35, fig. 4.2). Also see Frieland (2019, 2–15).

51. Nichols (2017, 133).

52. Spofford (1878, 131).

53. Nichols (2017, 132–33, 136–38, figs. 4.4–4.5).

54. Kisluk-Grosheide (1994, 151).

55. Deusner (2011, 757).

56. Kisluk-Grosheide (1994, 152).

57. Deusner (2017, 40, fig. 41); Morris (2017, 97).

58. Morris (2017, 97).

59. Deusner (2017, 41).

60. Deusner (2017, 41).

61. Deusner (2017, 41–43).

62. Deusner (2017, 57–58).

63. Deusner (2017, 57).

64. Deusner (2017, 56).

65. Morris (2017, 97).

66. Marquand would have undoubtedly read the 1879 *New York Times* report on the house (Morris 2017, 99–100).

67. Morris (2017, 111).

68. "Furniture designed by L. Alma-Tadema, R.A." (1885, 122).

69. Nichols (2017, 140–41).

70. Morris (2017, 103).

71. Kisluk-Grosheide (1994, 158–60).

72. Kisluk-Grosheide (1994, 160–62, 164, fig. 20–21).

73. Morris (2017, 116–17).

74. A letter from Leighton to Marquand, May 17, 1886, Metropolitan Museum of Art Archive.

75. The paintings were rotated. See Goodin and Morris (2017a, 88, 90, 92); compare plates 4 and 6 to 8 to see how this wall was hung at different times.

76. Kisluk-Grosheide (1994, 165, figs. 23–24).

77. Kisluk-Grosheide (1994, 163).

78. Morris (2017, 118).

79. See Goodin and Morris (2017a, 89, plate 5).

80. Morris (2017, 107). It is now in the Metropolitan Museum of Art, MMA #67.44.1.

81. Morris (2017, 119, fig. 112, cat. 27). Similar examples were made in London at this time; see Morris (2017, 119, fig. 113).

82. Morris (2017, 107, 119). Thirty-two ancient vases were sold in the estate sale, and most are now in the Metropolitan Museum of Art.

83. Morris (2017, 106–7, fig. 86, cat. 53).

84. Morris (2017, 108–9, fig. 87–88, cat. 55–56).

85. Morris (2017, 101).

86. Morris (2017, 111–13, figs. 95–96, cat. 43, 28).

87. Morris (2017, 113).

88. Morris (2017, 113–14).

89. Morris (2017, 114–16).

90. Morris (2017, 117, fig. 109, cat. 43).

91. Morris (2017, 111, figs. 95–96, cat. 43, 28).

92. Morris (2017, 121).

93. "Old World news by cable" (1887, 1).

94. Morris (2017, 123).

95. "Curiosities of Cost" (1888, 64).

96. Deusner (2011, 765–66).

97. Deusner (2017, 59).

98. Goodin and Morris (2017b, 139).

99. Goodin and Morris (2017b, 140).

100. Goodin and Morris (2017b, 148).

101. Deusner (2017, 60).

102. Deusner (2017, 61).

103. Deusner (2011, 769).

104. Malamud (2009, 172).

105. "How the Ancients Employed Color" (1881, 57) and "Furniture of the Ancients" (1882, 129).

106. "Industrial Art" (1880, 60–61).

107. Malamud (2009, 172–73). Henry Erkins, whose restaurant interiors are discussed in the next chapter, designed and sold his own ancient-inspired furnishings.

108. Bloom (2001, 284–85); Malamud (2009, 172).

109. Malamud (2009, 172).

110. As quoted in Goeschel (1987, 4).

111. Goeschel (1987, 6); Diamonstein-Spielvogel (2016, 686).

112. Goeschel (1987, 6); Diamonstein-Spielvogel (2016, 686).

113. Goeschel (1987, 6).

114. Malamud (2009, 173–79).

115. Holmes (2018, 141–46).

6. DINING LIKE NERO

1. Broadway was called the Great White Way because it was illuminated by an estimated million electric lights by 1900 (Churchill 1982).

2. This chapter expands on Macaulay-Lewis (2018b, 13–19).

3. Lobel (2010, 194).

4. Until the 1850s, most restaurants were segregated by gender (Lobel 2010, 207–8).

5. Erenberg (1981, 35).

6. Erenberg (1981, 36).

7. Lobel (2010, 219).

8. Erenberg (1981, 36).

9. Erenberg (1981, 36).

10. Erenberg (1981, 36).

11. Erenberg (1981, 36–37).

12. Lobel (2010, 202–4).

13. The restaurant moved locations in Manhattan several times during the nineteenth century.

14. Erenberg (1981, 35–36).

15. Erenberg (1981, 51).

16. Nichols (2017, 147n35).

17. Nichols (2017, 147n36).

18. Nichols (2017, 147).

19. Nichols (2017, 147).

20. Nichols (2017, 147–51).

21. Augustus Mau (1902, 471–84) identified four styles of Pompeian wall paintings. The first, or "incrustation," style (late first century BCE) imitates Hellenistic ashlar architecture. The second style, the "architectural style" (c. 80 BCE to end of the first century BCE), uses realistic architecture to frame illusionistic views of landscapes and/or architecture. The third style (c. 50 BCE to c. 40–50 CE) features ornate architecture that became more stylized, spindly, and unrealistic. Flat blocks of bright colors were used, and the so-called sacro-idyllic scenes of small shrines and pastoral livestock were also incorporated. The fourth style (c. 40–50 to 79 CE) combined these three earlier types and incorporated other themes, including mythology, genre, and landscape. On the problems of the "four styles" as an interpretive lens, see Clarke (1991) and Strocka (2008, 304, 307, 311–15).

22. Nichols (2017, 147).

23. Nichols (2017, 149).

24. Nichols (2017, 148–49, fig. 4.10).

25. Bevington (1908) refers to it as The Roman Gardens of Murray's, The Roman Garden of Murray's, and Murray's. Erkins (1906–1907, 574) calls it Murray's Roman Gardens.

26. Malamud (2009, 166) provides a date of 1907, but Bevington (1908) provides a date of "A.D. 1906" for the restaurant.

27. Bevington (1908).

28. Bevington (1908).

29. Nichols (2017, 146–47).

30. Bevington (1908).

31. Murray also owned Murray's Italian Gardens (at Thirty-Fourth and Broadway), which used Greek, Egyptian, and Roman-style sculptures in its decoration.

32. Bevington (1908).

33. Similar claims were made of the Pompeia in Saratoga Springs (von Stackelberg 2017, 233).

34. Bevington (1908).

35. Macaulay-Lewis (2016, 472).

36. Wallach (1998, 38–56); see the discussion of casts in Chapter 4.

37. Bevington (1908).

38. Suetonius, *Ner.* 31.2, described a revolving dining room. Recent excavations demonstrated that this room was located on the Palatine Hill under the Vigna Barberini (Villedieu 2010, 1089–1114; 2016, 107–26).

39. Malamud (2009, 168).
40. Bevington (1908).
41. Malamud (2009, 3).
42. Malamud (2009, 179–80; 2018, 38–62).
43. Malamud (2018, 57).
44. Malamud (2009, 165).
45. Malamud (2009, 166).
46. Bevington (1908).
47. Erkins (1906–1907, 574).
48. The painters Llewellyn Dodge, Heins Meixner, and Joseph Klar decorated the interiors (Bevington 1908).
49. Bevington (1908).
50. Erkins (1906–1907, 575).
51. Erkins (1906–1907, 575).
52. Erkins (1906–1907, 575).
53. Scientific excavations of Roman gardens would only start in the 1950s with the pioneering work of Wilhelmina Jashemski at Pompeii (1979–1992; Jashemski et al. 2018)
54. D'Arms (1970, 90–91, 94–96). Nero attempted to murder Agrippina by rigging her boat to collapse (Suet., *Ner.* 34.1–5; Tac., *Ann.* 14.1–8). Caligula also sailed on two pleasure barges on Lake Nemi (Carlson 2002, 26–31).
55. The term *tholos* also applied to ancient beehive tombs, but here the tholos is a circular structure like the Sanctuary of Athena Pronaea at Delphi, the Doric Temple at Hadrian's Villa, or the tholos on the west side of the Athenian Agora.
56. Erkins (1906–1907, 574).
57. Bevington (1908).
58. Neither Bevington nor Erkins give the exact location of these paintings.
59. "The Bath of Psyche."
60. Other paintings depicted Aphrodite or Venus and other women bathing.
61. Erenberg (1981, 50–52).
62. Bevington (1908).
63. See Irwin (1997, 332–33, fig. 190).
64. There was also a Gothic room off the balcony, but no record of its appearance survives, and another Roman-themed room.
65. Bevington (1908).
66. Erenberg (1981, 53).
67. Malamud (2000, 65; 2009, 179–80).
68. "Max Schaffer, 83, Who Operated Hubert's Museum, Arcades, Dies" (1974). See also Gray (1996).
69. Gray (1996).
70. "Famous Landmark Lost to Times Sq." (1915). Wallace (2017, 427–28) reported that the investment was $4 million with another $1.25 million for the interior. "New Restaurant Wonders" (1909) puts the amount at $4 million.
71. "The Café de l'Opéra" (1910, 155).
72. "The Café de l'Opéra" (1910, 155).
73. "The Café de l'Opéra" (1910, 155).
74. "The Café de l'Opéra" (1910, 155).
75. "The Café de l'Opéra" (1910, 155).
76. "New Restaurant Wonders" (1909).
77. "Famous Landmark Lost to Times Sq." (1915).

78. "New Restaurant Wonders" (1909) states that these capitals are composed of "double griffins taken from casts of the originals," but the capitals photographed (in "The Café de l'Opéra," 1910, 156, 158) are double bull capitals.

79. "The Café de l'Opéra" (1910, 155). The *New York Times* locates the Japanese room on the second floor; see "New Restaurant Wonders" (1909).

80. "New Restaurant Wonders" (1912).

81. "The Café de l'Opéra" (1910, 155).

82. "Famous Landmark Lost to Times Sq." (1915).

83. "Martin to Remodel the Cafe de L'Opera" (1910).

84. Malamud (2000; 2009, 179).

85. Malamud (2009, 229–52).

7. TO BE BURIED LIKE A PHARAOH

1. This chapter expands my earlier work; see Macaulay-Lewis (2017, 190–231).

2. Jenkyns (1992, 20); Dilley (2014, xiii).

3. Loeb translation by Heseltine and Rouse. The Latin reads, *"alde enim falsum est vivo quidem domos cultas esse, non curari eas, ubi diutius nobis habitandum est."*

4. Bergman (1988); Richman (2008); Keister (2011); Warren et al. (2014).

5. McDowell and Meyer (1994).

6. For example, Monorey (2009).

7. Dalton (1988, 48); Chernow (2004, 723).

8. Dalton (1988, 61).

9. Dalton (1988, 53).

10. Dalton (1988, 57–61, figs. 6–9).

11. Holley (1844, 46); Disturnell (1844, 6).

12. Sherman and Gaulkin (2009, 12).

13. Sherman and Gaulkin (2009, 13).

14. Monorey (2009); Webster (2015, 14–15, figs 1.1–1.2, 39–44, fig. 1.14). The monument was eventually dismantled, but it still appeared on a 1777 map by John Montrésor, titled the "Plan de New-York et des environs," now in New York Public Library.

15. McGowan (2018, 215–17, figs. 9.3–9.4).

16. Giguere (2014).

17. Richman (2008, 3).

18. Richman (2008, 3–4).

19. Richman (2008, 4). By 1851, all burials were banned south of Eighty-Sixth Street, except those in private cemeteries or vaults.

20. Sinclair (2016, 59, 73, 75).

21. Curl (2003).

22. Webster (2015, 30–38, figs. 1.8–11); Sinclair (2016, 73, 75).

23. Giguere (2014, 60–76, figs. 4, 6).

24. Giguere (2014, 127–62).

25. McDowell and Meyer (1994, 13); Curl (2003).

26. Hom., *Od.* 4.563–5; Verg., *Aen.* 6.637–78.

27. Richman (2008, 6).

28. Richman (2008, 8).

29. Green-Wood would continue to expand until the 1890s, and as of 2019, it is 478 acres.

30. Richman (2008, 11).

31. Meier (2006, 4).

32. Richman (2008, 11).

33. McDowell and Meyer (1994, 13).

34. Richman (2008, 15–16).

35. Richman (2008, 16).

36. Bergman (1988, 7).

37. Warren (2014, 16).

38. Warren (2014, 20–21).

39. Warren (2014, 27–28).

40. McDowell and Meyer (1994, 13).

41. McDowell and Meyer (1994, 13).

42. Broman (2001, 31).

43. McDowell and Meyer (1994, 4).

44. McDowell and Meyer (1994, 5).

45. McDowell and Meyer (1994, 5).

46. McDowell and Meyer (1994, 14).

47. Neff (2005, 19, 21, table 1).

48. McDowell and Meyer (1994, 24–50, figs. 9–26).

49. McDowell and Meyer (1994, 24).

50. McDowell and Meyer (1994, 24).

51. Broman (2001, 32–33).

52. Cleaveland and Smillie (1847, esp. 51).

53. McDowell and Meyer (1994, 24).

54. Richman (2008, 97–98).

55. King (1893, 976).

56. "John Anderson's Ways" (1885).

57. "John Anderson's Ways" (1885); Morris (1894, 213); Srebnick (1995, 55).

58. "John Anderson's Ways" (1885).

59. "John Anderson's Ways" (1885); Richman (2008, 98).

60. Richman (2008, 98); $60,000 is the equivalent of US$1.4 million in 2008.

61. Srebnick (1995, 54).

62. Srebnick (1995, 52).

63. Srebnick (1995, 55); Richman (2008, 98).

64. Richman (2008, 98).

65. It is impossible to identify each of the evangelists given the marble's eroded condition.

66. Lots 13724–41 were purchased on November 25, 1862, Lot books, Green-Wood Cemetery.

67. Meier and Beagan (2009, 26, no. 86).

68. Sources disagree about the costs. See "Jay Gould's Tomb" (1892, 377); Northrop (1892, 417); More and More (1893, 179); Warren (2014, 39).

69. More and More (1893, 178).

70. Mr. F. T. Fitz Mahony is listed as the architect in *Scientific American* ("Jay Gould's Tomb," 1892). The Woodlawn archive at Avery Library lists H. Q. French as the architect (see Series II, "Woodlawn Cemetery Records").

71. Northrop (1892, 416); "Jay Gould's Tomb" (1892, 377). Meier and Beagan (2009, 26, no. 86) repeat this error.

72. Northrop (1892, 417).

73. More and More (1893, 178).

74. Lawrence (1996, 120–21, figs. 186–89).

75. Stuart and Revett (1787, vol. 2, chap. 2, 16–22, plates 1–20); Tuthill (1848, plate VI).

76. Morrone (2018, 30).

77. "Jay Gould's Tomb" (1892, 377); Meier and Beagan (2009, 26, no. 86).

78. Northrop (1892, 414–15).

79. Plans of the plot show the position of the trees. "WCA FA Major Monuments, Gould, Jay 2006.009," Woodlawn Cemetery—Major Monuments Archive, Avery Architectural & Fine Arts Library, Columbia University.

80. More and More (1893, 178).

81. More and More (1893, 178).

82. Meier and Beagan (2009, 19, no. 39).

83. McDowell and Meyer (1994, 28, fig. 10); Meier and Beagan (2009, 45, no. 204).

84. Macaulay-Lewis (2017, 206–12, figs. 6.4–6.7).

85. See Giguere (2014, 163–94).

86. Richman (2008, 141–42).

87. Carrott (1978); Giguere (2014).

88. D'Alton (1993). An obelisk in Woodlawn copies the obelisk and the bronze crabs that supported it.

89. He purchased three lots, 300 square feet each (nos. 273–75), on July 25, 1843, at $80 per lot.

90. Benjamin Stephens's tomb (erected in 1890) was also a pyramid (Broman 2001, 57).

91. Broman (2001, 59).

92. J. Richman, personal communication, June 2, 2018.

93. Broman (2001, 58).

94. Shaw and Nicholson (2008, 345).

95. Lots 30279–82, Lot Record Book, Green-Wood Cemetery Archives.

96. Richman (2008, 205); "Albert R. Parsons, Musician, 85, Dead" (1933, 17).

97. Parsons (1893, 1–8, esp. 7).

98. Pyramid tombs were also built in Père Lachaise.

99. McDowell and Meyer (1994, 158) and Bedford (1998, 227) misreport the tomb's architect and date. Cortissoz credits Pope with the tomb (1924–1930), but contemporary literature identifies Davis, McGrath, and Kiessling as the architects; see "J. S. Bache Mausoleum, Woodlawn, N.Y., Davis, McGrath and Kiesling, Architects" (1920, 456–57).

100. Meier and Beagan (2009, 13–14, no. 7).

101. Patrick (2000).

102. E. Nelson, personal communication. Bache purchased a Senwosret statue, now in the Metropolitan Museum of Art, during this trip. For more details, see Nelson (2013).

103. Shaw and Nicholson (2008, 249).

104. McKenzie (2007, 121).

105. Arnold (2003, 25).

106. Arnold (2003, 25); McKenzie (2007, 140n68).

107. McKenzie (2007, 140n68, 145, fig. 255).

108. Smith (1998, 250, fig. 418); Baines and Malek (2000, 73).

109. Baedeker (1892, 281–97); Thomas Cook Ltd. (1897, 23, 238–43).

110. Meier and Beagan (2009, 13–14, no. 7).

111. Macaulay-Lewis (2017, 221).

112. Leland (1921, 314).

113. Leland (1921, 314).

114. Leland (1921, 314).

115. Leland (1921, 315).

116. "WCA Major Monuments—Bache, Jules S. 2006.009," Avery Architectural & Fine Arts Library, Columbia University.

117. Leland (1921, 314).

118. Leland (1921, 314).

119. Meier and Beagan (2009, 50, no. 237).

120. Curl (2005, 326–28, plate 192). It came to the Metropolitan Museum of Art in 1978.

121. Cf. McKenzie (2007, 123, fig. 205c).

122. Keister (2011, 73–74).

123. For more details on the tomb, see Macaulay-Lewis (2017, 222–28, figs. 6.13–15).

124. Farrington, Gould, and Hoagland also designed his mausoleum.

125. McDowell and Meyer (1994, 23–90).

8. HEROIC NEW YORKERS

1. McGowan (2018, 229–30, fig. 9.9).

2. See Webster (2015, 3–5, 91–173); McGowan (2018, 215–17, figs. 9.3–9.4).

3. Webster (2015, 5, 111–26).

4. Webster (2015, 161nn1–2, 164–65, fig. 5.2). Caffieri's instructions are preserved in the papers of the Continental Congress.

5. Montgomery's remains were interred here in 1818.

6. The original urn did not arrive, and a painted urn was used until the 1810s, when it was replaced by a limestone urn.

7. Webster (2015, 161–63, fig. 5.1).

8. Sutherland (1984, 218, 229–30). On Galba's coins, see BMC 258, RIC I (2nd ed.) Galba 479. On Vitellius's coins, see BMC 30, 31, 104, 105, RIC I (2nd ed.) Vitellius 43.

9. McGowan (2018, 215).

10. For a detailed account, see Webster (2015, 4, fig. I.3, 171–73, figs. 5.5–5.6, 186–87, fig. 5.13).

11. McGowan (2018, 215).

12. Webster (2015, 161–63).

13. Dalton (1988, 54–61, figs. 1–4); Rugg (1999, 207).

14. Webster (2015, 161).

15. Macaulay-Lewis (2016, 447–49).

16. Cassibry (2008, 418); Macaulay-Lewis (2016, 449).

17. Macaulay-Lewis (2016, 449–50).

18. Stevenson (2006, 35, 35n1).

19. Macaulay-Lewis (2016, 450–51).

20. Folpe (2002, 170–71). For a detailed study of the Washington Arches, see Macaulay-Lewis (2015, 209–38).

21. Folpe (2002, 171).

22. Cooper (1993, 239–40, fig. 192); Richard (2009, 35).

23. Macaulay-Lewis (2015, 222, fig. 12.3).

24. Unsigned and undated document, McKim, Mead & White Architectural Record Collection, PR 042, Archive-NYHS.

25. Folpe (2002, 172).

26. Folpe (2002, 174–75).

27. Folpe (2002, 177).

28. Untitled document, McKim, Mead & White Architectural Record Collection, PR 042, Archive-NYHS.

29. Untitled document, McKim, Mead & White Architectural Record Collection, PR 042, Archive-NYHS.

30. Untitled document, McKim, Mead & White Architectural Record Collection, PR 042, Archive-NYHS.

31. Broderick (2010, 310).

32. Broderick (2010, 311).

33. Folpe (2002, 185).

34. Durante (2007, 64). The text reads, "LET US RAISE A STANDARD TO WHICH THE WISE AND THE HONEST CAN REPAIR THE EVENT IS IN THE HAND OF GOD * WASHINGTON."

35. Originally these seals were planned as reliefs of trophies, ancient symbols of victory. They appear on the letterhead of the Committee on Erection of the Washington Arch at Washington Square, Archive-NYHS.

36. McKim, Mead & White Architectural Record Collection, PR 042, Archive-NYHS.

37. Letters to MacMonnies from White, dated February 28, 1895, and January 25, 1895, Archive-NYHS.

38. McKim, Mead & White Architectural Record Collection, PR 042, Archive-NYHS.

39. Also see letters to Stewart from MacMonnies, dated March 25, 1914, and June 8, 1914, and the letter to Stewart from McKim, Mead & White, May 18, 1914, from McKim, Mead & White, March 30, 1912, McKim, Mead & White, March 30, 1912, Archive-NYHS.

40. Two letters from McKim, Mead & White to McNeil and to Calder, both dated March 30, 1912, Archive-NYHS. The MacMonnies' sketches were also likely rejected because they were too similar to the sculptural groups he created for Brooklyn's Soldiers' and Sailors' Monument, discussed below.

41. These identifications, as well as Wisdom, Justice, and other personifications, are noted in a letter to H. A. McNeil from McKim, Mead & White, dated March 30, 1912, Archive-NYHS.

42. Durante (2007, 65).

43. Durante (2007, 63).

44. In American sculpture, Justice is typically a blindfolded woman with a sword and the scales of justice ("Figures of Justice").

45. Macaulay-Lewis (2015, 215).

46. "National Memorial Arch." Two arches were planned, but only one was funded.

47. For a detailed treatment of the Soldiers' and Sailors' Memorial Arch, see Macaulay-Lewis (2016, 447–78). Manhattan's Soldiers and Sailors Monument (completed in 1902) is located in Riverside Park and Eighty-Ninth Street and is modeled after the Choragic Monument of Lysicrates in Athens (*Soldiers and Sailors Monument* 1974, 2).

48. Kahn (1982, 213); Savage (1997, 162–208); Brown (2004, 22–41); Savage (2012); Macaulay-Lewis (2016, 453–54).

49. Kahn (1982, 219–21, figs. 12–16).

50. Kahn (1982, 224n51, citing Common Council, Brooklyn, 1888, I, 834–37).

51. Kahn (1982, 224).

52. "The Soldiers and Sailors' Memorial Arch in Brooklyn, N.Y." (1889, 549) states that thirty-six designs were submitted.

53. *Brooklyn Daily Eagle Almanac* (1895, 123); Sprague (2008, 69) reports that the cost was $450,000 but does not provide his source.

54. Kahn (1892, 225, fig. 23) shows the revised design (without a quadriga).

55. Undated letter, presumably from 1896, as the other material in the folder is from 1896, from F. MacMonnies to S. White, Prospect Park Folder, 1894–1898, folder no. 176, III, McKim, Mead & White Architectural Record Collection, PR 042, Archive-NYHS.

56. Kahn (1982, 225).

57. Kahn (1982, 225).

58. *Brooklyn Daily Eagle Almanac* (1895, 123); Kahn (1982, 225).

59. McKim, Mead & White Architectural Record Collection, PR 042, Archive-NYHS.

60. "Heroes Sleep" (1889, 6).

61. "We honor the Name" (1892, 1).

62. "We honor the Name" (1892, 1).

63. The Arch de l'Étoile is an alternative name for the Arc de Triomphe.

64. "We honor the Name" (1892, 2).

65. Cf. Winterer (2002, 9, 14–15).

66. Macaulay-Lewis (2016, 456–57, 460–63, figs. 4–6).

67. Savage (1997, 18, 89–128, fig. 4.1).

68. Sprague (2008, 67) also makes this observation.

69. Billings (1887, 250–68); *Brooklyn Daily Eagle Almanac* (1895, 123); Sprague (2008, 67–69).

70. Livy, 8.14.12; Plin., *HN* 34.20; Richardson (1992, 334–35).

71. Clark (1984, 7, fig. 2).

72. Bolotin and Laing (2002, 58–62).

73. Contemporary newspapers express confusion over the figure's identity; see "MacMonnies Quadriga" (1897, 4).

74. Sund (1993, 443–66).

75. Fleming (1965, 65–81; 1967, 37–66); Sund (1993, 443–66).

76. Blight (2001, 2).

77. Cf. Blight (2001, 4).

78. Kahn (1982, 225).

79. *Brooklyn Daily Eagle Almanac* (1895, 123); "The Soldiers and Sailors' Memorial Arch in Brooklyn, N.Y." (1889, 459).

80. Blight (2001, 206).

81. Savage (1997, 19).

82. The four hundred were compared to the three hundred Spartan soldiers who died at the Battle of Thermopylae to stall the Persian invasion in Greece in 480 BCE. They were commemorated with a memorial in Green-Wood (Simard 2015). The Battle of Long Island is also known as the Battle of Brooklyn.

83. Clark (1984, 15).

84. Schulten (2018).

85. Some New Yorkers have called for the statue's removal; however, in 2020 among its staunchest defenders are New York's mayor, Bill de Blasio, and governor, Andrew Cuomo, both Italian Americans. On Mayor de Blasio's decision not to remove it, see Neuman (2018). Six states have renamed Columbus Day as Indigenous Peoples' Day (Murphy 2019).

86. Schlereth (1992, 937); Carletta (2008, 19).

87. Carletta (2008, 19–20).

88. Carletta (2008, 20).

89. Carletta (2008, 20).

90. Carletta (2008, 20).

91. At Fifth-Ninth Street and Fifth Avenue, the society grandees erected a temporary arch to Columbus, which only survives in historical photographs (Carletta 2008, 23).

92. For an overview of the sculptures, statues, and other monuments to Columbus proposed or erected, see Ponce de León (1893, 115–28) and Carletta (2008, 21).

93. Carletta (2008, 21, 24).

94. Carletta (2008, 24).

95. Emma Stebbins's 1869 statue (now in Brooklyn) was joined in 1892 by a life-size bronze by the Spanish sculptor Jeronimo Sunol, which is very similar to his 1885 statue of the explorer in Madrid's Plaza de Colon. Six statues of Columbus would be erected in New York. See "Columbus on a Pedestal" (1991).

96. Ponce de León (1893, 117).

97. Ponce de León (1893, 117).

98. "Central Park: Columbus Monument."

99. Ponce de León (1893, 117–18).
100. Ponce de León (1893, 117).
101. Ponce de León (1893, 117).
102. Roller (2013, 121).
103. Richardson (1992, 96–97).
104. Pevsner (1997, 21, fig. 1.22).
105. "Fort Greene Park: Prison Ship Martyrs Monument."
106. "Henry Hudson Park: Henry Hudson Memorial."
107. "Pelham Bay Park: Bronx Victory Memorial."
108. "Central Park: *U.S.S. Maine* National Monument."
109. Bogart (1986, 48).
110. Bogart (1986, 42).
111. Bogart (1986, 49).
112. Bogart (1997, 108).
113. For a detailed discussion, see Bogart (1997, 271–92).
114. The letter, "'New War Memorials,'" was published on June 8, 1919.
115. Bogart (1997, 284).
116. "Discovering Columbus."
117. "Discovering Columbus."
118. "Structures: Arches."
119. "Structures: Arches."

9. ECLECTIC ANTIQUITY

1. Barry (2000); Baugher (2010, 475).
2. Shepherd (1976, 108–10).
3. Scholars use these names to describe the buildings in the twentieth and twenty-first centuries.
4. Baugher (2010, 479–85).
5. Shepherd (1976, 111–13); Barry (2000, 36–41).
6. Stuart and Revett (1762, vol. 1, chap. 2, 7–11, plates 1–8).
7. Shepherd (1976, 111–13); contra Hamlin (1944, 136).
8. Shepherd (1976, 119, fig. 14).
9. Shepherd (1976, 120).
10. Shepherd (1976, 114). Thomson also worked on the US Custom House; see Chapter 2.
11. The stone façade of St. James, another Catholic Church (1835–1837), at 32 James Street, had distyle Doric portico in antis. It either derives from one of Lafever's pattern books or he may have designed it (*St. James Church* 1966).
12. *St. Peter's Church* (1965). Vance (1989, 156–57) notes the Pantheon's unsuccessful conversion into a church.
13. "Our Remembrance of September 11, 2001."
14. Landy (1970, 55).
15. Landy (1970, 57).
16. Stuart and Revett (1762, vol. 1, chap. 2, 7–11, plates 1–8).
17. Landy (1970, 59).
18. See the 1846 edition's frontispiece, as well as plates 66, 67, and 86.
19. Landy (1970, 57).
20. See the discussion of Jay Gould's tomb in Chapter 7.
21. Morrone (2001, 36).
22. Morrone (2001, 36).

23. Morrone (2001, 36).

24. Hamlin (1944, 190, 249–53, plate LXIX).

25. Lowe (1992, 298).

26. See Chapter 4.

27. Lowe (1992, 298–301).

28. Lowe (1992, 298–301).

29. Kahn (2011).

30. McDavid (2018).

31. Yegül (1995); DeLaine (1999b); Fagan (1999).

32. Renner (2008, 504–31); see McDavid (2018, 205–7) for a list of baths in New York City erected between 1852 and 1925.

33. *The Fleischman Baths* (1908); Cleveland (1908, 21–29).

34. "Plans baths for Tired New Yorkers" (1907); *The Fleischman Baths* (1908); Cleveland (1908, 21–29).

35. Cleveland (1908, 22).

36. *The Fleischman Baths* (1908).

37. Malamud (2018, 48); *The Fleischman Baths* (1908).

38. "Plans baths for Tired New Yorkers" (1907); Cleveland (1908, 21–29).

39. "Plans baths for Tired New Yorkers" (1907); Malamud (2018, 48).

40. It had started at $1.50 but had been reduced. *The Fleischman Baths* (1908).

41. Malamud (2018, 48).

42. "Fleischman Baths Open for Public" (1908).

43. "Fleischman Baths Open for Public" (1908).

44. "Creditors Seeking Fleischman Books" (1909).

45. McDavid (2018, 195–96, fig. 8.8).

46. McDavid (2018, 205–7).

47. McDavid (2018, 190).

48. *Public Baths* (1974); McDavid (2018, 190–92, fig. 8.5).

49. McDavid (2018, 190).

50. McDavid (2018, 190).

51. McDavid (2018, 192).

52. Renner (2008, 525).

53. Curl (2002, 18–38).

54. Discussed in Chapter 4.

55. Macaulay-Lewis (2017, 212–15, figs. 6.8–6.9).

56. Lampen (2018).

57. "The Pythians: History."

58. Gray (2009b).

59. See the discussion in Chapter 2 about Layard.

60. "Egyptian Art." The New-York Historical Society had a major collection of Egyptian antiquities, which they sold to the Brooklyn Museum in 1937; see "Ancient Egyptian Art."

61. Gray (2009b).

62. Gray (2009b).

63. Avery Library only has drawings for renovations in the 1930s. Thomas Lamb Archive, Avery Library, Columbia University.

64. Gray (2009b).

65. Heckscher (2000, 171–72, fig. 131).

66. Goodrich (1828, 381).

67. Morrison (1999, 44–45).

68. Morrison (1999, 48–50).

69. He also staged spectacles with Roman themes; see Malamud (2009, 175–77, fig. 6.12).
70. Gray (2013).

REFLECTIONS: USEABLE PASTS AND NEO-ANTIQUE FUTURES

1. This chapter's epigraph is from Stuart (1901, 525).
2. Baigell (1965, 176); Trafton (2004, 148).
3. Macintosh (2010).
4. Herschman (2019, 18).
5. Herschman (2019, 18–19).
6. Bowlet (2019, 52–79).
7. Lapatin, Herschman, and Fitzgerald (2009, 84–85).
8. Lapatin, Herschman, and Fitzgerald (2009, 84–85, fig. 4.2).
9. Warren (2018).
10. Holmes and Marta (2017).
11. Squire, Cahill, and Allen (2018).
12. Tabet (2019); Benzel, Tabet, and Davies (2019).

REFERENCES

ARCHIVES CONSULTED

Andrew Jackson Davis, Prints, Photographs, and Architectural Collections, New-York Historical Society.
Green-Wood Cemetery Archive, Lot Purchase Books.
Henry G. Marquand Papers, Metropolitan Museum of Art. https://libmma.contentdm.oclc.org/digital/collection/p15324coll13/id/7642/rec/3; https://libmma.contentdm.oclc.org/digital/collection/p15324coll13/id/6942.
Lewisohn Stadium Archive, City College Archives, The City University of New York.
McKim, Mead & White Architectural Record Collection, PR 042, Department of Prints, Photographs, and Architectural Collections, New-York Historical Society.
New York City miscellaneous collection, New York Public Library.
New York State Roosevelt Memorial, Central Archive 1178.3, American Museum of Natural History Library.
Thomas Lamb Archive, Avery Architectural & Fine Arts Library, Columbia University.
Wildlife Conservation Society Archive.
Woodlawn Cemetery—Major Monuments Archive, Avery Architectural & Fine Arts Library, Columbia University.

LATIN AND GREEK SOURCES

Herodotus, *Histories* 8.98.1
Homer, *Odyssey* 4.563–65
Livy, 8.14.12
Petronius, *Satyricon* 71
Pliny the Elder, *Natural History* 34.20, 36.30–31
Suetonius, *Nero* 31.2
Tacitus, *Annales* 14.1–8
Virgil, *Aeneid* 9.447
Virgil, *Georgics* 4
Vitruvius, *De architectura* 2.8.10–15, 7. Pref.12–13

BIBLICAL SOURCES

Genesis 11:3–4
Matthew 2:13–23

ABBREVIATIONS

RIC: Mattingly, Harold, et al. 1923–. *The Roman Imperial Coinage*. London: British Museum.
BMC: Mattingly, Harold, et al. 1923–. *Coins of the Roman Empire in the British Museum*. London: British Museum.

PRIMARY AND SECONDARY SOURCES

"About Grand Central Terminal." n.d. https://www.grandcentralterminal.com/about/.

Adams, Janet. 1987. *New York Central Building/Now Helmsley Building*. New York: Landmarks Preservation Commission.

Addiss, Gail. 2019. "The Critique Became the Counter-Narrative: Planning Manhattan North of the Street Grid." MA diss., The Graduate Center, The City University of New York.

"Against the Beer Garden." 1891. *New York Times*, March 12.

"Albert R. Parsons, Musician, 85, Dead." 1933. *New York Times*, June 15.

The American Museum of Natural History. 1967. New York: Landmarks Preservation Commission.

"Ancient Egyptian Art." n.d. Brooklyn Museum. https://www.brooklynmuseum.org /opencollection/exhibitions/3329.

"Ancient Near East." n.d. Metropolitan Museum of Art. https://www.metmuseum.org/press /general-information/2010/ancient-near-east.

Anderson, Stanford. 1991. "The Legacy of German Neoclassicism and Biedermeier: Behrens, Tessenow, Loos, and Mies." *Assemblage* 15 (August): 62–87.

The Arch and Colonnade of the Manhattan Bridge Approach. 1975. New York: Landmarks Preservation Commission.

Architectural League of New York, and Association of the Bar of the City of New York. 1977. *Temple of Justice: The Appellate Division Courthouse: An Exhibition Sponsored by the Architectural League of New York and the Association of the Bar of the City of New York, June 24–July 22, 1977*. New York: The House of the Association.

Armstrong, Christopher. 2012. *Julien-David Leroy and the Making of Architectural History*. Abingdon: Routledge.

Arnold, Dieter. 2003. "Augustus, Kiosk of (Philae)." In *The Encyclopedia of Ancient Egyptian Architecture*, ed. Nigel Strudwick and Helen Strudwick, trans. Sabine H. Gardiner and Helen Strudwick, 25. Princeton, NJ: Princeton University Press.

Arrowsmith, Thomas. 1800[?]. *A catalogue consisting of a small (but choice) collection of books recently purchased; . . . which are now selling . . . by T. Arrowsmith, bookseller*. London: T. Arrowsmith.

"Artistic Design for Manhattan End of New Bridge." 1912. *Brooklyn Daily Eagle*, March 31.

Audubon Terrace Historic District. 1979. New York: Landmarks Preservation Commission.

Baedeker, Karl. 1892. *Egypt, Handbook for Travellers: Part Second, Upper Egypt, with Nubia as Far as the Second Cataract and the Western Oases*. Leipsic: Karl Baedeker.

Baigell, Matthew. 1965. "John Haviland." PhD diss., University of Pennsylvania.

Baines, John, and Jaromir Malek. 2000. *Cultural Atlas of Ancient Egypt*. New York: Facts on File.

Ballon, Hilary. 2012. *The Greatest Grid: The Master Plan of Manhattan, 1811–2011*. New York: Museum of the City of New York/Columbia University Press.

Ballon, Hilary, and Norman McGrath. 2002. *New York's Pennsylvania Stations*. New York: Norton.

"The Bankers Trust Company Building." 1912. *New York Architect* 4, no. 63 (May): 245–47.

Barry, Gerald. 2000. *The Sailors' Snug Harbor: A History*. New York: Fordham University Press.

Bartman, Elizabeth. 2018. "Archaeology Versus Aesthetics: The Metropolitan Museum of Art's Classical Collection in Its Early Years." In *Classical New York: Discovering Greece and Rome in Gotham*, ed. Elizabeth Macaulay-Lewis and Matthew M. McGowan, 63–84. New York: Fordham University Press.

"The Bath of Psyche." n.d. Tate Galleries. http://www.tate.org.uk/art/artworks/leighton-the-bath-of-psyche-n01574.

Baugher, Sherene. 2010. "Landscapes of Power: Middle Class and Lower Class Power Dynamics in a New York Charitable Institution." *International Journal of Historical Archaeology* 14, no. 4: 475–97.

Bedford, Steven. 1998. *John Russell Pope: Architect of Empire*. New York: Rizzoli.

Belle, John, and Maxinne Rhea Leighton. 2000. *Grand Central: Gateway to a Million Lives*. New York: Norton.

Benzel, Kim, Rayyane Tabet, and Clare Davies. 2019. "Rayyane Tabet: Alien Property." *Metropolitan Museum of Art Bulletin* 77, no. 2 (Fall): 1–48.

Bergdoll, Barry, Hollee Haswell, and Janet Parks. 1997. *Mastering McKim's Plan: Columbia's First Century on Morningside Heights*. New York: Miriam and Ira Wallach Art Gallery, Columbia University.

Bergman, Edward. 1988. *Woodlawn Remembers: Cemetery of American History*. Utica, NY: North Country.

Betts, Mary Beth. 2001. "The Aesthetics of an Eclectic Architect." In *Cass Gilbert, Life and Work: Architect of the Public Domain*, ed. Robert A. M. Stern, 73–84. New York: Norton.

Bevington, Charles. 1908. *New York Plaisance: Number One—MDCCCVII. An Illustrated Series of New York Places of Amusement*. New York: H. Erkins.

Beyer, Andreas. 2003 "Palladio, Andrea." Grove Art Online. https://www.oxfordartonline.com/groveart/view/10.1093/gao/9781884446054.001.0001/oao-9781884446054-e-7000064879.

Billings, John. 1887. *Hardtack and Coffee, or The Unwritten Story of Army Life*. Boston: G. M. Smith and Co.

Blight, David. 2001. *Race and Reunion: The Civil War in American Memory*. Cambridge, MA: Harvard University Press.

Blondel, François. 1675. *Cours d'architecture enseigné dans l'Académie royale d'architecture*. Paris: Lambert Roulland.

Bloom, Ivo. 2001. "Quo Vadis? From Painting to Cinema and Everything in Between." In *La decima musa. Il cinema e le altre arti / The Tenth Muse. Cinema and Other Arts*, ed. Leonardo Quaresima and Laura Vichi, 281–96. Udine: Forum.

Bobinski, George. 1969. *Carnegie Libraries: Their History and Impact on American Public Library Development*. Chicago: American Library Association.

Bogart, Michele. 1986. "'Maine Memorial' and 'Pulitzer Fountain': A Study in Patronage and Process." *Winterthur Portfolio* 21, no. 1: 41–63.

Bogart, Michele. 1997. *Public Sculpture and the Civic Ideal in New York City, 1890–1930*. Washington, DC: Smithsonian Institution Press.

Bohn, John. 1843. *Catalogue of English Books in All Classes of Literature*. London: John Bohn.

Bolotin, Norman, and Christina Laing. 2002. *The World's Columbian Exposition: The Chicago World's Fair of 1893*. Urbana: University of Illinois Press.

Born, Pamela. 2002. "The Canon Is Cast: Plaster Casts in American Museum and University Collections." *Art Documentation: Journal of the Art Libraries Society of North America* 21, no. 2: 8–13.

Breiner, David. 1988. *Tudor City Historic District*. New York: Landmarks Preservation Commission.

———. 1989. *Seagram Building, Including the Plaza*. New York: Landmarks Preservation Commission.

Bridges, William. 1974. *Gathering of Animals: An Unconventional History of the New York Zoological Society*. New York: Harper & Row.

Brier, Bob. 1992. *Egyptomania*. Brookville, NY: Hillwood Art Museum.

Broderick, Mosette. 2010. *Triumvirate: McKim, Mead & White: Art, Architecture, Scandal, and Class in America's Gilded Age*. New York: Knopf.

Broman, Elizabeth. 2001. "Egyptian Revival Funerary Art in Green-Wood Cemetery." *Markers: A Journal of the Association for Gravestone Studies* 18:30–66.

Brooklyn Borough Hall. 1966. New York: Landmarks Preservation Commission.

Brooklyn Daily Eagle Almanac. A Book of Information, General of the World, and Special of Brooklyn and Long Island. 1895. Vol. 10. Brooklyn: Press of Brooklyn Daily Eagle Book and Job Department.

"Brooklyn Institute: The Plans for Its New Building and How They Were Selected." 1894. *Brooklyn Daily Eagle*, April 1.

Bowlet, John. 2019. "'Bold and Dazzling': Leon Bakst and Antiquity." In *Hymn to Apollo: The Ancient World and the Ballets Russes*, ed. Clare Fitzgerald, 52–79. Princeton, NJ: Institute for the Study of the Ancient World at New York University/Princeton University Press.

Brinkmann, Vinzenz, and Raimund Wünsche, eds. 2007. *Gods in Color: Painted Sculpture of Classical Antiquity*. Cambridge, MA: Harvard University Art Museums.

Brown, Thomas. 2004. *The Public Art of Civil War Commemoration: A Brief History with Documents*. Boston: Bedford/St. Martin's.

Bulwer-Lytton, Edward. 1834. *The Last Days of Pompeii*. London: Richard Bentley.

———. 1946. *The Last Days of Pompeii*. New York: Dodd, Mead & Company.

Burrows, Edwin, and Mike Wallace. 1999. *Gotham: A History of New York City to 1898*. New York: Oxford University Press.

Bushman, Richard. 1992. *The Refinement of America: Persons, Houses, Cities*. New York: Vintage.

Butler, Shane. 2016. "Introduction: On Origins of 'Deep Classics.'" In *Deep Classics: Rethinking Classical Reception*, ed. Shane Butler, 1–20. London: Bloomsbury Academic.

"The Café de l'Opéra." 1910. *Architects' and Builders' Magazine* 42:155–62.

Calder, Alexander. 1919. "'New War Memorials.'" *New York Times*, June 8.

Camp, John. 1996. "The 'Marathon Stone' in New York." *Metropolitan Museum Journal* 31:5–10.

Capitale. "Architecture." n.d. Accessed June 23, 2019. https://capitaleny.com/architecture/.

Carletta, David. 2008. "The Triumph of American Spectacle: New York City's 1892 Columbian Celebration." *Material Culture* 40, no. 1: 19–40.

Carlson, Deborah. 2002. "Caligula's Floating Palaces." *Archaeology* 55, no. 3 (May/June): 26–31.

Carrott, Richard. 1978. *The Egyptian Revival: Its Sources, Monuments, and Meaning, 1808–1858*. Berkeley: University of California Press.

Cassas, Louis. 1800. *Voyage pittoresque de la Syrie, de la Phoenicie, de la Palaestine et de la Basse Aegypte: ouvrage divisé en trois volumes contenant environ trois cent trente*. 3 Vols. Paris.

Cassibry, Kimberly. 2008. "Provincial Patrons and Commemorative Rivalries: Rethinking the Roman Arch Monument." *Mouseion* 8, no. 3: 417–50.

de Caylus, Comte. 1752–67. *Recueil d'antiquités égyptiennes, étrusques, grecques, romaines et gauloises*. 7 vols. Paris.

"Central Park: Columbus Monument." n.d. New York City Parks Department. https://www.nycgovparks.org/parks/central-park/monuments/299.

"Central Park: U.S.S. Maine National Monument." n.d. New York City Parks Department. https://www.nycgovparks.org/parks/central-park/monuments/966.

Chernow, Ron. 2004. *Alexander Hamilton*. New York: Penguin.

Christen, Barbara S. 2009. "Patronage, Politics, and Civic Identity: The Development of Cincinnati's Union Central Life Insurance Company Building." *Ohio Valley History* 9, no. 2 (Summer): 54–77.

Churchill, Allen. 1982. "Recalling the Heyday of the Great White Way." *New York Times*, January 24.

Claridge, Amanda. 2010. *Rome: An Oxford Archaeological Guide*. Oxford: Oxford University Press.

Clark, Robert. 1984. "Part I: Frederick MacMonnies: An American Sculptor in Paris and New York." *Record of the Art Museum, Princeton University* 43, no. 2: 6–25.

Clarke, John R. 1991. *The Houses of Roman Italy, 100 BC–AD 250: Ritual, Space, and Decoration.* Berkeley: University of California Press.

"Classicizing Chicago." n.d. https://classicizingchicago.northwestern.edu/.

Cleaveland, Nehemiah, and James Smillie. 1846. *Green-Wood in 1846.* New York: R. Martin.

Cleveland, Lucy. 1908. "The Fleischman Baths, New York City." *Modern Sanitation* 4, no. 8: 21–29.

Coleman, Nancy. 2019. "Angered by This Roosevelt Statue? A Museum Wants Visitors to Weigh in." *New York Times*, July 15.

Colla, Elliott. 2007. *Conflicted Antiquities: Egyptology, Egyptomania, Egyptian Modernity.* Durham, NC: Duke University Press.

Collon, Dominique, J. D. Hawkins, Beatrice Teissier, et al. 2003. "Ancient Near East." Grove Art Online. https://www.oxfordartonline.com/groveart/view/10.1093/gao/9781884446054.001.0001/oao-9781884446054-e-7000002561.

"Columbus on a Pedestal." 1991. *New York Times*, October 14.

Condit, Carl. 1980. *The Port of New York: A History of the Rail and Terminal System from the Beginnings to Pennsylvania Station.* Vol. 1. Chicago: University of Chicago Press.

Cooper, Wendy A. 1993. *Classical Taste in America: 1800–1840.* New York: Abbeville.

Cortissoz, Royal. 1924–1930. *The Architecture of John Russell Pope.* New York: W. Helburn.

"Creditors Seeking Fleischman Books." 1909. *New York Times*, June 5.

"The Croton Aqueduct: Croton Aqueduct Distributing Reservoir." 1842. *New-York Daily Tribune*, June 22.

"Curiosities of Cost." 1988. *Decorator and Furnisher* 12, no. 2 (May): 64.

Curl, James Stevens. 2002. *The Art and Architecture of Freemasonry: An Introductory Study.* London: B. T. Batsford.

———. 2003. "Cemetery." Grove Art Online. https://www.oxfordartonline.com/groveart/view/10.1093/gao/9781884446054.001.0001/oao-9781884446054-e-7000015177.

———. 2005. *The Egyptian Revival: Ancient Egypt as an Inspiration for Design Motifs in the West.* London: Routledge.

D'Alton, Martina. 1993. "The New York Obelisk, or, How Cleopatra's Needle Came to New York and What Happened When It Got Here." *Metropolitan Museum of Art Bulletin* 50, no. 4: 1–72.

Dalton, Allison. 1988. "The Alexander Hamilton Monument in Trinity Courtyard, New York City: History, Analysis, and Conservation." MS diss., Columbia University.

D'Arms, John. 1970. *Romans on the Bay of Naples.* Cambridge, MA: Harvard University Press.

"The David N. Dinkins Manhattan Municipal Building." n.d. http://www.nyc.gov/html/dcas/html/about/man_munibldg.shtml.

Davies, Paul, David Hemsoll, and Mark Wilson Jones. 1987. "The Pantheon: Triumph of Rome or Triumph of Compromise?" *Art History* 10, no. 2: 133–53.

"Death of an Eminent Artist." 1852. *Daily National Intelligencer*, April 16.

DeLaine, Janet. 1999a. "The Romanitas of the Railway Station." In *The Uses and Abuses of Antiquity*, ed. Michael Biddiss and Maria Wyke, 145–66. Bern: P. Lang.

———. 1999b. *Roman Baths and Bathing: Proceedings of the First International Conference on Roman Baths held at Bath, England, 30 March–4 April 1992.* Portsmouth, RI: Journal of Roman Archaeology.

Denon, Dominique-Vivant. *Voyage dans le Basse et Haute Égypte pendant les campagnes du general Bonaparte.* Paris: De l'Imprimerie de P. Didot L'Aîné.

Department of Ancient Near Eastern Art. 2000–. "Animals in Ancient Near Eastern Art." Heilbrunn Timeline of Art History, Metropolitan Museum of Art. http://www.metmuseum.org/toah/hd/anan/hd_anan.htm.

Description de l'Egypte. (1809–1821). 22 Vols. Paris: C. L. F. Panckoucke.

Deusner, Melody Barnett. 2011. "'In Seen and Unseen Places': The Henry G. Marquand House and Collections in England and America." *Art History* 34, no. 4: 754–73.

———. 2017. "Building a Reputation: Henry Gurdon Marquand's New York Mansion." In *Orchestrating Elegance: Alma-Tadema and the Marquand Music Room*, ed. Kathleen M. Morris and Alexis Goodin, 37–61. Williamstown, MA: Clark Art Institute.

Diamonstein-Spielvogel, Barbaralee. 2016. *The Landmarks of New York: An Illustrated, Comprehensive Record of New York City's Historic Buildings, Historic Districts, Interior Landmarks, Sidewalk Clocks, Streetlights, and Cultural Medallions*. New York: Washington Mews Books/New York University Press.

Dilley, Thomas. 2014. *The Art of Memory: Historic Cemeteries of Grand Rapids, Michigan*. Detroit, MI: Wayne State University Press.

"Discovering Columbus." n.d. Public Art Fund. http://www.publicartfund.org/view/exhibitions/5495_discovering_columbus#sthash.RdU9Fvls.dpuf.

Disturnell, John. 1837. *New-York as It Is*. New York: J. Disturnell.

———. 1844. *The Northern Traveller: Containing the Hudson River Guide, and Tour in the Springs, Lake George and Canada, Passing through Lake Champlain*. New York: J. Disturnell.

Dolkart, Andrew. 1982. *Richmond County Courthouse*. New York: Landmarks Preservation Commission.

———. 2010. "Brooklyn Borough Hall." In *Encyclopedia of New York City*, 2nd ed., ed. Kenneth T. Jackson, 174. New Haven, CT: Yale University Press.

Durante, Dianne. 2007. *Outdoor Monuments of Manhattan: A Historical Guide*. New York: New York University Press.

Dyson, Steven. 2001. "Rome in America." In *Images of Rome: Perceptions of Ancient Rome in Europe and the United States in the Modern Age*, ed. Richard Hingley, 57–70. Portsmouth, RI: Journal of Roman Archaeology.

"Egyptian Art." Metropolitan Museum of Art. https://www.metmuseum.org/about-the-met/curatorial-departments/egyptian-art.

Erenberg, Lewis A. 1981. *Steppin' Out: New York Nightlife and the Transformation of American Culture, 1890–1930*. Westport, CT: Greenwood.

Erkins, Henry. 1906–1907. "Murray's Roman Gardens." *Architects' and Builders' Magazine* 8:574–79.

Evren, Robert. 1983. *Charles Cary Rumsey, 1879–1922*. Buffalo, NY: State University College at Buffalo.

Fagan, Garrett G. 1999. *Bathing in Public in the Roman World*. Ann Arbor: University of Michigan Press.

"Famous Landmark Lost to Times Sq." 1915. *New York Times*, March 7.

Fenske, Gail. 2003. "City Beautiful Movement." Grove Art Online. https://www.oxfordartonline.com/groveart/view/10.1093/gao/9781884446054.001.0001/oao-9781884446054-e-7000017886.

Ferriss, Hugh. 1929. *The Metropolis of Tomorrow*. New York: Ives Washburn.

"Figures of Justice." Supreme Court. http://www.supremecourt.gov/about/figuresofjustice.pdf.

"Fine Approaches Suggested for East River Bridges; Plans Prepared Aim to Combine Practical Handling of Traffic with Ornamental Treatment of Terminal Plazas." 1913. *New York Times*, June 22.

Fiske, Amos. 1898. "Murray Hill and the Reservoir." *New York Times*, February 27.

Fitzsimmons, Emma G., Emily Palmer, Noah Remnick, et al. 2017. "Highlights from the Opening of the Second Avenue Subway." *New York Times*, January 1.

The Fleischman Baths: Bryant Park Building, Forty-Second St. & Sixth Ave., New York City. 1908. New York: Gudé-Bayer Co.

"Fleischman Baths Open for Public." 1908. *New York Times*, February 7.

Fleming, E. McClung. 1965. "The American Image as Indian Princess 1765–1783." *Winterthur Portfolio* 2:65–81.

———. 1967. "From Indian Princess to Greek Goddess: The American Image, 1783–1815." *Winterthur Portfolio* 3:37–66.

Fletcher, Banister. 1987. *A History of Architecture.* 19th ed. Ed. John Musgrove. London: Butterworth.

Frieland, Elise. 2019. "Pompeii on the Potomac: Constantino Brumidi's Nineteenth-Century, Roman-Style Murals for the Naval Affairs Committee Room in the United States Capitol." *Capital Dome* 65, no. 1: 2–15.

Folpe, Emily. 2002. *It Happened on Washington Square.* Baltimore, MD: Johns Hopkins University Press.

"Fort Greene Park: Prison Ship Martyrs Monument." n.d. New York City Parks Department. https://www.nycgovparks.org/parks/fort-greene-park/monuments/1222.

"Furniture Designed by L. Alma-Tadema, R.A." 1885. *Building News and Engineering Journal* 49 (July 24): 122.

"Furniture of the Ancients." 1882. *Art Amateur* 6, no. 6 (May): 129.

Furnival, William. 1904. *Leadless Decorative Tiles, Faience, and Mosaic, Comprising Notes and Excerpts on the History, Materials, Manufacture & Use of Ornamental Flooring Tiles, Ceramic Mosaic, and Decorative Tiles and Faience, with Complete Series of Recipes for Tile-Bodies, and for Leadless Glazes and Art-Tile Enamels.* Stone, Staffordshire: W. J. Furnival.

Galanos, Amy, and Janet Adams. 1986. *Fred French Building.* New York: Landmarks Preservation Commission.

Gensheimer, Maryl B. 2018. "Rome Reborn: Old Pennsylvania Station and the Legacy of the Baths of Caracalla." In *Classical New York: Discovering Greece and Rome in Gotham,* ed. Elizabeth Macaulay-Lewis and Matthew M. McGowan, 161–81. New York: Fordham University Press.

Gerety, Rowan. 2010. "Central Park Zoo." In *The Encyclopedia of New York City,* 2nd rev. and exp. ed., ed. Kenneth T. Jackson, 225. New Haven, CT: Yale University Press.

Giguere, Joy. 2014. *Characteristically American Memorial Architecture, National Identity, and the Egyptian Revival.* Knoxville: University of Tennessee Press.

Gilfoyle, Timothy. 2003. "'America's Greatest Criminal Barracks': The Tombs and the Experience of Criminal Justice in New York City, 1838–1897." *Journal of Urban History* 29, no. 5: 525–54.

Goeschel, Nancy. 1987. *San Remo Apartments.* New York: Landmarks Preservation Commission.

Goodin, Alexis, and Kathleen Morris, eds. 2017a. *Orchestrating Elegance: Alma-Tadema and the Marquand Music Room.* Wiliamstown, MA: Clark Art Institute.

———. 2017b. "The Fate of the Marquand Room." In *Orchestrating Elegance: Alma-Tadema and the Marquand Music Room,* ed. Alexis Goodin and Kathleen Morris, 139–67. Wiliamstown, MA: Clark Art Institute.

Goodrich, A. T. 1828. *The Picture of New-York, and Stranger's Guide to the Commercial Metropolis of the United States.* New York. A. T. Goodrich.

Gordon, E. Adina. 1998. "The Sculpture of Frederick William MacMonnies: A Critical Catalogue." PhD diss., Institute of Fine Arts, New York University.

Gordon, Sophie. 2013. *Cairo to Constantinople: Francis Bedford's Photographs of the Middle East.* London: Royal Collection Trust.

Graff, Sarah. 2014. "Demons, Monsters, and Magic." In *Assyria to Iberia at the Dawn of the Classical Age,* ed. Joan Aruz, Sarah B. Graff, and Yelena Rakic, 263–71. New York: Metropolitan Museum of Art.

Grafton, Anthony, Glenn W. Most, and Salvatore Settis, eds. 2010. *The Classical Tradition.* Cambridge, MA: Harvard University Press.

Gray, Christopher. 1987. "Streetscapes: Brooklyn Borough Hall; A Greek Revival Temple Fronts an 1848 City Hall." *New York Times*, June 7.

———. 1992. "Streetscapes: The Fred R. French Building; Refurbishing 'Mesopotamia.'" *New York Times*, May 24.

———. 1996. "Streetscapes/230 West 42d Street; From School to Residences, Flea Circus and Brothel." *New York Times*, June 16.

———. 2009a. "Stanford White's Backdrop for the Panic of 1907." *New York Times*, March 5.

———. 2009b. "An Improbable Cradle of Rock Music." *New York Times*, June 18.

———. 2011. "The Library's Extremely Useful Predecessor—Streetscapes." *New York Times*, January 20.

———. 2013. "Architecture: Pre-Emptive Moves, Predemolition." *New York Times*, July 18.

"Great Roosevelt Memorial." 1922. *New York Times*, March 12.

Green, Christopher, and Jens Daehner, eds. 2011. *Modern Antiquity: Picasso, de Chirico, Léger, Picabia*. Los Angeles: J. Paul Getty Museum.

Greene, Joseph. 2017. "A Complicated Legacy: The Original Collections of the Semitic Museum." *Journal of Eastern Mediterranean Archaeology and Heritage Studies* 5, no. 1: 57–69.

Gros, Pierre. 1996. *L'architecture Romaine: du début du IIIe siècle av. J.-C. à la fin du Haut-Empire 1. Les Monuments Publics*. Paris: Picard.

Hagaman, Edward. 1910. "A Brief History of City Hall Park, New York." *Fifteenth Annual Report of the American Scenic and Historic Preservation Society* 15:383–424.

Hales, Shelley. 2006. "Re-Casting Antiquity: Pompeii and the Crystal Palace." *Arion: A Journal of Humanities and the Classics* 14, no. 1: 99–134.

Hales, Shelley, and Nic Earle. 2017. "A Copy—or Rather a Translation . . . with Numerous Sparkling Emendations. Re-Rebuilding the Crystal Palace." In *What's to Be Done with the Crystal Palace?*, ed. Kate Nichols and Sarah Turner, 197–203. Manchester: Manchester University Press.

Hamlin, Talbot. 1944. *Greek Revival Architecture in America: Being an Account of Important Trends in American Architecture and American Life Prior to the War between the States*. New York: Oxford University Press.

Hardwick, Lorna. 2003. *Reception Studies. Greece and Rome*. New Surveys in the Classics 33. Oxford: Published for the Classical Association by Oxford University Press.

Hardwick, Lorna, and Christopher Stray. 2011. *A Companion to Classical Receptions*. Malden: Wiley-Blackwell.

Harris, Gale. 1997. *14 Wall Street Building (Formerly Bankers Trust Building)*. New York: Landmarks Preservation Commission.

———. 2006. *American Telephone & Telegraph Company Building*. New York: Landmarks Preservation Commission.

Heckscher, Morrison H. 1995. "The Metropolitan Museum of Art: An Architectural History." *Metropolitan Museum of Art Bulletin* 53, no. 1: 1–80.

———. 2000. "Building the Empire City: Architects and Architecture, 1825–1861." In *Art and the Empire City. New York, 1825–1861*, ed. Catherine Hoover Voorsanger and John K. Howat, 169–87. New York/New Haven, CT: Metropolitan Museum of Art/Yale University Press.

"Henry Hudson Park: Henry Hudson Memorial." n.d. New York City Parks Department. http://www.nycgovparks.org/parks/HenryHudsonPark/monuments/751.

"Heroes Sleep." 1889. *Brooklyn Eagle*, October 30, 1889.

Herschman, Rachel. 2019. "Introduction." In *Hymn to Apollo: The Ancient World and the Ballets Russes*, ed. Clare Fitzgerald, 14–27. Princeton, NJ: Institute for the Study of the Ancient World at New York University/Princeton University Press.

Hetland, Lise. 2007. "Dating the Pantheon." *Journal of Roman Archaeology* 20:95–112.

Hewitt, Mark Alan, Kate Lemos, William Morrison, and Charles Warren. 2006. *Carrère and Hastings: Architects*. New York: Acanthus.

"History of the U.S. Capitol Building–Architecture." n.d. Architect of the Capitol. https://www.aoc.gov/history-us-capitol-building.

Hoepfner, Wolfram. 2003. "Hippodamos." Grove Art Online. https://www-oxfordartonline-com.ezproxy.gc.cuny.edu/groveart/view/10.1093/gao/9781884446054.001.0001/oao-9781884446054-e-7000038217.

Hoganson, Kristin. 2002. "Cosmopolitan Domesticity: Importing the American Dream, 1865–1920." *American Historical Review* 107, no. 1: 55–83.

———. 2007. *Consumers' Imperium the Global Production of American Domesticity, 1865–1920*. Chapel Hill: University of North Carolina Press.

Holley, Orville Luther. 1844. *The Picturesque Tourist: Being a Guide through the Northern and Eastern States and Canada; Giving an Accurate Description of Cities and Villages, Celebrated Places of Resort, etc.* New York: J. Disturnell.

Holliday, Peter James. 2016. *American Arcadia: California and the Classical Tradition*. Oxford: Oxford University Press.

Holmes, Brooke. 2016. "Cosmopoiesis in the Field of 'The Classical.'" In *Deep Classics: Rethinking Classical Reception*, ed. Shane Butler, 269–90. London: Bloomsbury.

———. 2018. "On Liquid Antiquity." In *The Classical Now*, ed. Michael Squire, James Cahill, and Ruth Allen, 141–50. London: Elephant.

Holmes, Brooke, and Karen Marta, eds. 2017. *Liquid Antiquity*. Athens: Deste Foundation for Contemporary Art.

Holusha, John. 1998. "From Temple of Capitalism to an All-Suite Hotel." *New York Times* November 28.

Homberger, Eric. 2002. *New York: A Cultural and Literary Companion*. Oxford: Signal.

"How About the Tombs Facade? Unless Some Agreement Is Reached Work Will Be Begun To?" 1897. *New-York Tribune*, June 11.

"How the Ancients Employed Color." 1881. *Art Amateur* 5, no. 3 (August): 57.

Hrychuk Kontokosta, Anne. 2019. "Building the Thermae Agrippae: Private Life, Public Space, and the Politics of Bathing in Early Imperial Rome." *American Journal of Archaeology* 123, no. 1: 45–77.

Hu, Winnie. 2018. "New York Subway's On-Time Performance Hits New Low." *New York Times*, April 6.

"Human-headed winged bull (lamassu)." n.d. Metropolitan Museum of Art. https://www.metmuseum.org/art/collection/search/322608.

Humbert, Jean-Marcel, and Clifford Price, eds. 2003. *Imhotep Today: Egyptianizing Architecture*. London: University College London Press.

Huxtable, Ada Louise. 1963. "Architecture: That Was the Week That Was." *New York Times*, November 3.

Hyson, Jeffrey N. 1999. "Urban Jungles: Zoos and American Society." PhD diss., Cornell University.

"Industrial Art." 1880. *Art Amateur* 3, no. 3 (August): 60–61.

Irish, Sharon. 1999. *Cass Gilbert Architect: Modern Traditionalist*. New York: Monacelli.

Irwin, David G. 2011. *Neoclassicism*. London: Phaidon.

"J. S. Bache Mausoleum, Woodlawn, N.Y., Davis, McGrath and Kiesling, Architects." 1920. *Architectural Record* 47, no. 5 (May): 456–57.

Jashemski, Wilhelmina F. 1979–1992. *The Gardens of Pompeii: Herculaneum and the Villas Destroyed by Vesuvius*. 2 Vols. New Rochelle, NY: Caratzas Bros.

Jashemski, Wilhelmina F., Kathryn L. Gleason, Kim J. Hartswick, and Amina-Aïcha Malek, eds. 2018. *Gardens of the Roman Empire*. Cambridge: Cambridge University Press.

"Jay Gould's Tomb." 1892. *Scientific American* 67, no. 24: 377.

Jeffreys, David. 2003. *Views of Ancient Egypt since Napoleon Bonaparte: Imperialism, Colonialism, and Modern Appropriations.* London: University College London Press.

Jenkyns, Richard. 1992. *Dignity and Decadence: Victorian Art and the Classical Inheritance.* Cambridge, MA: Harvard University Press.

Jeppesen, Klaus. 1976. "Neue Ergebnisse zur Wiederherstellung des Maussolleions von Halikarnassos." *Istanbuler Mitteilungen* 26:47–99.

———. 1977–78. "Zur Gründung und Baugeschichte des Maussolleions von Halikarnassos." *Istanbuler Mitteilungen* 27–28:169–211.

Jeppesen, Klaus, and Jan Zahle. 1975. "Investigations on the Site of the Mausoleum, 1970/1973." *American Journal of Archaeology* 79, no. 1: 67–79.

Jervis, John B. 1842. *Description of the Croton Aqueduct.* New York: Slamm and Guion.

———. 1971. *The Reminiscences of John B. Jervis, Engineer of the Old Croton.* Ed. Neal FitzSimons. Syracuse, NY: Syracuse University Press.

"John Anderson's Ways." 1885. *New York Times*, July 15.

Johnston, Norman. 2006. *Forms of Constraint: A History of Prison Architecture.* Urbana, IL: University of Illinois Press.

Jonnes, Jill. 2007. *Conquering Gotham. A Gilded Age Epic: The Construction of Penn Station and Its Tunnels.* New York: Viking, 2007.

Kahn, David. 1982. "The Grant Monument." *Journal of the Society of Architectural Historians* 41, no. 3: 212–31.

Kahn, Eve M. 2011. "Madison Square Presbyterian Church Fragments Found." *New York Times*, December 1.

Kallendorf, Craig, ed. 2007. *A Companion to the Classical Tradition.* Malden, MA: Wiley-Blackwell.

Keister, Douglas. 2011. *Stories in Stone New York: A Field Guide to New York City Cemeteries and Their Residents.* Salt Lake City, UT: Gibbs Smith.

Kennedy, Roger G. 2010. *Greek Revival America.* Rev. ed. New York: Rizzoli.

King, Charles. 1843. *A Memoir of the Construction, Cost, and Capacity of the Croton Aqueduct, Compiled from Official Documents: Together with an Account of the Civic Celebration of the Fourteenth October 1842, on Occasion of the Completion of the Great Work: Preceded by a Preliminary Essay on Ancient and Modern Aqueducts.* New York: C. King.

King, Moses. 1893. *King's Handbook of New York City: An Outline History and Description of the American Metropolis.* 2nd ed. Boston: Moses King.

Kisluk-Grosheide, Daniëlle O. 1994. "The Marquand Mansion." *Metropolitan Museum Journal* 29:151–81.

Knapp, Mary L. 2012. *An Old Merchant's House: Life at Home in New York City, 1835–65.* New York: Girandole.

Koeppel, Gerard T. 2015. *City on a Grid: How New York Became New York.* Boston: Da Capo.

Kostof, Spiro. 1995. *A History of Architecture: Settings and Rituals.* Ed. Greg Castillo. Oxford: Oxford University Press.

Krinsky, Carol. 1982. "The Fred F. French Building: Mesopotamia in Manhattan." *Antiques* 121, no. 1: 284–91.

Kurshan, Virginia. 1999. *(Former) National City Bank Building.* New York: Landmarks Preservation Commission.

———. 2001. *130 West 30th Street Building.* New York: Landmarks Preservation Commission.

Kuttner, Ann. 2017. "(Re)Presenting Romanitas at Sir John Soane's House and Villa." In *Housing the New Romans: Architectural Reception and Classical Style in the Modern World*, ed. Katharine von Stackelberg and Elizabeth Macaulay-Lewis, 24–53. New York: Oxford University Press.

"La Grange Terrace." 1836. *The Ladies Companion, New-York* (November): 5.

Lafever, Minard. 1846. *The Modern Builder's Guide.* Rev. ed. New York: Paine & Burgess & Co.

Lambert, Phyllis. 2013. *Building Seagram.* New Haven, CT: Yale University Press.

Lampen, Claire. 2018. "A Look Inside NYC's Mysterious Masonic Hall." *Gothamist*. http://gothamist.com/2018/10/22/masonic_hall_nyc_photos_history.php.

Lanciani, Rodolfo Amedeo. 1894. *Ancient Rome in the Light of Recent Discoveries*. Houghton Mifflin & Company.

Landau, Sarah Bradford, and Carl Condit. 1999. *Rise of the New York Skyscraper, 1865–1913*. New Haven, CT: Yale University Press.

Landfester, Manfred, ed. 2006–2011. *Brill's New Pauly, Classical Tradition*. 5 vols. Leiden: Brill.

Landy, Jacob. 1970. *The Architecture of Minard Lafever*. New York: Columbia University Press.

Lapatin, Kenneth, Rachel Herschman, and Clare Fitzgerald. 2019. "'Bold and Dazzling': Leon Bakst and Antiquity." In *Hymn to Apollo: The Ancient World and the Ballets Russes*, ed. Clare Fitzgerald, 80–115. Princeton, NJ: Institute for the Study of the Ancient World at New York University/Princeton University Press.

Lawrence, A. W. 1996. *Greek Architecture*. Ed. R. A Tomlinson. New Haven, CT: Yale University Press.

Layard, A. H. 1849. *Nineveh and Its Remains: With an Account of a Visit to the Chaldean Christians of Kurdistan, and the Yezidis, or Devil Worshippers; and an Inquiry into the Manners and Arts of the Ancient Assyrians*. 2 vols. London: John Murray.

———. 1849–1853. *The Monuments of Nineveh*. London: John Murray.

———. 1852. *A Popular Account of Discoveries at Nineveh*. London: John Murray.

———. 1853. *Discoveries among the Ruins of Nineveh and Babylon; with Travels in Armenia, Kurdistan, and the Desert: Being the Result of a Second Expedition Undertaken for the Trustees of the British Museum*. London: John Murray.

———. 1854. *The Ninevah Court in the Crystal Palace*. London: John Murray.

Leland, Ernest Stevens. 1922. "Planting the Mausoleum Plot: IV—The Woolworth Mausoleum." *Park and Cemetery and Landscape Gardening* 32, no. 2: 39–42.

Le Roy, Julien-David. 2004. *The Ruins of the Most Beautiful Monuments of Greece*. Trans. David Britt. Los Angeles: Getty Publications.

"Lewisohn Stadium, Center for Culture, to Be Razed." 1973. *New York Times*, April 5.

"The Library Site Again." 1895. *New York Times*, April 25.

Lobel, Cindy. 2010. "'Out to Eat': The Emergence and Evolution of the Restaurant in Nineteenth-Century New York City." *Winterthur Portfolio* 44, nos. 2/3 (Summer/Autumn): 193–220.

Lombardi, Leonardo, Angelo Corazza, and Filippo Coarelli. 1995. *Le terme di Caracalla*. Rome: Fratelli Palombi.

Lord, Marie. 2009. "Improving the Public: Cultural and Typological Changes in Nineteenth-Century Libraries." PhD diss., The Graduate Center, The City University of New York.

Lowe, David. 1992. *Stanford White's New York*. New York: Doubleday.

Lyon, D. G. 1903. *Addresses Delivered at the Formal Opening of the Semitic Museum of Harvard University*. February 5.

Macaulay-Lewis, Elizabeth, 2015. "Triumphal Washington: New York City's 'Roman' Arch." In *War as Spectacle: Ancient and Modern Perspectives on the Display of Armed Conflict*, ed. Anastasia Bakogianni and Valerie Hope, 209–39. London: Bloomsbury Academic.

———. 2016. "The Architecture of Memory and Commemoration: The Soldiers' and Sailors' Memorial Arch, Brooklyn, New York and the Reception of Classical Architecture in New York City." *Classical Receptions Journal* 8, no. 4: 447–78.

———. 2017. "Entombing Antiquity: A New Consideration of Classical and Egyptian Appropriation in the Funerary Architecture of Woodlawn Cemetery." In *Housing the New Romans: Architectural Reception and Classical Style in the Modern World*, ed. Katharine von Stackelberg and Elizabeth Macaulay-Lewis, 190–231. New York: Oxford University Press.

———. 2018a. "The Gould Memorial Library and Hall of Fame: Reinterpreting the Pantheon in the Bronx." In *Classical New York: Discovering Greece and Rome in Gotham*, ed. Elizabeth Macaulay-Lewis and Matthew M. McGowan, 85–113. New York: Fordham University Press.

———. 2018b. "Dining Like Nero: Antiquity and Immersive Dining Experiences in Early Twentieth-Century New York." *Classical Outlook* 93, no. 1: 13–19.

———. 2018c. "Antiquity in Gotham." https://ancientarchny.commons.gc.cuny.edu/.

Macaulay-Lewis, Elizabeth, and Matthew M. McGowan, eds. 2018a. *Classical New York: Discovering Greece and Rome in Gotham*. New York: Fordham University Press.

———, eds. 2018b. "Classical New York." In *Classical New York: Discovering Greece and Rome in Gotham*, ed. Elizabeth Macaulay-Lewis and Matthew M. McGowan, 1–13. New York: Fordham University Press.

Macintosh, Fiona, ed. 2010. *The Ancient Dancer in the Modern World: Responses to Greek and Roman Dance*. Oxford: Oxford University Press.

Mackay, Andrew, and A. A. Canfield. 1944. *The Murals in the Theodore Roosevelt Memorial Hall*. Science Guide 119. New York: American Museum of Natural History.

Malamud, Margaret. 2000. "The Imperial Metropolis: Ancient Rome in Turn-of-the-Century New York." *Arion* 7, no. 3: 64–108.

———. 2001. "Roman Entertainments for the Masses in Turn-of-the-Century New York." *Classical World* 95, no. 1: 49–57.

———. 2009. *Ancient Rome and Modern America*. Malden, MA; Oxford: Wiley-Blackwell.

———. 2018. "The Imperial Metropolis." In *Classical New York: Discovering Greece and Rome in Gotham*, ed. Elizabeth Macaulay-Lewis and Matthew M. McGowan, 38–62. New York: Fordham University Press.

"Manhattan Bridge Portal, New York." 1918. *National Real Estate and Building Journal* 17–20: 32.

"Martin to Remodel the Cafe de l'Opera." 1910. *New York Times*, September 10.

Martindale, Charles. 1993. *Redeeming the Text: Latin Poetry and the Hermeneutics of Reception*. Cambridge: Cambridge University Press.

Martindale, Charles, and Richard Thomas. 2006. *Classics and the Uses of Reception*. Oxford: Blackwell.

Matheson, Susan B., and J. J. Pollitt. 1994. *An Obsession with Fortune: Tyche in Greek and Roman Art*. New Haven, CT: Yale University Art Gallery.

Mau, August. 1902. *Pompeii, Its Life and Art*. Trans. Francis W. Kelsey. New York: Macmillan.

"Max Schaffer, 83, Who Operated Hubert's Museum, Arcades, Dies." 1974. *New York Times*, February 15.

McDavid, Allyson. 2018. "The Roman Bath in New York: Public Bathing, the Pursuit of Pleasure and Monumental Delight." In *Classical New York: Discovering Greece and Rome in Gotham*, ed. Elizabeth Macaulay-Lewis and Matthew M. McGowan, 182–210. New York: Fordham University Press.

McDowell, Peggy, and Richard Meyer. 1994. *The Revival Styles in American Memorial Art*. Bowling Green, OH: Bowling Green State University Popular Press.

McEntee, Arthur J. 1921. "Recent Developments in the Architectural Treatment of Concrete Industrial Buildings." *Architecture* 43:18–21.

McGeehan, Patrick. 2017. "Manhattan's Farley Post Office Will Soon Be a Grand Train Hall." *New York Times*, December 22.

McGowan, Matthew M. 2018. "'In Ancient and Permanent Language': Artful Dialogue in the Latin Inscriptions of New York City." In *Classical New York: Discovering Greece and Rome in Gotham*, ed. Elizabeth Macaulay-Lewis and Matthew McGowan, 211–34. New York: Fordham University Press.

McKenzie, Judith. 2007. *The Architecture of Alexandria and Egypt, c. 300 BC to AD 700*. New Haven, CT: Yale University Press.

Meier, Lauren. 2006. "Green-Wood Cemetery." National Historic Landmarks Nomination. US Department of the Interior. National Park Service NPS Form 10-900.

Meier, Lauren, and Christopher Beagan. 2009. "Woodlawn Cemetery." National Historic Landmarks Nomination. US Department of the Interior. National Park Service NPS Form 10-900.

Monorey, Morgan. 2009. "Touring the New York City Obelisks—Manhattan." *Archaeology Magazine*. https://archive.archaeology.org/online/features/obelisk_tour/manhattan.html.

Moore, Charles. 1929. *The Life and Times of Charles Follen McKim*. New York: Houghton Mifflin.

More, David Fellows, and Charles Church More. 1893. *History of the More Family: And an Account of Their Reunion in 1890*. Binghamton: S. P. More.

"The Morgan House." n.d. https://www.themorgan.org/about/architectural-history/12.

Morris, Charles. 1894. *Makers of New York: An Historical Work, Giving Portraits and Sketches of the Most Eminent Citizens of New York*. Philadelphia: L. R. Hamersly & Company.

Morris, Kathleen M. 2017. "Unrivaled in Originality: The Marquand Music Room." In *Orchestrating Elegance: Alma-Tadema and the Marquand Music Room*, ed. Kathleen M. Morris and Alexis Goodin, 95–125. Wiliamstown, MA: Clark Art Institute.

Morrison, William. 1999. *Broadway Theatres: History and Architecture*. Mineola, NY: Dover.

Morrone, Francis. 2001. *An Architectural Guidebook to Brooklyn*. Layton, UT: Gibbs Smith.

———. 2018. "The Custom House of 1833–42: A Greek Revival Building in Context." In *Classical New York: Discovering Greece and Rome in Gotham*, ed. Elizabeth Macaulay-Lewis and Matthew M. McGowan, 15–37. New York: Fordham University Press.

Moser, Stephanie. 2012. *Designing Antiquity: Owen Jones, Ancient Egypt, and the Crystal Palace*. New Haven, CT: Yale University Press.

———. 2015. "Reconstructing Ancient Worlds: Reception Studies, Archaeological Representation, and the Interpretation of Ancient Egypt." *Journal of Archaeological Method and Theory* 22, no. 4: 1263–308.

———. 2020. *Painting Antiquity: Ancient Egypt in the Art of Lawrence Alma-Tadema, Edward Poynter, and Edwin Long*. Oxford: Oxford University Press.

Mumford, Lewis. 1955. *Sticks and Stones: A Study of American Architecture and Civilization*. 2nd ed. New York: Dover.

———. 1959. "The Lesson of the Master." *Journal of the AIA* 31 (January): 19–20.

———. 1998. *Sidewalk Critic: Lewis Mumford's Writings on New York*. Ed. Robert Wojtowicz. New York: Princeton Architectural Press.

Municipal Building. 1966. New York: Landmarks Preservation Commission.

Murphy, Heather. 2019. "Maine Is the Latest State to Replace Columbus Day with Indigenous Peoples' Day." *New York Times*, April 28.

Nagel, Alexander. 2019. "Research on Color Matters: Towards a Modern Archaeology of Ancient Polychromies." In *Science in Color. Visualizing Achromatic Knowledge*, ed. B. Bock von Wuelfingen, 45–58. Berlin: De Gruyter.

———. 2014. "Color in Ancient Near Eastern and Egyptian Sculpture." In *Transformations—Classical Sculpture in Color*, ed. Jan Stubbe Østergaard and Anne Marie Nielsen, 130–45. Copenhagen: Ny Carlsberg Glyptotek.

Nash, Eric. 2010. *Manhattan Skyscrapers*. Rev. ed. New York: Princeton Architectural Press.

"National Memorial Arch." n.d. National Parks Service. https://www.nps.gov/vafo/learn/historyculture/arch.htm.

Neff, John R. 2005. *Honoring the Civil War Dead: Commemoration and the Problem of Reconciliation*. Lawrence: University Press of Kansas.

Nelson, Erika. 2013. "The Art Collection of Jules S. Bache." MA diss., Institute of Fine Arts, New York University.

Neuman, William. 2018. "No Traveling for New York's Columbus Statue, Mayor Decides." *New York Times*, January 12.

"The New House of Detention." 1837. *New York Evening Post*, April 1.

"New Restaurant Wonders." 1909. *New York Times*, December 12.

New World. 1842. Vol. 5, no. 2 (July 9): 32.

New-York Historical Society. 1966. New York: Landmarks Preservation Commission.

Newton, Charles T. 1862–1863. *A History of Discoveries at Halicarnassus, Cnidus and Branchidae*. 2 vols. London: Day & Son.

Nichols, Frederick D. 2003. "Jefferson, Thomas." Grove Art Online. https://www .oxfordartonline.com/groveart/view/10.1093/gao/9781884446054.001.0001/oao -9781884446054-e-7000044540.

Nichols, Kate. 2015. *Greece and Rome at the Crystal Palace: Classical Sculpture and Modern Britain, 1854–1936*. Oxford: Oxford University Press.

Nichols, Marden. 2017. "Domestic Interiors, National Concerns: The Pompeian Style in the United States." In *Housing the New Romans: Architectural Reception and Classical Style in the Modern World*, ed. Katharine von Stackelberg and Elizabeth Macaulay-Lewis, 126–53. New York: Oxford University Press.

Northrop, Henry Davenport. 1892. *Life and Achievements of Jay Gould, the Wizard of Wall Street: Being a Complete and Graphic Account of the Greatest Financier of Modern Times*. Philadelphia: National Publishing Company.

"A Notable Skyscraper." 1912. *Cassier's Magazine* 42 (July): 61–66.

O'Gorman, James. 2015. *Isaiah Rogers: Architectural Practice in Antebellum America*. Boston: University of Massachusetts Press.

"The Old Reservoir," 1986. *New York Times*, June 30.

"Old World news by cable." 1887. *New York Times*, August 28.

Osborn, Henry Fairfield. 1922. "Report of the Roosevelt Memorial Commission: Report of Progress by the New York State Roosevelt Memorial Commission, 1920 and 1921." *New York Legislative Documents, One Hundred and Forty-Fifth Session* 14 (31–57): 1–22.

———. 1928. *History Plan and Design of the New York State Roosevelt Memorial*. New York: The Board of Trustees, American Museum of Natural History.

Østergaard, Jan Stubbe, and Anne Marie Nielsen, eds. 2014. *Transformations—Classical Sculpture in Color*. Copenhagen: Ny Carlsberg Glyptotek.

"Our Remembrance of September 11, 2001." n.d. St. Peter's Church. https://spcolr.org/events-of -9-11-at-st-peters-church-st-josephs-chapel-seton-shrine-nyc.

Panzanelli, Roberta, Eike D. Schmidt, and Kenneth D. S. Lapatin, eds. 2008. *The Color of Life: Polychromy in Sculpture from Antiquity to the Present*. Los Angeles: J. Paul Getty Museum and Getty Research Institute.

Parsons, Albert Ross. 1893. *New Light from the Great Pyramid: The Astronomico-Geographical System of the Ancients Recovered and Applied to the Elucidation of History, Ceremony, Symbolism, and Religion, with an Exposition of the Evolution from the Prehistoric, Objective, Scientific Religion of Adam Kadmon, the Macrocosm, of the Historic, Subjective, Spiritual Religion of Christ Jesus, the Microcosm*. New York: Metaphysical Publishing Company.

Patrick, Sue. 2000. "Bache, Jules Semon." *American National Biography Online*. http://www.anb .org.ezproxy.gc.cuny.edu/articles/10/10-01905.html.

Pearson, Paul. 1997. *The City College of New York: 150 Years of Academic Architecture*. New York: City College.

Peck, Amelia, ed. 1992. *Alexander Jackson Davis: American Architect 1803–1892*. New York: Rizzoli.

Pedde, Brigitte. 2001. "Das 'Neue Babylon'. Alter Orient und Hochhausarchitektur in Den USA." *Alter Orient Aktuell* 2:8–12.

———. 2012. "Ancient Near Eastern Motifs in the European Art of the 20th Century AD." In *Proceedings of the 7th International Congress on the Archaeology of the Ancient Near East, 12 to 16 April 2010, The British Museum and University College London*, ed. Roger Matthews and John Curtis, 2:89–100. Wisebaden: Harrassowitz.

————. 2013. "Reception of Ancient Near Eastern Architecture in Europe and North America in the 20th Century." In *Time and History in the Ancient Near East: Proceedings of the 56th Rencontre Assyriologique Internationale at Barcelona*, ed. L. Feliu, J. Llop, A. Millet Albà, and J. Sanmartín, 413–22. Winona Lake, IN: Eisenbrauns.

"Pediment for the Brooklyn Museum." n.d. Brooklyn Museum. https://www.brooklynmuseum .org/opencollection/objects/21738.

"Pelham Bay Park: Bronx Victory Memorial." n.d. New York City Parks Department. https:// www.nycgovparks.org/parks/pelham-bay-park/monuments/163.

Pennsylvania Railroad Company. 1910. *The New York Improvement Project and Tunnel Extension of the Pennsylvania Railroad*. Philadelphia: Pennsylvania Railroad Company.

Petronius, Arbiter and Annaeus Seneca. 1913. *Satyricon. Apocolocyntosis*. Trans. Michael Heseltine and William Henry Denham. Rev. by Eric Herbert Warmington. Loeb Classical Library 15. Cambridge, MA: Harvard University Press.

Pevsner, Nikolaus. 1997. *A History of Building Types*. Rev. ed. Princeton, NJ: Princeton University Press.

"The Piccirilli Brothers." n.d. New York Public Library. https://www.nypl.org/help/about-nypl /library-lions/piccirilli-brothers.

Picon, Carlos A., Seán A Hemingway, Christopher Lightfoot, et al. 2007. *Art of the Classical World in the Metropolitan Museum of Art: Greece, Cyprus, Etruria, Rome*. New York: Metropolitan Museum of Art.

"Pictures of Life in New York: John Henry Visits the Tombs." 1875. *Pomeroy's Democrat* 1, no. 12 (March 20).

Pierson, William H. 1970. *American Buildings and Their Architects*. Vol. 1: *The Colonial and Neoclassical Styles*. New York: Oxford University Press.

Pincus, Lionel, and Princess Firyal Map Division, New York Public Library. "Plan de New-York et des environs." New York Public Library Digital Collections. http://digitalcollections.nypl .org/items/510d47da-ee31-a3d9-e040-e00a18064a99.

Pindar, George. 1930. "The New York State Roosevelt Memorial." *Scientific Monthly* 31, no. 3 (September): 284–88.

————. 1931. *The Theodore Roosevelt Memorial*. New York: American Museum Press.

Piranesi, Giovanni Battista. 1769. *Diverse maniere d'adornare i cammini ed ogni altra parte degli edifizj desunte dall'architettura Egizia, Etrusca, e Greca, con un ragionamento apologetico in difesa dell'architettura Egizia e Toscana*. Rome: Generoso Salomoni.

"Plan no. 6 The Winner." 1893. *Brooklyn Daily Eagle*, May 20.

"Plans baths for Tired New Yorkers." 1907. *New York Times*, September 22.

Pogrebin, Robin. 2020. "Roosevelt Statue to Be Removed from Museum of Natural History." *New York Times*, June 21.

Pollitt, J. J. 1986. *Art in the Hellenistic Age*. Cambridge: Cambridge University Press.

Ponce de León, Néstor. 1893. *The Columbus Gallery: The "Discoverer of the New World" as Represented in Portraits, Monuments, Statues, Medals, and Paintings*. New York: N. Ponce de León.

Postal, Matthew. 2005. *Austin, Nichols & Co. Warehouse*. New York: Landmarks Preservation Commission.

Postal, Matthew, and Joseph C. Brooks. 2000. *Baird (Now Astor) Court, New York Zoological Park (Bronx Zoo)*. New York: Landmarks Preservation Commission.

Postclassicisms Collective. 2019. *Postclassicisms*. Chicago: University of Chicago.

Powell, Ken. 1996. *Grand Central Terminal: Warren and Wetmore*. London: Phaidon.

Prettejohn, Elizabeth. 2012. *The Modernity of Ancient Sculpture: Greek Sculpture and Modern Art from Winckelmann to Picasso*. London: I. B. Tauris.

Price, C. Matlack, 1911. "'Colonnade Row' La Grange Terrace, New York City." *American Architect* 99 (1852): 245–50.

Public Baths. 1974. New York: Landmarks Preservation Commission.

"The Pythians: History." Knights of Pythias. https://knightsofpythias.squarespace.com/supreme /history.

Reier, Sharon. 2000. *The Bridges of New York.* 2nd ed. Mineola, NY: Dover.

Renner, Andrea. 2008. "A Nation That Bathes Together: New York City's Progressive Era Public Baths." *Journal of the Society of Architectural Historians* 67, no. 4: 504–31.

Rice, Michael, and Sally MacDonald. 2003. "Introduction—Tea with a Mummy: The Consumer's View of Egypt's Immemorial Appeal." In *Consuming Ancient Egypt,* ed. Sally MacDonald and Michael Rice, 1–22. London: University College London Press/Institute of Archaeology.

Richard, Carl. 1994. *The Founders and the Classics: Greece, Rome, and the American Enlightenment.* Cambridge, MA: Harvard University Press.

———. 2009. *The Golden Age of the Classics in America: Greece, Rome, and the Antebellum United States.* Cambridge, MA: Harvard University Press.

Richardson, Lawrence. 1992. *A New Topographical Dictionary of Ancient Rome.* Baltimore, MD: Johns Hopkins University Press.

Richman, Jeffrey. 2008. *Brooklyn's Green-Wood Cemetery: New York's Buried Treasure.* Rev. ed. Brooklyn: Green-Wood Cemetery.

Ritter, Jonathan. 2007. "The American Civic Center: Urban Ideals and Compromise on the Ground." PhD diss., Institute of Fine Arts, New York University.

———. 2018. "'The Expression of Civic Life:' Civic Centers and City Beautiful in New York City." In *Classical New York: Discovering Greece and Rome in Gotham,* ed. Elizabeth Macaulay-Lewis and Matthew M. McGowan, 114–39. New York: Fordham University Press.

Roaf, Michael. 2003. *Cultural Atlas of Mesopotamia and the Ancient Near East.* Rev. ed. New York: Facts on File.

Robinson, Charles M. 1903. *Modern Civic Art; or, The City Made Beautiful.* New York, G. P. Putnam's Sons.

Robinson, Edward. 1926. "Part 2: The Southern Extension of the Building, Wing K." *Metropolitan Museum of Art Bulletin* 21, no. 4: 3–7.

Roller, Matthew. 2013. "On the Intersignification of Monuments in Augustan Rome." *American Journal of Philology* 134, no. 10: 119–31.

Root, Margaret Cool. 2003. "Persepolis." Grove Art Online. https://www.oxfordartonline.com /groveart/view/10.1093/gao/9781884446054.001.0001/oao-9781884446054-e-7000066557.

Rosenthall, Karen M. 2016. "A Generative Populace: Benjamin Franklin's Economic Agendas." *Early American Literature* 51, no. 3: 571–98.

Ross, William. 1835. "Street Houses of the City of New York." *Architectural Magazine* 2:490–93.

Roth, Leland M. 1983. *McKim, Mead & White, Architects.* New York: Harper & Row.

———. 1988. "McKim, Mead & White and the Brooklyn Museum, 1893–1934." In *A New Brooklyn Museum: The Master Plan Competition,* ed. Joan Darragh, 26–51. New York: Brooklyn Museum.

Roth, Leland M., and Amanda C. R. Clark. 2014. *Understanding Architecture: Its Elements, History, and Meaning.* 3rd ed. Boulder, CO: Westview.

Rowell, Diana. 2012. *Paris: The "New Rome" of Napoleon I.* London: Bloomsbury Academic.

Rudy, Willis S. 1949. *The College of the City of New York, a History, 1847–1947.* New York: City College Press.

Rugg, Julie. 1999. "From Reason to Regulation: 1760–1850." In *Death in England: An Illustrated History,* ed. Peter C. Jupp and Clare Gittings, 202–29. Manchester: Manchester University Press.

Rumsey, Charles Cary. 1917. "Three Sculptures." *Arts & Decoration* 7, no. 6: 311.

Ryan, Mary P. 2000. "'A Laudable Pride in the Whole of Us': City Halls and Civic Materialism." *American Historical Review* 105, no. 4: 1131–70.

Sanger, Victoria, and Isabelle Warmoes. 2003. "The City Gates of Louis XIV." *Journal of Urban History* 30, no. 1: 50–69.

Savage, Kirk. 1997. *Standing Soldiers, Kneeling Slaves: Race, War, and Monument in Nineteenth-Century America*. Princeton, NJ: Princeton University Press.

———. 2012. "New Directions in Commemoration, Commemorative Landscapes of North Carolina." Commemorative Landscapes. http://docsouth.unc.edu/commland/features/essays/savage/.

Schlereth, Thomas. 1992. "Columbia, Columbus, and Columbianism." *Journal of American History* 79, no. 3: 937–68.

Schlichting, Kurt. 2001. *Grand Central Terminal: Railroads, Engineering, and Architecture in New York City*. Baltimore, MD: Johns Hopkins University Press.

Schulten, Katherine. 2018. "Should Columbus Day Be Replaced with Indigenous Peoples Day?" *New York Times*, October 4.

Schulze, Franz. 1985. *Mies van Der Rohe: A Critical Biography*. Chicago: University of Chicago Press.

Schuyler, Montgomery. 1904. "'A Modern Classic.' Knickbocker Trust Co. McKim, Mead, & White, Architects." *Architectural Record* 15, no. 5 (May): 431–44.

Scott, R. Jeffery. 1981. "The Historical Origins of the Zoological Park in American Thought." *Environmental Review* 5, no. 2: 52–65.

Seymour, Michael. 2015. "The Babylon of D. W. Griffith's Intolerance." In *Imagining Ancient Cities in Film: From Babylon to Cinecittà*, ed. Marta García Morcillo, Pauline Hanesworth, and Óscar Lapeña Marchena, 18–34. New York: Routledge.

Shaw, Ian, and Paul Nicholson. 2008. *The Princeton Dictionary of Ancient Egypt*. Princeton, NJ: Princeton University Press.

Sheldon, George William. 1883. *Artistic Houses: Being a Series of Interior Views of a Number of the Most Beautiful and Celebrated Homes in the United States: With a Description of the Art Treasures Contained Therein*. Vol. 1, Part 1. New York: Printed for subscribers by D. Appleton and Company.

Shepherd, Barnett. 1976. "Sailors' Snug Harbor Reattributed to Minard Lafever." *Journal of the Society of Architectural Historians* 35, no. 2: 108–23.

Sherman, Lauren, and Ellen Robb Gaulkin. 2009. *Weehawken*. Charleston, SC: Arcadia.

Silk, M. S., Ingo Gildenhard, and R. J. Barrow, eds. 2014. *The Classical Tradition: Art, Literature, Thought*. London: Wiley Blackwell.

Silver, Kenneth, ed. 2010. *Chaos & Classicism: Art in France, Italy, and Germany, 1918–1936*. New York: Guggenheim Museum.

Simard, Jared. 2015. "The Monument and Altar to Liberty: A Memory Site for the United States' Own Thermopylae." In *War as Spectacle*, ed. Anastasia Bakogianni and Valerie Hope, 181–208. London: Bloomsbury Academic.

———. 2016. "Classics and Rockefeller Center: John D. Rockefeller Jr. and the Use of Classicism in Public Space." PhD diss., The Graduate Center, The City University of New York.

———. 2018. "The Titans of Rockefeller Center: *Prometheus* and *Atlas*." In *Classical New York: Discovering Greece and Rome in Gotham*, ed. Elizabeth Macaulay-Lewis and Matthew M. McGowan, 140–60. New York: Fordham University Press.

Sinclair, Jill. 2016. "'These Beautiful Pleasure-Grounds of Death': Nineteenth-Century America's Adaptation of the Parisian Rural Cemetery." In *Foreign Trends in American Gardens: A History of Exchange, Adaptation, and Reception*, ed. Raffaella Fabiani Giannetto, 59–87. Charlottesville: University of Virginia Press.

Smith, A. H. 1900. *A Catalogue of Sculpture in the Department of Greek and Roman Antiquities, British Museum*. Vol. 2. London: Trustees of the British Museum.

Smith, William Stevenson. 1998. *The Art and Architecture of Ancient Egypt*. 3rd ed. Ed. William Kelly Simpson. New Haven, CT: Yale University Press.

"The Soldiers and Sailors' Memorial Arch in Brooklyn, N.Y." 1889. *Engineering News* 22 (November 16): 459.

Soldiers and Sailors Monument. 1974. New York: Landmarks Preservation Commission.

Sowerby, E. Millicent. 1952–1959. *Catalogue of the Library of Thomas Jefferson.* 5 Vols. Washington, DC: Library of Congress.

Spofford, Harriet. 1878. *Art Decoration Applied to Furniture.* New York: Harper and Brothers.

Sprague, Elmer. 2008. *Brooklyn Public Monuments: Sculpture for Civic Memory and Urban Pride.* Indianapolis, IN: Dog Ear.

Squire, Michael, James Cahill, and Ruth Allen, eds. *The Classical Now.* London: Elephant.

Srebnick, Amy Gilman. 1995. *The Mysterious Death of Mary Rogers: Sex and Culture in Nineteenth-Century New York.* New York: Oxford University Press.

St. James Church. 1966. New York: Landmarks Preservation Commission.

St. Peter's Church. 1965. New York: Landmarks Preservation Commission.

"Stadium for the Whole City; The Donor, Adolph Lewisohn, Tells of Program for 1916." 1915. *New York Times,* October 26.

Stargard, William, and Marjorie Pearson. 1985. *New York Stock Exchange Building.* New York: Landmarks Preservation Commission.

Stern, Robert A. M., Thomas Mellins, and David Fishman. 1995. *New York 1960: Architecture and Urbanism between the Second World War and the Bicentennial.* New York: Monacelli.

Stevenson, Christine. 2006. "Occasional Architecture in Seventeenth-Century London." *Architectural History* 49:35–74.

Strocka, Volker. 2008. "Domestic Decoration: Painting and the 'Four' Styles." In *The World of Pompeii,* ed. John Joseph Dobbins and Pedar W. Foss, 302–21. London: Routledge.

"Structures: Arches." n.d. Public Art Fund. https://www.publicartfund.org/exhibitions/view/ai-weiwei-good-fences-make-good-neighbors/.

Stuart, James, and Nicholas Revett. 1762–1816. *The Antiquities of Athens.* 4 Vols. London.

Stuart, Percy. 1901. "The New York Stock Exchange." *Architectural Record* 11 (July): 525–52.

Sturgis, Russell. 1898. "A Review of the Work of George B. Post." *Architectural Record–Great American Architects Series* 4 (June): 1–102.

———. 1904. "Facade of the New York Stock Exchange." *Architectural Record* 16 (November): 464–82.

Sullivan, Louis H. 1896. "The Tall Office Building Artistically Considered." *Lippincott's Magazine* 339 (March): 403–9.

Sund, Judy. 1993. "Columbus and Columbia in Chicago, 1893: Man of Genius Meets Generic Woman." *Art Bulletin* 75, no. 3: 443–66.

Sutherland, C. H. V. 1984. *Roman Imperial Coinage.* Vol. 1. London: Spink.

Sutton, Charles. 1973. *The New York Tombs: Its Secrets and Its Mysteries.* Ed. James Mix and Samuel Mackeever. Patterson Smith Series in Criminology, Law Enforcement & Social Problems 178. Montclair, NJ: Patterson Smith.

Tabet, Rayyane. 2018. *Fragments.* Beirut: Kaph.

Tappan, Lewis. 1870. *The Life of Arthur Tappan.* New York: Hurd and Houghton.

Taube, Isabel L. 2015. "Aesthetic Movement in America." Grove Art Online. July 10. https://www.oxfordartonline.com/groveart/view/10.1093/gao/9781884446054.001.0001/oao-9781884446054-e-7002277552.

Thomas Cook Ltd. 1897. *Cook's Tourists' Handbook for Egypt, the Nile, and the Desert.* London: T. Cook & Son.

Thomas, Edmund. 1997. "The Architectural History of the Pantheon in Rome from Agrippa to Septimius Severus via Hadrian." *Hephaistos* 15:163–86.

"To Beautify Manhattan Bridge." 1912. *Brooklyn Daily Eagle,* July 7.

"The Tombs, New York's Historic Prison, Now Being Torn Down." 1897. *Plain Dealer* (Cleveland, OH), June 14.

"The Tombs Prison Last Days of The Famous New York Building. It's [*sic*] Grime and Gloomy Record of Nearly Sixty Years-Notable Criminals Who Were Kept there." 1897. *Oregonian* (published as *Morning Oregonian*), July 9.

"Topic of the Times." 1899. *New York Times*, September 20.

Torres, Louis. 1964. "John Frazee and the New York Custom House." *Journal of the Society of Architectural Historians* 23, no. 3: 143–50.

Tower, Fayette. 1843. *Illustrations of the Croton Aqueduct*. New York: Wiley and Putnam.

Trachtenberg, Marvin, and Isabelle Hyman. 1986. *Architecture: From Prehistory to Post-Modernism / The Western Tradition*. New York: Abrams.

Trafton, Scott. 2004. *Egypt Land: Race and Nineteenth-Century American Egyptomania*. Durham, NC: Duke University Press.

Tunick, Susan. 1997. *Terra-Cotta Skyline: New York's Architectural Ornament*. New York: Princeton Architectural Press.

Turner, Jane. 2002. *Encyclopedia of American Art before 1914*. Oxford: Oxford University Press.

Turner, Paul Venable. 1995. *Campus: An American Planning Tradition*. Cambridge, MA: MIT Press.

Tuthill, Louisa. 1848. *History of Architecture, from the Earliest Times; Its Present Condition in Europe and the United States; with a Biography of Eminent Architects, and a Glossary of Architectural Terms*. Philadelphia: Lindsay and Blakiston.

"Two Highly Interesting Rooms." 1903. *New-York Tribune Illustrated Supplement*, December 6.

Vance, William. 1989. *America's Rome*. New Haven, CT: Yale University Press.

"Vanity Fair—Fads, Foibles, and Fashions." 1889. *Current Opinion* 3:118.

Verplanck, Gulian. 1824. *Address Delivered before the American Academy of the Fine Arts at the Opening of the Tenth Exhibition*. New York: Charles Wiley.

Victoria and Albert Museum. 2012. "Style Guide: Medieval Revivals." http://www.vam.ac.uk /content/articles/s/style-guide-medieval-revivals/.

Vidler, Anthony. 2019. "Building Segram: A Memoir of Mies and Modernism." *Architectural Review*. https://www.architectural-review.com/essays/building-seagram-a-memoir-of-mies -and-modernism/8652671.article.

Villedieu, Françoise. 2010. "La cenatio rotunda de la Maison Dorée de Néron." *Comptes rendus des séances de l'Académie des Inscriptions et Belles-Lettres*. 154e année, no. 3: 1089–1114. doi:10.3406/ crai.2010.92993.

———. 2016. "La "cenatio rotunda" de Néron: état des recherches." *Comptes rendus / Académie des inscriptions et belles-lettres* 1, no. 1: 107–26.

von Stackelberg, Katharine. 2017. "Reconsidering Hyperreality: 'Roman' Houses and Their Gardens." In *Housing the New Romans: Architectural Reception and Classical Style in the Modern World*, ed. Katharine von Stackelberg and Elizabeth Macaulay-Lewis, 232–68. New York: Oxford University Press.

von Stackelberg, Katharine, and Elizabeth Macaulay-Lewis. 2017. "Architectural Reception and the Neo-Antique." In *Housing the New Romans: Architectural Reception and Classical Style in the Modern World*, ed. Katharine von Stackelberg and Elizabeth Macaulay-Lewis, 1–23. New York: Oxford University Press.

Ucko, Peter, and Timothy C. Champion. 2003. *The Wisdom of Egypt: Changing Visions through the Ages*. London: University College London Press / Institute of Archaeology.

Wallace, Mike. 2017. *Greater Gotham: A History of New York City from 1898 to 1919*. New York: Oxford University Press.

Wallach, Alan. 1998. *Exhibiting Contradiction: Essays on the Art Museum in the United States*. Amherst: University of Massachusetts Press.

Ward, J. P., Mary Warner Marien, and Gerald W. R. Ward. 2003. "Photography." Grove Art Online. https://www.oxfordartonline.com/groveart/view/10.1093/gao/9781884446054.001 .0001/oao-9781884446054-e-7000067117.

Ward-Perkins, John B. 1991. *Cities of Ancient Greece and Italy: Planning in Classical Antiquity*. New York: Braziller.

Warren, Charles. 2014. "Garden Necropolis: Planning Woodlawn's Landscape." In *Sylvan Cemetery: Architecture, Art & Landscape at Woodlawn*, ed. Charles Warren, Carole Ann Fabian, and Janet Parks, 13–51. New York: Avery Architectural & Fine Arts Library and the Woodlawn Conservancy.

Warren, Charles, Carole Ann Fabian, and Janet Parks, eds. 2014. *Sylvan Cemetery: Architecture, Art & Landscape at Woodlawn*. New York: Avery Architectural & Fine Arts Library and the Woodlawn Conservancy.

Warren, Richard. 2018. *Art Nouveau and the Classical Tradition*. London: Bloomsbury.

Warren, Whitney. 1913. "Facade of Terminal the Keynote to the Structure." *New York Times*, February 2.

Waywell, Geoffery. 1978. *The Free-Standing Sculptures of the Mausoleum at Halicarnassus in the British Museum*. London: British Museum Publications.

———. 2003. "Halikarnassos." Grove Art Online. https://www.oxfordartonline.com/groveart/view/10.1093/gao/9781884446054.001.0001/oao-9781884446054-e-7000036236.

"We honor the Name." 1892. *Brooklyn Eagle*, October 21.

Webster, Sally. 2015. *The Nation's First Monument and the Origins of the American Memorial Tradition: Liberty Enshrined*. Burlington, VT: Ashgate.

Wilson Jones, Mark. 2000. *Principles of Roman Architecture*. New Haven, CT: Yale University Press.

Wilson Jones, Mark, Eugene Dwyer, Sergio L. Sanabria, et al. 2003. "Orders, architectural." Grove Art Online. https://www.oxfordartonline.com/groveart/view/10.1093/gao/9781884446054.001.0001/oao-9781884446054-e-7000063721.

Wilton-Ely, John. 2003. "Egyptian Revival." Grove Art Online. https://www.oxfordartonline.com/groveart/view/10.1093/gao/9781884446054.001.0001/oao-9781884446054-e-7000025629.

Winckelmann, Johann. 1764. *Geschichte der Kunst des Alterthums, or History of Ancient Art: Among the Greeks*. London: John Chapman.

Winterer, Caroline. 2002. *The Culture of Classicism: Ancient Greece and Rome in American Intellectual Life, 1780–1910*. Baltimore, MD: Johns Hopkins University Press.

Yegül, Fikret. 1995. *Baths and Bathing in Classical Antiquity*. New York: Architectural History Foundation.

The Yorkville Branch of the New York Public Library. 1967. New York: Landmarks Preservation Commission.

ELIZABETH MACAULAY-LEWIS is Associate Professor of Liberal Studies and Middle Eastern Studies. She is also the Executive Officer of the MA Program in Liberal Studies at The Graduate Center, The City University of New York.

ESE

Select titles from Empire State Editions

Dorothy Day and the Catholic Worker: The Miracle of Our Continuance. Edited, with an Introduction and Additional Text by Kate Hennessy, Photographs by Vivian Cherry, Text by Dorothy Day

Mark Naison and Bob Gumbs, *Before the Fires: An Oral History of African American Life in the Bronx from the 1930s to the 1960s*

Robert Weldon Whalen, *Murder, Inc., and the Moral Life: Gangsters and Gangbusters in La Guardia's New York*

Joanne Witty and Henrik Krogius, *Brooklyn Bridge Park: A Dying Waterfront Transformed*

Sharon Egretta Sutton, *When Ivory Towers Were Black: A Story about Race in America's Cities and Universities*

Pamela Hanlon, *A Wordly Affair: New York, the United Nations, and the Story Behind Their Unlikely Bond*

Britt Haas, *Fighting Authoritarianism: American Youth Activism in the 1930s*

David J. Goodwin, *Left Bank of the Hudson: Jersey City and the Artists of 111 1st Street.* Foreword by DW Gibson

Nandini Bagchee, *Counter Institution: Activist Estates of the Lower East Side*

Susan Celia Greenfield (ed.), *Sacred Shelter: Thirteen Journeys of Homelessness and Healing*

Elizabeth Macaulay-Lewis and Matthew M. McGowan (eds.), *Classical New York: Discovering Greece and Rome in Gotham*

Susan Opotow and Zachary Baron Shemtob (eds.), *New York after 9/11*

Andrew Feffer, *Bad Faith: Teachers, Liberalism, and the Origins of McCarthyism*

Colin Davey with Thomas A. Lesser, *The American Museum of Natural History and How It Got That Way.* Foreword by Neil deGrasse Tyson

Wendy Jean Katz, *Humbug: The Politics of Art Criticism in New York City's Penny Press*

Lolita Buckner Inniss, *The Princeton Fugitive Slave: The Trials of James Collins Johnson*

Mike Jaccarino, *America's Last Great Newspaper War: The Death of Print in a Two-Tabloid Town*

Angel Garcia, *The Kingdom Began in Puerto Rico: Neil Connolly's Priesthood in the South Bronx*

Jim Mackin, *Notable New Yorkers of Manhattan's Upper West Side: Bloomingdale–Morningside Heights*

Matthew Spady, *The Neighborhood Manhattan Forgot: Audubon Park and the Families Who Shaped It*

Robert O. Binnewies, *Palisades: The People's Park*

Marilyn S. Greenwald and Yun Li, *Eunice Hunton Carter: A Lifelong Fight for Social Justice*

Jeffrey A. Kroessler, *Sunnyside Gardens: Planning and Preservation in a Historic Garden Suburb*

For a complete list, visit www.fordhampress.com/empire-state-editions.